PHOTO BY
SAMMY DAVIS, JR.

SAMMY

Text by BURT BOYAR

PHOTO BY
DAVIS, JR.

REGAN *An Imprint of HarperCollinsPublishers*

Also by Burt Boyar:

Yes, I Can. The Story of Sammy Davis, Jr.
with Sammy Davis, Jr., and Jane Boyar

Why Me? The Sammy Davis, Jr., Story
with Sammy Davis, Jr., and Jane Boyar

Sammy: The Autobiography of Sammy Davis, Jr.
with Sammy Davis, Jr., and Jane Boyar

H.L. and Lyda by Margaret Hunt Hill
with Burt Boyar and Jane Boyar

World Class
with Jane Boyar

Hitler Stopped by Franco
with Jane Boyar

HarperCollins books may be purchased for educational, business, or sales promotional use. For information please write: Special Markets Department, HarperCollins Publishers Inc., 10 East 53rd Street, New York, NY 10022.

FIRST EDITION

Book and cover design: Stephen Schmidt / Duuplex

Library of Congress Cataloging-in-Publication Data has been applied for.

ISBN-13: 978-0-06-114605-3
ISBN-10: 0-06-114605-6

07 08 09 10 11 TP 10 9 8 7 6 5 4 3 2 1

For Jane
and for our beloved friend,
Al G. Hill, Jr.

CONTENTS

FOREWORD VIII

CHAPTER 1
THE EARLY YEARS 3

CHAPTER 2
WITH THE BOYS 27

CHAPTER 3
THE RED CARPET 69

CHAPTER 4
THE FAMILY ROOM 223

CHAPTER 5
THE STRUGGLE 247

CHAPTER 6
IMAGES FROM THE ROAD 277

AFTERWORD 336

ACKNOWLEDGMENTS 338

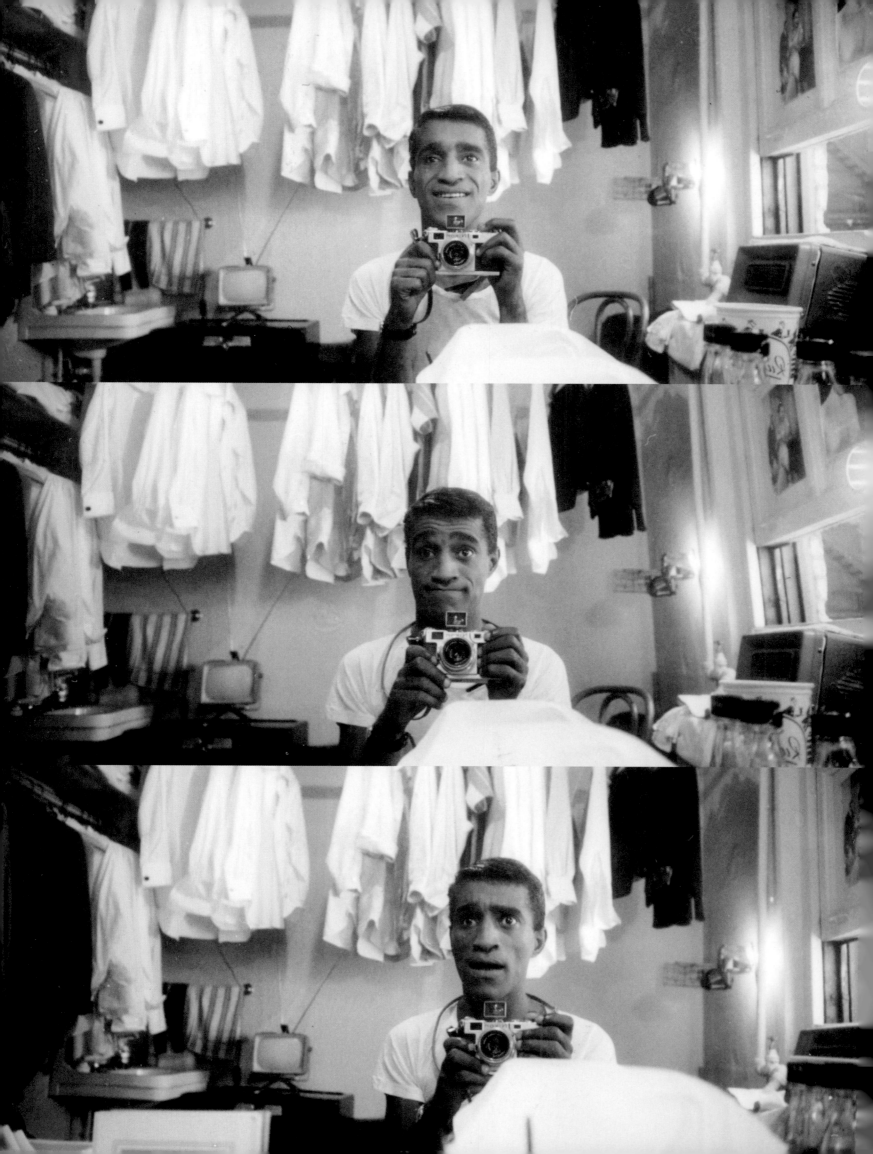

FOREWORD

In the downstairs office of Sammy's Beverly Hills home on Summit Drive, there was a waist-high cabinet that ran the length of the twenty-five-foot wall. It had two shelves filled with the newest of every kind of camera made, with lenses and filters for all of them. I am certain that no professional photographer ever owned half the photography equipment that Sammy had.

"Jerry [Lewis] gave me my first important camera, my first 35 millimeter, during the Ciro's period, early '50s," Sammy told me. "And he hooked me. Then, during *Mr. Wonderful*, the musical [1957–58] when I was in New York for a year I met Milton [Greene]. He got me involved with serious photography and using available light."

Milton Greene's son Joshua once said: "Milton taught Sammy to see as a camera. It may sound rough, but having one eye was an advantage to Sammy as a photographer because it eliminated the peripheral vision and depth. With only one eye he saw as a camera lens sees."

As Sammy's knowledge grew, so did his obsession with having the latest and best equipment. "Of course once I had a little education I needed a new Nikon this and a Canon that, both with eighteen lenses and sixty-two filters. In terms of addiction I think there is nothing more powerful than men's toys. This may sound a little paranoid but I am positive that somewhere in Germany, in Japan, there are men awake in the middle of the night, thinking, 'Now, Sammy Davis has an extra $50,000, let's think of something he doesn't have that we can sell him, the ultimate, the definitive... he'll jump to be the first one to have it and we'll get that $50,000.' I am positive of that. I am positive that they sit and plot and plan, because whenever I think I've got the ultimate, the definitive of anything, somebody says, 'We're here, with the newest, the latest.' I'm positive of it, man."

When Sammy first started taking pictures, he used a Brownie or whatever inexpensive camera was available. "In 1945 I was playing the Beachcomber in Florida. Steve Lawrence was down there, too, in the army, doing a Special Services camp show, and we went to my hotel and hung out. Steve said, 'Oh, you've got the new Polaroid. I just got some stock in that. You ought to buy some, too.'

"I said, 'Stock? What stock?'

"Steve said, 'I bought it for two dollars a share.'

"'Two dollars? For a piece of paper?' But complete dumbness. 'Stock? How do you know the stock market won't crash? You don't blow good money, you have fun with it. First of all, ain't nobody going to buy these Polaroids unless they want to take dirty pictures. That's what I got it for, so I can take pictures of chicks' boobs. And nudes. You can't send them to a drugstore to get developed 'cause when you come to get your pictures the guy looks at you and his face twists and he hisses, 'You degenerate!' Now, you could have been doing a nude study, art, with serious lighting and everything, but it wouldn't matter, the druggist who gives you your film would look at you like this, 'You filthy sex fiend . . . taking nude pictures. . . .'''

But Sammy's adolescence passed and he became a serious photographer. "The best pictures I ever took were in New York, during *Mr. Wonderful*. I'd go picture taking, walk the streets. First of all, in those days [late 1950s] you were safe, comparatively safe. I'd go down Avenue of the Americas, get down to 42nd Street, walk up and down, and drunks would be stumbling around, bums, and I had my Rollei around my neck, blue jeans and a pea jacket, and just take pictures and nobody would notice you or bother you. I couldn't do it anymore because of the popularity. And because of the danger. Nobody could do it anymore. In the '40s they talked about war photographers. Well, a guy that does street photography today [the '80s], he's a war photographer. He really is. He's out there with that 35 . . . oughta get combat pay. Because when you see those gritty stories about the drug operations and this guy's in there taking pictures, he's taking his life in his hands.

"I carry a lot of my cameras on the road with me. I've gotten some of the greatest pictures from the penthouse suites of every important hotel all over the world: from Japan, from Germany, England to Paris, the Philippines, Australia . . . just great shots. And a lot of wasted shots. But that's where I take my pictures now. The flip side of this popularity is I no longer have the privilege of walking the streets without attracting crowds, so being confined to the hotels, that's where I shoot from."

"When are you going to take me to El Morocco?" Sammy asked one night. Despite the glory of starring on

Broadway in *Mr. Wonderful*, he knowingly insisted that I call ahead to New York's "chic" nightclub to let them know I was bringing him. Ladies of the evening and pornographers were welcome at Morocco, so were dark-skinned men if they wore turbans. As I dialed the number Sammy picked up a camera and kept himself busy shooting pictures through the window of his penthouse suite at the Hotel Gorham. He was using the camera as a prop as he heard me having a heated conversation with the racist maitre d' who asked, "He's very dark, isn't he?" When I hung up my face surely was blanched because Sammy forced a smile and said, "It's okay to be white, but you're overdoing it."

We didn't go to the club that night, but the call wasn't wasted. One of the pictures he shot through his window became the cover of an instrumental album, *Manhattan Towers*.

Sammy's camera often served as a shield, a barrier to conversations he didn't want to have with people he didn't want to know. Nobody interrupts a man taking a picture to ask "fan" questions, or worse: "What's that nigger doin' in here?"

Largely, I think Sammy employed photography as an extension of his artistic self. You can't sing, dance, and tell jokes all day and all night. So, when he could, he wandered the streets, camouflaged in blue jeans, hat, sunglasses, oversized coat, and preserved the ironic: a drunk sleeping it off on the street in front of a liquor store called "Fine Wines." He captured the beauty of children's innocent faces, the despair of places he had lived as an underprivileged child. And he used his camera and his talent as a gift to friends, taking our pictures and always giving us 11 x 14 prints of what he liked, the way he saw us.

Sammy danced, joked, sang, did impressions, played instruments, and was a fine actor. Everything he did was world class. He was a gentleman, a nobleman, a bon vivant, a humanitarian, and the Great American Hipster.

My dear, late wife Jane and I met Sammy in the '50s and had a friendship that deepened over the almost fifty years that followed. We were privileged to be present when many of these photos were taken. The stories that accompany them are from taped conversations Sammy and I had over the course of our friendship. We used a handful of them in Sammy's autobiographies *Yes I Can* and *Why Me?*, but many are being told here for the first time.

SO, WITHOUT
FURTHER ADO,
I GIVE YOU YET
ANOTHER FACET
OF THE WORLD'S
GREATEST
ENTERTAINER
SAMMY DAVIS, JR.
—PHOTOGRAPHER

—Burt Boyar

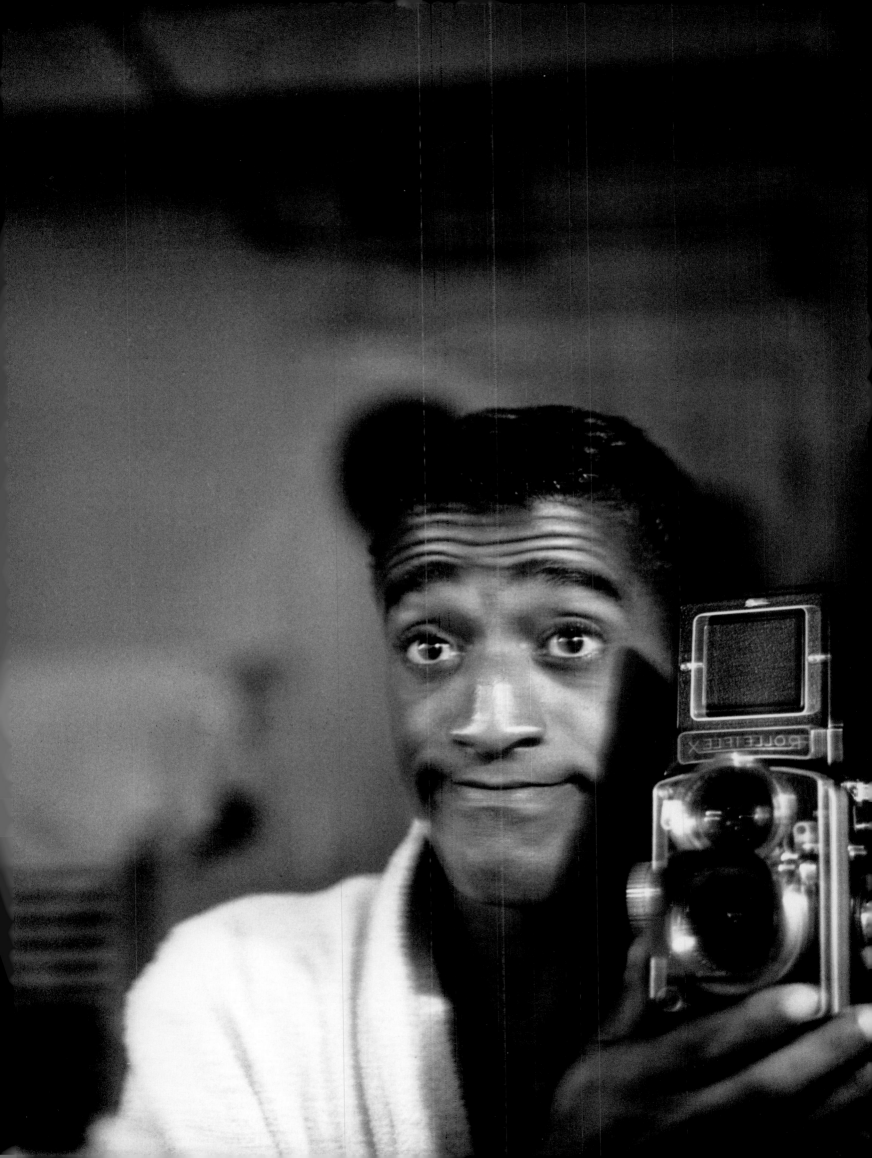

CHAPTER 1
THE EARLY YEARS

SAMMY WAS BORN IN HARLEM ON DECEMBER 8, 1925.

HIS FATHER, SAM DAVIS, SR., WAS THE LEAD DANCER IN WILL MASTIN'S *HOLIDAY IN DIXIELAND*, A VAUDEVILLE TROUPE IN WHICH HIS MOTHER, ELVERA "BABY" SANCHEZ, WAS A TOP CHORUS GIRL.

Good jobs were scarce, so Elvera remained in the line until two weeks before Sammy was born. As soon as she was able to dance again she boarded him with some friends and went back on the road. Sam Sr.'s mother, Rosa B. Davis, who worked as a housekeeper, went to see how her grandson was doing and wrote to Sam Sr., "I never saw a dirtier child in my life. They leave Sammy alone all day so I've taken him with me. I'm going to make a home for that child."

Sam Sr. and Elvera separated a few years later, and she went to work in another touring show called *Connors' Hot Chocolate*. Sam Sr. went home to get Sammy. Rosa B. ("Mama") protested but Senior was adamant: "I'm his father and I say he goes on the road. I ain't leavin' him here so's Elvera can come in and take him away. I want my son with me." When the train moved into the tunnel of Pennsylvania Station, Sammy finally stopped waving goodbye to Mama and settled back in his seat. As his father removed Sammy's coat and hat, the child asked, "Where we goin' Daddy?" Sam Sr. smiled and put his arm around his boy. "We're goin' into show business, son."

OPPOSITE: Sammy's parents, Sam Davis, Sr. and Elvera Sanchez

PAGES VIII AND 1: Sammy taking self-portrait photos in a mirror

PAGE 2: Sam Davis, Sr.

ABOVE: Sam Davis, Sr. (left) and Will Mastin

OPPOSITE: Sam Sr. (right) and Nathan Crawford in the 1940s.
This is one of Sammy's vintage pictures, probably taken with a
Brownie camera.

WEST SIDE, VEGAS, 1940s

West Side was the section of Las Vegas in which Sammy had to live until he "made it." The landlady gouged him on the rent. When Will Mastin heard the price he almost choked. "But that's probably twice what it would cost at El Rancho Vegas." "Well," said the landlady, "Then why don't you go live at El Rancho Vegas?" As Will counted out the first week's rent, Sr. smiled sardonically, "Looks like if the ofays* don't get us, then our own will." People used to marvel, "Where does he get the energy?" In truth, he got it from escaping places like this where he once used to I ve.

*Ofay: pig latin for "foe."

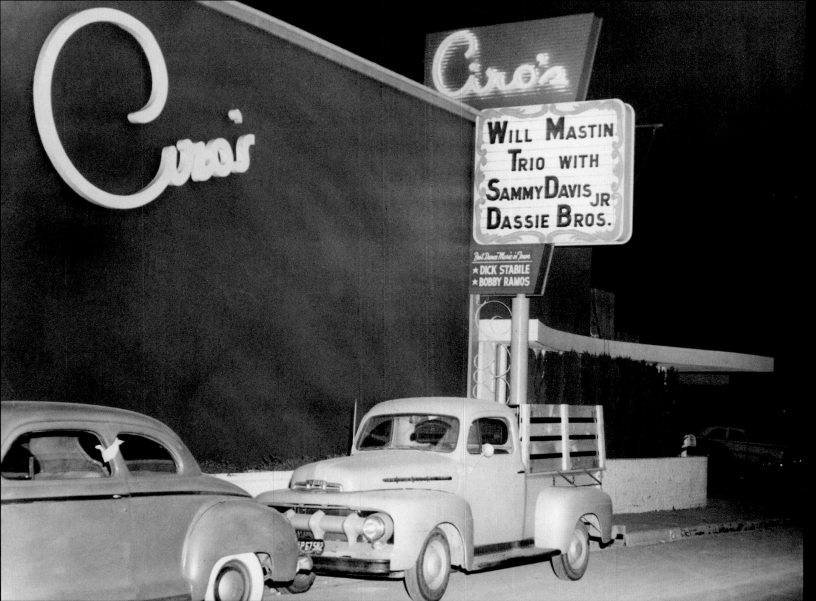

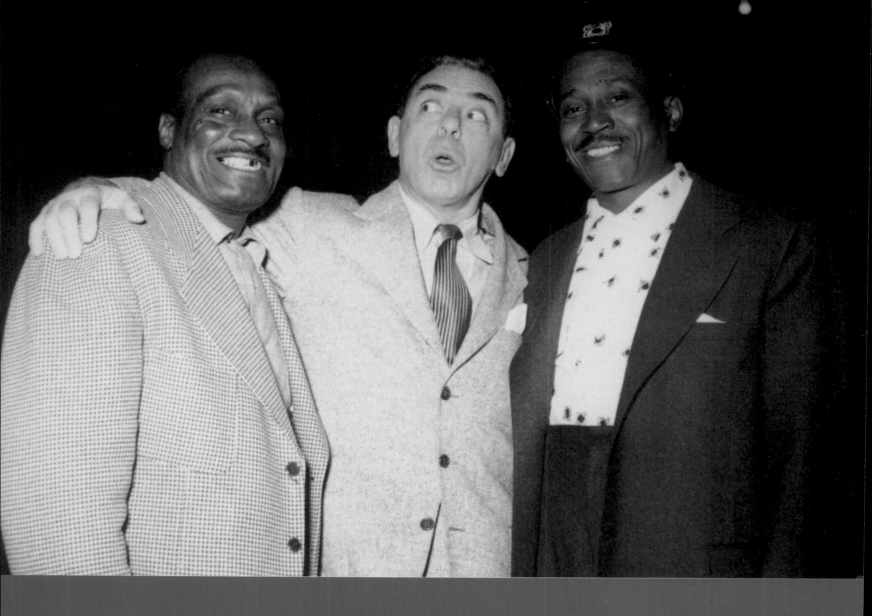

THE COLGATE COMEDY HOUR

Eddie Cantor was one of America's great vaudevillians, in the same league as Al Jolson and Bill "Bojangles" Robinson. He became a television star with a hugely successful show *The Colgate Comedy Hour*. He hired Sammy and the Trio. According to Sammy, this became a great break for them. "My father, Will, and I took our bows. They went off and I stayed on to join Mr. Cantor. They were still applauding when he came on. He hugged me and took a handkerchief from his pocket and blotted my face, beaming at me like a proud father." A few days later NBC forwarded Sammy's fan mail. The bundles and bundles of "fan" mail turned out to be an avalanche of hate mail castigating Eddie Cantor and the network for putting a black man on the show. Sammy assumed his career with *The Colgate Comedy Hour* was over. But despite pressure from the sponsors and the network, Cantor offered the Trio a contract for the rest of the season. "How could you figure it? Here there were people going out of their way to kick me in the face with nothing to gain by doing it, then along comes a man like Eddie Cantor with everything to lose, but he deals himself into my fight and says, "They'll have to kick me too."

ABOVE: Will Mastin, Eddie Cantor, and Sam Davis, Sr.

OPPOSITE: Marquee at the Flamingo in Las Vegas

GRUEN WATCH TIME

HOTEL *Flamingo*

ALWAYS OPEN ··· EVERYONE WELCOME

MYRON COHEN
WILL MASTIN TRIO
SAMMY DAVIS JR

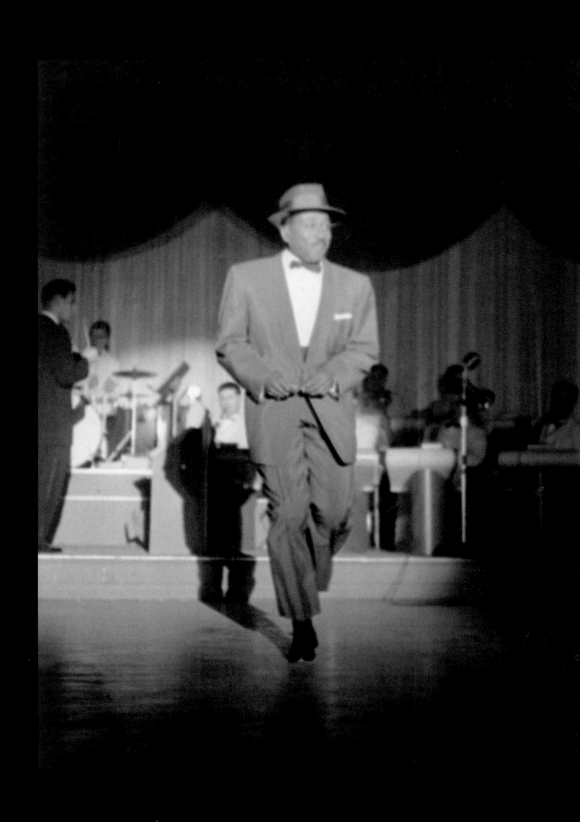

ABOVE: Sam Sr.

OPPOSITE: Will Mastin

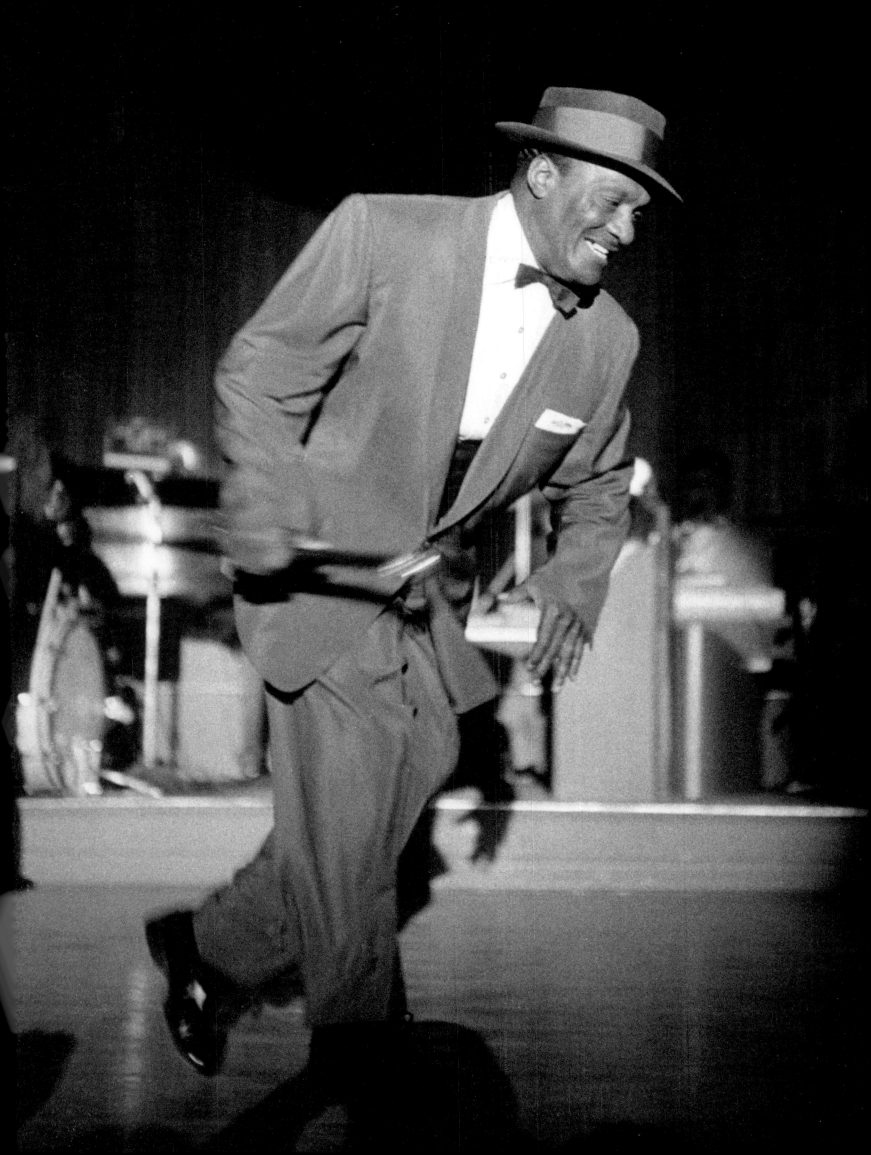

IT WAS OSCAR NIGHT, 1951,
AND ALL HOLLYWOOD ENDED THE EVENING AT CIRO'S TO CHEER ON THEIR FRIEND JANIS PAIGE. AMONG THEM WERE DEAN MARTIN & JERRY LEWIS, THE HOTTEST COMEDY ACT IN THE BUSINESS.

JERRY LEWIS

No one could have foreseen that the opening act, the virtually unknown Will Mastin Trio featuring Sammy Davis, Jr., would be so powerful, so endearing to the audience that they literally would not let Sammy off the stage. Standing on their feet, at least fifty major movie stars were pounding on the tables, demanding more and more. Sammy did encore after encore. Finally, with nothing left in his repertoire, he ended with an impromptu, wildly adrenalized impression of Jerry Lewis. That wrecked them. Totally. Nothing could follow that. The show was over and Sammy Davis, Jr., had just become a star.

Even the critics went crazy. *The Hollywood Reporter*: "Once in a long time an artist hits town and sends the place on its ear. Such a one is young Sammy Davis, Jr., of the Will Mastin Trio at Ciro's." Paul Coates in the *Mirror*: "The surprise sensation of the show was the Will Mastin Trio, a father-uncle-son combination that is the

greatest act Hollywood has seen ... [They] left the audience begging for more." And in the *Los Angeles Times*: "The Will Mastin Trio, featuring dynamic Sammy Davis, Jr., are such show stoppers at Ciro's that star Janis Paige has relinquished the closing spot to them."

The next night, after the show, Sammy was in his "dressing room," a corner of Ciro's attic. He heard someone clearing his throat. Jerry Lewis was banging his fist against the wall. "I'd knock on

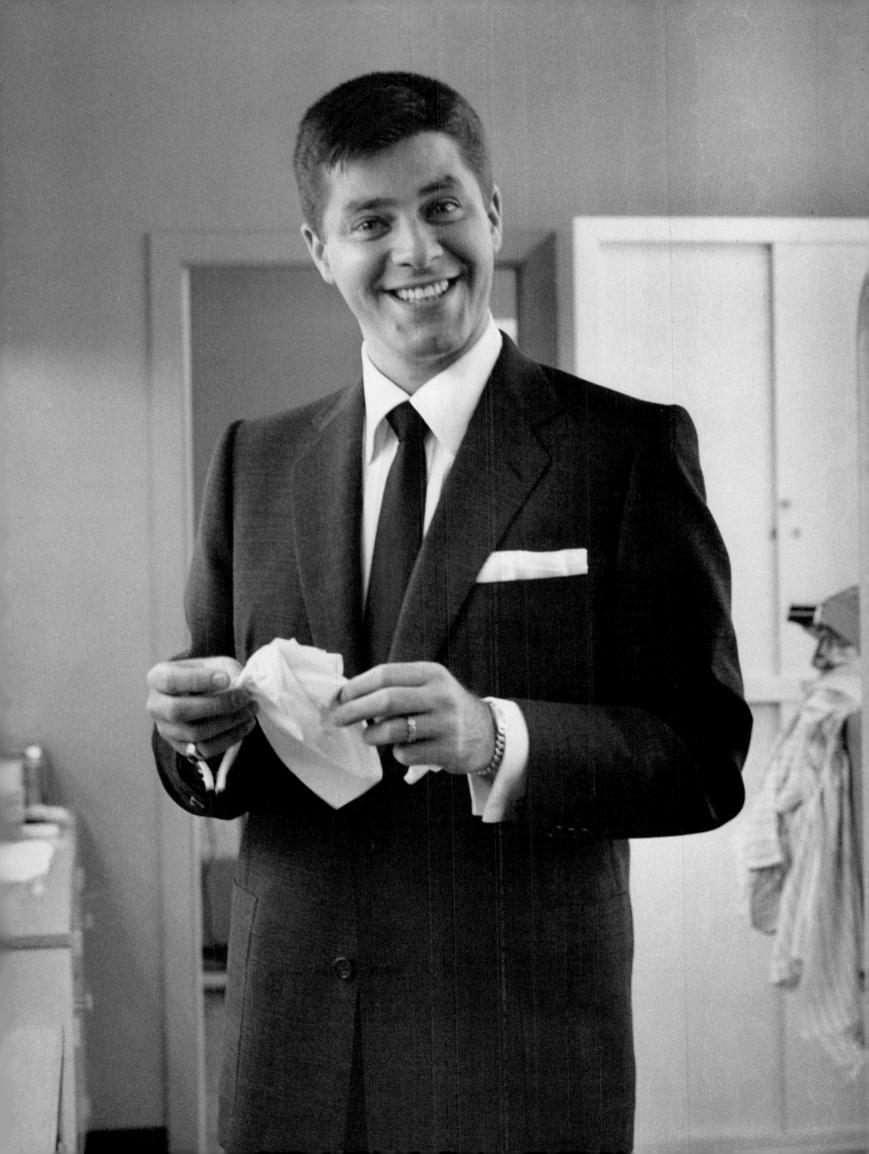

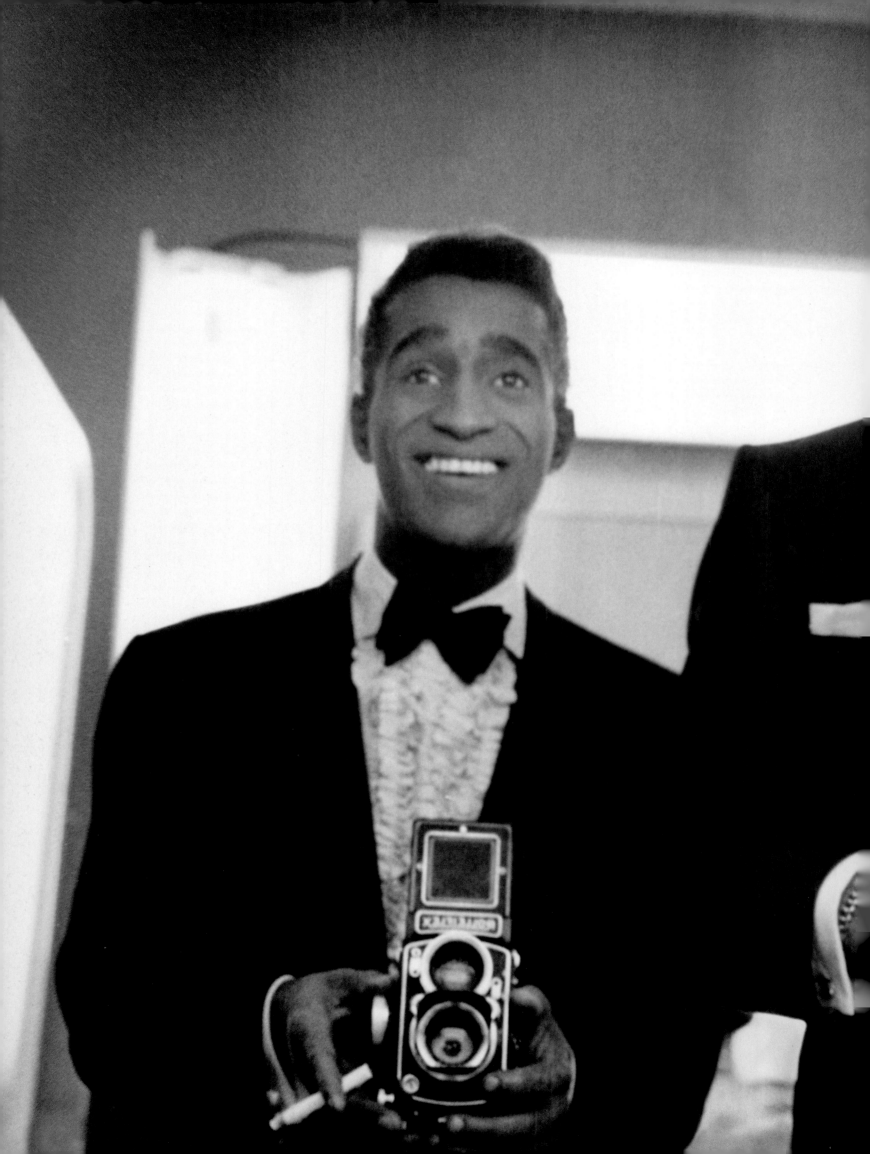

the door if you had one. May I come in?"

"Mr. Lewis! Of course, please," Sammy said. Sammy pulled up a chair and almost pushed him into it.

"Don't give me a 'Mister.' I'm a Jerry, not a Mister. How can we be friends if we're 'misters' and you'll call me up, saying 'Hello, Mister, let's have dinner tonight'?" Jerry smiled. "I came back because I love the act and if you don't mind I'd like to give you a little advice."

Sammy was thrilled. "Mind? My God. Are you kidding? Please do."

Jerry shouted, "Get outta the business! I don't need such competition. I don't want it, I was doing fine. Who asked you to come along?" Sammy laughed hysterically. Later he told me, "The idea of him sitting in our ridiculous dressing room and doing bits with me was too much."

But Jerry did have some serious advice for Sammy. "Now listen, you shouldn't hit me in the mouth from what I'll tell you 'cause it's only good I mean you. Okay? Sammeleh, you're a great performer, but you're making some mistakes. I'll tell you what I saw and maybe you'll change a few little schticks; it'll be nice, it'll be better for the act; the people should like you even more." Jerry reached into his pocket and took out a wad of notes. "First of all, you talk too good."

"That's how I speak," Sammy said. "What do you expect me to say, 'Yassuh ladies and gen'-men'? Look, I appreciate your interest, but not all Negroes talk that way . . ."

Jerry continued. "Ah-hah! You promised you wouldn't get angry. But I'll forgive you. Just listen to yourself. You don't talk that way now, in here with me. You talk nice, like a regula fella. But I know Englishmen who don't talk as good as you did onstage with such an accent. Sam,

people don't go for that English crap, not from you and me."

Sammy was stunned. Jerry had said "You and me." He wasn't putting the Mastin Trio down as another Negro act that should shuffle around and say, "Yassuh, folks." He was speaking as one performer to another.

"I don't mean you should come on and do Amos and Andy. I just mean you talk *too* good. Let's face it, American you are, but the Duke of Windsor you ain't."

"I'm not sure I know what you mean."

"Sammy, you walk on and you say, 'Ah, yes, time, with your very kind permission we have some impersonations to offer. We do hope you'll enjoy them."

"I sounded like a colored Laurence Olivier," he admitted later. "In trying to elevate myself I had gone from one extreme to the other. And there was no honesty in it. I wasn't leveling with the audience. It was phony. Luckily I hadn't done enough of it to stifle whatever they saw in me that they liked, but I could see that if I kept it up eventually my personality would become buried beneath an English accent just as surely as it had been buried beneath 'Yassuh.'

"YOU WANT MASS APPEAL! YOU CAN'T AFFORD TO MAKE THE AVERAGE GUY FEEL LIKE HE'S AN ILLITERATE. YOU'VE GOT TO BRING YOURSELF DOWN."

hello there, ladies and gentlemen.' That's an English actor! Forget it. Nobody is gonna like a guy who sings and dances and tells jokes as good as you, and who talks that good, too. You want mass appeal! You can't afford to make the average guy feel like he's an illiterate. You've got to bring yourself down.

"Not colored, but a little less grand . . . When you figure they like you—when you've got them, and they're thinking: 'Hey, this guy's okay, he's like me'—then you can switch it and talk good. When they figure you're just a simple kind of a bum, then surprise them with it. But save it, hold it back, let it work for you."

As Jerry spoke, Sammy realized he'd been saying things like, "Ladies and gentlemen, at this

"Jerry was pointing out things only another performer could see. Nobody else had ever done this for me. Nobody whose opinions I could respect above my own had ever sat in the audience with a pad on his knee and made notes, trying to help me."

Jerry's advice: "In all these things, find a happy medium. Just keep them in mind and you'll know how to do them."

"Jerry," Sammy said, "This is the greatest advice I ever got in my life. I just don't know how to thank you.

"He was on his feet, glaring at me. 'You wanta thank me? Then like I said in the first place, get outa the business. That'll be a thank you.' We shook hands and he smiled, 'Let's see each other.'"

Dean Martin and Jerry Lewis on a movie set before
their breakup.

S-48-263

TAHOE
Harrah's

Harrah's

SAMMY DAVIS JR
RALPH POPE
SPECIAL ADDED ATTRACTION
LAURINDO ALMEIDA
3RD SHOW FRI & SAT 2.15 AM

HARRY JAMES
ERNIE ANDREWS JUDY BRANCH
SONNY PAYNE
JIMMY WAKELY

FREE
PARKING

SAMMY'S "REAL MONEY" DATES

WERE HARRAH'S CLUB IN LAKE TAHOE AND RENO, AND THE HOTELS HE PLAYED IN LAS VEGAS.

HARRAH'S, LAKE TAHOE

Bill Harrah was the first club/casino operator to recognize the value of keeping his star attractions as happy as money could make them. There were no limits to the extras they needed only to ask for: suites for their friends, champagne, caviar, the finest Bordeaux—anything. At Lake Tahoe, Bill Harrah provided the stars with a house on the lake, staffed by a cook and butler, with all the support necessary from the hotel. Sammy preferred to stay in the Presidential Suite at the hotel for security, so when Jane and I were visiting, he gave us the house. When we ordered lamb chops and red wine from the cook for dinner before going over to catch his show, they served us each an entire rack of lamb and a great vintage of Chateau Lafite-Rothschild.

During the day we browsed through the kitchen and pantry, and the butler showed us the supply of Oreo cookies they had "for Mr. Sinatra," as well as the special foods preferred by Connie Francis, Bill Cosby, Dean Martin—everyone who played there.

Jane and I were heading out to play tennis one day when we ran into Sammy. When he saw us in our whites he said, "You need a different car, something to go with what you're wearing." The next day, Bill Harrah, a Rolls Royce dealer as well as casino owner, provided us with a white Rolls convertible, with white leather seats. We took huge bath towels with us to cover the seats after we'd finished hitting for an hour and a half.

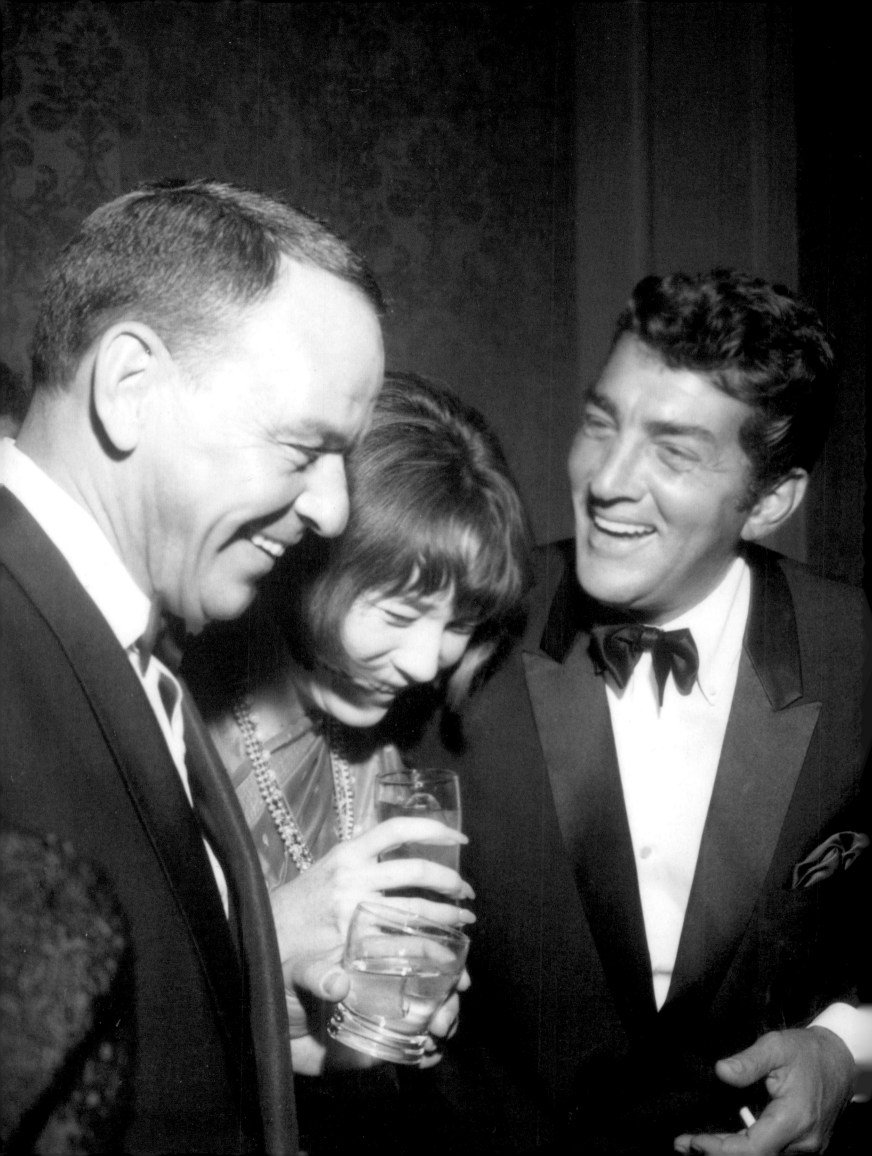

CHAPTER 2
WITH THE BOYS

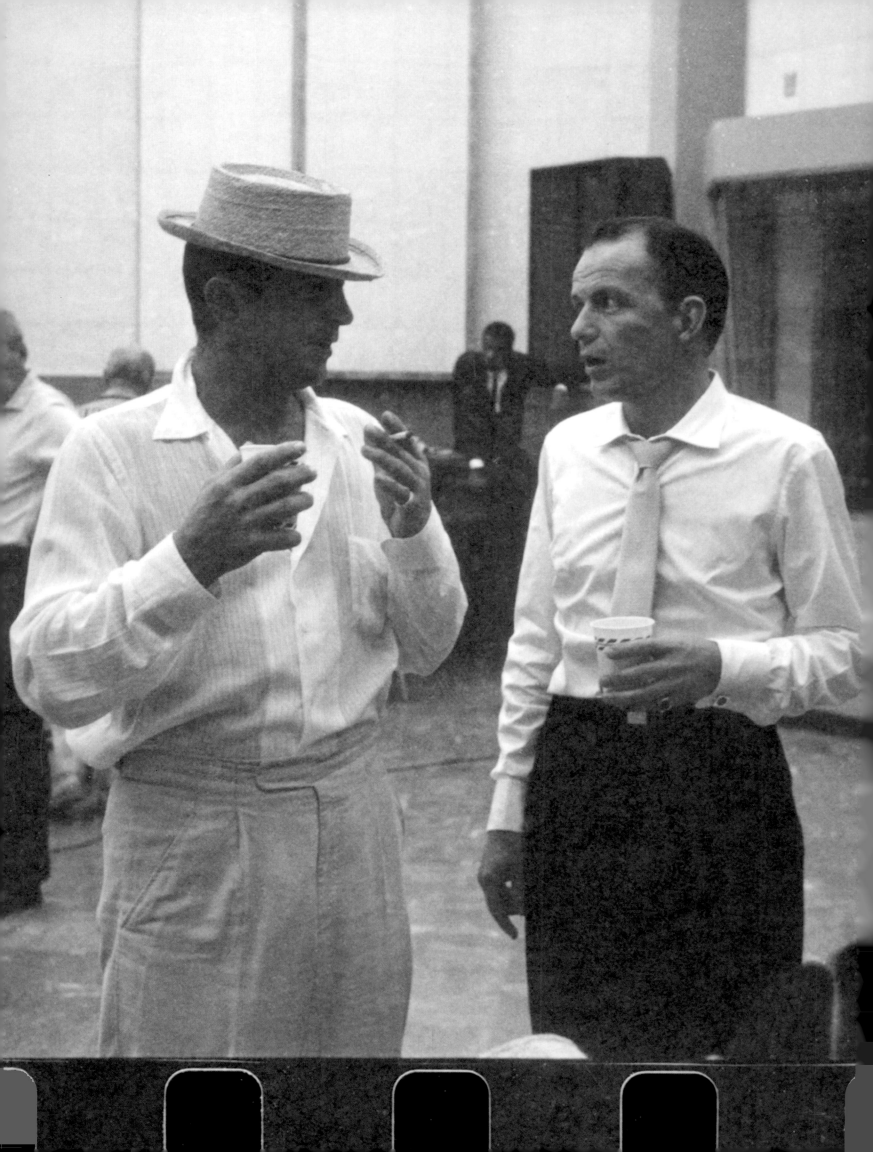

IN SHOW BUSINESS MYTHOLOGY, "THE RAT PACK" WAS FRANK SINATRA DEAN MARTIN SAMMY DAVIS, JR. PETER LAWFORD AND JOEY BISHOP LIVING, PERFORMING, AND BOOZING, AS A MONOLITHIC GROUP OF PALS.

It all started in 1960 when Frank Sinatra made a multipicture production deal. The first was *Ocean's Eleven*, an attempted heist of a Las Vegas casino. He cast Dean, Sammy, Peter, and Joey and said, 'We all normally play The Sands so we'll stay there and whoever feels like doing the shows that night . . .'' As it turned out, they all did all the shows together almost every night because they had so

OPPOSITE: Frank Sinatra and Dean Martin taking a break during a recording session.

PAGE 26: Frank Sinatra, Dean Martin, and Shirley MacLaine

much fun clowning onstage together—like when they wheeled out a room service table full of bottles and glasses—and ad-libbing hilariously. Their acts, what they did with them, were never better than those days, because they were performing for each other.

News of these three superstars, plus Peter and Joey, creating bedlam on the same stage every night spread around the world in about fifteen seconds. Suddenly, Las Vegas overflowed with people willing to live in their cars, just in hope of getting a look at this kind of glamour. An English journalist wrote that Frank, Sammy, Dean, Peter, and Joey filmed together, performed onstage together, drank all night long together, hit the steam room together every day and, in general, moved like a rat pack. Sinatra was quick to see the commercial value and encouraged the image.

But all too soon it ended. With the movies completed it was time for this gang to go their separate ways. As nightclub performers, they were always traveling individually and performing in different parts of the world. More important, when occasionally they were together, Frank was the only one who wanted to stay up all night and drink. Dean always left everybody after the second show and went to his room so he could be up in the morning to play golf. Sammy could usually last until around 4 a.m., but even he couldn't handle Frank's hours. But despite it being virtual fiction, the idea and the name "The Rat Pack" stuck and survives to this day because, in Sammy's words, "You can think you have all the smarts in the world, but finally it's the people who decide." And the people wanted The Rat Pack.

OPPOSITE: Frank Sinatra onstage

OVERLEAF: Frank Sinatra and Dean Martin in their dressing room, waiting to go on.

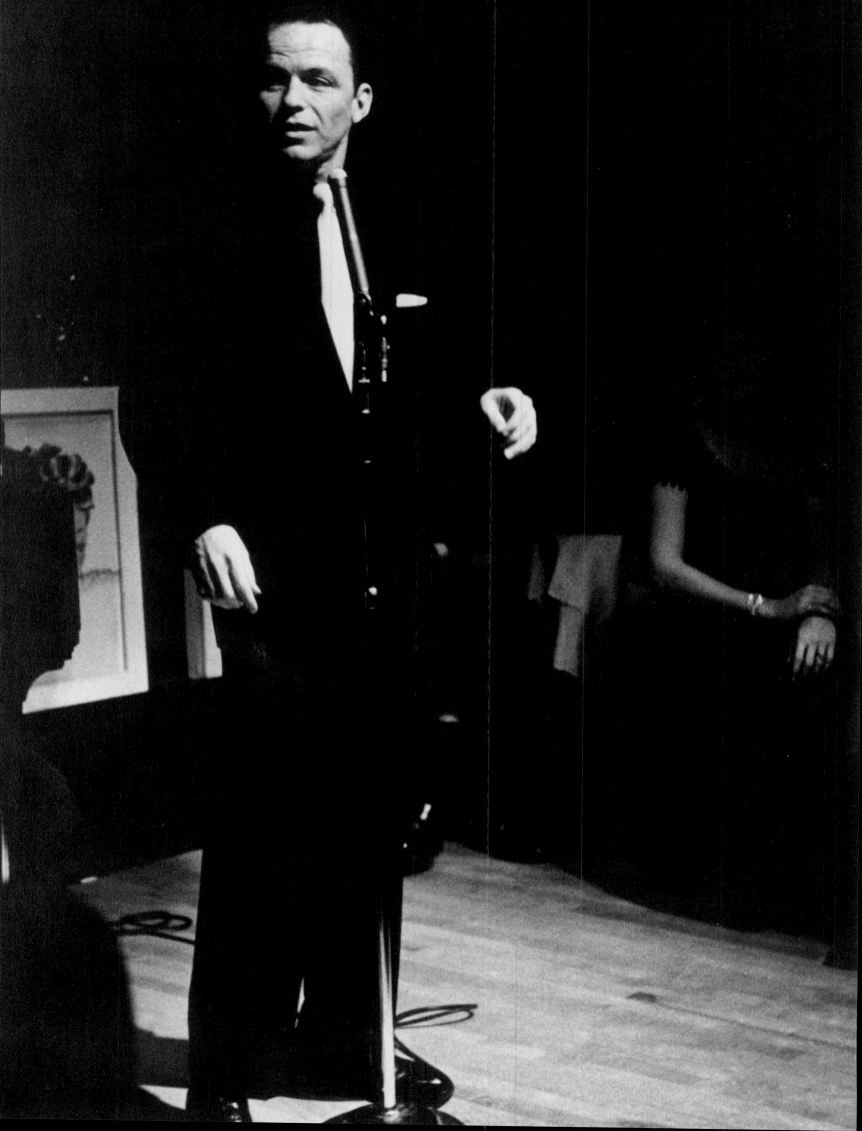

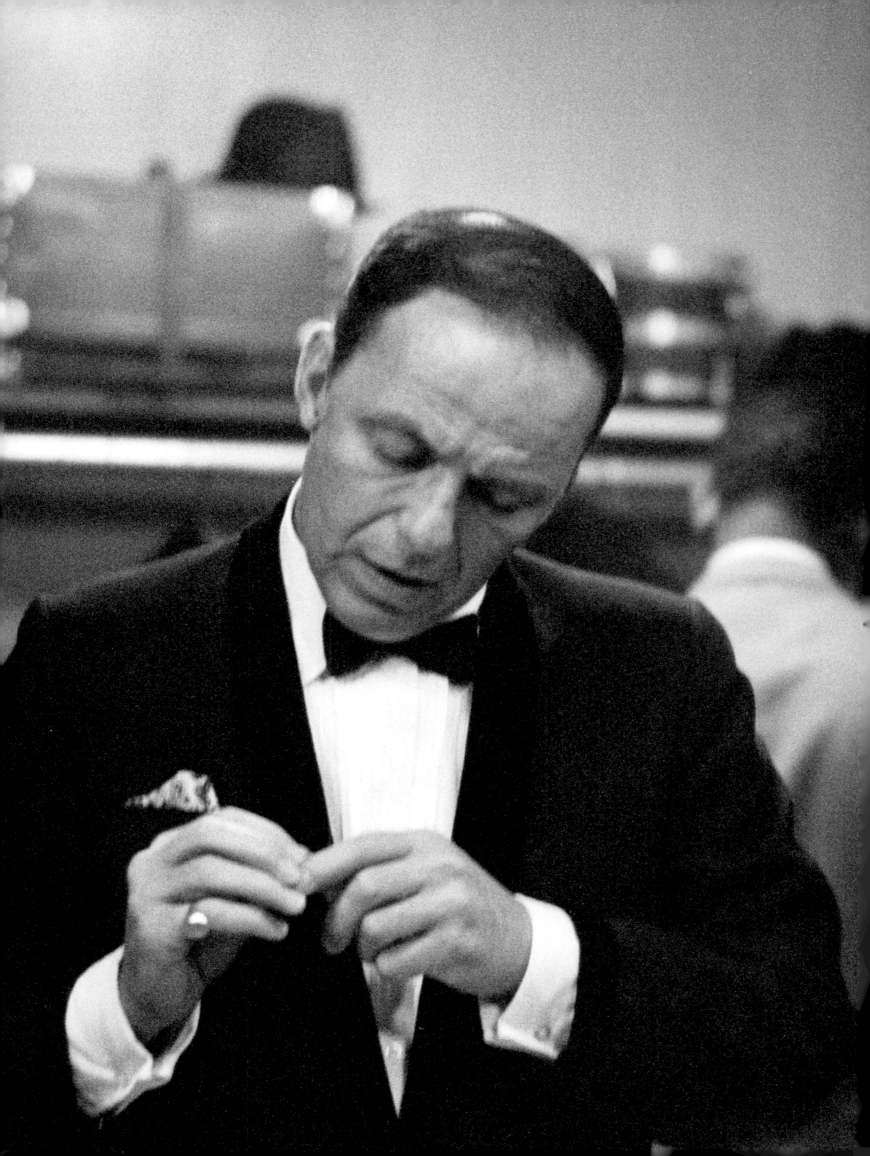

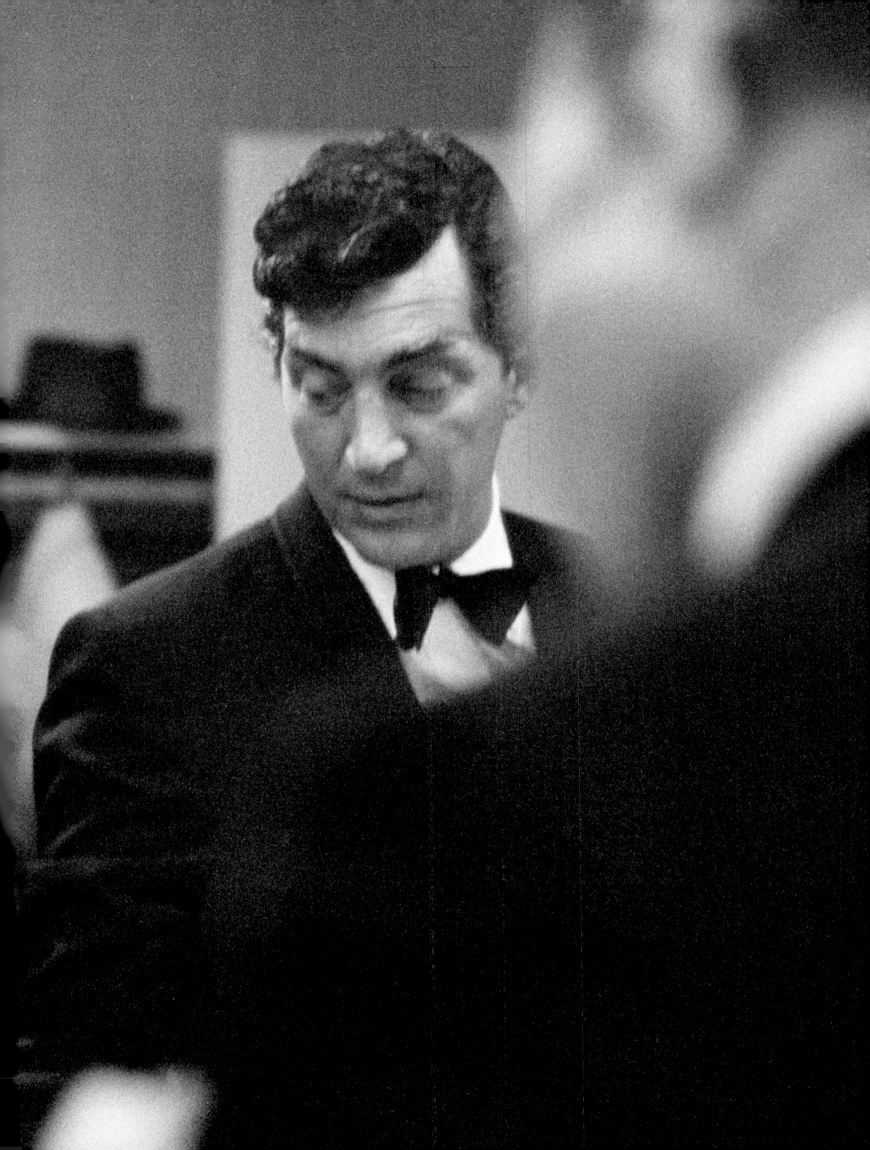

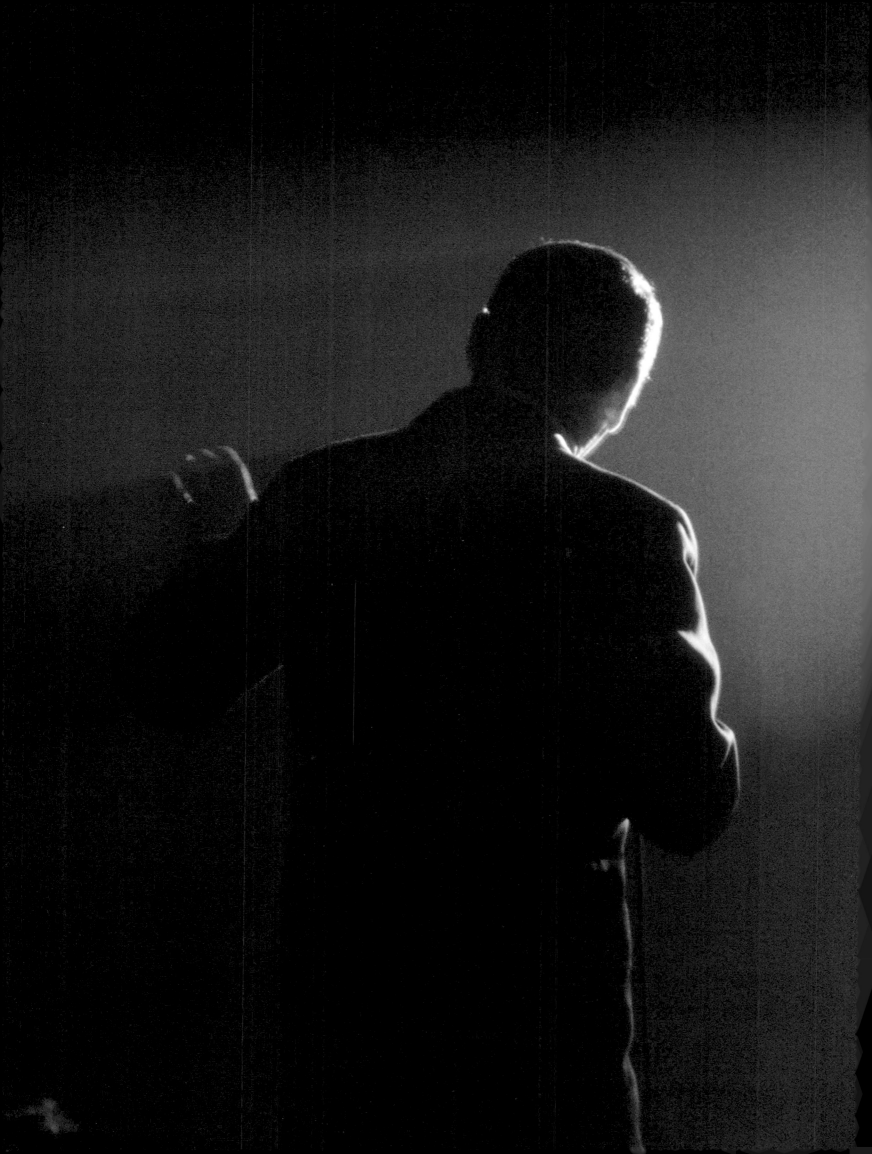

FRANK WAS IN CONTROL EVERYWHERE, BUT NEVER SO MUCH AS ON A NIGHTCLUB STAGE. THIS WAS HIS LAST TIME AT THE COPACABANA IN NEW YORK.

FRANK AT THE COPA

He had won the Oscar for *From Here to Eternity* and he was back on top. He had a movie career for the taking, and was making a last round of night clubs in 1965 as a favor to the friends who owned them. The engagement at the Copa was 100 percent sold out with three shows a night, just on the rumor that Frank would be appearing for ten nights. There was no item in the gossip columns, no ad in the paper, just the rumor, and you couldn't even bribe the headwaiter for a table. Sammy was starring on Broadway in *Golden Boy* and he had a ringside table for ten for every midnight show. Jane and I were his hosts until he could get over from the theater.

Opening night was so completely filled with all the big stars that major celebrities like Marlene Dietrich and Joe DiMaggio had small tables in the back of the room. Head hood Frank Costello, the secret owner of the Copa, rarely seen publicly, came out for this one and was discreetly present among the revelers. Halfway through the run of performances, Humphrey Bogart died. Frank went back to Los Angeles for the funeral and to comfort Lauren

Bacall Bogart. That would have been a nightmare for the Copa and Jules Podell who ran it, but Frank asked Sammy to take over the midnight shows. Jerry Lewis did the supper shows, and they worked together, creating pandemonium for the 2:00 a.m. overflow crowd.

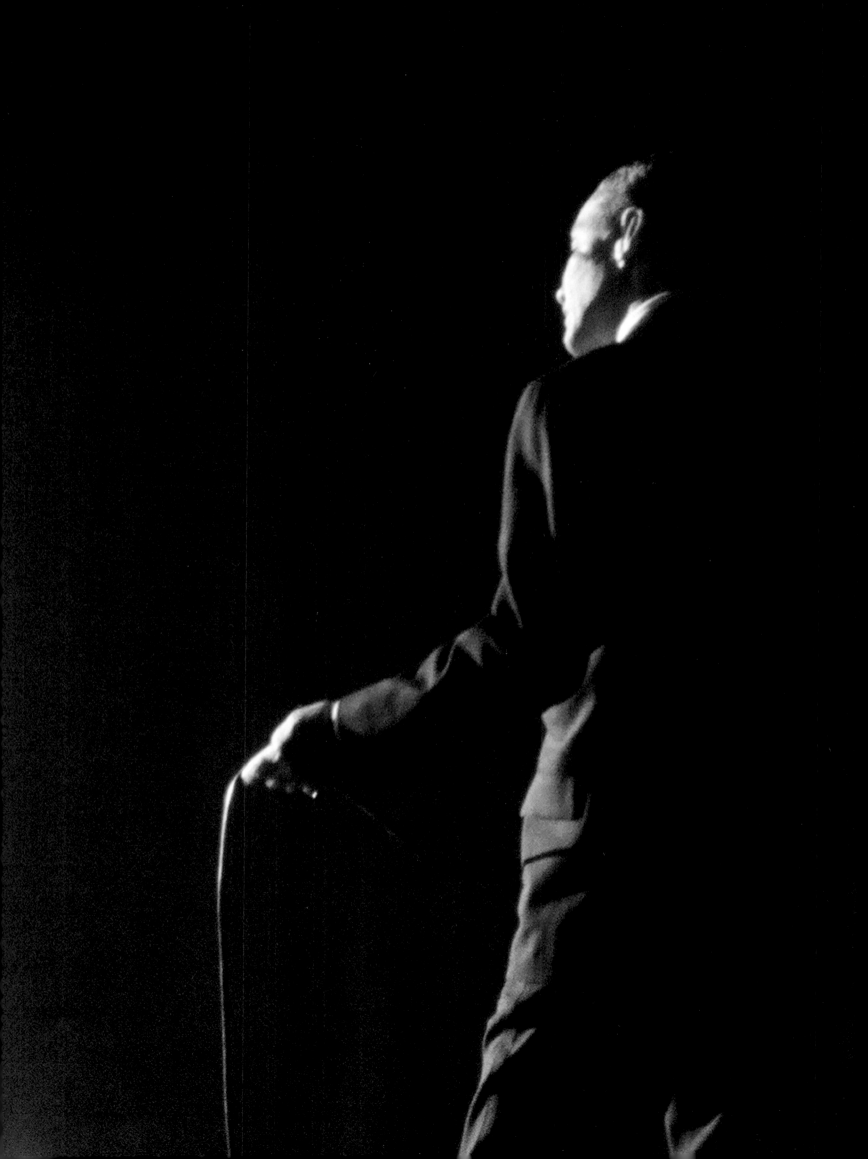

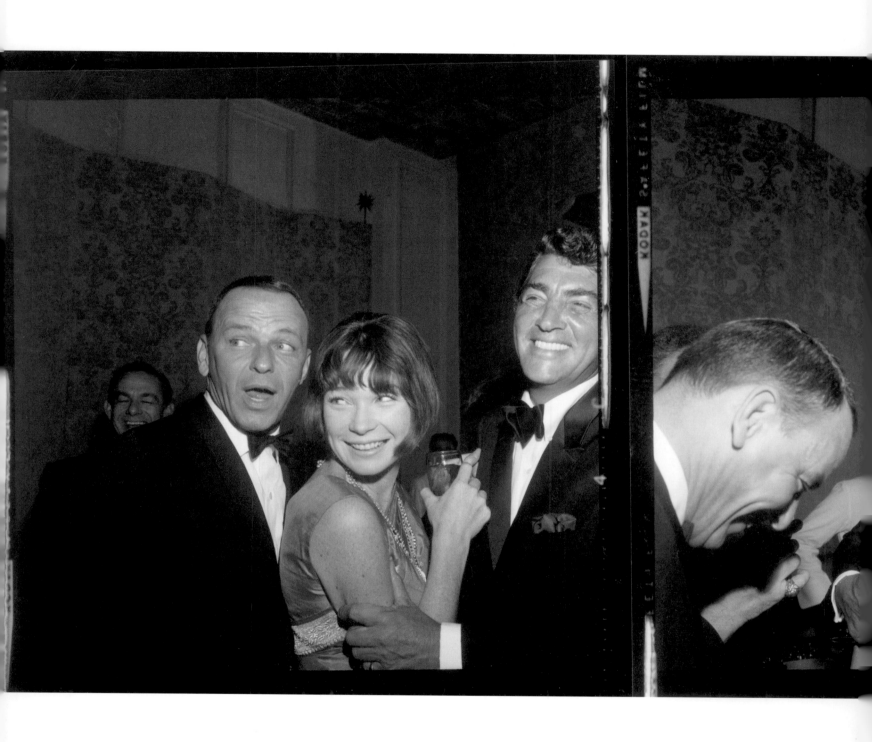

Frank Sinatra, Dean Martin, and Shirley MacLaine

OVERLEAF: Frank Sinatra

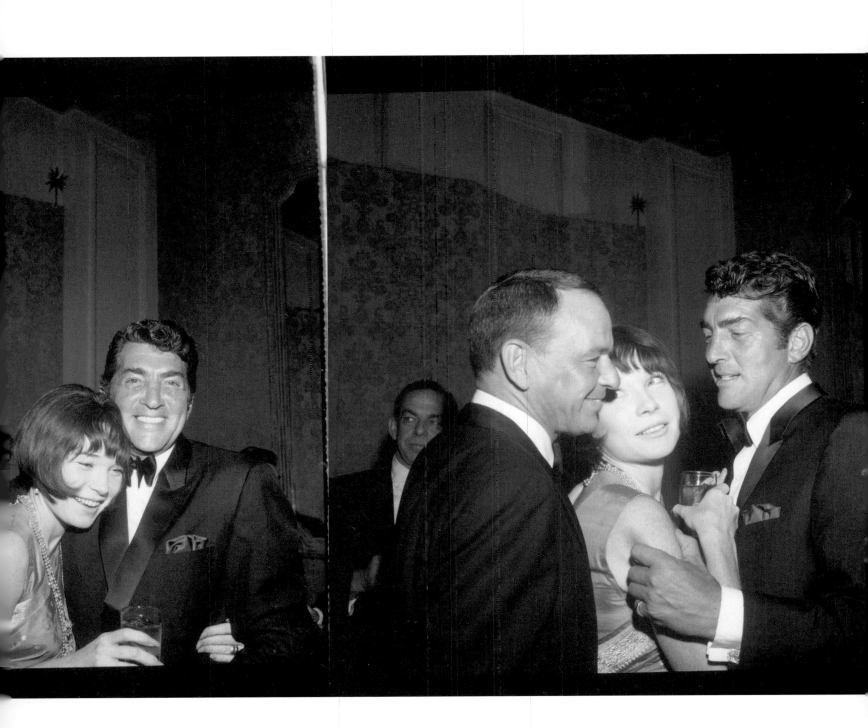

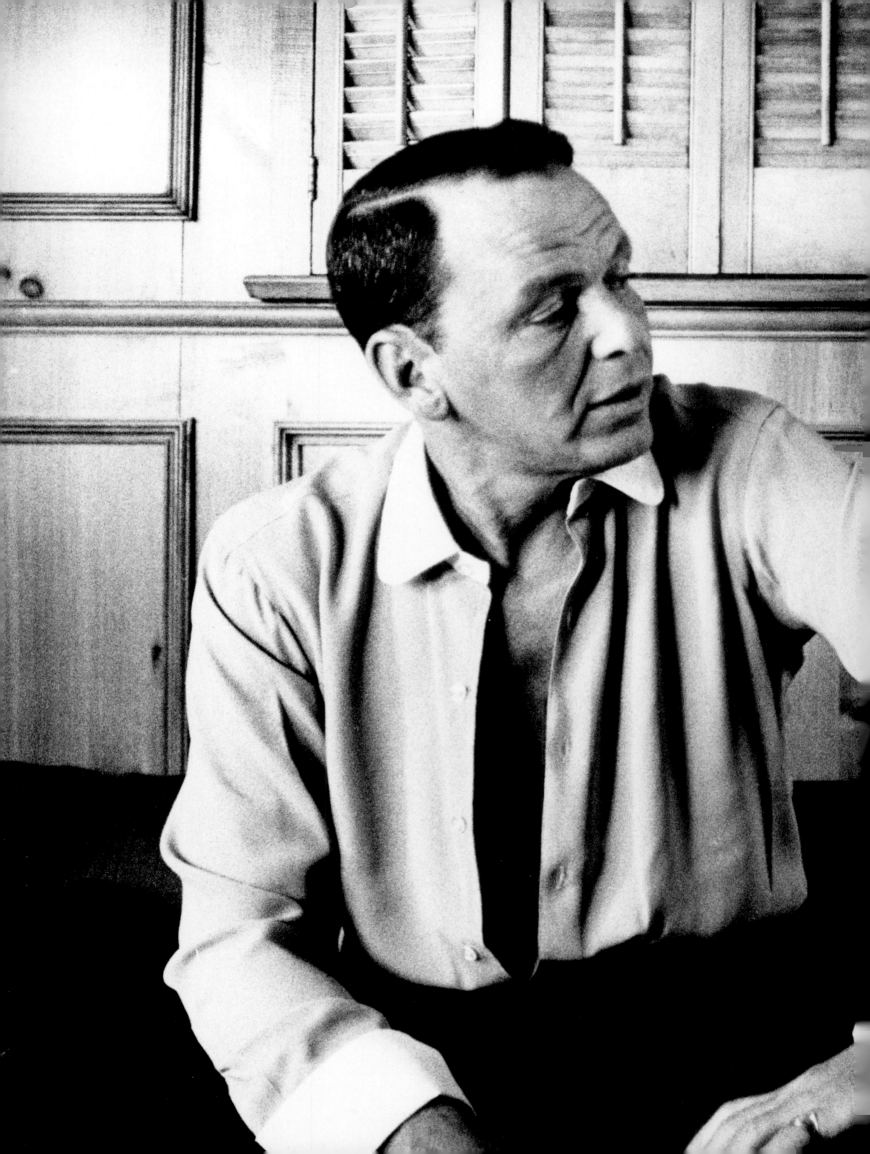

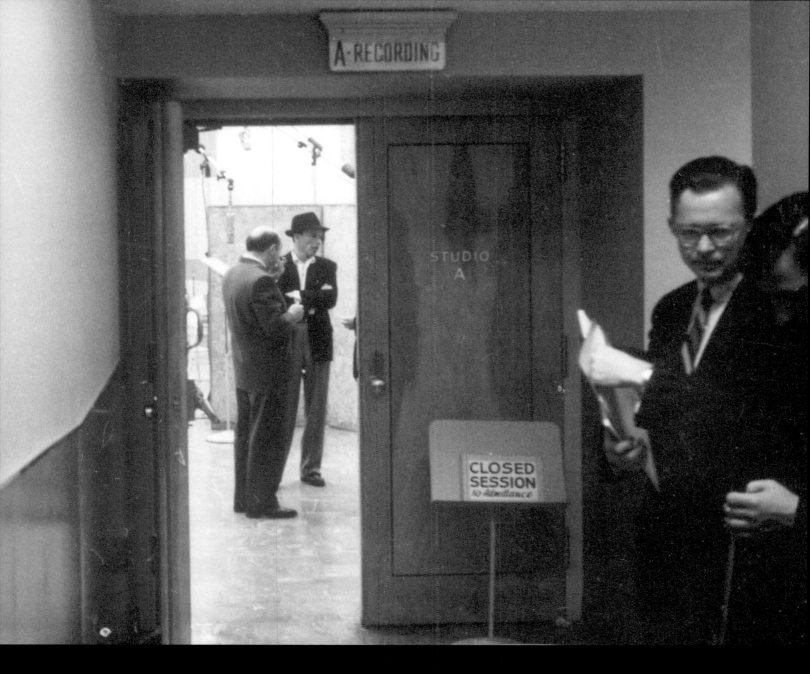

Frank would rehearse and rehearse until whatever he was performing was perfect. Nothing short of that was good enough. But he knew when he'd caught the brass ring. After they played back the dress rehearsal of the TV special, "A Man and His Music," nineteen-time Emmy Award–winning director Dwight Hemion said, "That's great, Frank. Let's do it." Sinatra reached for his coat and said, "We just did it," and the dress rehearsal is what aired. The dress rehearsal won Emmys for Frank, Dwight, and the show itself.

OVERLEAF: Frank Sinatra and Peter Lawford

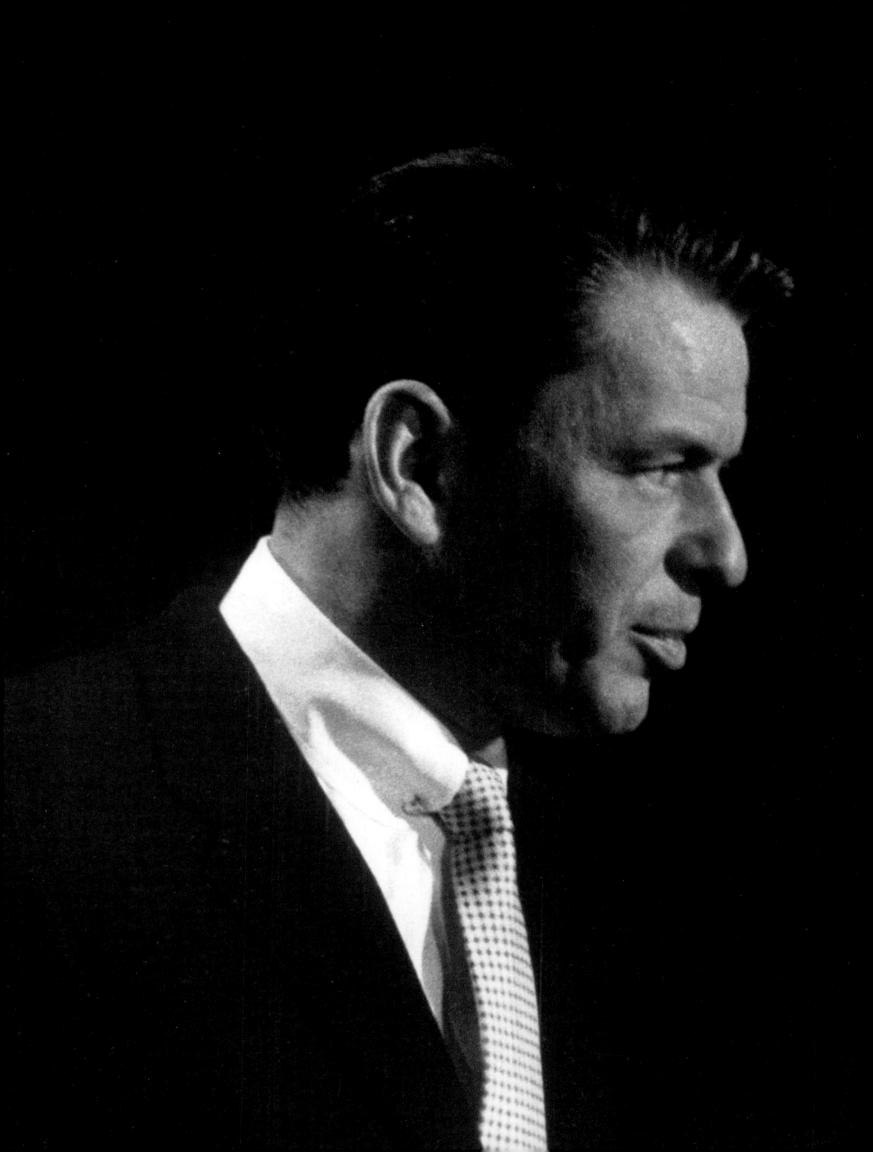

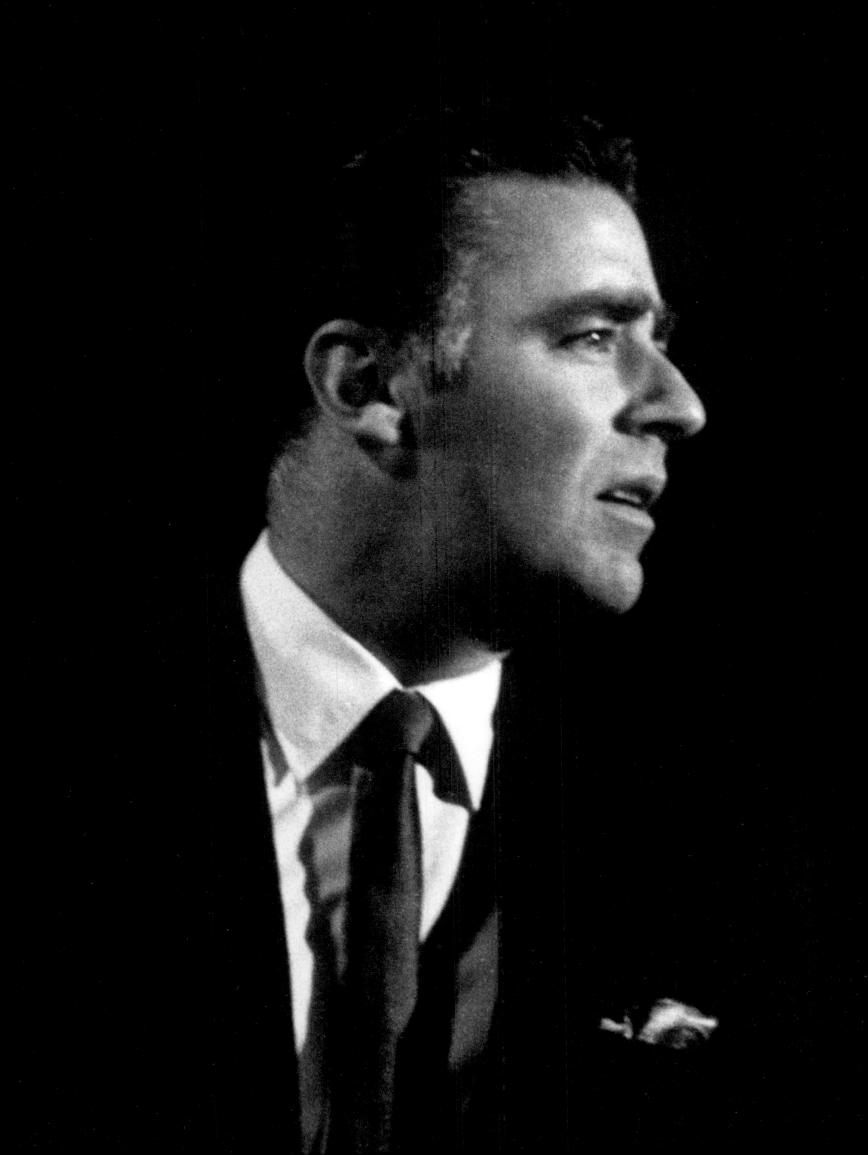

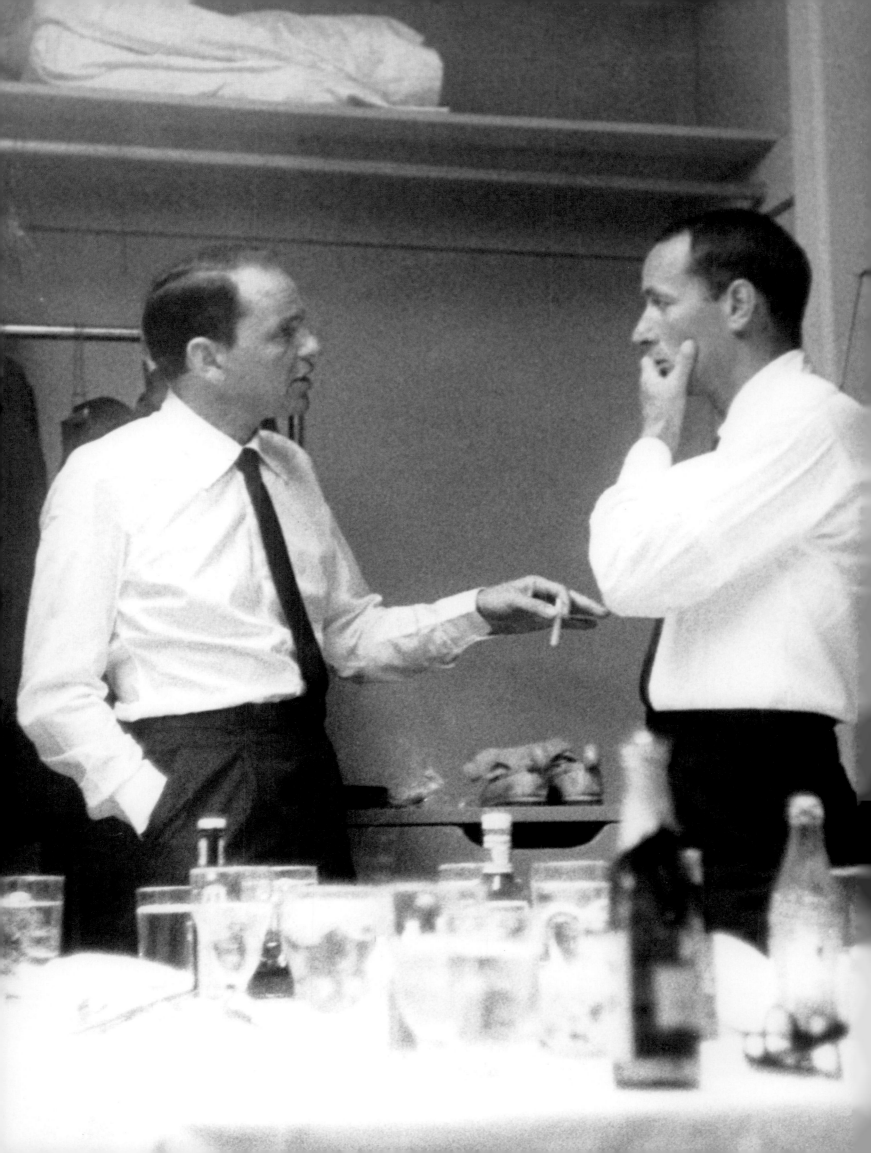

AT OPENING NIGHT DURING SINATRA'S SOLD-OUT ENGAGEMENT AT THE COPA, THE ROOM WAS PACKED FULL WITH MAJOR CELEBRITIES, CRACKLING WITH EXCITEMENT, ANTICIPATING SINATRA'S PRESENCE.

JOEY BISHOP

Frank skipped the dinner show for opening night. He would open at midnight for the heavy hitters. Every columnist, every "name" in New York was there, glued to their coveted seats, waiting for Sinatra. The buzz around the room was restrained hysteria. Two words could be heard over everything: Sinatra…Frank…Sinatra. Finally, the band blared, a drum roll, the show was starting. The announcer said, "Ladies and gentlemen, Mr. Joey Bishop," and on walked a virtually unknown comic, Frank's opening act. The disinterest in him was embarrassing. People hardly turned their heads toward him. He stood in the center of the tiny stage, just a few feet away from tables on his left, right, and in front of him. He did not speak. He waited. Slowly the room began quieting down, focusing on this curiosity. When there was silence he looked meaningfully around at the overflow crowd. "You think this is something? Wait'll Frank's people get here."

It shattered the ice. Joey had worked for months on a brand new act, but he threw it all away that night and ad-libbed himself into becoming a star.

OPPOSITE: Frank Sinatra and Joey Bishop in Frank's dressing room at the Hotel Fourteen during his last Copacabana engagement, 1965

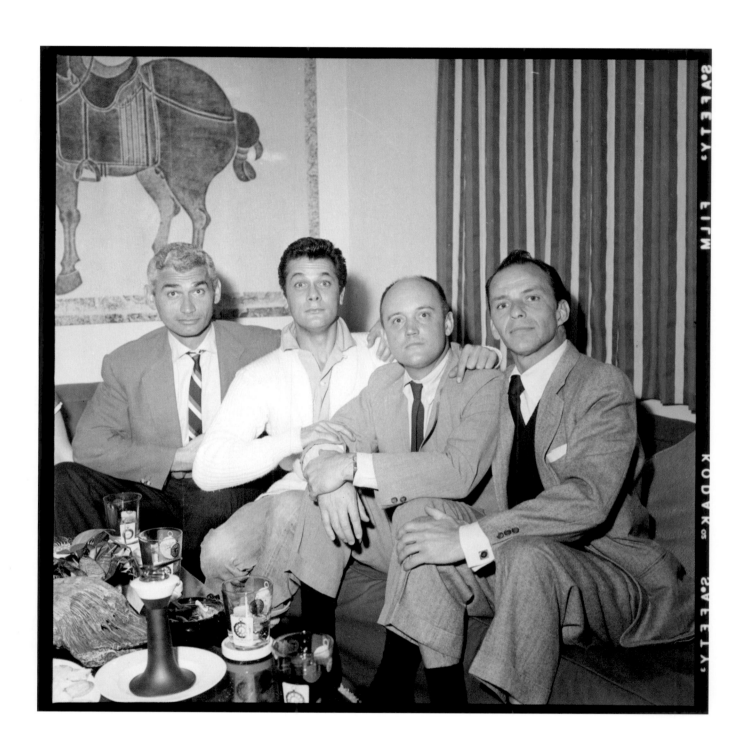

ABOVE: Jeff Chandler, Tony Curtis, unidentified man, and
Frank Sinatra

Jeff and Tony were Sammy's first and best friends in Hollywood.

OPPOSITE: Frank Sinatra and Cindy Bitterman, an old
friend of Sammy's

Sammy took this picture at the party celebrating his twenty-
ninth birthday.

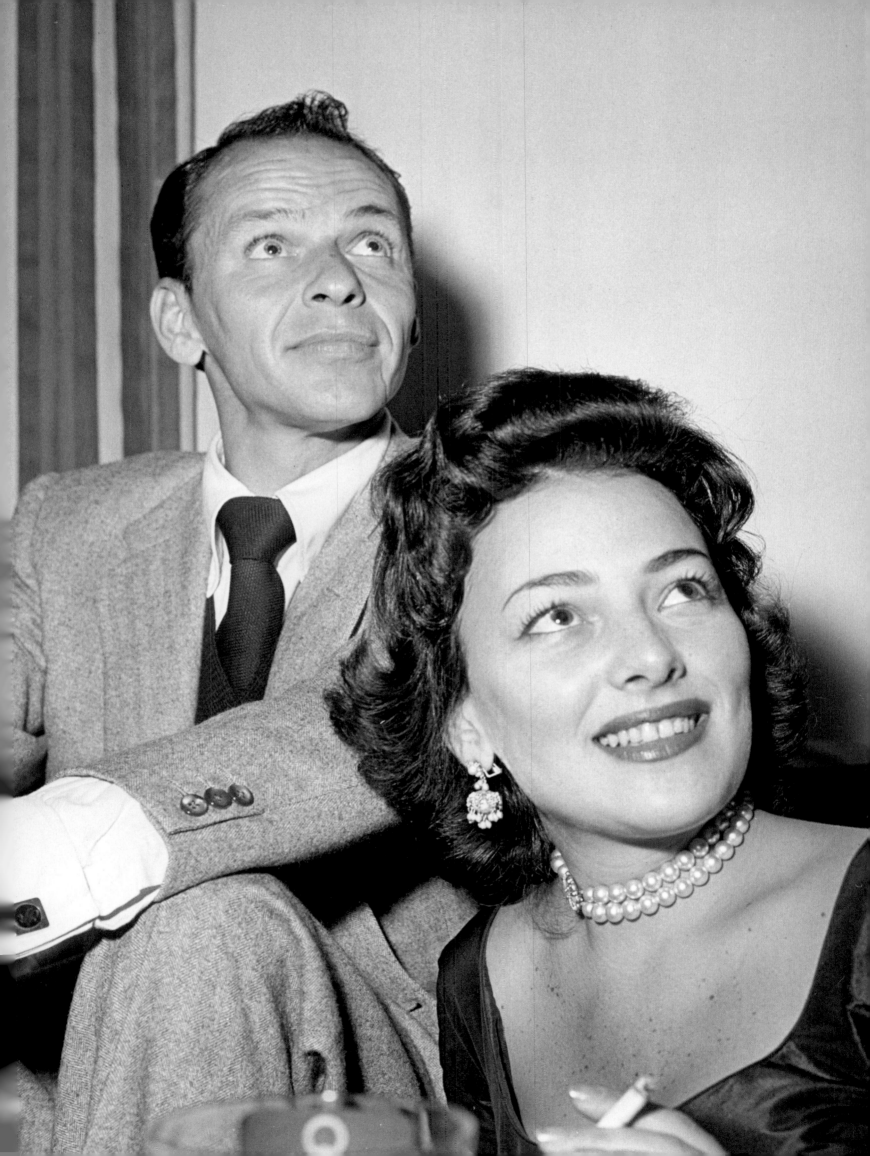

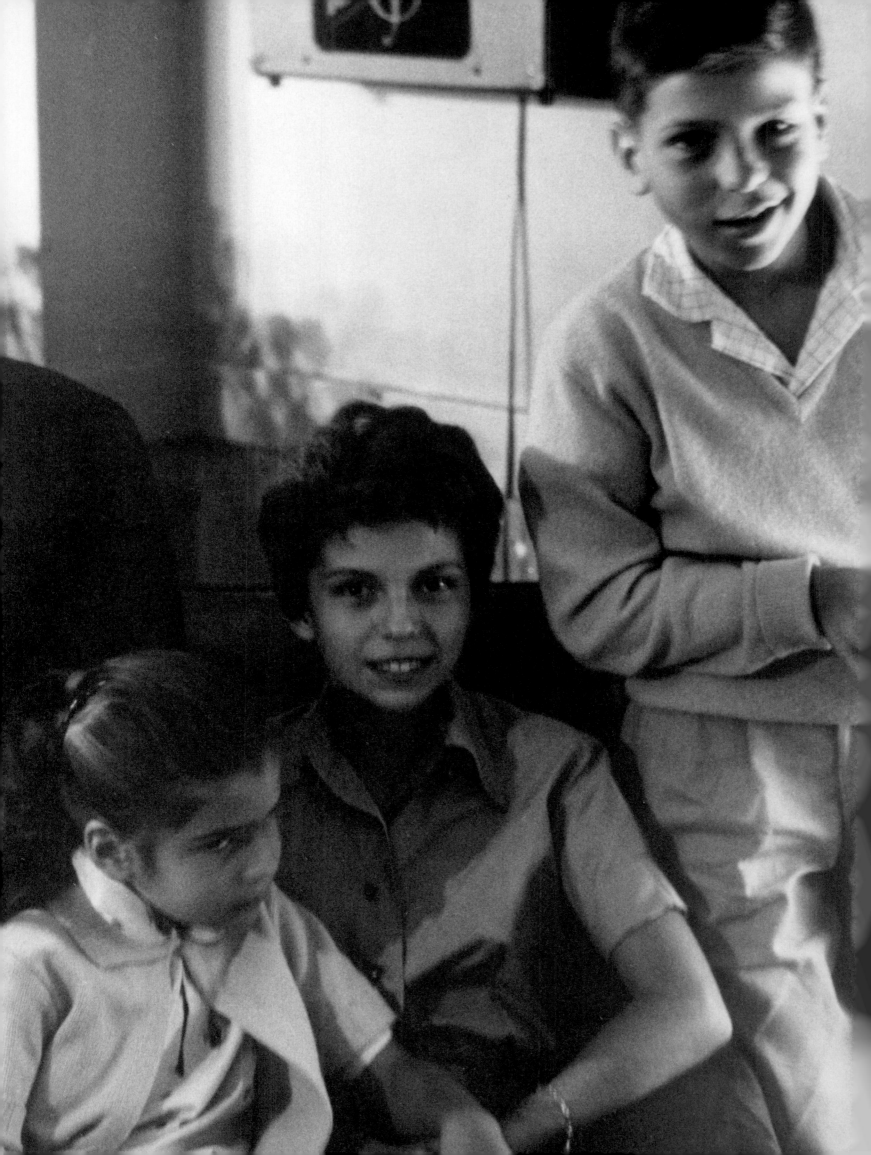

TINA, NANCY, AND FRANK, JR.

A scandal magazine had a front cover "exposé" of Sammy and June Allyson. It was a completely concocted story—they had met only once when she came backstage at Ciro's to congratulate him—but Sammy and white women were the flavor of the month. Sinatra called, saying, "Hiya, Charley" (one of his nicknames for Sammy), "listen, you dig all this Donald Duck jazz. You want to go to a thing at Disneyland tomorrow?"

When Frank arrived the next morning to pick up Sammy, he was stunned to see Frank's kids. "His children were leaning out of the back window waving to me," Sammy told me, "and the sight of them almost threw me. It had seemed impossible that he'd be going to Disneyland without them, yet, knowing how he protected them like all the gold in Fort Knox, I'd wondered if he'd let them be seen with me, the town monster.

"The guard waved us through the gates at Disneyland, we pulled into the parking lot, and the photographers crowded around before Frank could open his door. I stayed in the car while he and the children got out. I turned my face away from the mob and tried to keep busy tying my shoelaces. I could hear them yelling, 'One more with your arms around the kids, Frank?' and 'Can you move closer together, please?'

"There was a knock on the window. Frank was beckoning me with his finger. 'Hey, Charley, did we come here together or not? Let's go, let's get into these pictures.' He pulled me over and put one arm around his children, rested the other on my shoulder, and the photographers began shooting. I looked at him smiling at the world through those cameras, as much as saying, 'In your ear. He's my friend.'"

Celeste Holme and Frank Sinatra rehearsing for *High Society*,
released in 1956

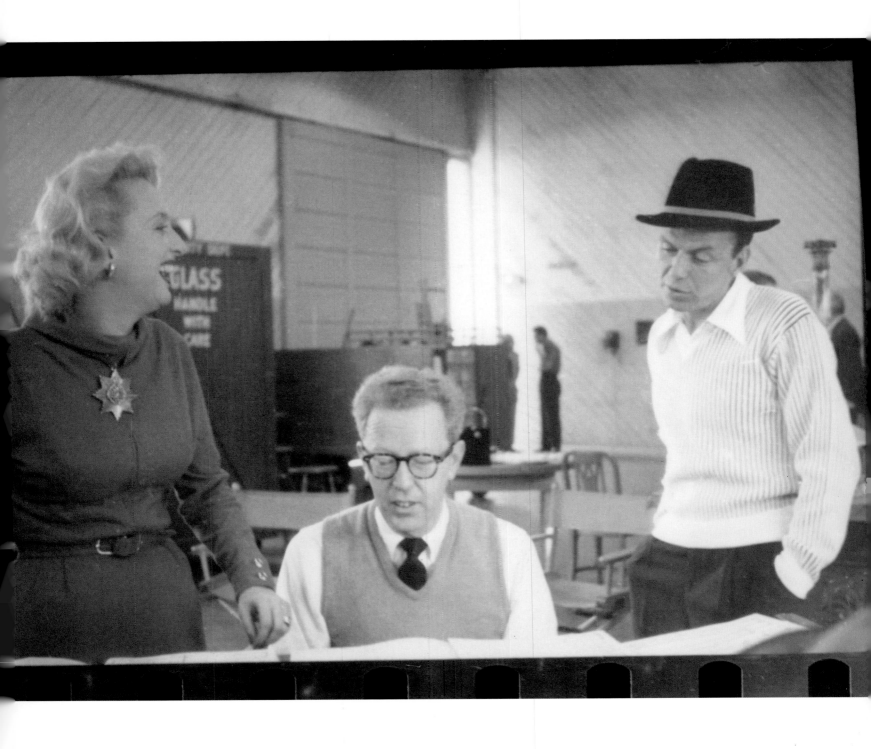

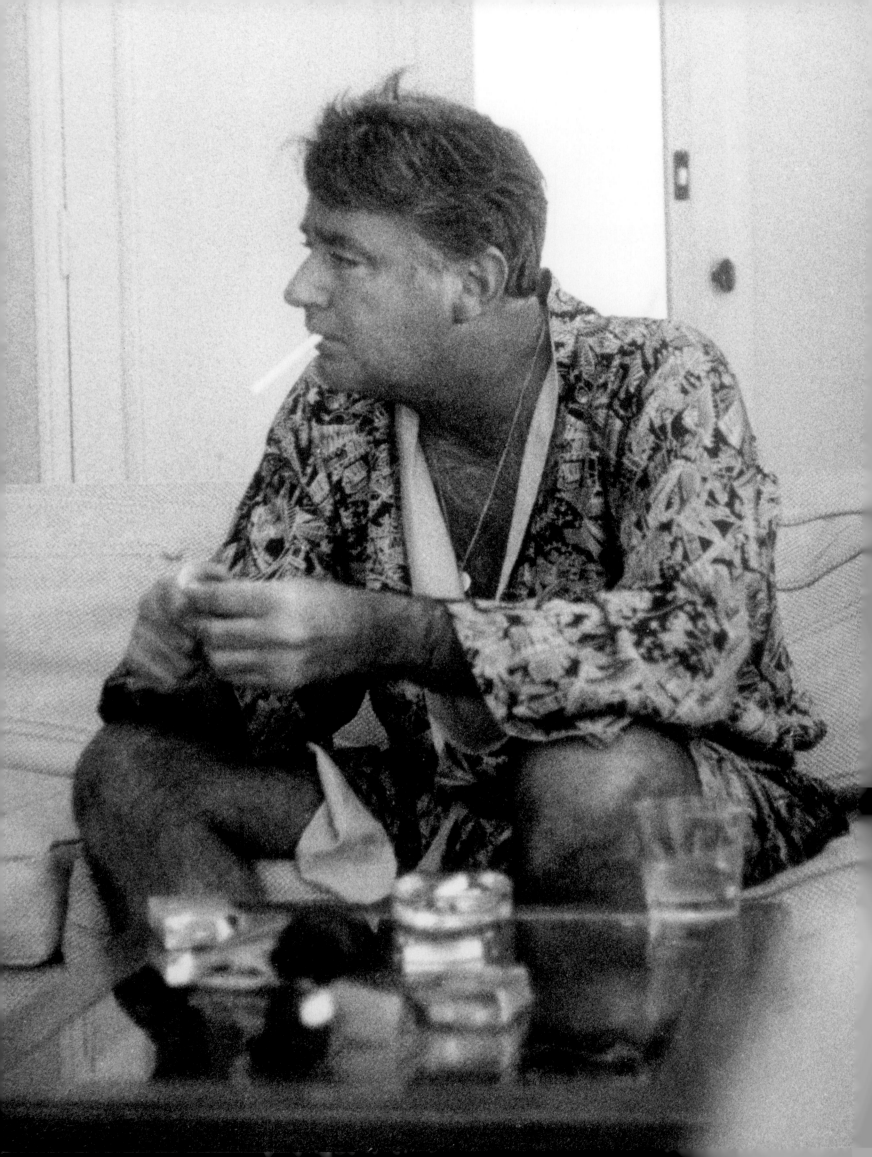

ABOVE: Frank Sinatra

Not everybody got to shoot Frank in his PJs.

OPPOSITE: Peter Lawford, definitely in need of an hour in
the steam room.

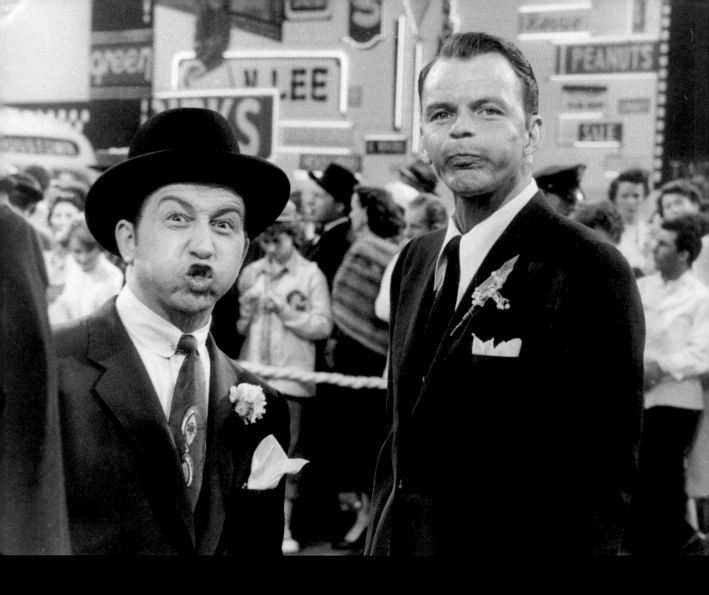

ABOVE: Frank Sinatra (right) on the set of *Guys and Dolls* (1955)

OPPOSITE: Jerry Lewis, when everybody smoked

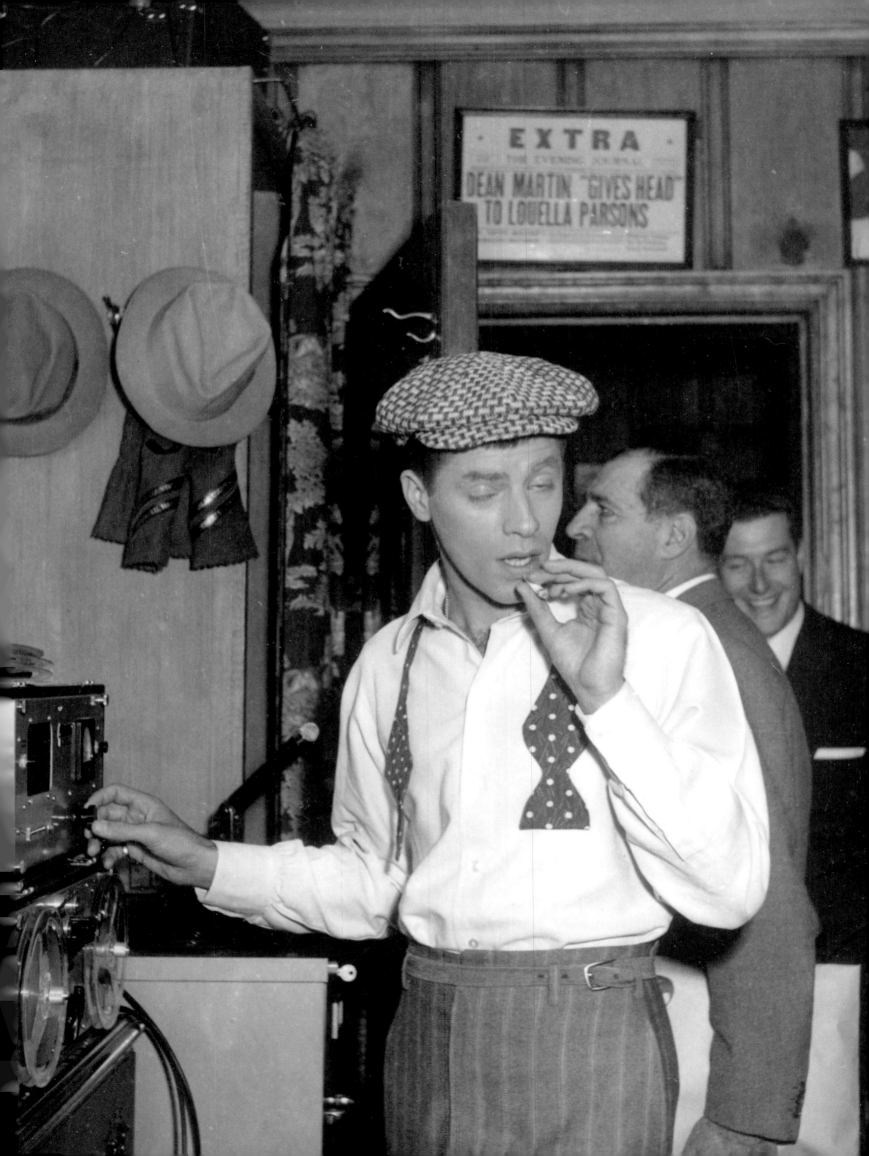

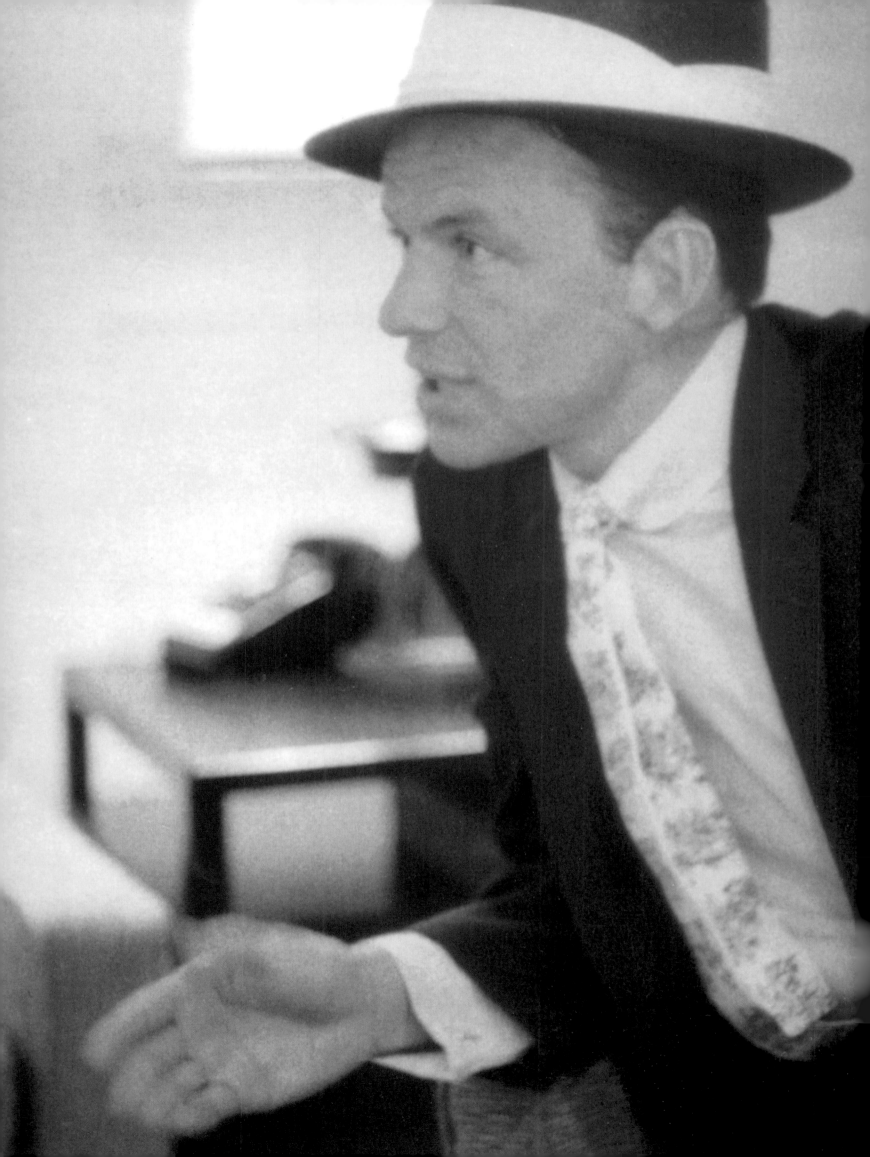

Frank Sinatra

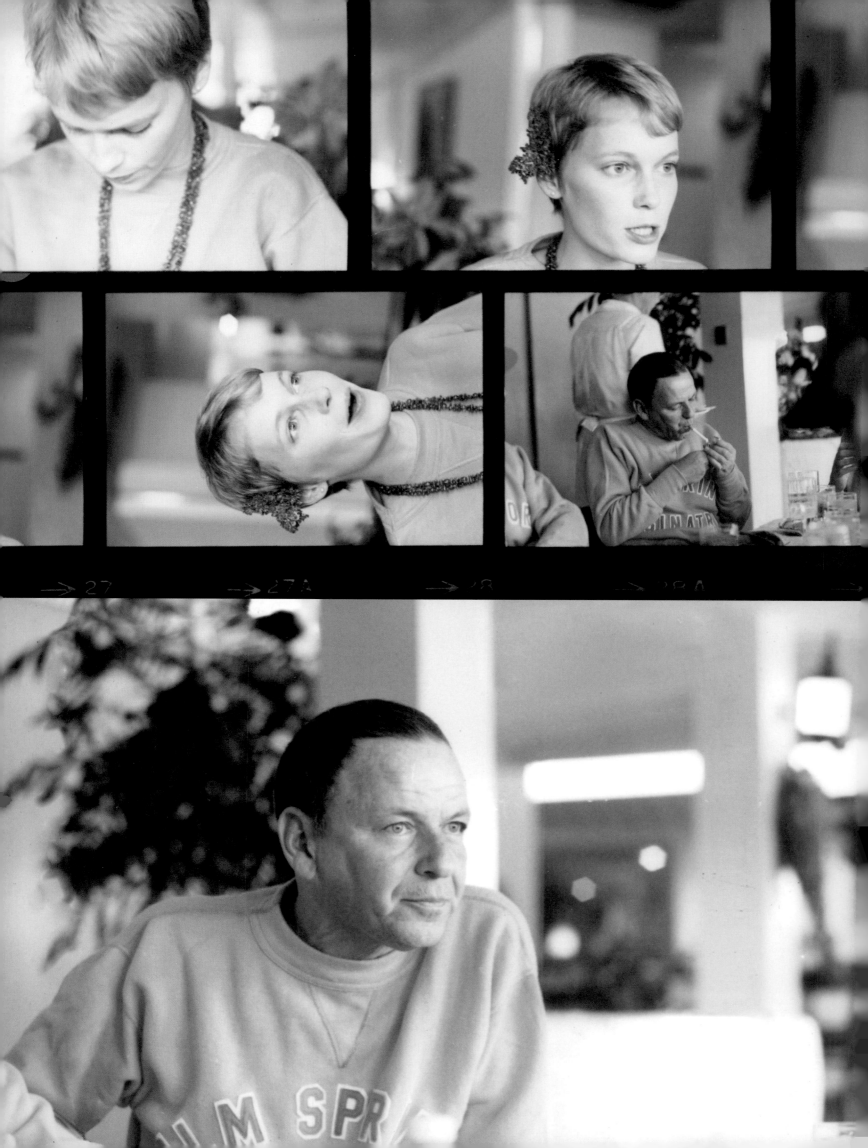

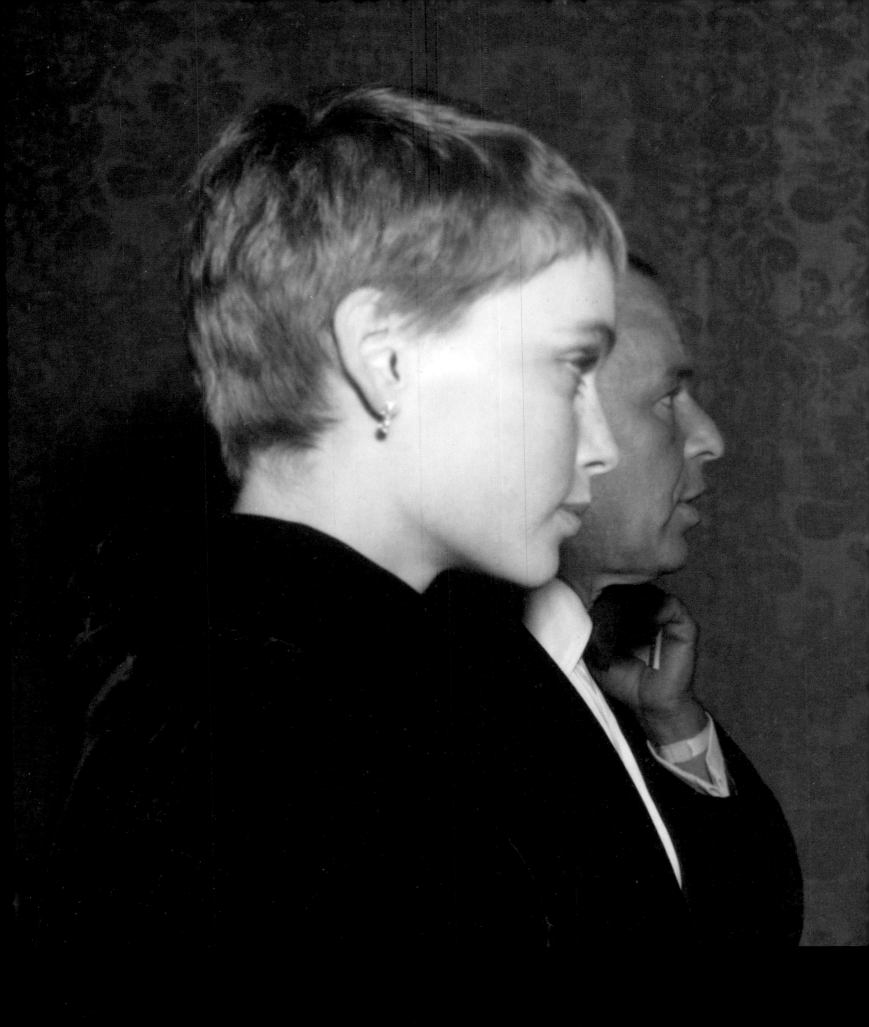

ABOVE: A rare photo of Frank Sinatra and Mia Farrow together

OPPOSITE: Frank Sinatra and Mia Farrow

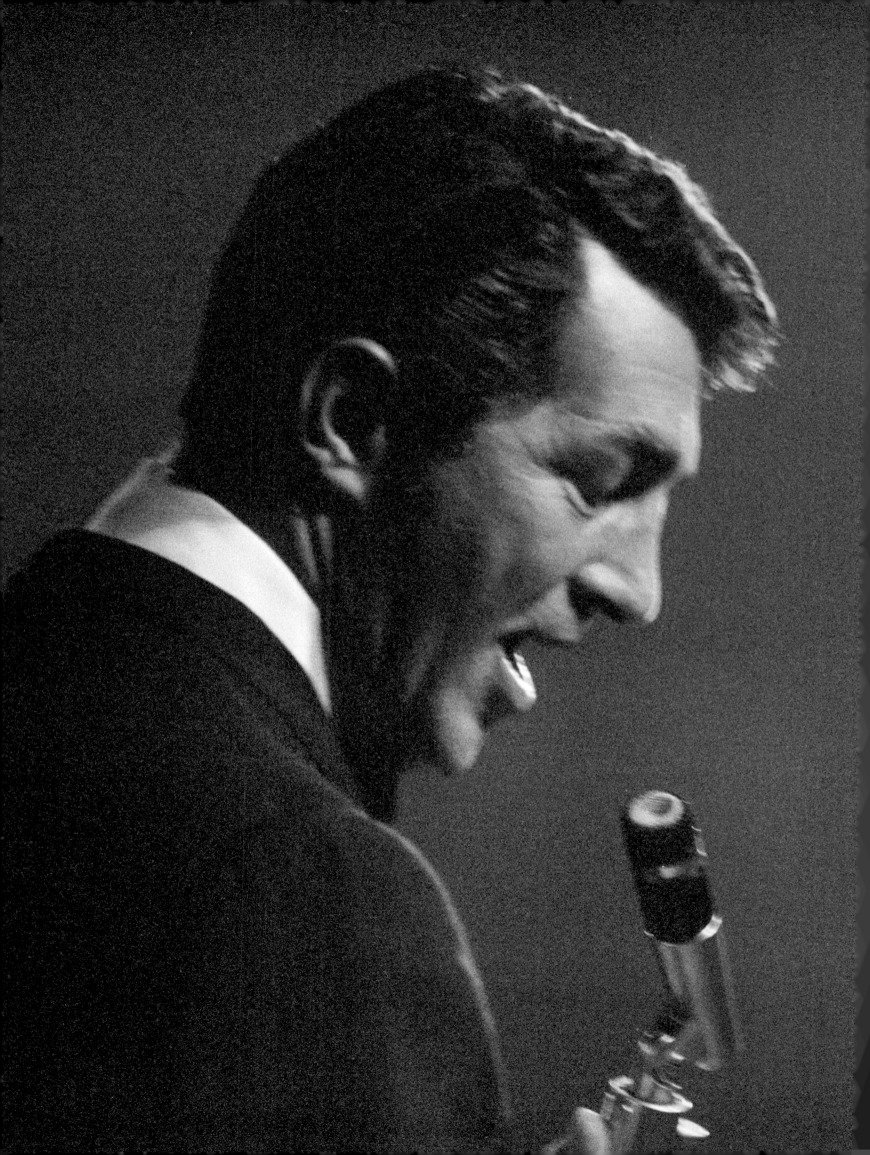

WHEN PERFORMING, DEAN WOULD PLAY

THE CAREFREE BOOZER, ALWAYS WITH A DRINK IN HIS HAND. HE WOULD WALK ONSTAGE, TAKE A LONG SIP FROM THE GLASS AND ASK HIS PIANIST, "HOW LONG HAVE I BEEN ON?" OR "WHICH WAY IS THE AUDIENCE, PALLY?" IT WAS A SURE LAUGH.

DEAN MARTIN

Then he sang, "When it rains it always rains, bourbon from heaven…" to the tune of "Pennies from Heaven." When he finished it he asked, "Have I got time for one more?" and he sang, "When you're drinkin', you get stinkin'…and the whole world smiles with you…"

When Dean's son, Dino, died in a 1987 Air National Guard plane crash, Dean was shattered. He was unwilling to work, to socialize, to do anything. Frank Sinatra suffered for his friend and told Sammy, "We've got to shake him out of this. He needs to get out and work." So Frank conceived a concert tour. He sold Dean on the idea and the tour called *The Ultimate Event* began in Oakland, California. A few cities later, they were in Chicago where Frank noticed Dean onstage weaving and slurring his words drunkenly, not like the usual Dean Martin make-believe drunk. Sinatra was so disappointed and professionally offended that he bawled Dean out publicly. Dean quit the tour and returned to Los Angeles. Liza Minnelli replaced him for the remaining engagements. When Frank dropped the curtain on someone it was as if they no longer existed. Like there was a blank space where they had been standing.

When Dean learned of Frank's eightieth birthday celebration he called and asked to participate. Frank sent word that he was not welcome. Dean called again but Frank held onto that grudge. Dean died of respiratory failure ten days later and Frank learned that, in fact, Dean had not been drinking that night, but had been medicated for the illness that ultimately killed him. Frank didn't stop crying for a week.

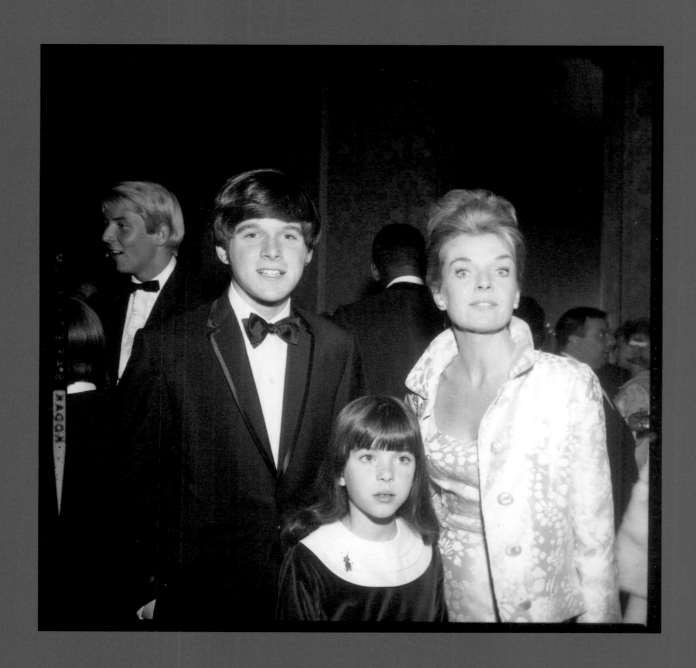

ABOVE: Dean Martin's wife, Jeannie Martin, with son Dino and daughter, Gina

OPPOSITE: Dean, Jeannie, and Bill Cosby with Dino, Gina, and son Ricci

OVERLEAF: Frank Sinatra and Dean Martin preparing to go onstage.

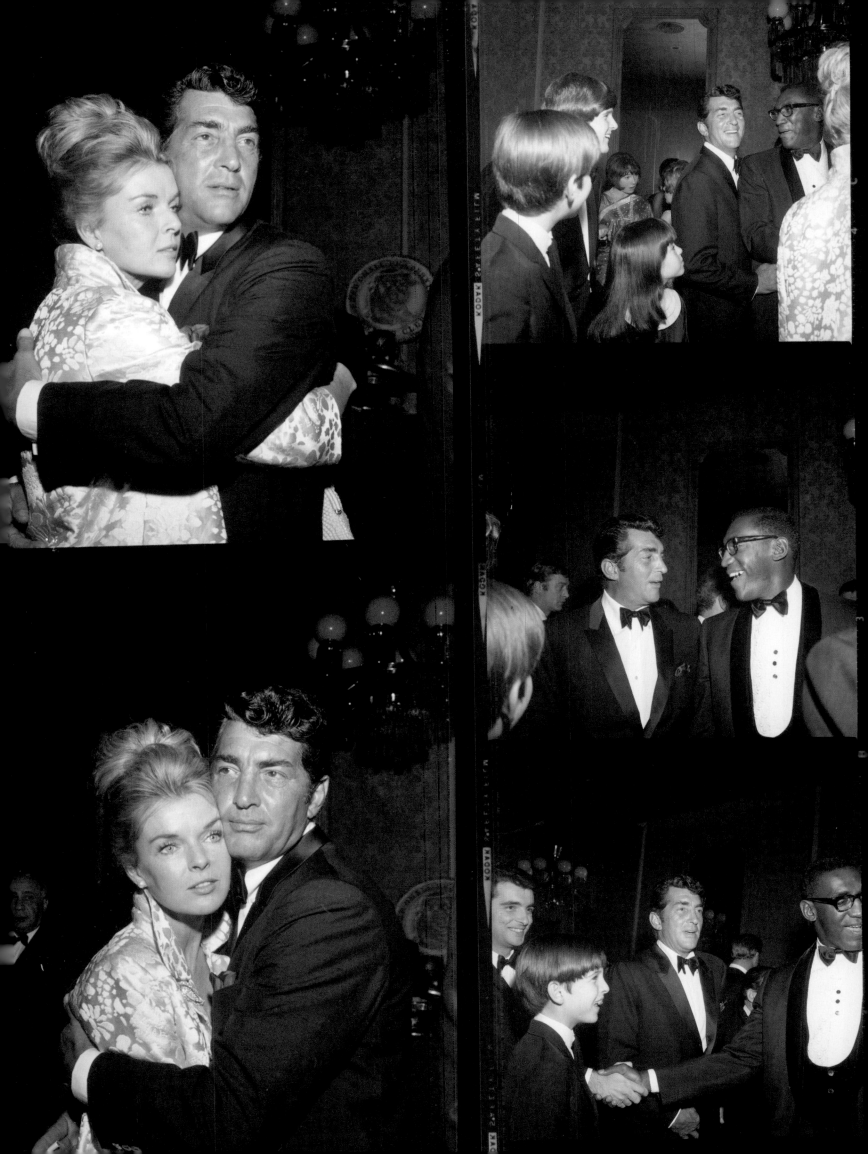

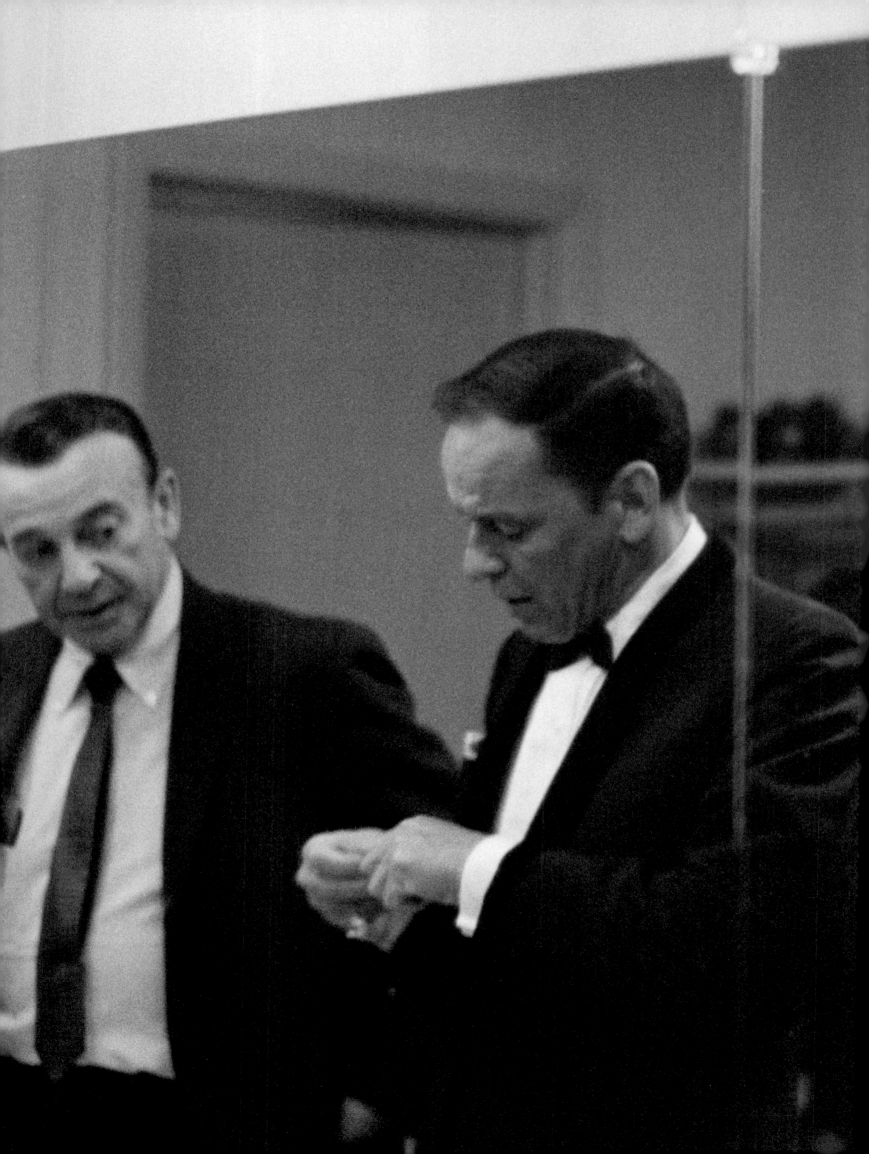

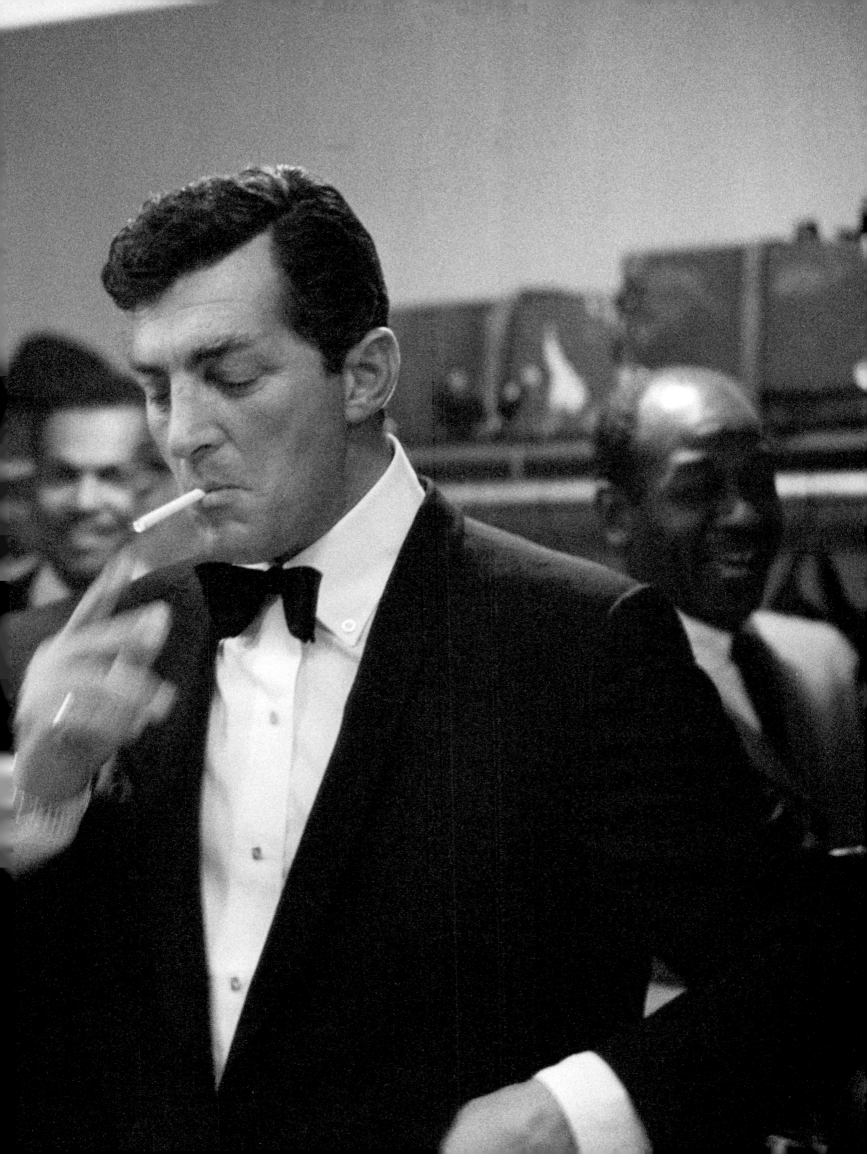

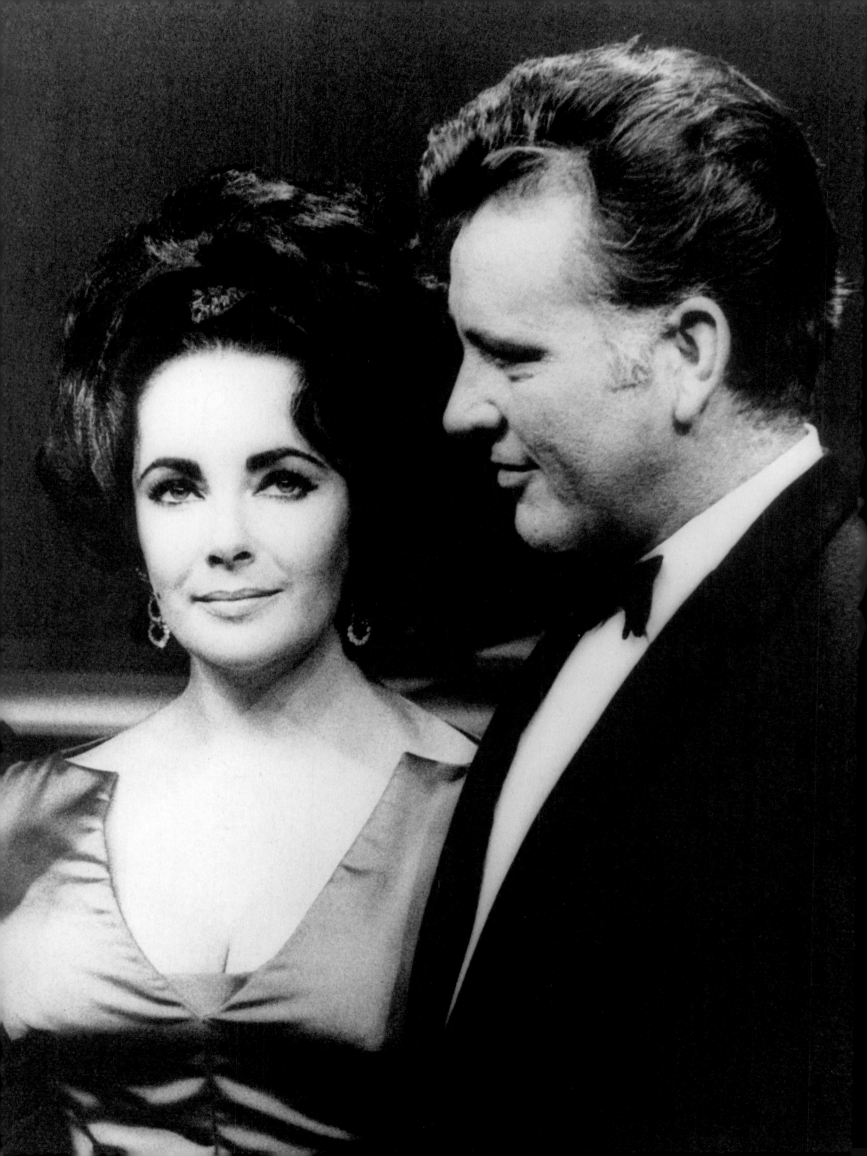

CHAPTER 3
THE RED CARPET

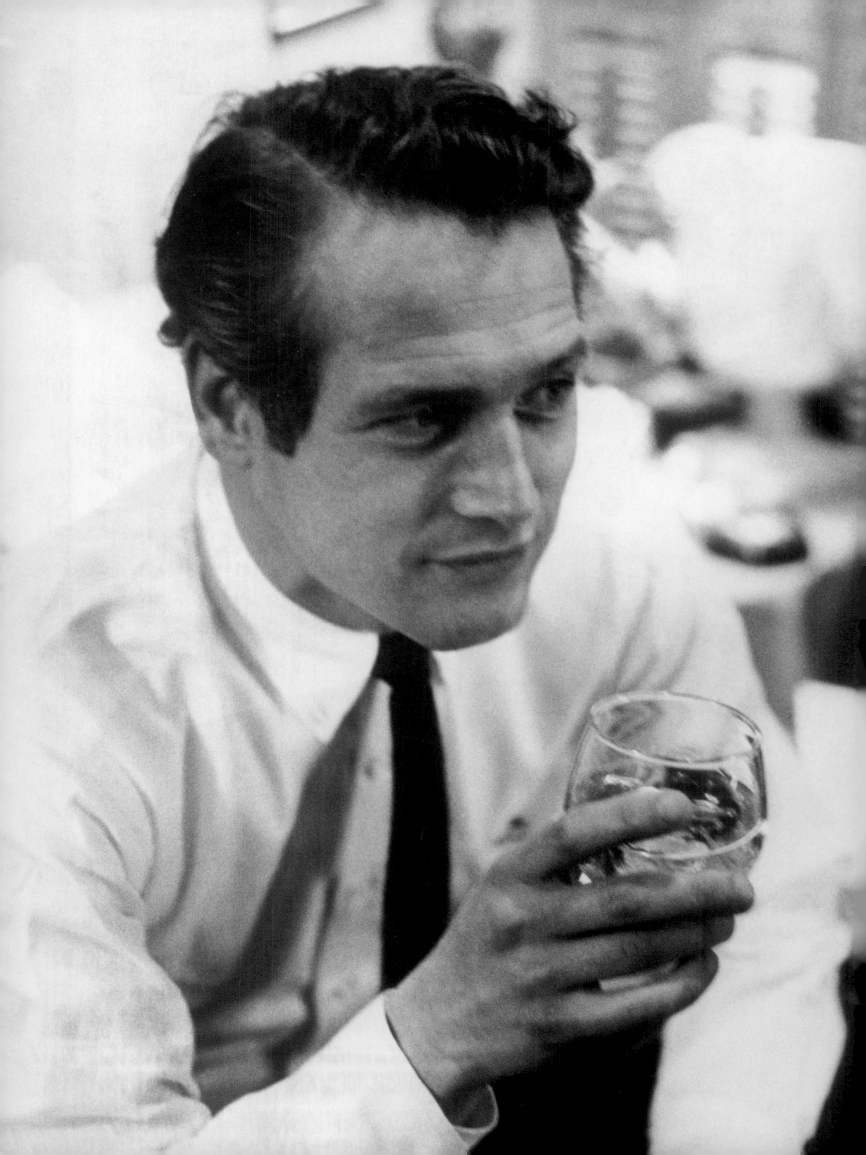

IT WAS A TYPICAL SUNDAY NIGHT IN 1965, SAMMY HAD A NIGHT OFF FROM HIS HIT BROADWAY SHOW *GOLDEN BOY*. HE DECIDED TO THROW A PARTY.

He spent most of the day catching up on sleep. By early evening his guests began arriving: Judy Garland and daughter Liza, Leonard Bernstein, Jule Stein, and Betty and Adolph (Comden and Green). Frank Sinatra was in town so he stopped by Sammy's by-word-of-mouth Sunday Open House. Somewhere on Long Island or in the Midwest, in other warm and cozy homes, families and friends stood around the pianos singing songs they enjoyed, delighting in one another. So it was on 93rd Street, New York, in Sammy's town house, only here the pianist was Jule Stein playing and singing his score from *Gypsy* with Judy and Liza taking turns with the songs; then Betty and Adolph playing their scores from *On the Town* and *Bells Are Ringing* and Leonard Bernstein playing his *West Side Story*. Seated on the floor, chewing on light buffet food and enjoying them-selves, were Tony Curtis and Janet Leigh, Marilyn Monroe, Elizabeth Taylor, Marlon Brando—whoever was in town and wanted to have a quiet, relaxing evening with pals. Sammy knew that he was a superstar and he felt like one. How could he not when simply arriving at a Broadway theater to see a show caused the rest of the audience to stand and applaud him? He knew that if he went shopping at Saks Fifth Avenue his presence would virtually shut down the

OPPOSITE: Paul Newman

PAGE 68: Elizabeth Taylor and Richard Burton

main floor—and he had been told that it was so costly to the store that they would be happy to open an hour early or stay open an hour late just for him. But Sammy remained even more star-struck than his own fans. It was normal for him, when in L.A., to be at the Bogarts for dinner, among Spencer Tracy and Katharine Hepburn, Frank, Gary Cooper, Marlene Dietrich (who cut his daughter Tracey's hair), Judy Garland, Elizabeth Taylor, and Richard Burton . . . the greatest in all the Hollywood pantheon. A little voice within him was always saying, "Enjoy this. I am sitting next to Humphrey Bogart, he is listening to what I'm saying and he is calling me Sam. . . . Don't lose this moment. Enjoy the stardust." It was the little boy in him speaking, or the wise old man.

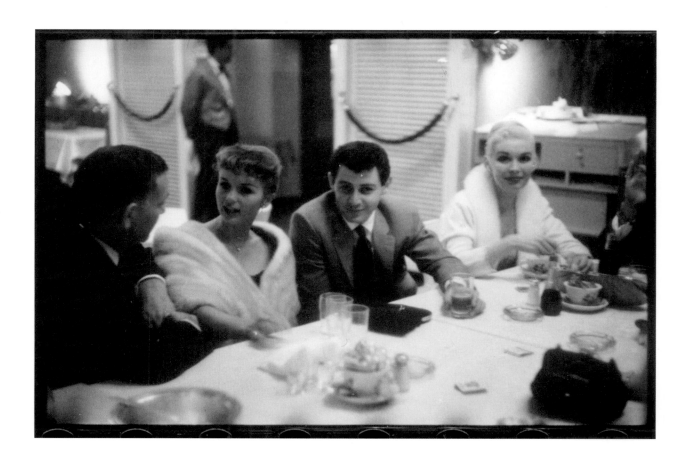

ABOVE: Debbie Reynolds and Eddie Fisher

OPPOSITE: Milton Berle doing a card trick

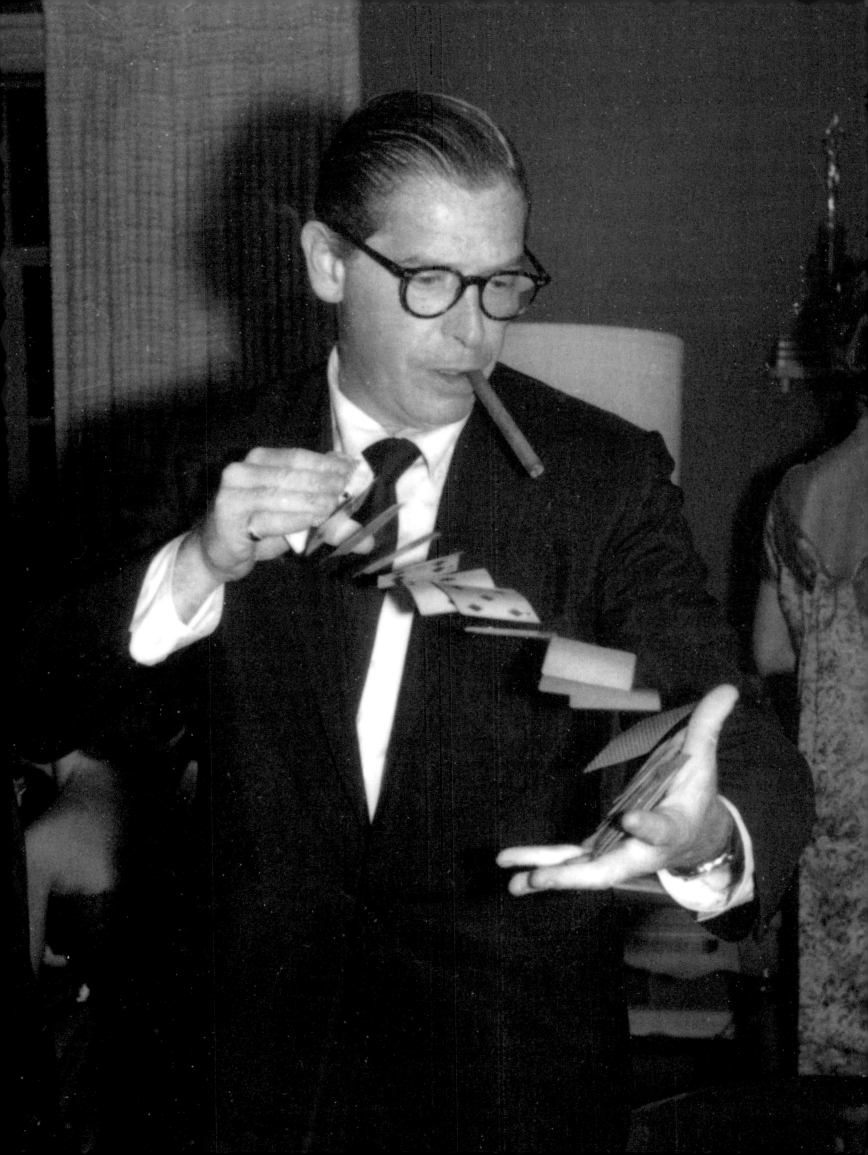

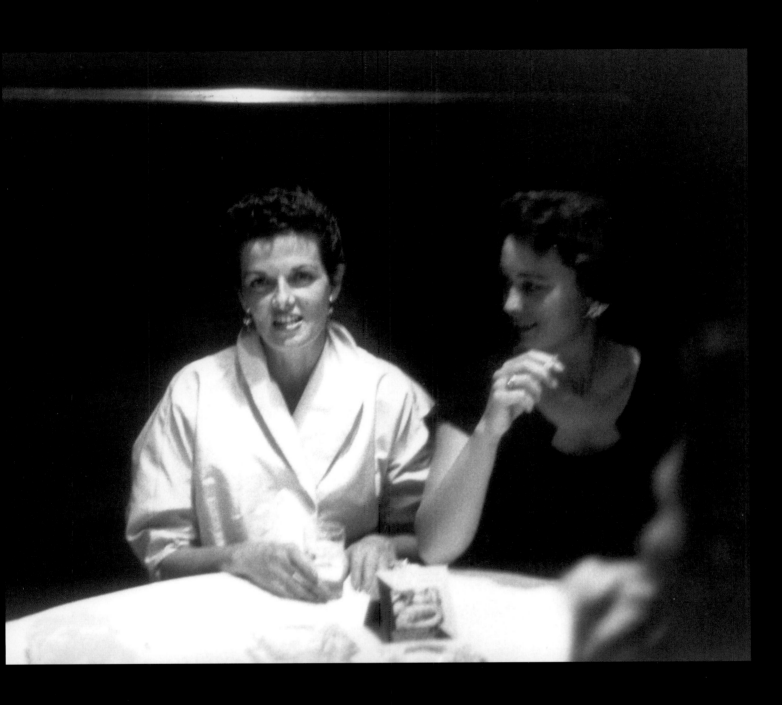

ABOVE: Jane Russell (left) and unidentified woman

OPPOSITE: Katy Jurado

OVERLEAF: Lauren Bacall, Betty Grable, and Marilyn Monroe
taking a break on the set of the movie *How to Marry a
Millionaire*, 1953

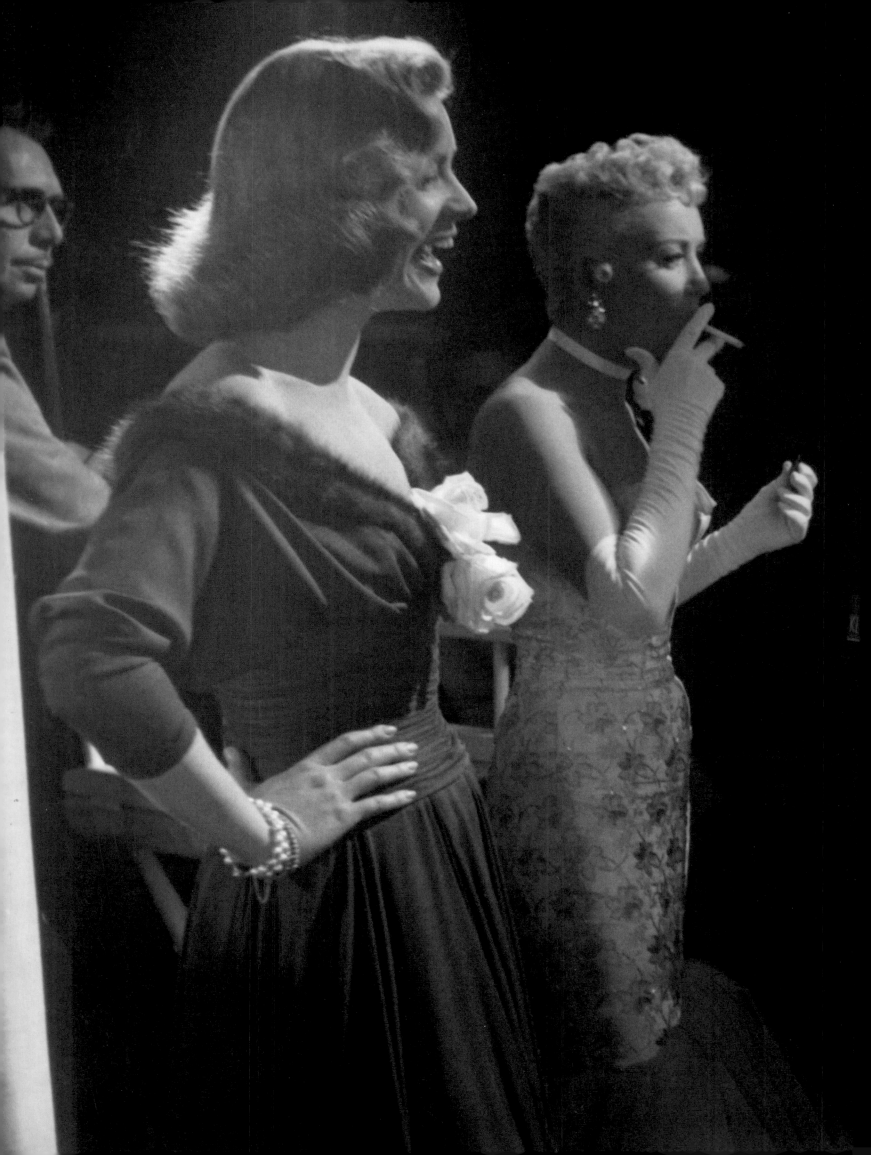

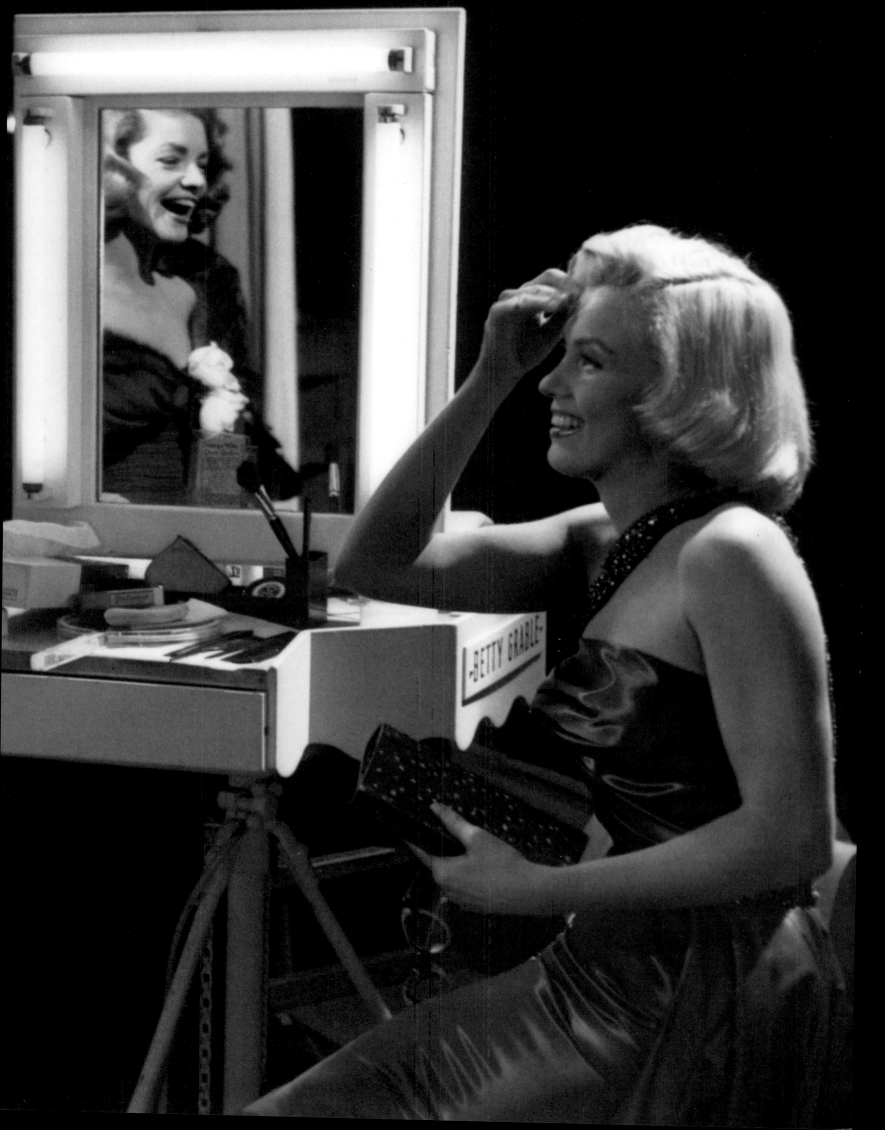

SAMUEL GOLDWYN

Sammy was working for Samuel Goldwyn in *Porgy and Bess* but had to ask for a day off due to the Yom Kippur holiday.

Mr. Goldwyn sat forward at his desk and peered at me over his glasses. "You're a what?"

"I'm a Jew, Mr. Goldwyn, and I can't work on the high holy days."

"You mean it? It's not one of your little jokes?"

"NO. I'LL DO ANYTHING IN THE WORLD FOR YOU, MR. GOLDWYN, BUT I WON'T WORK ON YOM KIPPUR."

"You're a real Jew?"

"Yes, sir. I converted several months ago."

"You know what it'll cost to suspend production for a day? We can't change the schedule, it's too late. Twenty-five thousand. Maybe more."

"I just learned today that I'm scheduled to shoot on Yom Kippur, sir. I came up as soon as I heard."

He threw up his hands. "Sammy—answer me a question. What did I ever do to you?"

"Sir, you've been wonderful and I feel terrible about the problems I'm causing you, but I've gone to temple a lot less often than I would have liked because people still look at me like they think it's a publicity stunt or like they can't understand it. I must draw the line on Yom Kippur. It's one day of the year I won't work. I'm sorry. I really am."

He took off his glasses. "Sammy, you're a little so and so, but go with your yarmulke and your tallis—we'll work it out somehow." He sighed, like now he's seen everything and as I left his office he was behind his desk talking to the four walls. "Directors I can fight. Fires on the set I can fight. Writers, even actors I can fight. But a Jewish colored fellow? This I can't fight."

OPPOSITE: Samuel Goldwyn in front of his office

OPPOSITE: Ed Sullivan's tenth anniversary of
Toast of the Town, 1958

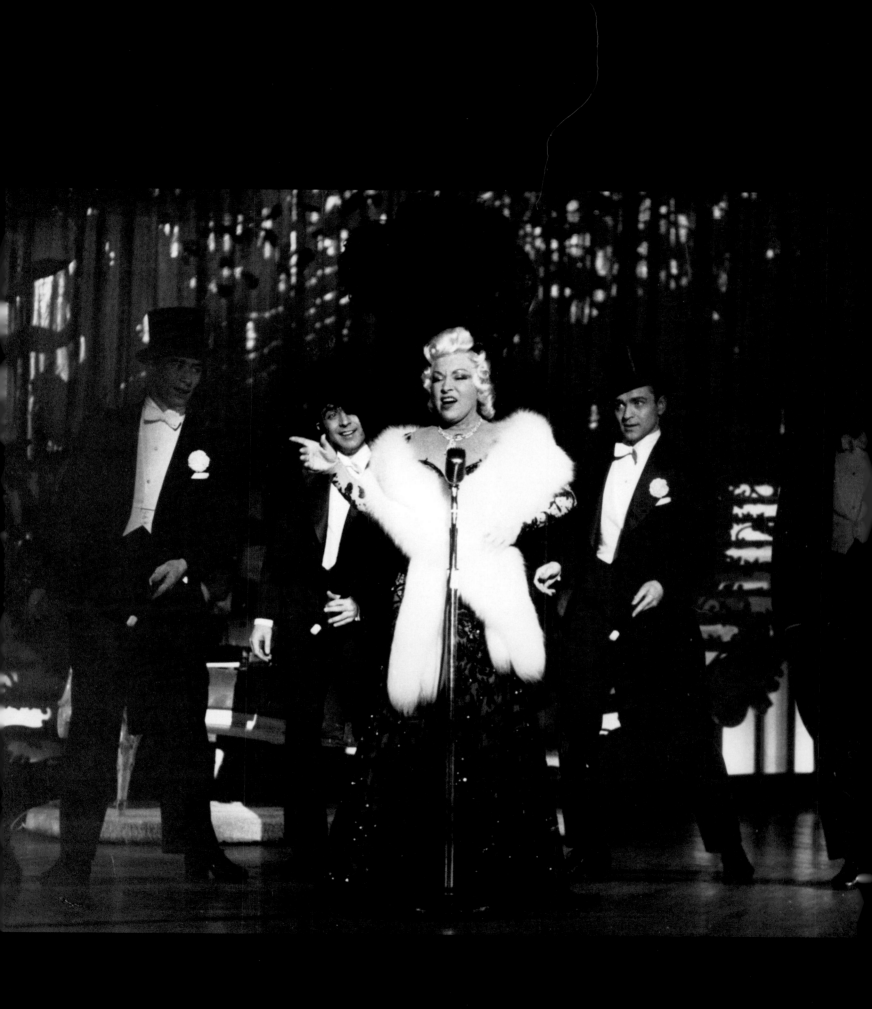

ABOVE: Mae West at the Latin Quarter, New York City, 1950s

OPPOSITE: Shirley Jones and unidentified actor

ABOVE: Larry Storch

OPPOSITE: George Raft and Walter Winchell
What did the movie star (Raft) and America's most powerful
columnist (Winchell) have in common with Sammy? As kids they
had both been hoofers on Broadway. Raft and Winchell couldn't
make it, so they found other jobs.

OVERLEAF: Tony Curtis in the center, back row, third from right.

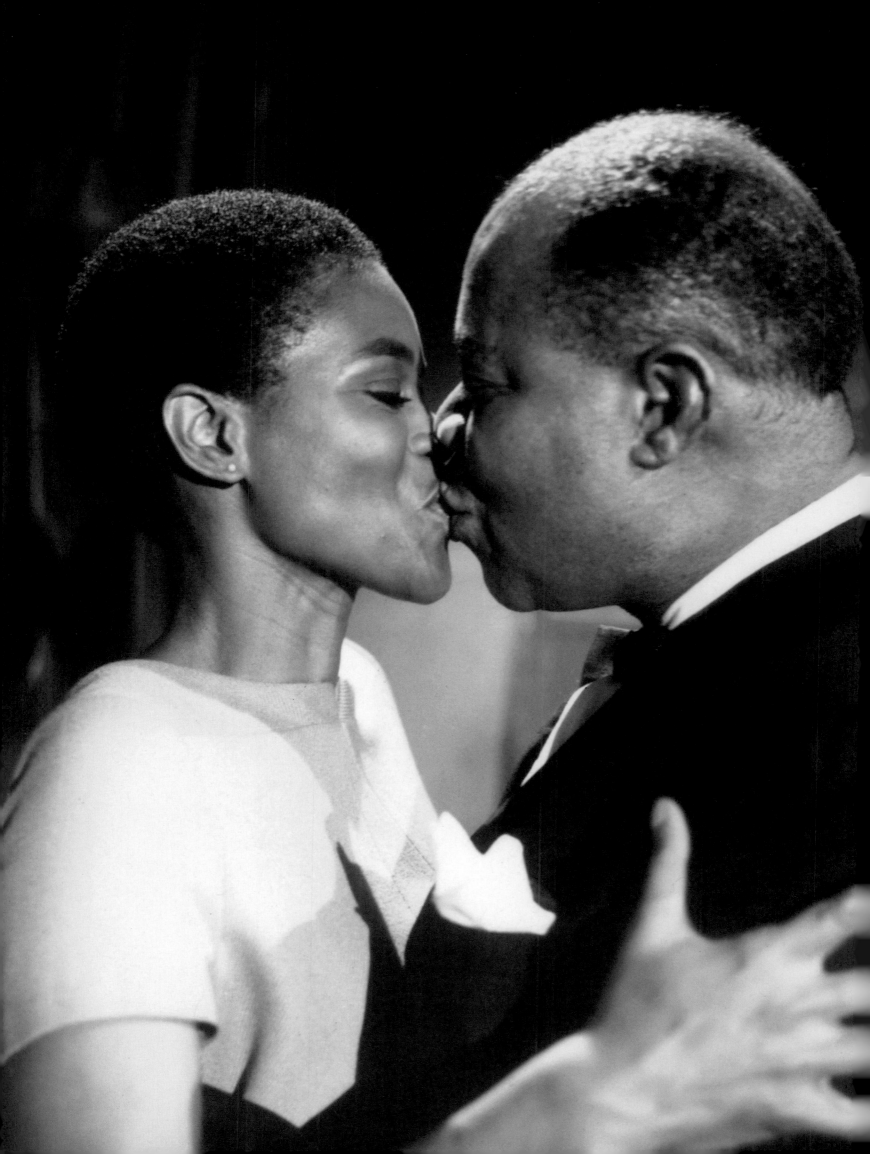

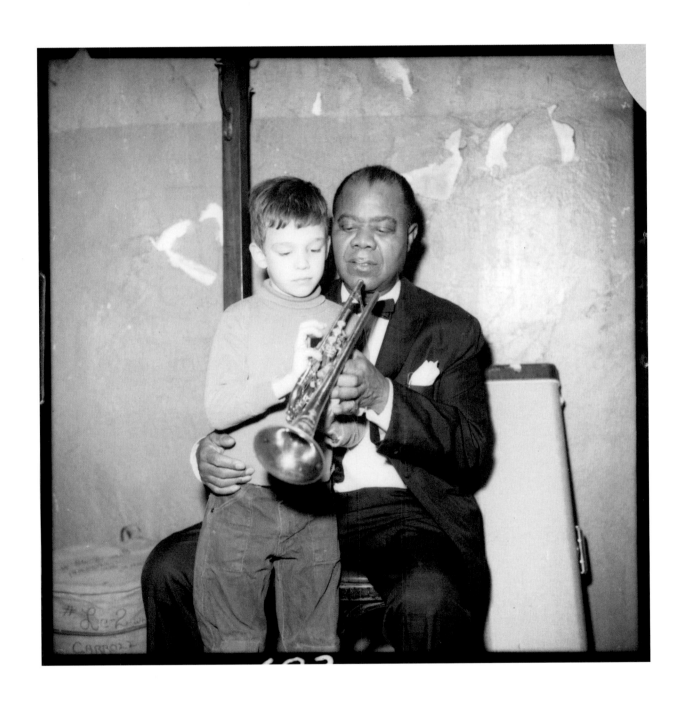

ABOVE: Louis Armstrong with unidentified boy

OPPOSITE: Cicely Tyson with Louis Armstrong

OVERLEAF: Louis Armstrong performing

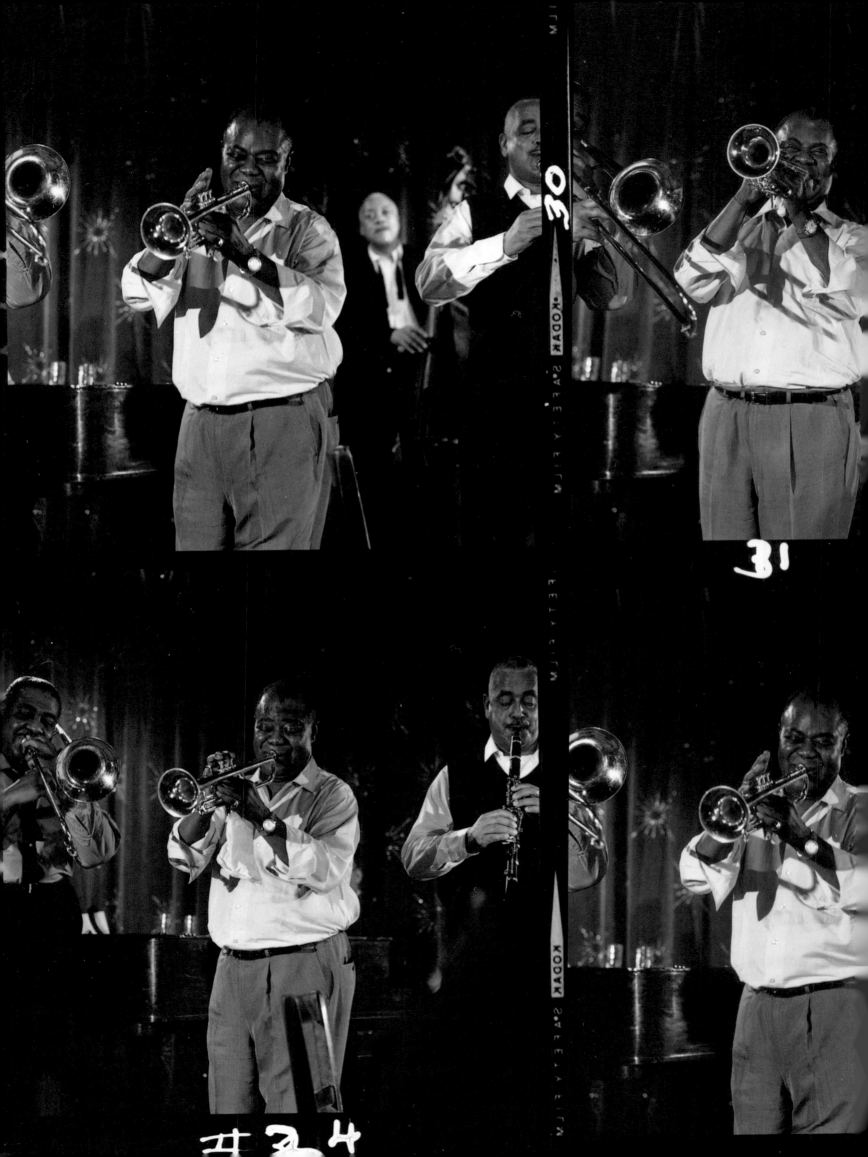

#22

Morty Stevens

Morty played clarinet in the band at Bill Miller's Riviera on the New Jersey side of New York. He wrote Sammy's first arrangement, *Birth of The Blues*, for $50, went on tour with the Will Mastin Trio as their conductor, and later became head of music for CBS television. He also wrote the theme for *Hawaii 5-0*. Once while visiting Jane and me in Marbella, Spain, Morty confided that the residuals from that one piece of music made him financially independent for life.

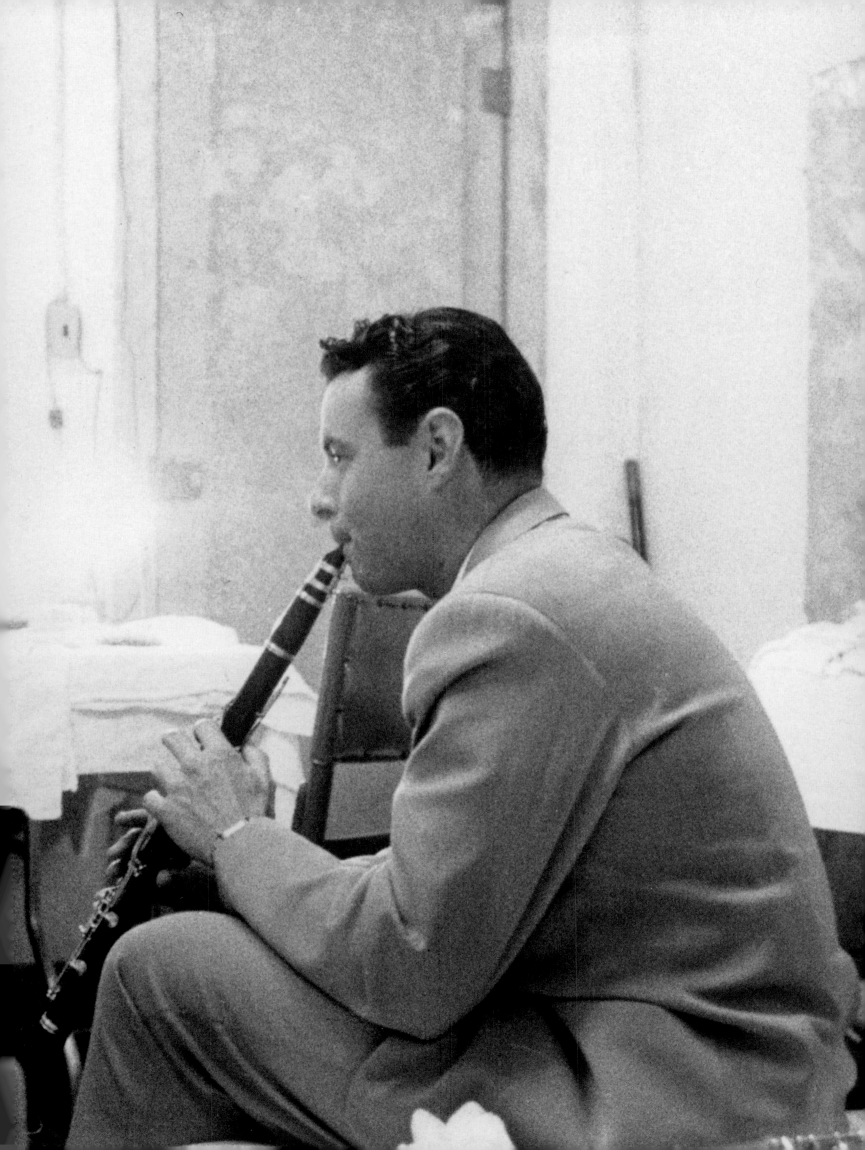

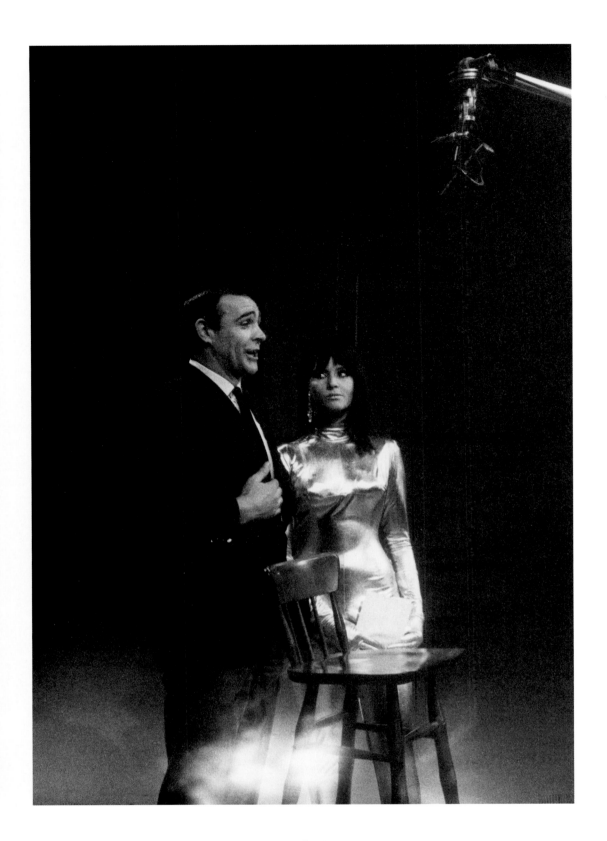

Sean Connery, with unidentified woman, on *The Sammy Davis, Jr. Show*, NBC 1965

Sean Connery hosted one show of Sammy's NBC series, *The Sammy Davis, Jr. Show*. In the "when it rains it pours . . ." department, Sammy was starring on Broadway in *Golden Boy* when he was suddenly offered the NBC series. But due to an ABC Special he had already taped, he was forbidden to appear on television two weeks before and after that special, so he had to miss four of his own shows. He called on two of his closest friends to pinch hit: Sean Connery and Jerry Lewis.

OVERLEAF: Tony Bennett

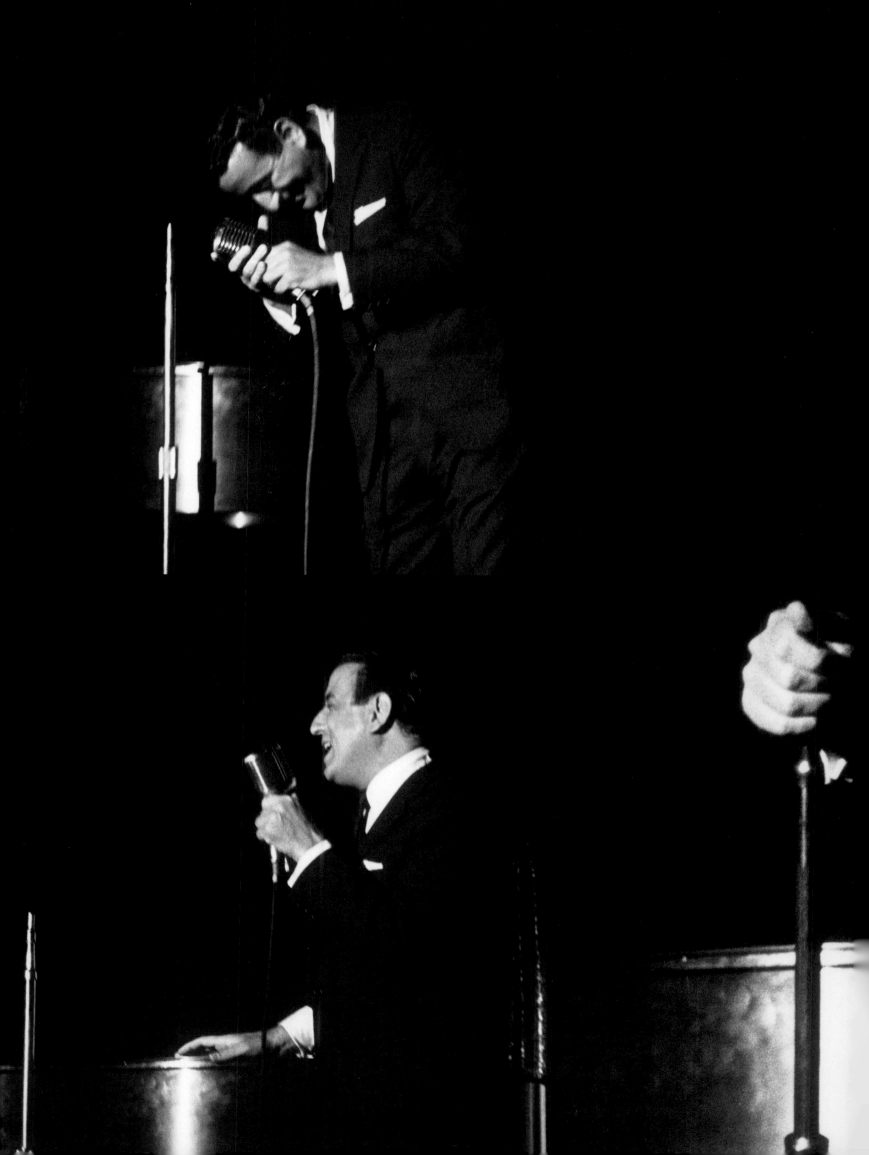

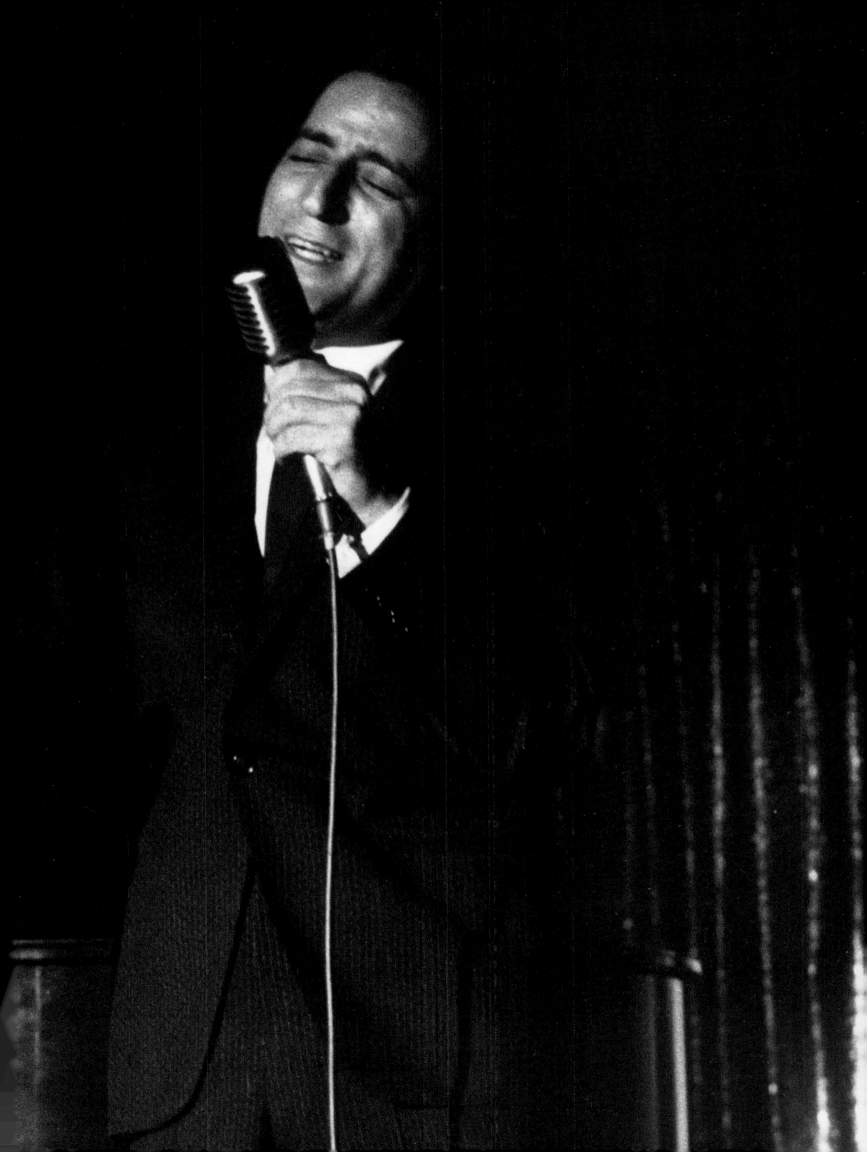

ABOVE: Vic Damone and unidentified woman

OPPOSITE: Mel Tormé

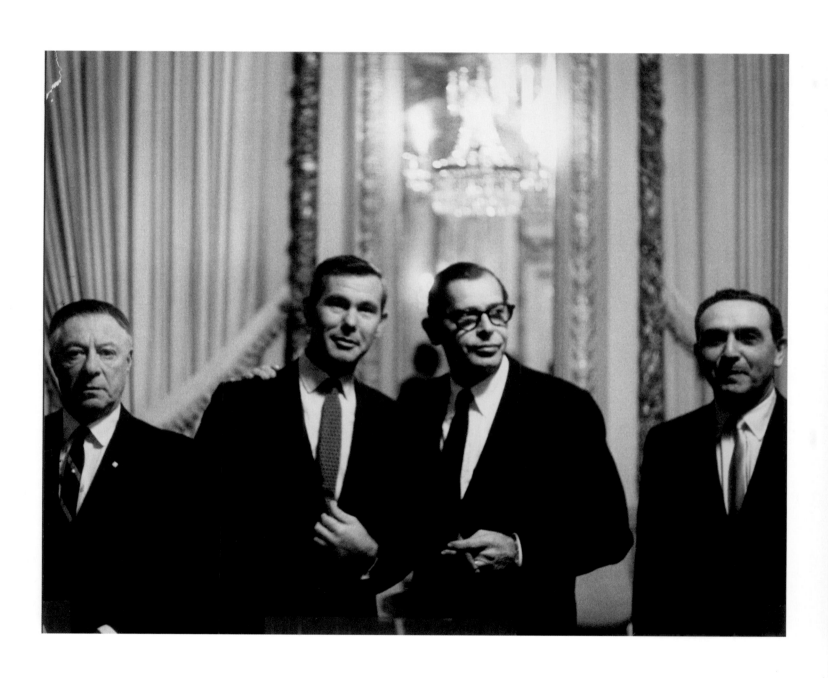

ABOVE: George Jessel (the Toastmaster General),
Johnny Carson, and Milton Berle (unidentified man at right)

OPPOSITE: Woody Allen

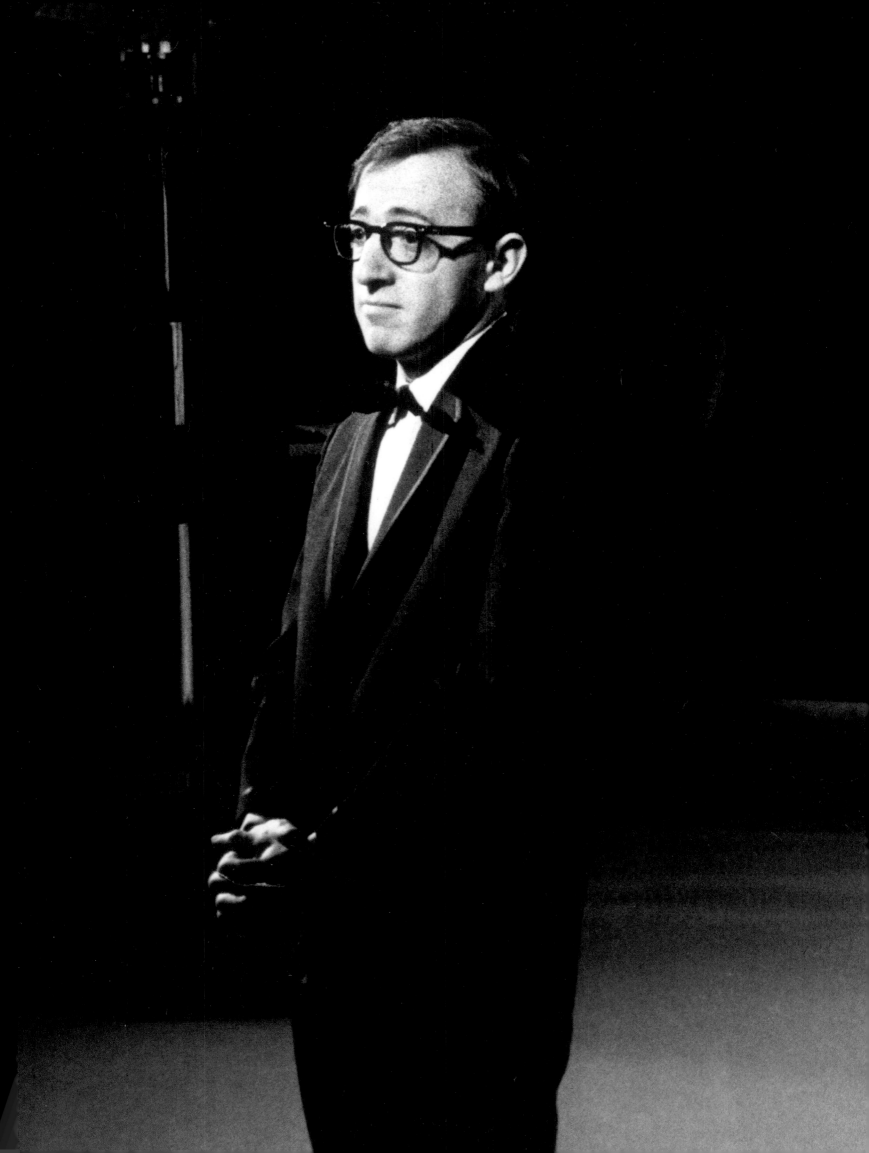

Anthony Quinn and
Paul Anka

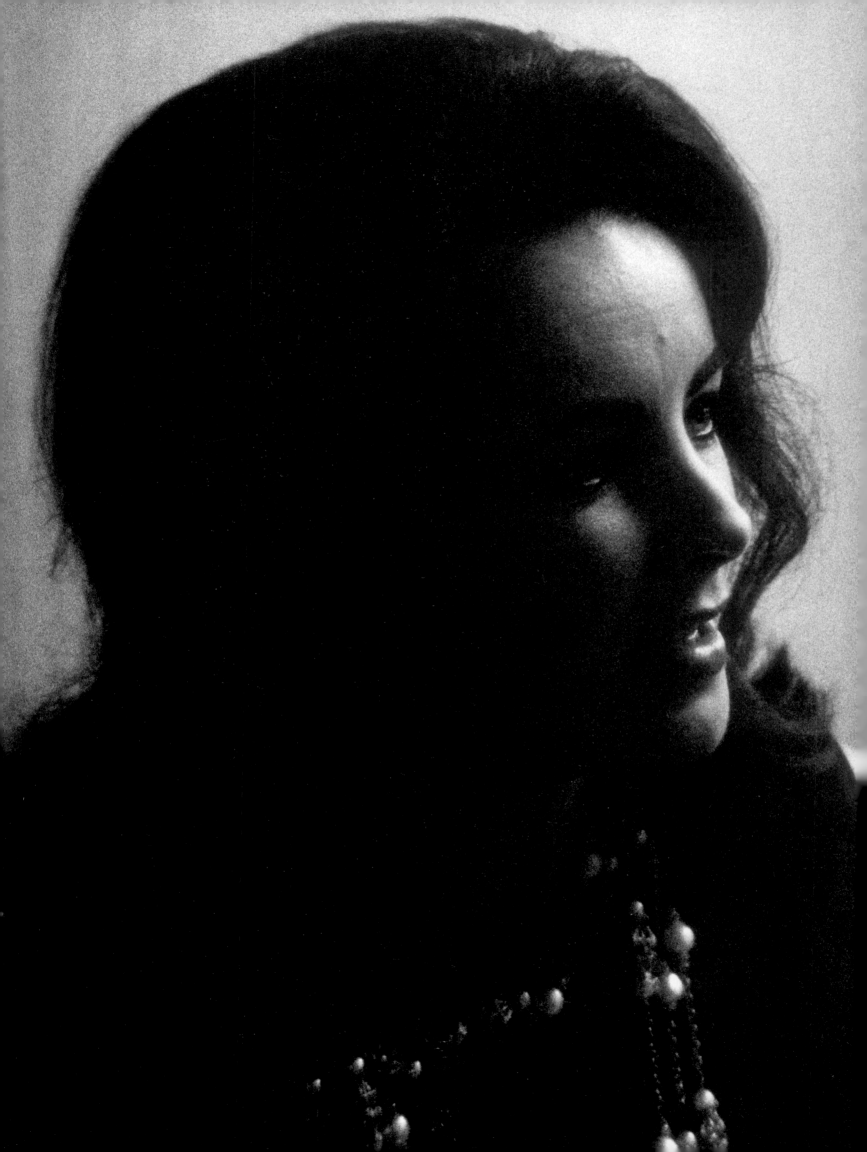

"DON COOK HAD A DINNER PARTY AT SCANDIA. 'SAM, COME, WE'LL HAVE A DINNER FOR YOU AND ALTOVISE.' SO, I'M DONE UP IN MY BEST BIB AND TUCKER, SIT DOWN AND I SEE AN EMPTY CHAIR. 'WHO'S COMING? ARE YOU MISSING PEOPLE HERE?' HE SAYS, 'NO, A FRIEND OF YOURS WANTS TO BE HERE.' AND IN WALKED ELIZABETH TAYLOR.

ELIZABETH TAYLOR

"Now, Elizabeth and I, we've been drunk together, gotten pissed together, everything you can imagine that pals have gone through. Even before she married Richard. Well, when she came in, it was like Wyatt Earp walking into a western saloon. The music stopped. And if it didn't, nobody heard it, nobody cared. Cause Elizabeth Taylor just walked in!!!! Every eye in Scandia went whoosh! It was almost like a scene in a film with everybody breathing together as she walked in.

"No one makes an entrance like Elizabeth Taylor. Cause it's casual, she's never made an entrance that's bigger than she is. She's small in height and when she walks in, she knows exactly, the move is here, and she always makes a pause before . . . And then it's 'Oh, well, thank you. Thank you very much.' And it becomes very humble, but with an elegance that no humble person could ever have. And before she sits, she stands, waiting for the guy to pull out the chair and she scans the room, 'Thank you,' and sits down. Oh, well,

that's a performance! I've learned so much from watching these people who are the friends. And I still can't get over the fact that they're friends of mine. I mean in my heart of hearts. And I'm not doing humble pie. Jesus, man, how lucky I am. I never expected this. This is gravy. Sure, you're a star and along the way you meet people that are royalty, presidents, whatever and it's, suddenly they're human beings. I'm talking about sitting with Bogart. Humphrey Bogart. And I'm thinking,

'I'm sitting with Bogart. Humphrey Bogart. And he's talking to me and calling me Sammy.' I'm sorry. I never want to lose that. It's fun to be impressed with people.

"Elizabeth said, 'Samson' and grabbed me and hugged me and kissed me. And, 'Altovise!' She went around the table, then sat down and I turned to Don Cook and I said, 'I don't want to eat now. This is it. I'm full. Right to the top.' And he said, 'Oh, come on you know she loves you.' I said, 'Of course I know. But I'm impressed with the fact that she's a movie star. She's my friend and I can talk to her on many levels that a lot of people can't, because we talk one to one.' I said, 'What are you doing with that guy? He's using

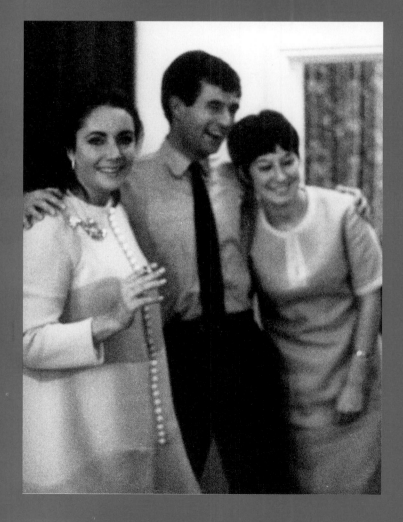

you. The guy in New York. What're you doing with him? He's not your style. Is he a giggle? If he's a good ball, okay, but you're not going to marry him, are you?' and she said, 'You're the only one who's ever said that to me.' I said, 'Well, I love you and I don't want you to get hurt anymore. You've had enough hurt in your life. And he's not for you.' I don't know how much influence I had but with me and a few other people that she takes their opinions seriously, she re-evaluated and said, 'It was great fun but it was just one of those things.' Because the guy was using her. And he's got money. I don't mean he's poor and he was going to rob her, that jazz. But I don't want her to marry that kind of a guy. That's what I said to her. 'You've got to have somebody that's equal to you.' But to have her there as a surprise guest . . . we giggled and we laughed. She's sitting next to me. People are coming over to the table, Scandia's packed, and this woman asks me, 'Would you ask Elizabeth to sign this?' And I went, 'She's a human being. She understands English. You can ask her.' And Elizabeth couldn't have been more gracious, she signed with mar-velous flamboyance. She looked magnificent, she'd just lost weight, looking good, dressed to the nines, and she had the streaks in her hair. Not that punk thing that she's into now, but she had that . . . she just looked so super elegant. And I leaned over and I said, 'I should have nailed you when I had the chance.' That was my joke with her, 'It's too late for us. Could have nailed you, y'know. Too late now . . .' and she almost blushed and said, 'Oh, Samson . . .'"

ABOVE: Elizabeth Taylor with unidentified couple

OPPOSITE: Elizabeth Taylor appearing on the *The Sammy Davis, Jr. Show*, NBC 1965

PAGE 105: Elizabeth Taylor speaking with Sydney Poitier (far left)

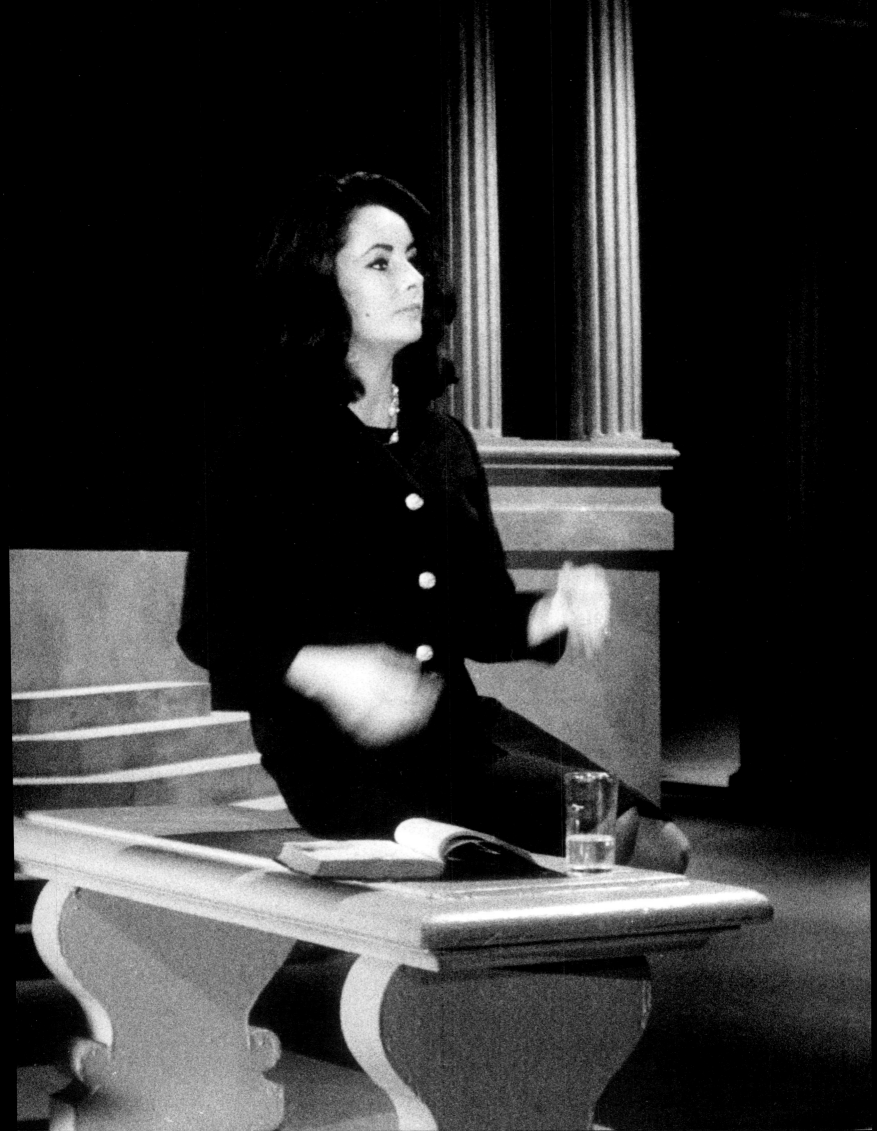

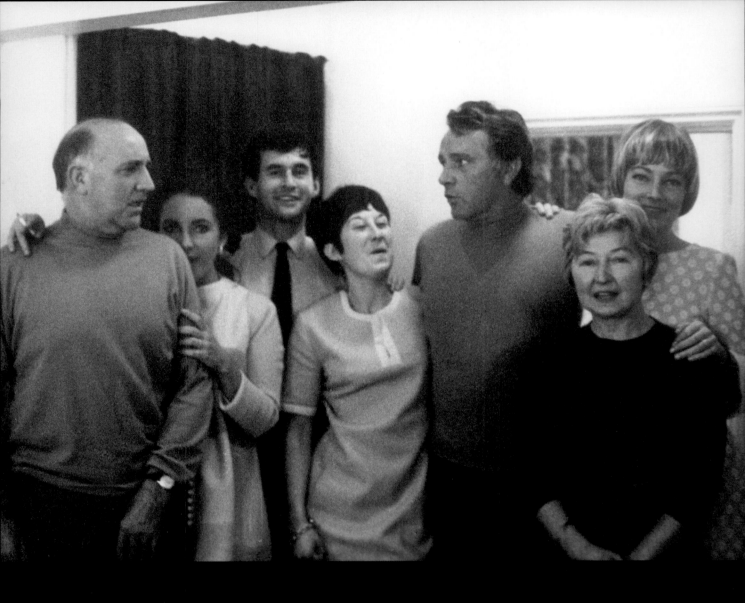

Richard Burton with May Britt and her mother, Hillevi,
Mrs. Ernst HugoWilkens

Elizabeth is standing behind Richard's brother Graham Jenkins of
Swansea, Wales. The other couple is unknown.

Richard Burton during rehearsals for *The Sammy
Davis, Jr. Show*, NBC 1965

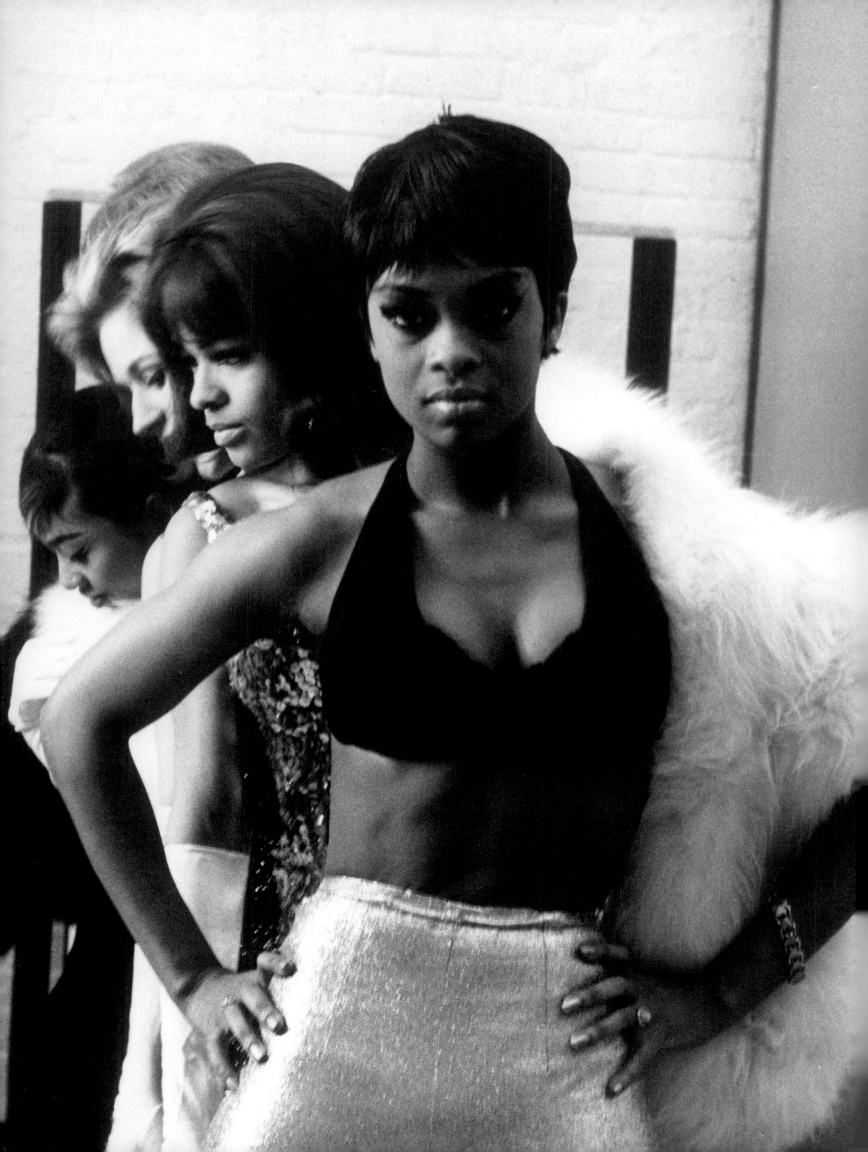

ABOVE: Lola Falana in London during the run of *Golden Boy*

Hugh Hefner loaned Sammy his penthouse suite at The Playboy Club in London, and Sammy rented a suite for Lola, who was his girlfriend at the time. He had separated from May Britt almost a year earlier. Another dancer from the show, Altovise Gore, had a long commute to her rooming house, so Lola invited her to share her suite. Big mistake… Altovise became his third wife. Lola would later quit show business and become a missionary.

OPPOSITE: Lola Falana and girls from *Golden Boy*

OVERLEAF: Lola Falana performing

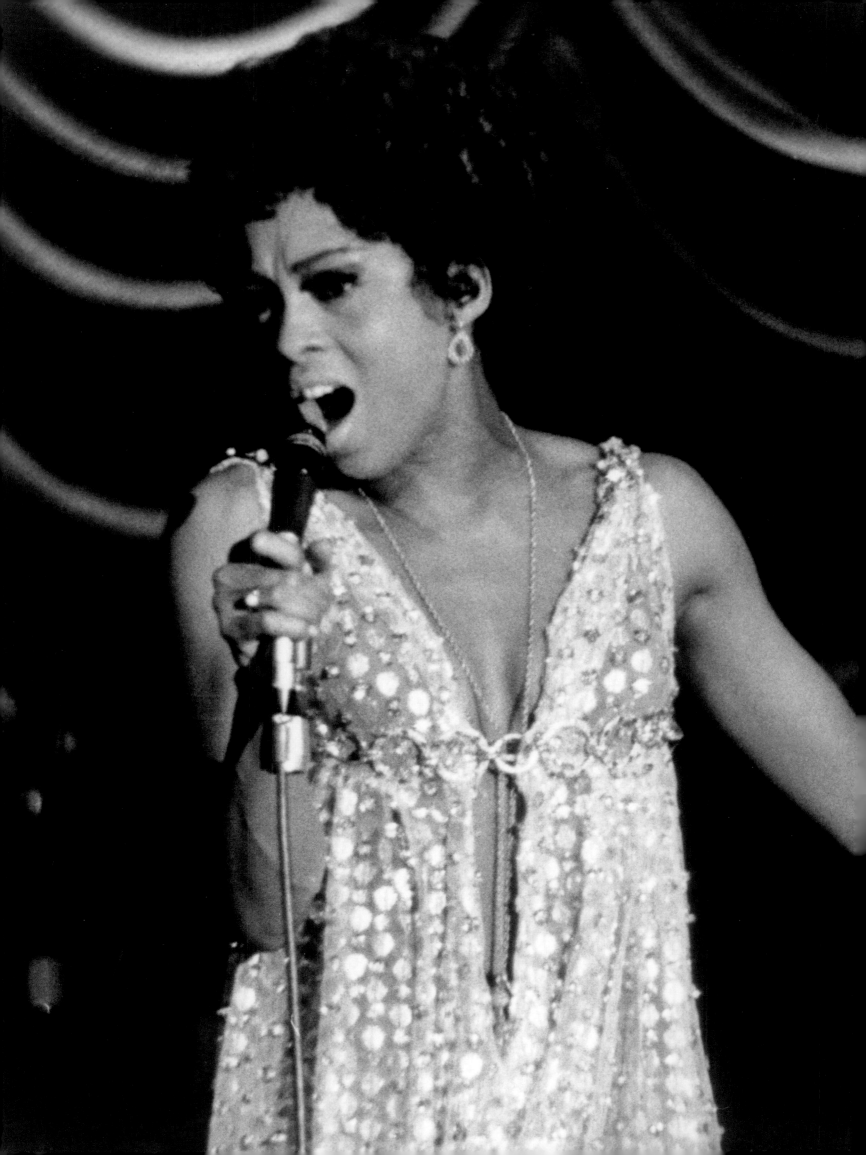

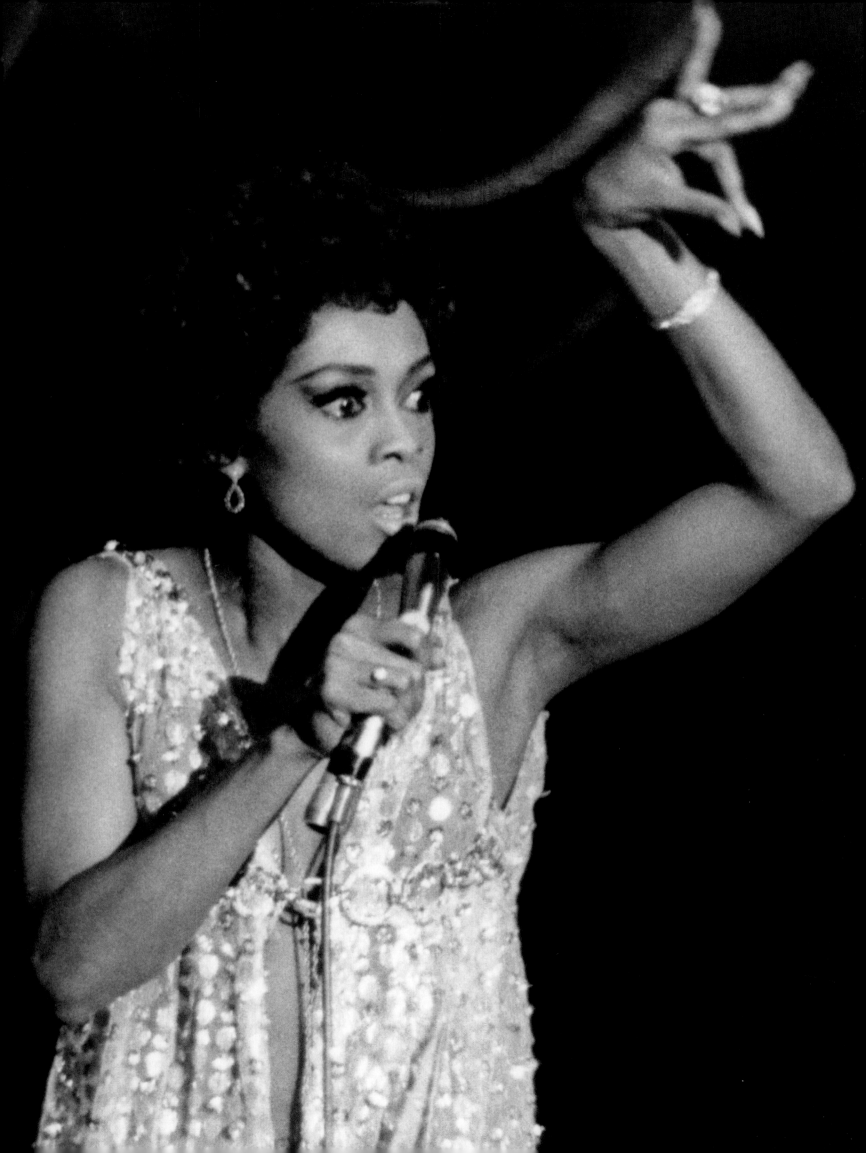

ABOVE: Steve Lawrence and Eydie Gorme

Steve and Eydie were very close, dear friends. They had a house
a few blocks from Sammy's in Beverly Hills, and he would often
drive over and just hang out.

OPPOSITE: Nancy Wilson on *The Sammy Davis, Jr. Show*, NBC 1965

OVERLEAF: Duke Ellington and Arthur Fiedler of the Boston Pops

IN SAMMY'S EARLY YEARS IN HOLLYWOOD, TONY CURTIS WAS ONE OF HIS CLOSEST FRIENDS.

TONY CURTIS

When they first met, Sammy had just made his huge success at Ciro's, a nightclub, but Tony and his wife, Janet Leigh, were already movie stars! Theirs was the first celebrity home Sammy visited in Beverly Hills.

A few years later in 1954, Tony and Janet were among the first to rush to Sammy's side upon learning of the near-fatal auto accident which left him with only one eye. In the hospital in San Bernardino, California, the morning after the accident, Sammy pointed to adhesive tape on the palm of his right hand and asked the nurse what had happened:

"'Hey, isn't this kind of a strange place for me to get a cut? I mean I was holding onto the steering wheel with both hands.'

"'That didn't happen in the accident.' She opened the night table drawer and handed me a gold medal the size of a silver dollar. It had St. Christopher on one side and the Star of David on the other. 'You were holding this when you went into the operating room. We had to pry your hand open to make you let go of it. You were holding it so tight that it cut into your flesh. It's going to leave a scar.'

"I'd never seen it before, but I had a vague recollection of Tony and Janet walking alongside me as I was being wheeled down a hall, and of Janet pressing something into my hand and telling me, 'Hold tight and pray and everything will be all right.'

"I gave it back to the nurse and lifted one end of the bandage and looked at the cut. It was a clear outline of the Star of David."

Their friendship would span their lifetimes.

In the last few days of his life, Sammy's great pleasure was to be in his wheelchair with Shirley Rhodes pushing it, telling him, "Yes, enjoy looking at it. It's yours. You earned it, you bought it, it's yours. You own this house and these two acres in Beverly Hills. It's all yours…"

It was, of course, the house that he had first visited, Tony and Janet's movie star house on Summit Drive.

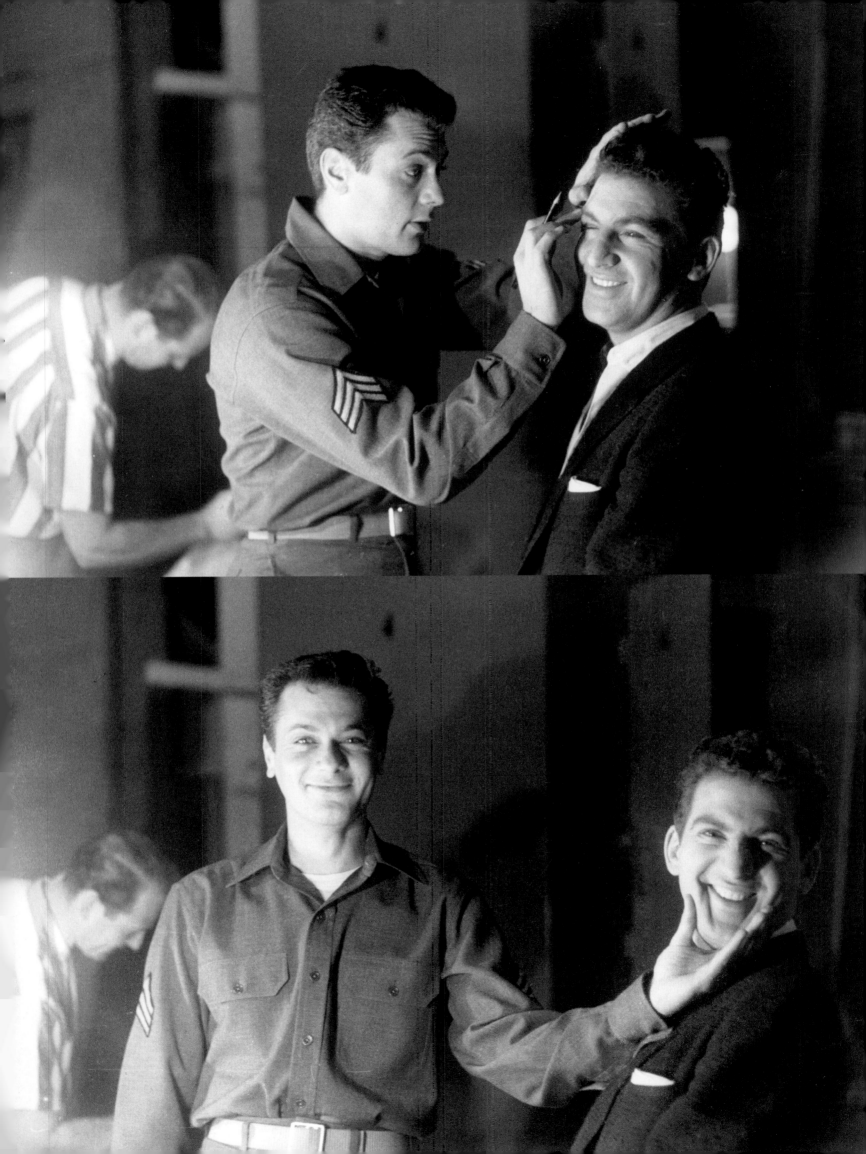

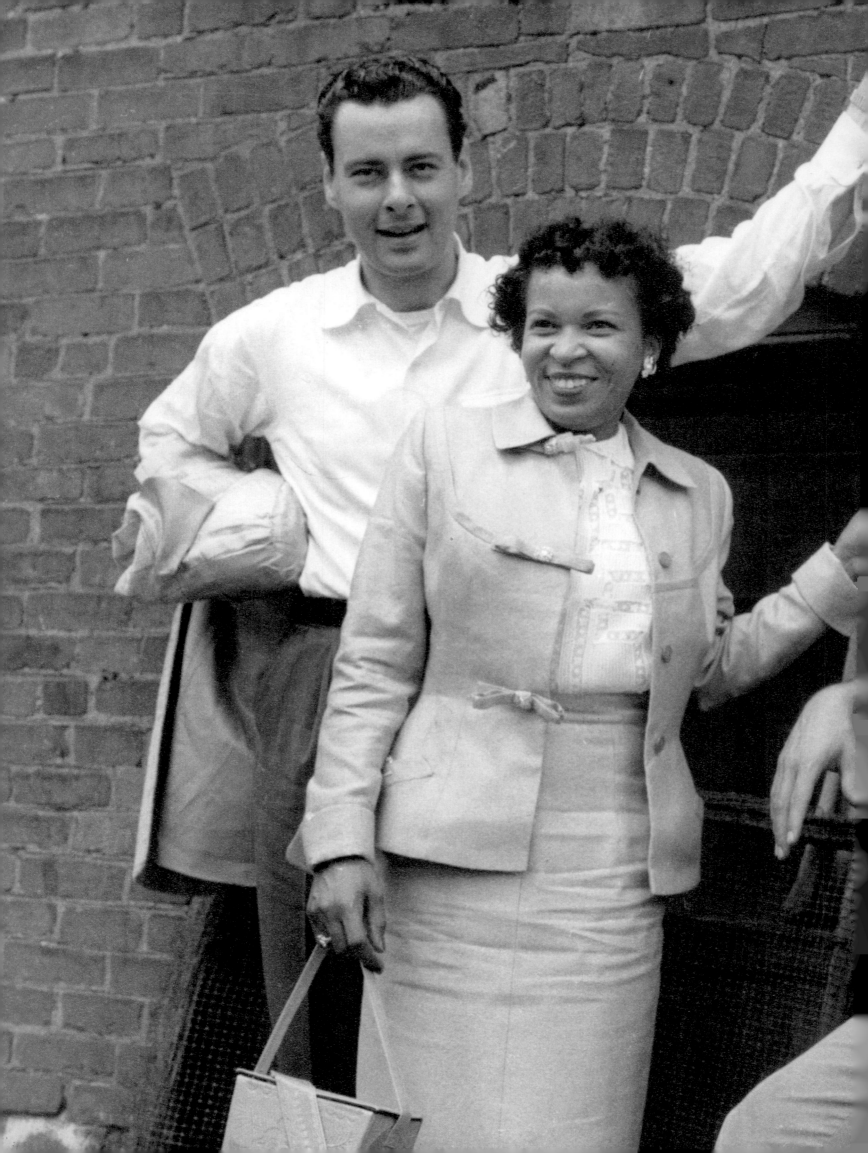

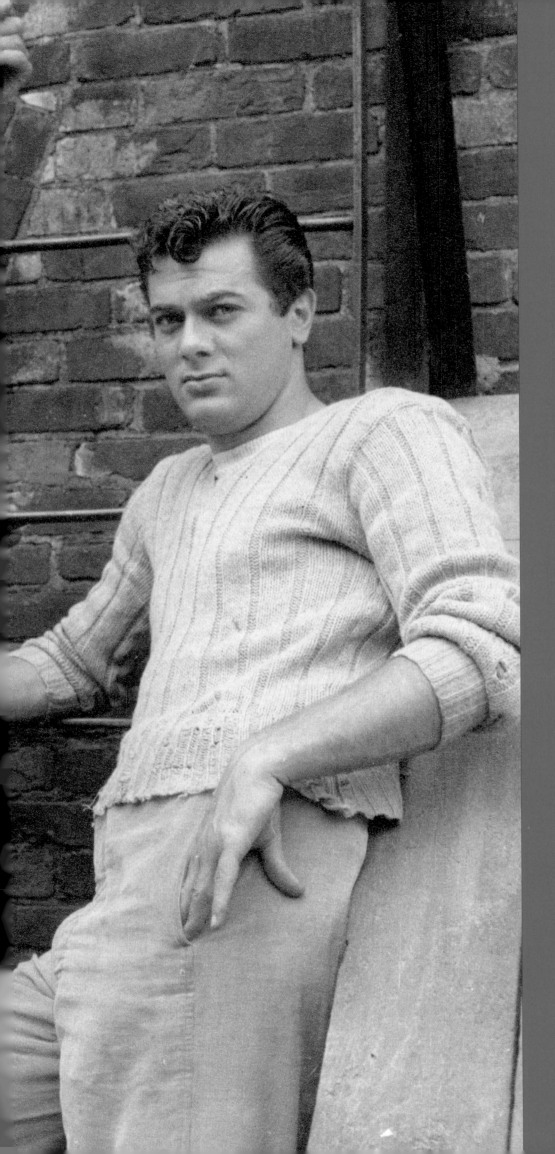

Morty Stevens, Peewee (Sam Davis, Sr.'s girlfriend, then wife), and Tony Curtis

PAGE 119: Tony Curtis with unidentified man

OVERLEAF: Tony Curtis and Rock Hudson

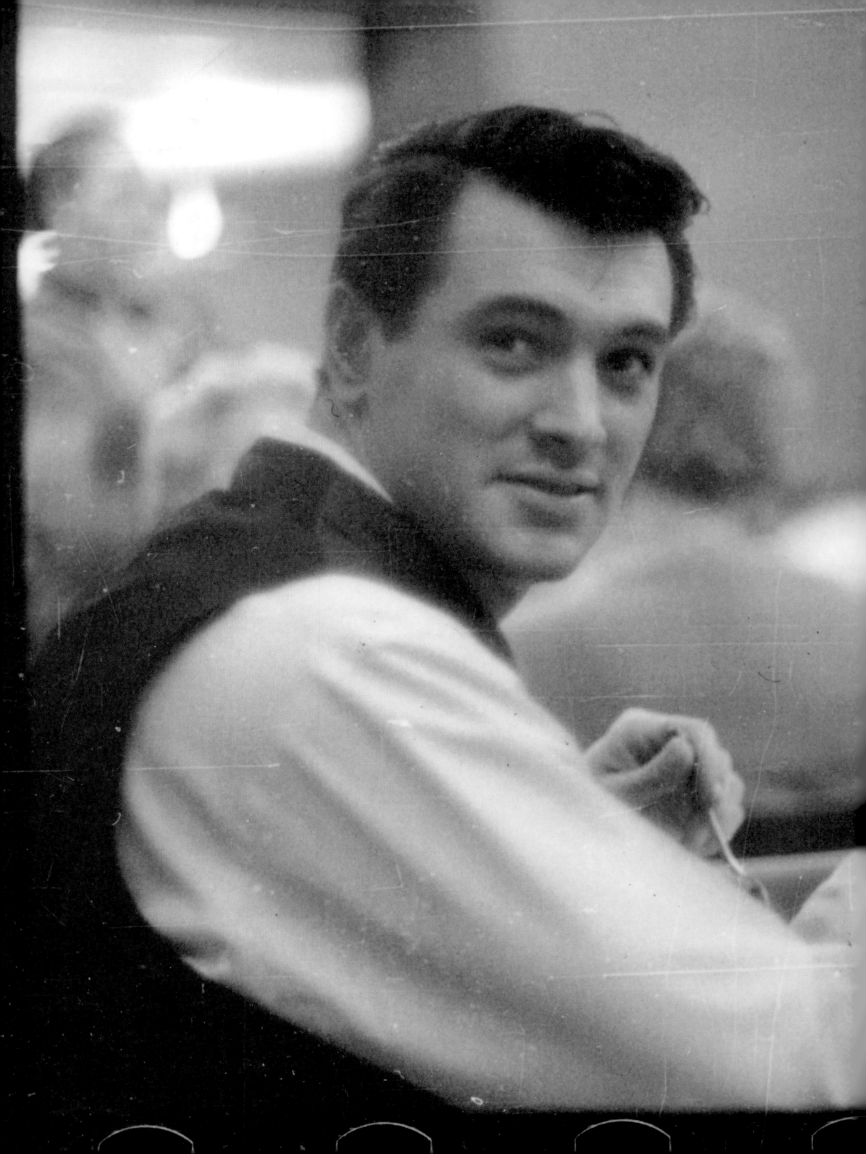

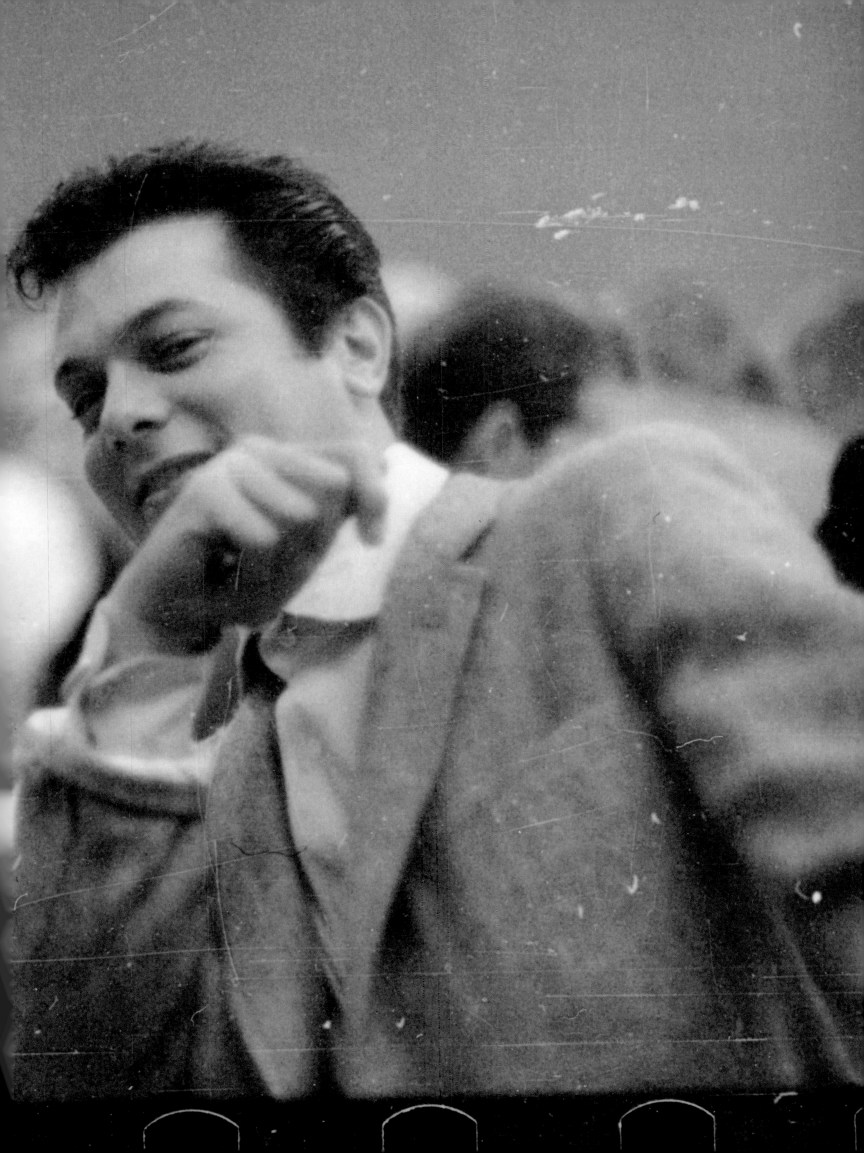

ABOVE: Tina Louise

OPPOSITE: Juliet Prowse

OVERLEAF: Charlotte Rampling
"Charlie" was part of the British scene Sammy happily fell into
in the early '60s, the Kings Road crowd that included the eclectic
mix of Anthony Newley, Joan Collins, Mama Cass, Richard
Harris, Jimi Hendrix, Peter O'Toole—just to name a few.

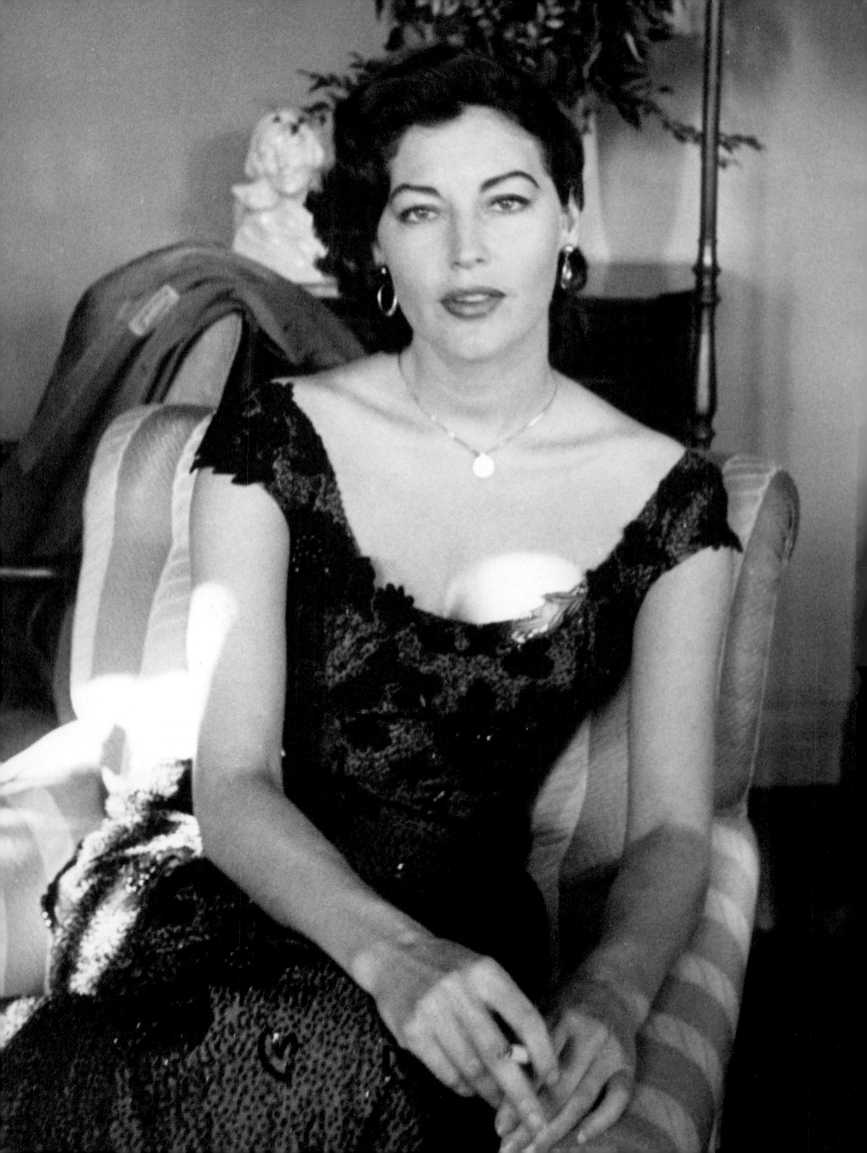

AVA WAS IN NEW YORK ON A PUBLICITY TOUR FOR *THE BAREFOOT CONTESSA* AND SAMMY WAS PLAYING THE APOLLO THEATER IN HARLEM. SAMMY INVITED AVA TO TAKE A BOW AT THE APOLLO.

AVA GARDNER

He knew full well that her presence would bring the house down, and it did. She was a great pal, and very aware of her stardom and how it would raise Sammy's prestige. After the show they went around to a few places to have drinks and be seen. They were accompanied by studio press people every minute of the evening. Months later, that evening out together would come back to haunt them.

"My father came in carrying a magazine," said Sammy. "He seemed upset as he handed it to me. It was *Confidential* [a scandal magazine] and the headline on the cover was: WHAT MAKES AVA GARDNER RUN FOR SAMMY DAVIS, JR? The cover was a picture of us together. I turned to the story. The same picture was captioned: 'Ava and Sammy cheek-to-cheeking it in her 16th floor suite at New York's Drake Hotel.'

"'Poppa [Sam Davis, Sr.'s nickname for Sammy]—just between us—is there anything to that?'

"'Dad, are you losing your mind?' I skimmed through it. 'Some girls go for gold but it's bronze that "sends" sultry Ava Gardner…Said Sammy after his first meeting with Ava, 'We just dig each other, that's all…' They'd based the whole thing on the night she'd come up to the Apollo and on the 'Our World' story her studio had written. They'd capitalized on its title, 'Sammy Sends Me,' but they left out 'as a performer' and slanted all her quotes like 'exciting, thrilling, masculine' about my performance onstage to make them sound like she meant in bed. Then they wrote in some smirks and left the rest to the reader's imagination. And they'd done it so well that if you didn't look carefully it sounded like Ava and I were having the swingingest affair of all time."

OVERLEAF: Marilyn Monroe

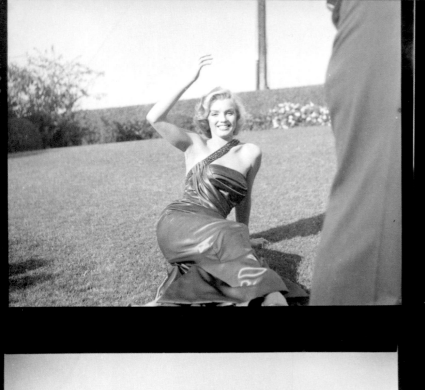
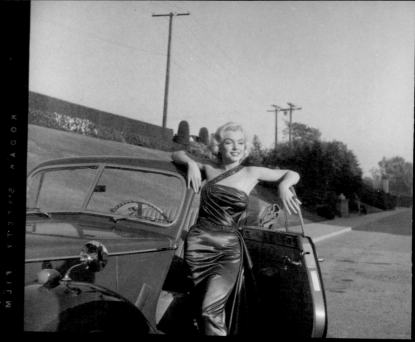
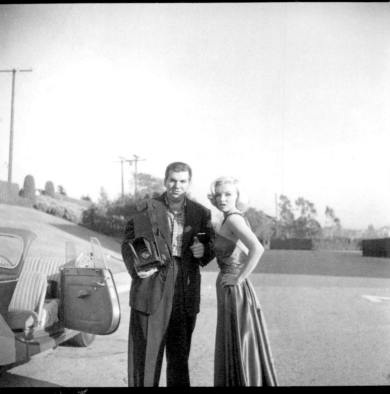

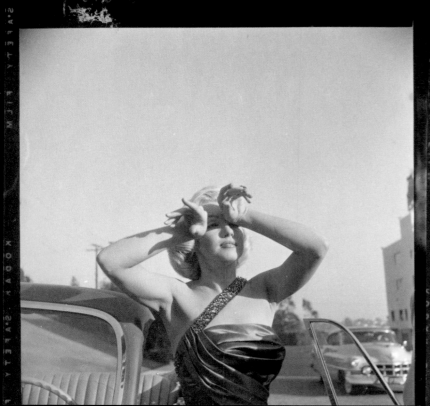
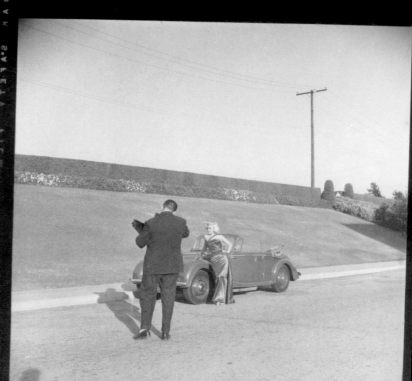

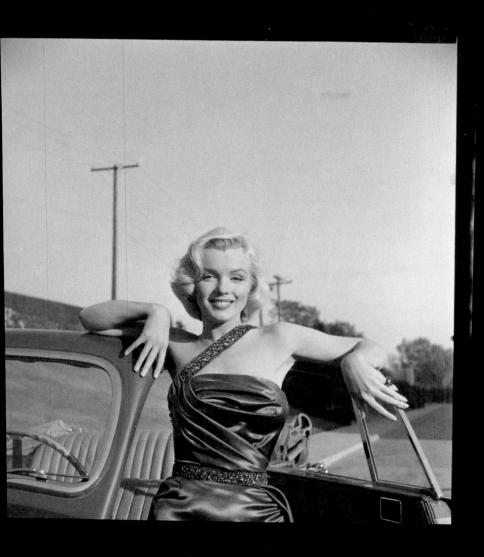
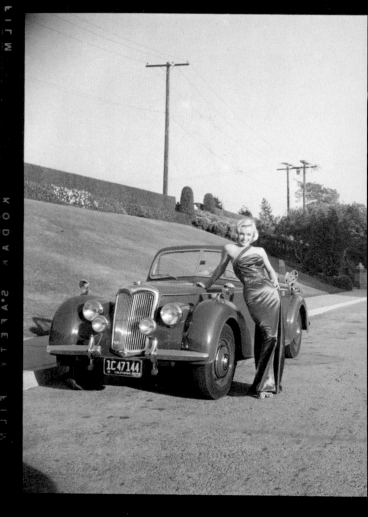
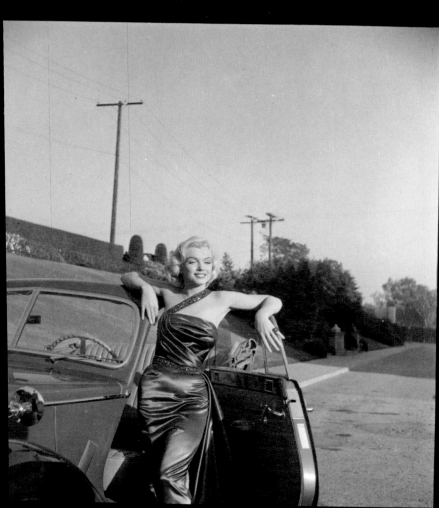
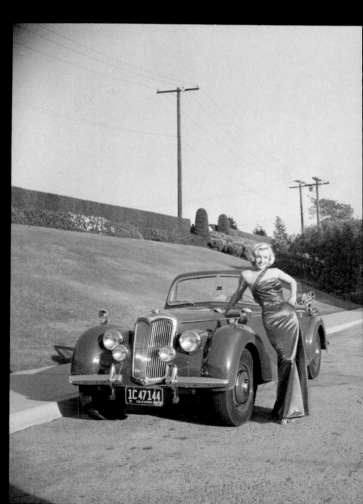

SAMMY FIRST MET KIM NOVAK
AT THE HOME OF TONY CURTIS AND JANET LEIGH. EVEN THOUGH IT WAS A QUICK AND HARMLESS INTRODUCTION, IT JOLTED THE SEISMOGRAPH IN HOLLYWOOD.

KIM NOVAK

In one of our many conversations, Sammy told me the story of their relationship and the fallout:

Kim Novak held out her hand, smiled, and said, "I'm awfully glad to meet you. I admire your work tremendously."

The next afternoon Arthur [Silber, a close buddy] came to the house and sat down at the end of the bar. I nodded hello, listening to one of the new sides I'd just made for Decca. When it was over he said, "I never thought you'd hold out on me like this."

I slipped the next side onto the turntable. "Like what, baby?"

His grin broadened into a "mysteriosa" smile. "You know what I mean. Come on, you don't have to do bits with me! It's all over town."

"What's all over town?"

"You and Kim Novak."

He was staring at me, first realizing that I hadn't known what he was talking about. He asked, "Didn't you see the papers today?"

"Certainly I saw them. But they didn't say nothing about me and no Kim Novak."

He showed me one of the columns: "Kim Novak's new interest will make her studio bosses turn lavender…" I'd skimmed past it earlier, never imagining it meant me. I started to tell him that we'd hardly spoken twenty words to each other, but as I looked up and saw the admiration in his face I smiled, shrugged noncommittally, and turned on the record machine.

When he left I got her home phone number and called her. "Kim, this is Sammy Davis, Jr."

"Hi! How are you?"

"Well, frankly, I'm feeling horrible over a rumor that's going around."

"I heard it."

"I'm calling to say I'm sorry as hell and I hope you know I didn't have anything to do with it."

"Of course I know that."

"We can handle it any way you think best. I realize the position you're in with the studio."

"The studio doesn't own me!"

"Well, but they'll probably feel…."

"'Don't worry about what they'll feel. I don't. Listen, I'm cooking some dinner. It's not much, but would you like to join me?"

And so it began. Kim was the great love of Sammy's life, certainly at that point.

She was also Columbia's hottest star. In those days an interracial affair was so taboo that columnists would not even have thought to mention both parties by name. So, it was a non-secret that continued appearing in blind items in gossip columns written by Hedda Hopper, Louella Parsons, and others. "What gorgeous blonde movie star is risking her career by trysting with a hugely talented sepia entertainer?" In fact, their romance was so serious that Sammy went to Chicago, secretly, to spend Thanksgiving with Kim and her family.

As the rumors continued, Sam Giancana, the FBI's Number Two Most Wanted Man and a good friend of Sammy's, traveled to Las Vegas to see him and tell him that Harry Cohn, President of Columbia, was so outraged by the romance, so fearful that it would kill off his big box office star, that he used his mob connections and took out a contract on Sammy. Giancana warned, "They're gonna crush both your kneecaps—this is no joke. They'll do it and they'll do it good. These guys enjoy hurting people. And maybe they'll also put a sharp stick in your good eye. They'd love doing that."

It didn't make sense that the mob, which owned all the clubs and casinos where Sammy performed, would allow any harm to come to their big moneymaker. But there were factions and hit men who were not connected. It sobered Sammy. Giancana continued, "I can protect you here, in Chicago and New York, but I've got no juice in L.A. so you can never go home unless you make peace with Cohn. I'm strongly advising you to cover this up: marry a nice colored girl, have a big wedding, get a lot of publicity, and take the focus off of you and Novak. Then when the heat's off you get a divorce."

Sammy made a deal with a beautiful dancer, Loray White, who was working in downtown Las Vegas. They had dated and remained friends, and she agreed to be Mrs. Sammy Davis, Jr., for a few months for something like $10,000, a lot of money then, and all the shoes she could buy. The wedding was held in Las Vegas, with comedian Joe E. Lewis and Harry Belafonte among the celebrity guests. The arranged marriage lasted a few months.

Though the romance between Sammy and Kim diminished and finally ended, their affection for each other remained. Thirty years later, when Sammy was a few weeks away from death in Cedars-Sinai hospital, one of the last people to visit him was Kim Novak.

Jack Benny on tour in the late 1940s
Benny hired The Will Mastin Trio as his opening act on a 1940s
tour and was so taken with Sammy's talent that he befriended
him, including him in his upper strata Hollywood social life.

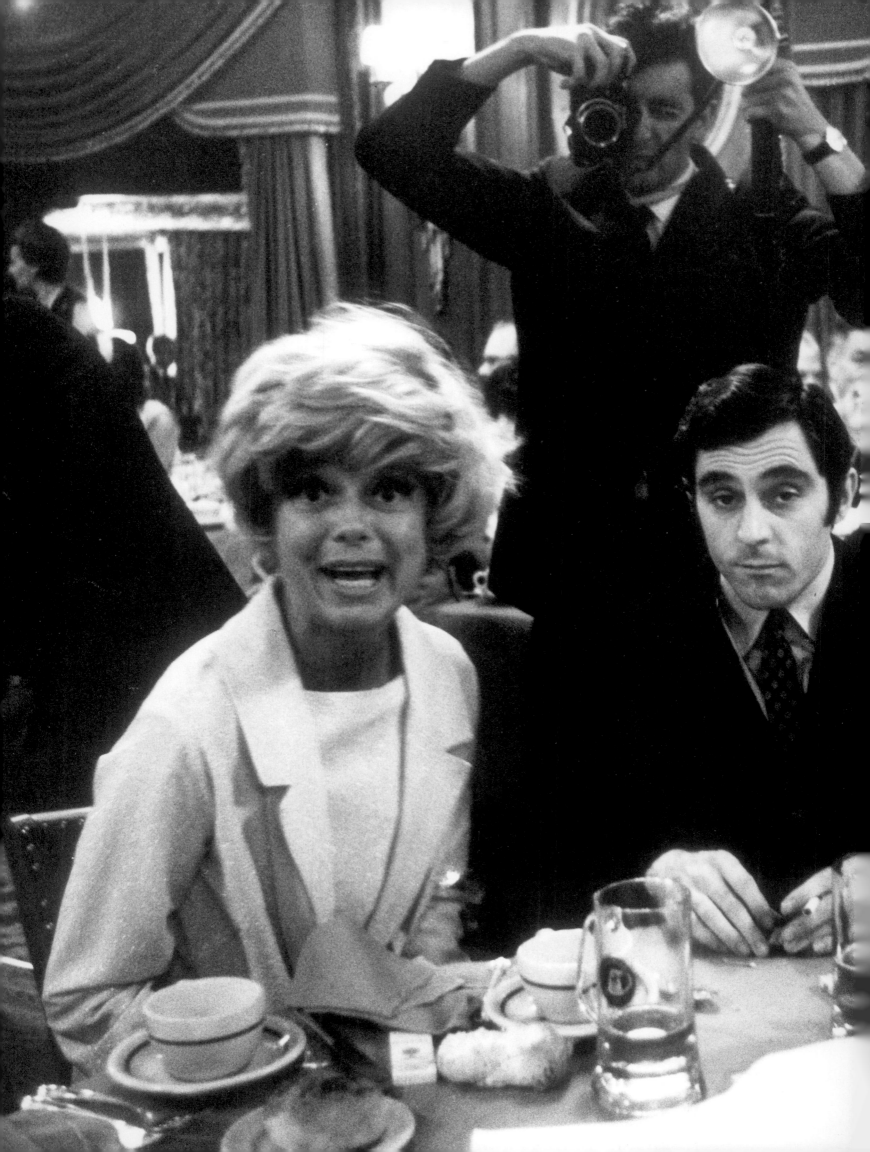

Carol Channing, Tony
Newley, and Joan Collins

ABOVE: Andres Segovia, world renowned classical guitarist

OPPOSITE: Judy Garland in rehearsal for *The Sammy Davis, Jr. Show*, NBC 1965.

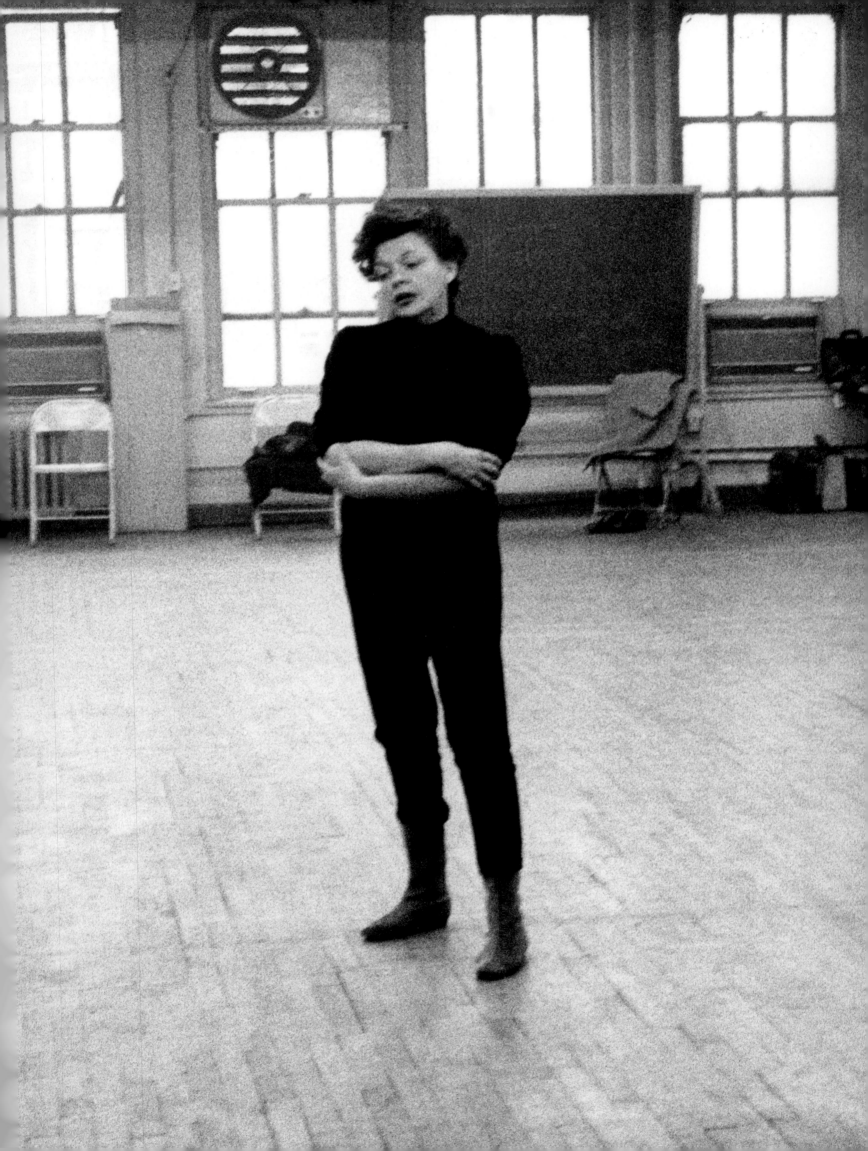

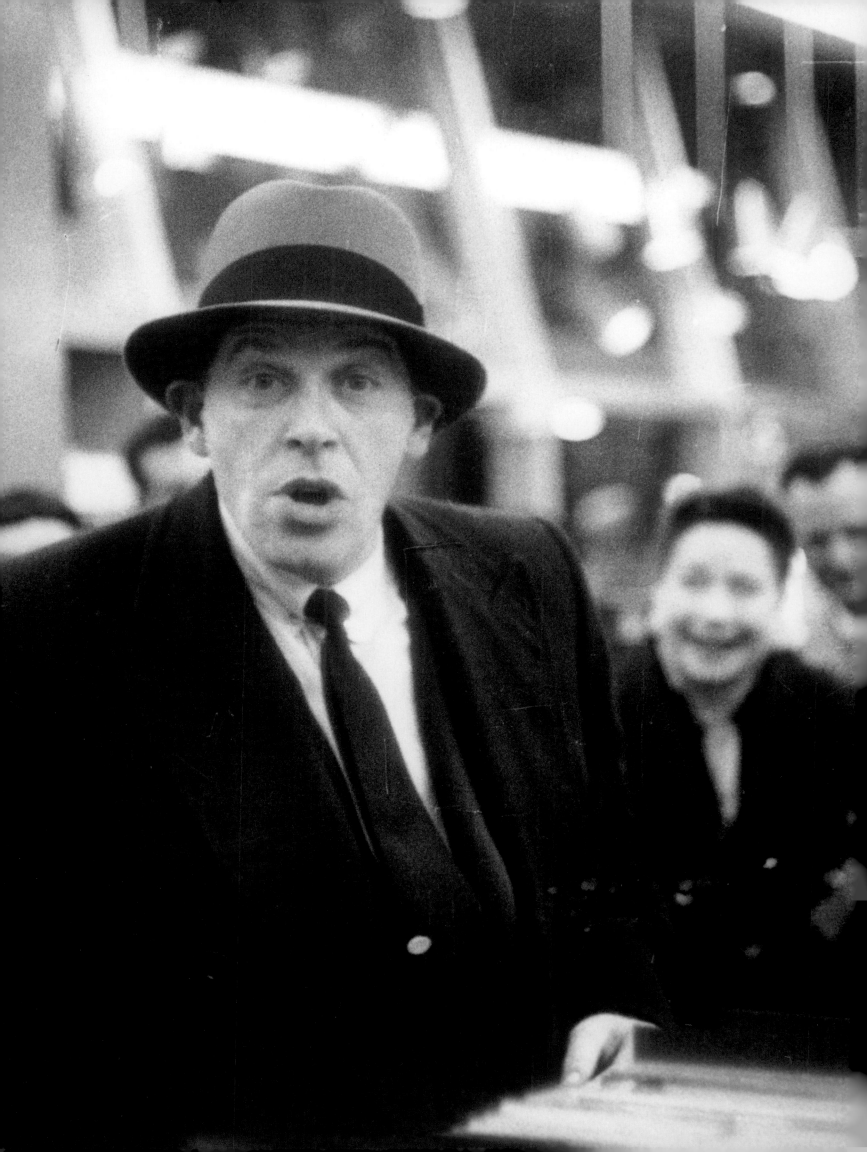

MILTON BERLE

"Occasionally, his head would nod like he was saying to himself, 'Yeah, that's good,'" Sammy told me.

"I put a little extra steam into everything I did because as a performer his little nods or the lack of them told me far more than a layman's applause could.

"I dressed quickly, knowing that he would stop backstage to say hello. After we'd spoken about the performance Berle lit a cigar.

"'Lemme suggest something to you,' he said. 'Y'know the line you did when the drunk heckled you? The way you're doing it now, it's, "If you're ever in California I hope you'll come by my house and take some drowning lessons in my pool." It's a cute line, but you're not getting the most out of it. Switch it around. Frame it as a straight invitation, like, "If you're ever in California, sir, I do hope you'll come by and use my pool." A guy has been heckling you and you say something nice to him? This confuses the audience and they're waiting. Now you hit him with the punch line: "I'd love to give you some drowning lessons!" The element of sur-

prise has to get you a bigger laugh. Also, the joke phrase is "drowning lessons" so let those be the last words. You can't follow them with "in my pool" or you're stepping on your own laugh. You force them to pause or listen and if they can't laugh the second they want to you'll lose part of it.'"

143

ABOVE: Jimmy Durante and unidentified woman

OPPOSITE: Bob Hope and Steve Allen

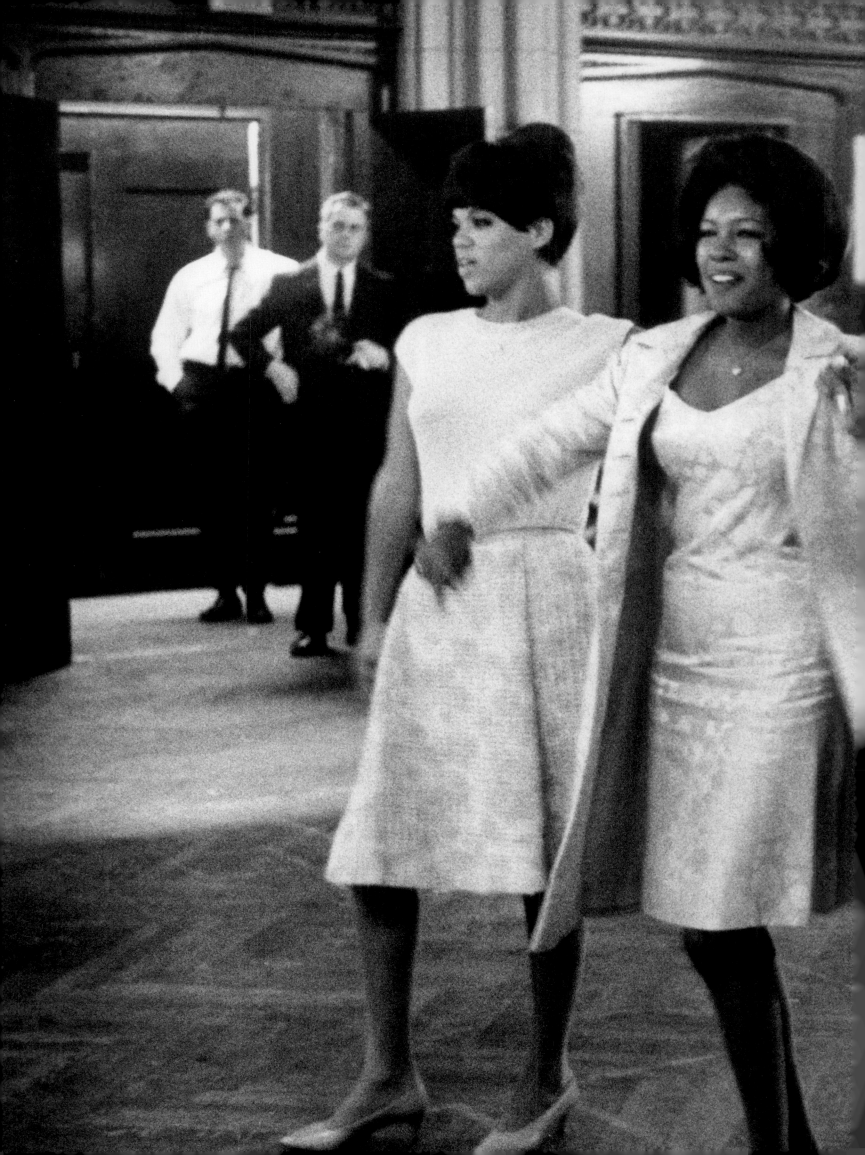

The original Supremes
Florence Ballard, Mary
Wilson, and Diana Ross

147

ABOVE: Bob Newhart on the set of the popular television show
The Entertainers, 1964

OPPOSITE: Art Buchwald

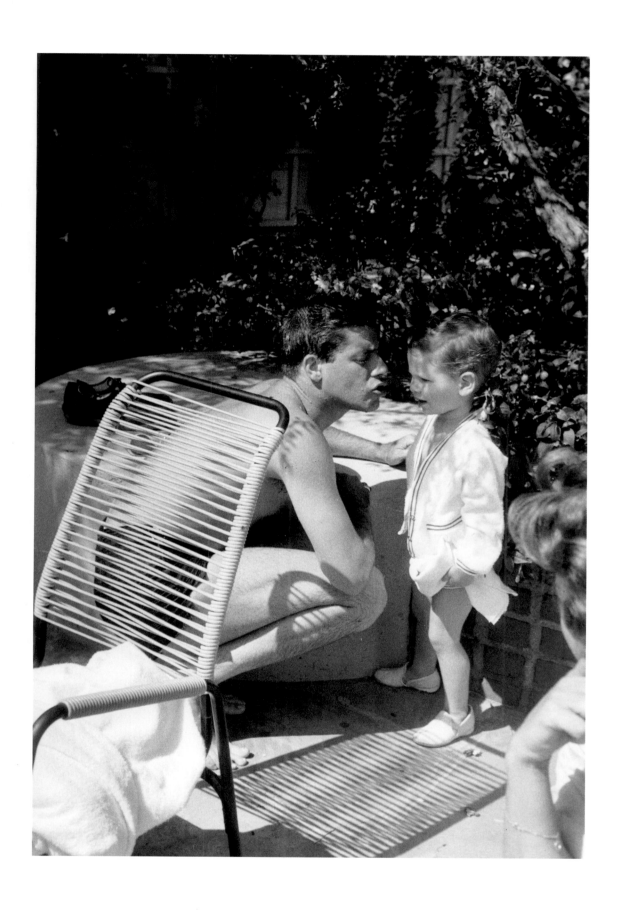

ABOVE AND OPPOSITE: Jerry Lewis

OVERLEAF: Sonny and Cher

PAGES 154 AND 155: Cher

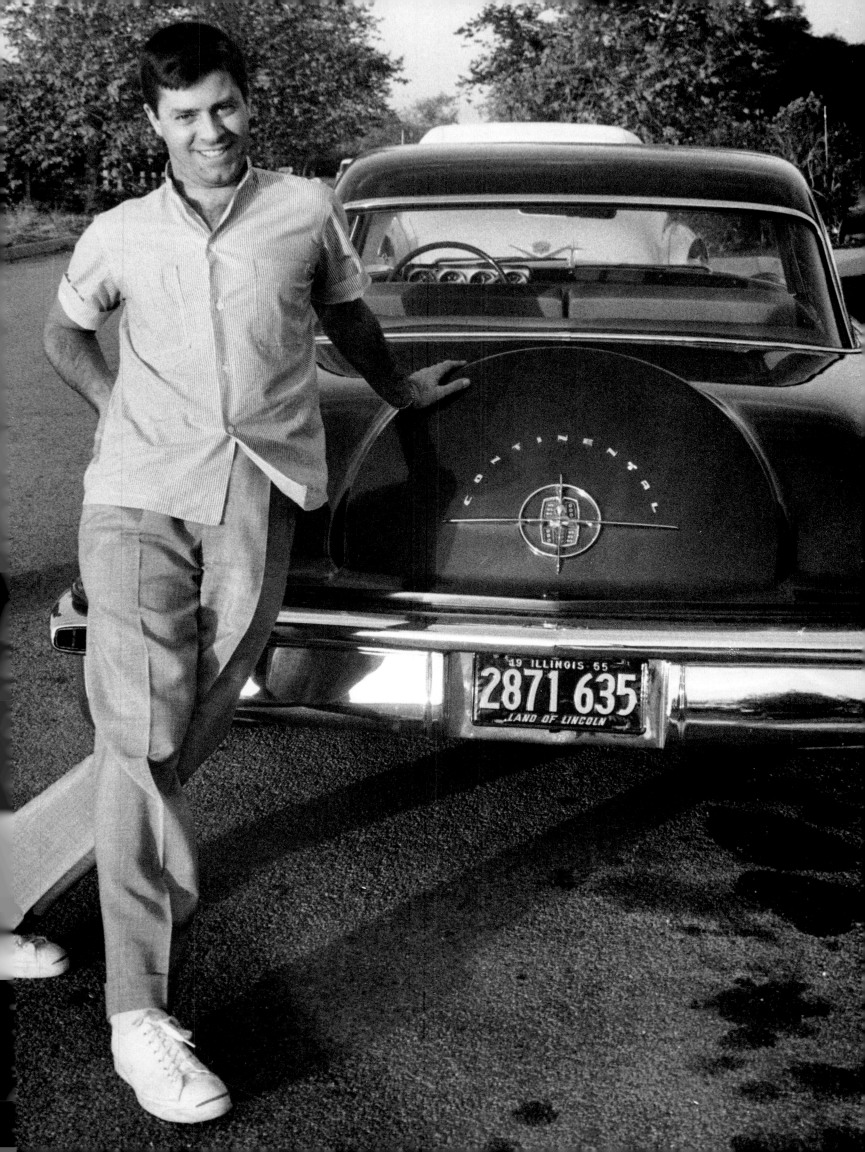

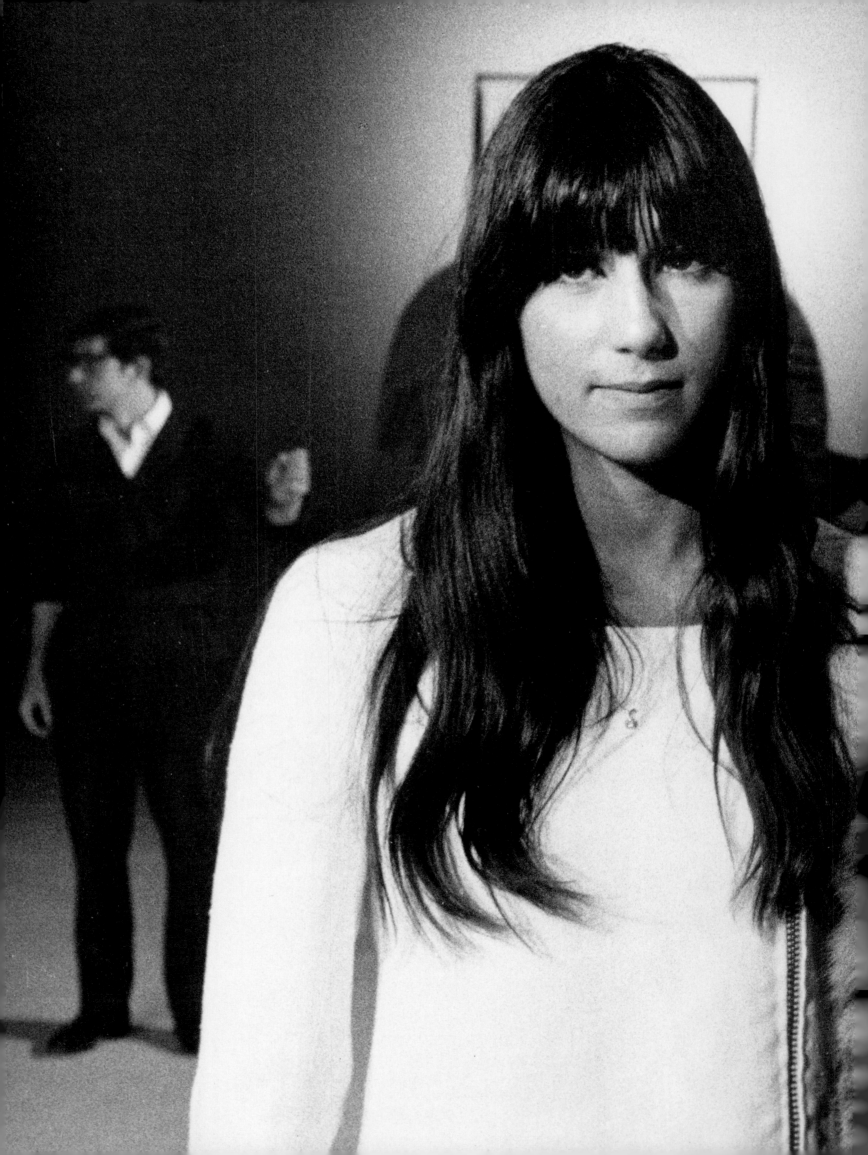

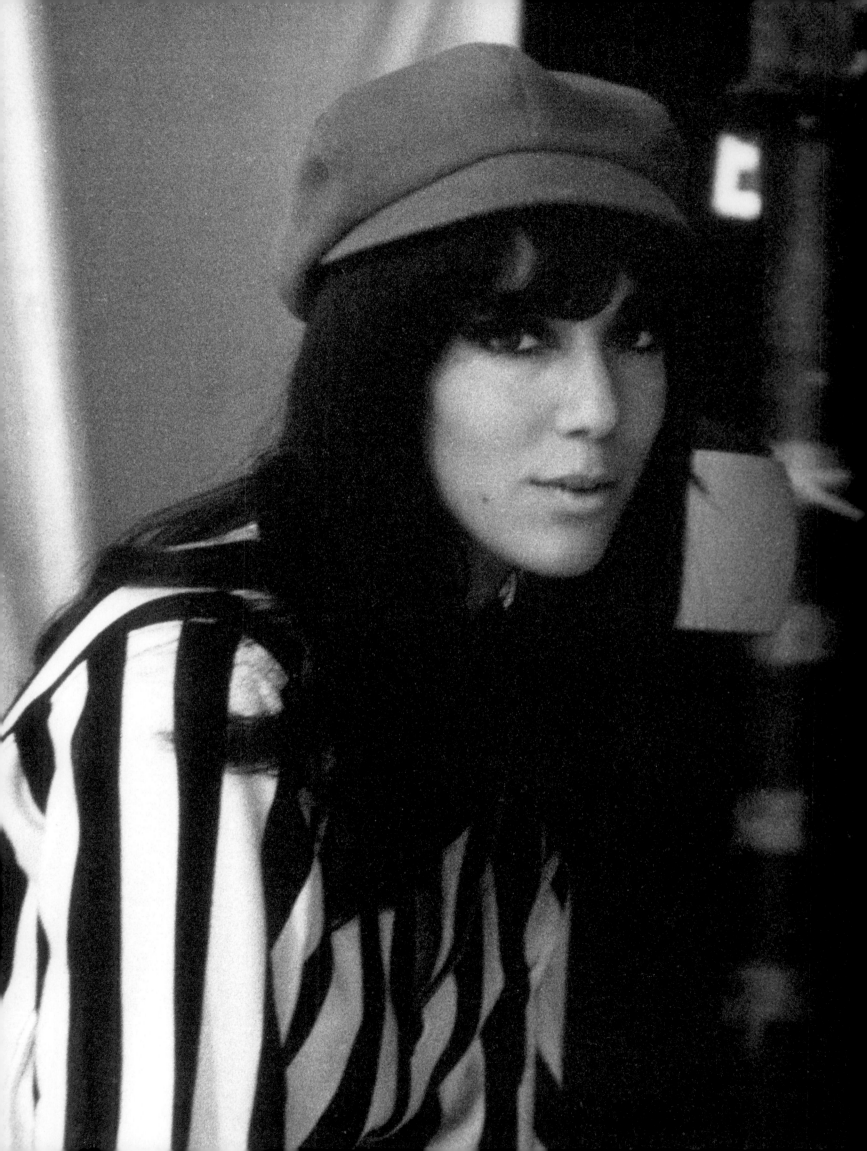

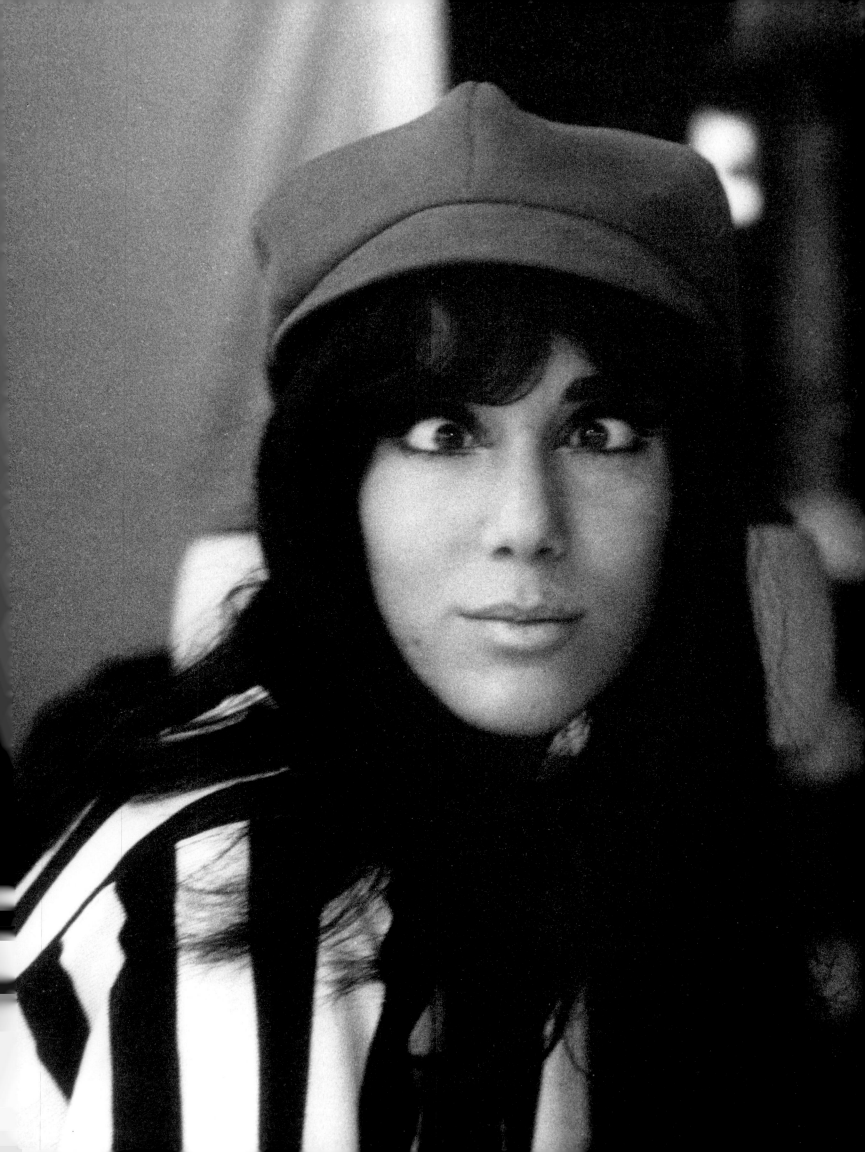

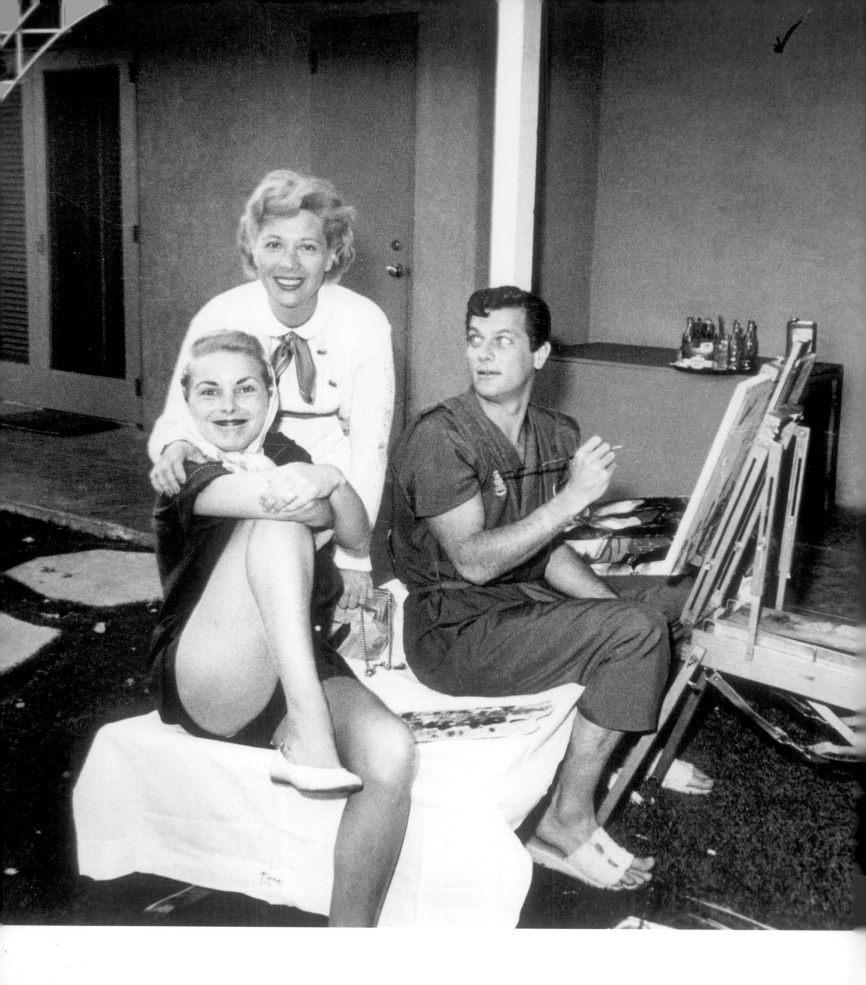

ABOVE: Janet Leigh, Dinah Shore, and Tony Curtis

OPPOSITE: Janet Leigh and Tony Curtis photographing a sidewalk artist.

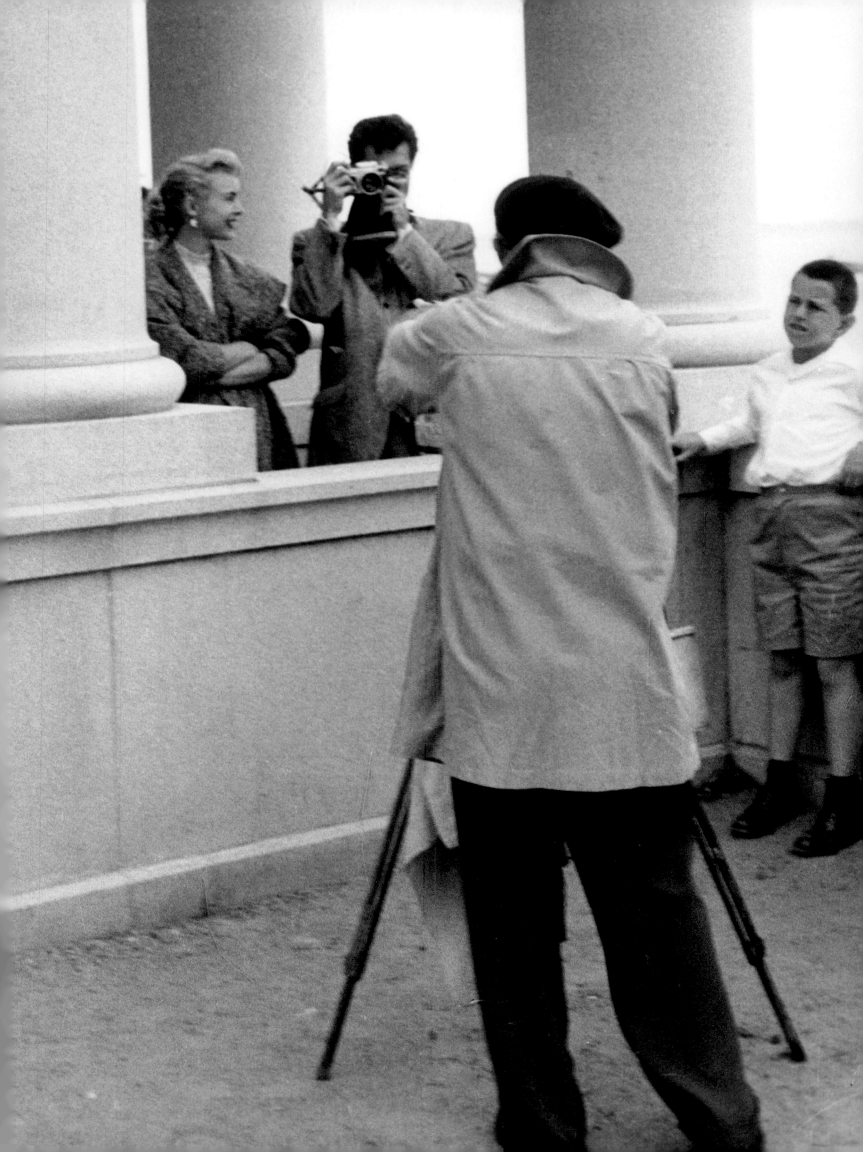

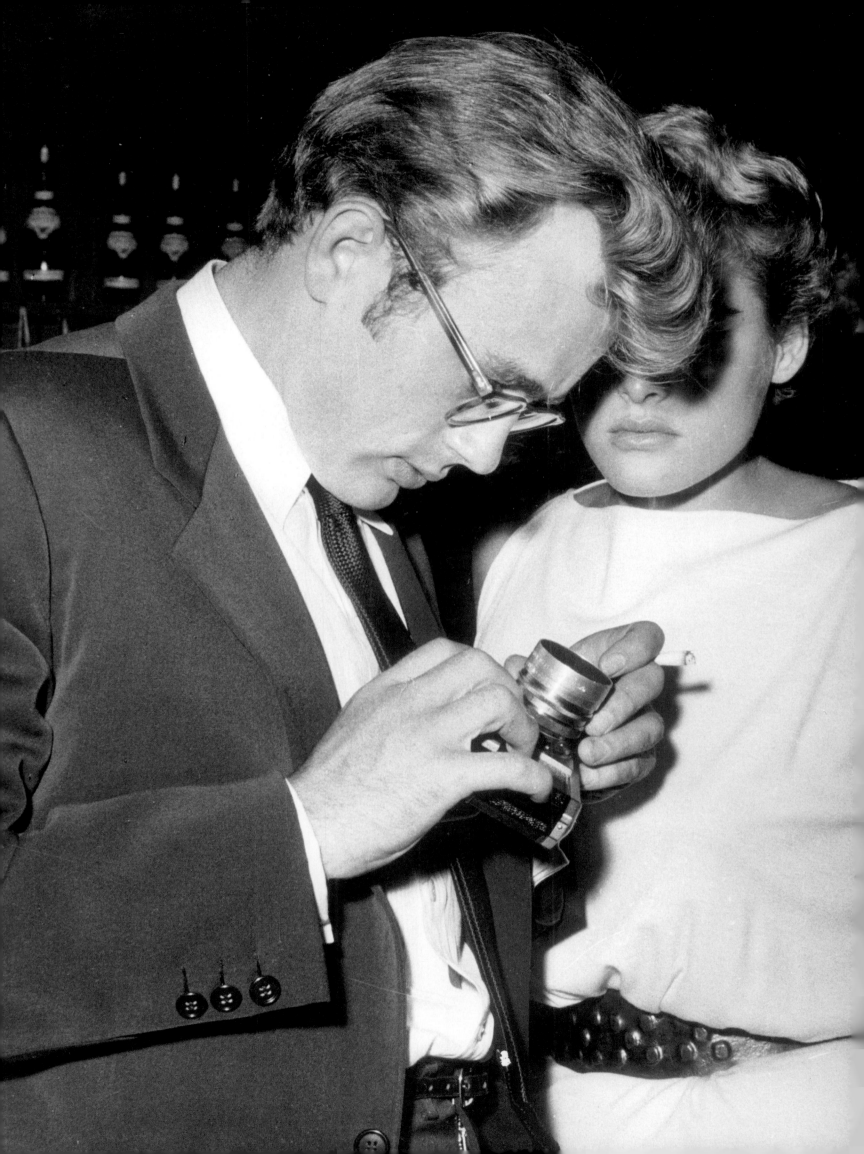

JIMMY USED TO COME TO PARTIES AT SAMMY'S HOUSE

AND SIT IN A CORNER, JUST STARING AT PEOPLE, NEVER MIXING, JUST ABSORBING EVERYONE.

JAMES DEAN

Sammy once asked him, "Hey, you shy? Y'want me to introduce you to one of the chicks?"

"No thanks," Jimmy said. "All I want is to be an actor."

"So be an actor." Sammy was wearing his quick draw holster. He did all the fancy moves and spins with the gun.

"Sam? Can I try that?" Jimmy buckled on the holster, pushed his glasses up on his nose and tried to draw. He dropped the gun. It hit the floor. Hard. Sammy folded his arms, Oliver Hardy-style, "Every move's a picture."

Sammy also recollected, "I was sailing down the road when I spotted a Porsche coming up the hill, honking its horn. It was Jimmy with Ursula Andress. He jumped out of the car looking like he was in costume for *Giant*. 'Hey, Sam, I gotta show you something I learned in Texas.' In two seconds he had a rope spinning. 'And I'm getting a little faster with the guns.'

"But you still have no chance against me, no chance at all, right? Listen, gotta run, but I'll be back in a month. I've got something I want to tell you.

"And we were back in our cars and it was *rrrrrr* and away we went trying to see who could kick up the most dust."

Sammy was in his dressing room when the report of Dean's death in a car crash came over the radio.

"I never got a chance to tell him. I never gave him the pleasure of hearing it. I did to him what I wouldn't want anyone to do to me. I tolerated him. I treated him like a kook. He was a sensitive man. He felt everything and I made jokes about him.

"How could I have judged a man before I knew what he was all about. Me, who's suffered from prejudgment. Oh, God, I just hope—as corny as it sounds—I hope he knows I mean it, that I wish I'd said to him, 'I know you were my friend and I wish I'd been your friend, too.'

"Even on the hill when I could have said something—I could have yelled, 'Hey, you were great'—I'd wanted the pleasure of telling it to him just right.

"Why don't you tell someone you appreciate them while you still can?"

159

ABOVE: James Cagney

OPPOSITE: Jack Klugman

Sammy did an NBC television show called *Poor Devil*. Klugman was the devil and Sammy was an apprentice the devil would send to earth to hurt people. Sammy, the "poor devil" of the show title, would wind up helping them.

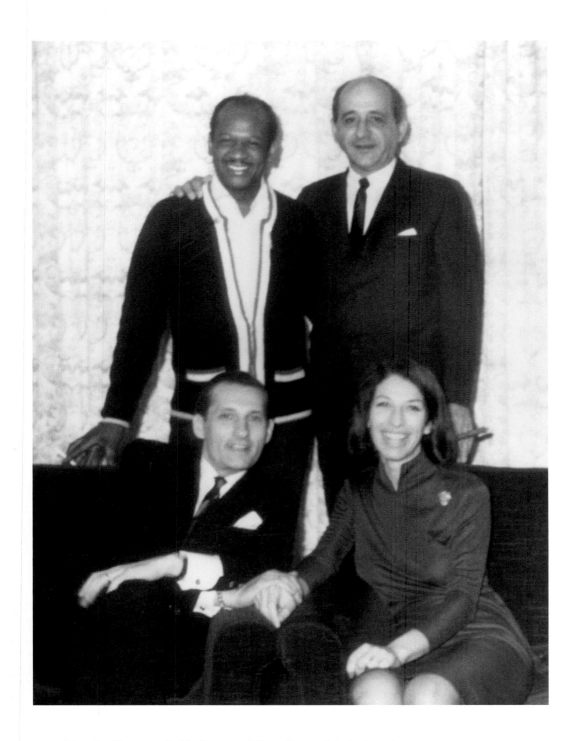

Murphy Bennett (left), Jane and Burt Boyar (sitting) and "Dr. Goldberg" the code name used by the FBI's No. 2 Most Wanted Man, Sam Giancana, photographed by Sammy, at Giancana's request, before dinner with Phyllis McGuire.

Jane Boyar

This photo was taken at Danny's Hideaway in New York, on the night we met Sammy. Jane was twenty-five and wearing her honeymoon travel dress. I was a Broadway columnist then and had called him to get something for my column. Sammy suggested dinner and we met that evening at Danny's. It was one of those oh-so-rare cases of instant great chemistry. At 7:30 he apologized for having to leave and do his show, *Mr. Wonderful*, and said, "Why don't we have dinner together..." he paused, thinking, then finished, "...like five nights a week." He was an Original. We were together every night for the entire year he was in town. And our friendship continued until his passing more than forty years later.

Van Johnson, Eddie
Fisher, Frank Sinatra in
hat and half face, and
Humphrey Bogart

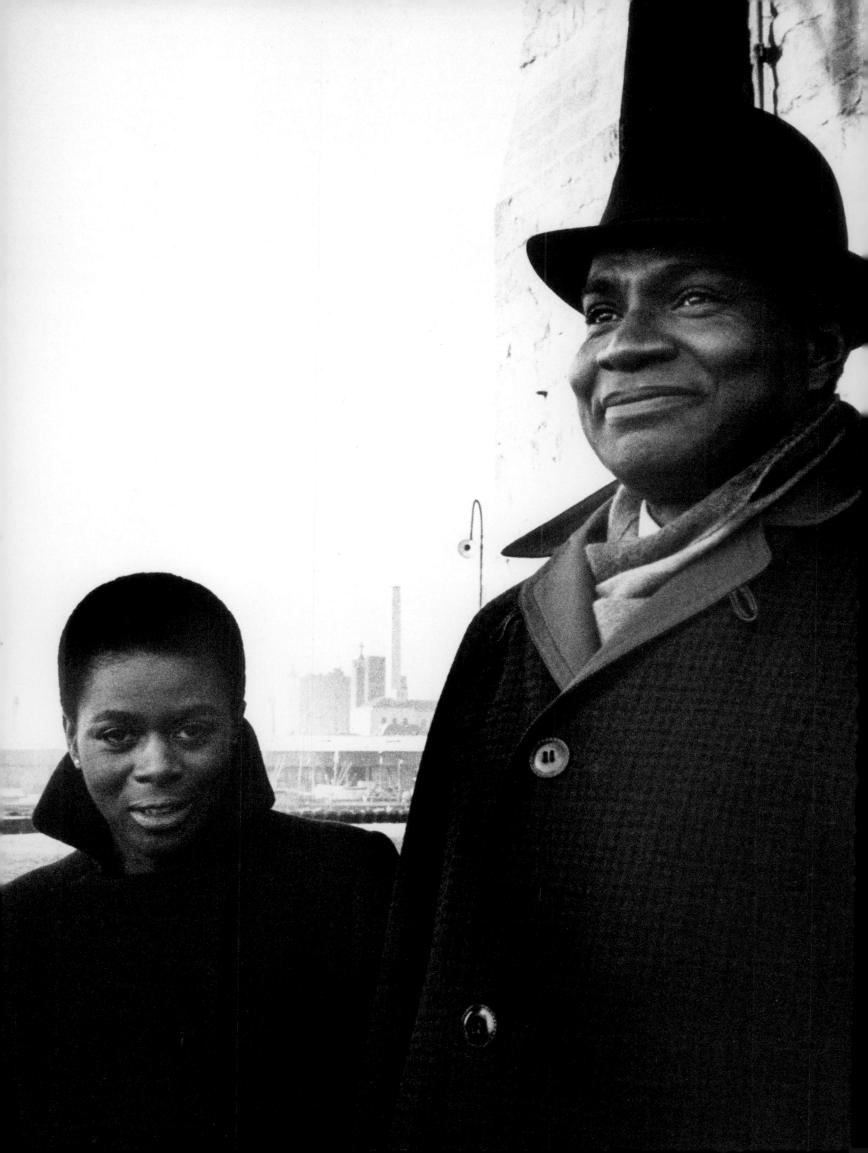

ABOVE: Jackie Gleason

OPPOSITE: Cicely Tyson and Ossie Davis

OVERLEAF: Burt Boyar performing for Sammy and Jane Boyar

On rare occasion Sammy would go out of character and feel glum, be "down," or in his words, ". . . have a case of the humbles." This was usually because of some grossly unfair racial hurt. We were with him when he heard Sidney Poitier referred to as "black." Sammy was incensed, "There is no such thing as a black man. There are brown, yellow, white but I've never seen a man with black skin." This was when "black" was a slur, before James Brown's "Black Is Beautiful" changed the lexicon. Sammy sat down, saddened, and wearily asked me, "Do that corny Jolson thing you do." I had seen *The Jolson Story* a dozen times, worn out the album, and knew every song Jolie ever sang. This was when karaoke was called cornball. So, I started doing Jolson: "California Here I Come," "Swanee," "April Showers," "The Red Red Robin," and by the time I was on one knee starring at the Wintergarden, selling "Mammy" for all I was worth, Sammy began smiling and the storm had passed. Jane seemed to be enjoying it, too.

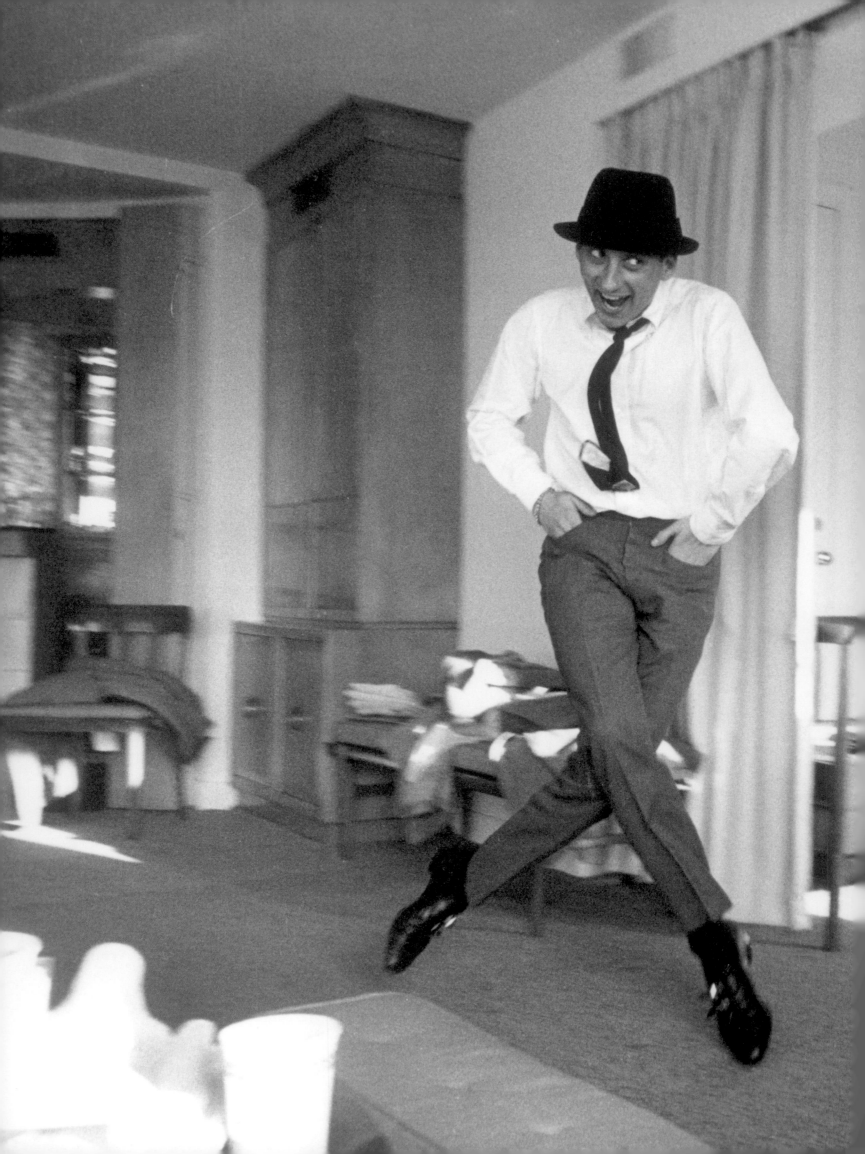

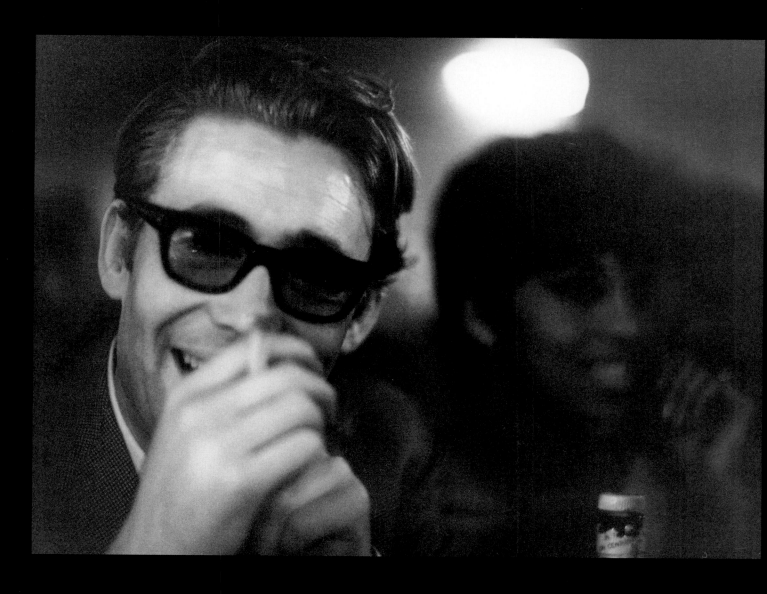

ABOVE: Peter O'Toole

OPPOSITE: Alan King

Sammy loved that Judy Garland took Alan King, a Borscht Belt
comic, to London with her when she starred at the Palladium. A
few months later, Alan returned to America wearing Saville Road
clothes with a vest, driving a Rolls Royce, and occasionally speak-
ing with a slight touch of an English accent.

There is a story that Alan, so influenced by English elegance,
would go to dinner parties, lift up the china to see who the
maker was and make approving signs to the hostess. This
became well known and spoken of until at another dinner party
he picked up the salad plate, to which there was a note
attached: "Put it down, schmuck. You're lucky you got invited."

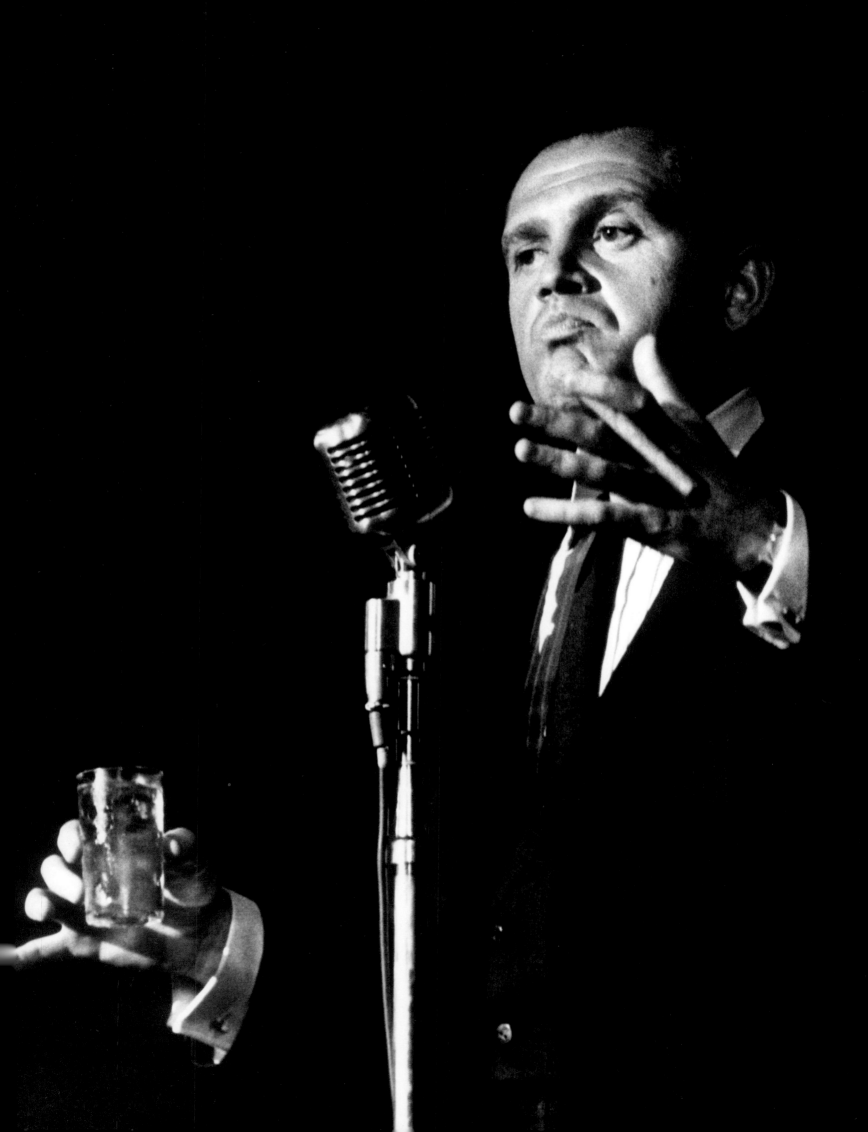

ABOVE AND OPPOSITE: Carol Burnett rehearsing for, and performing on the television show, *The Entertainers*, 1964

OVERLEAF: Judy Garland, appearing on *The Sammy Davis, Jr. Show*.

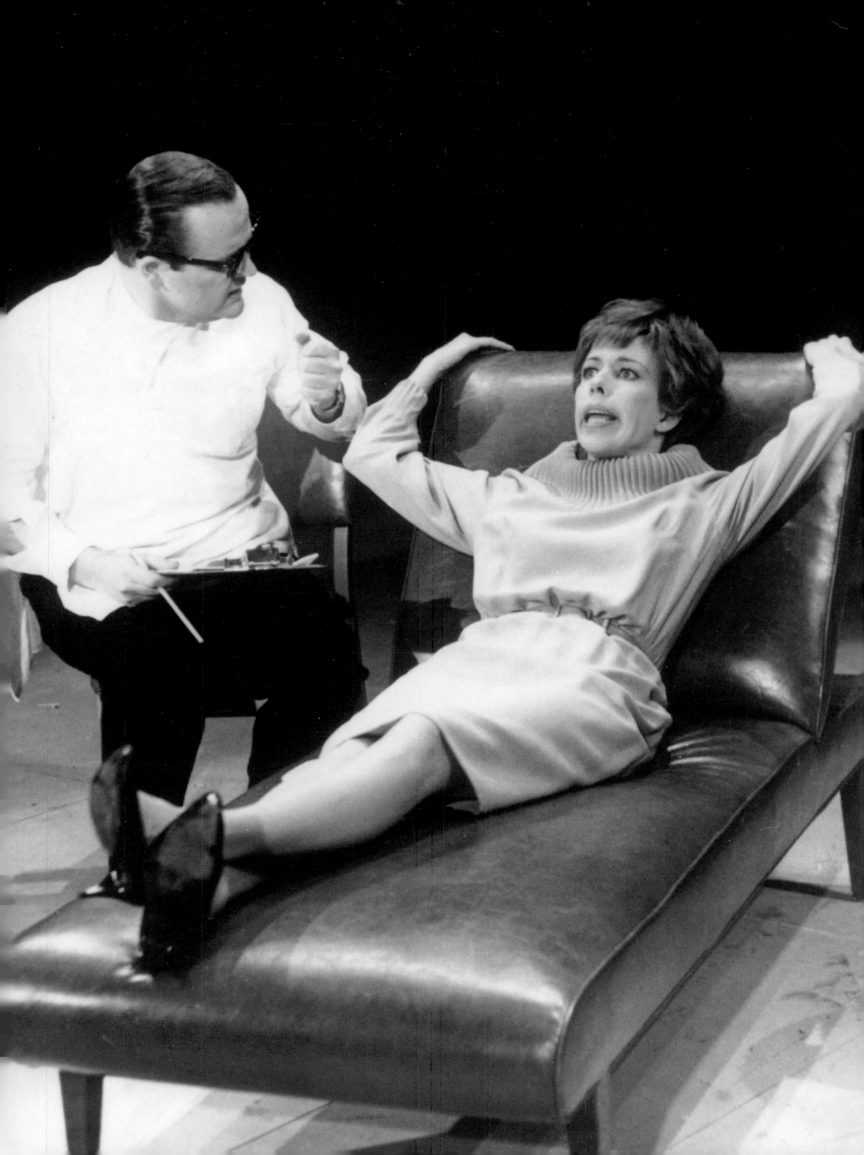

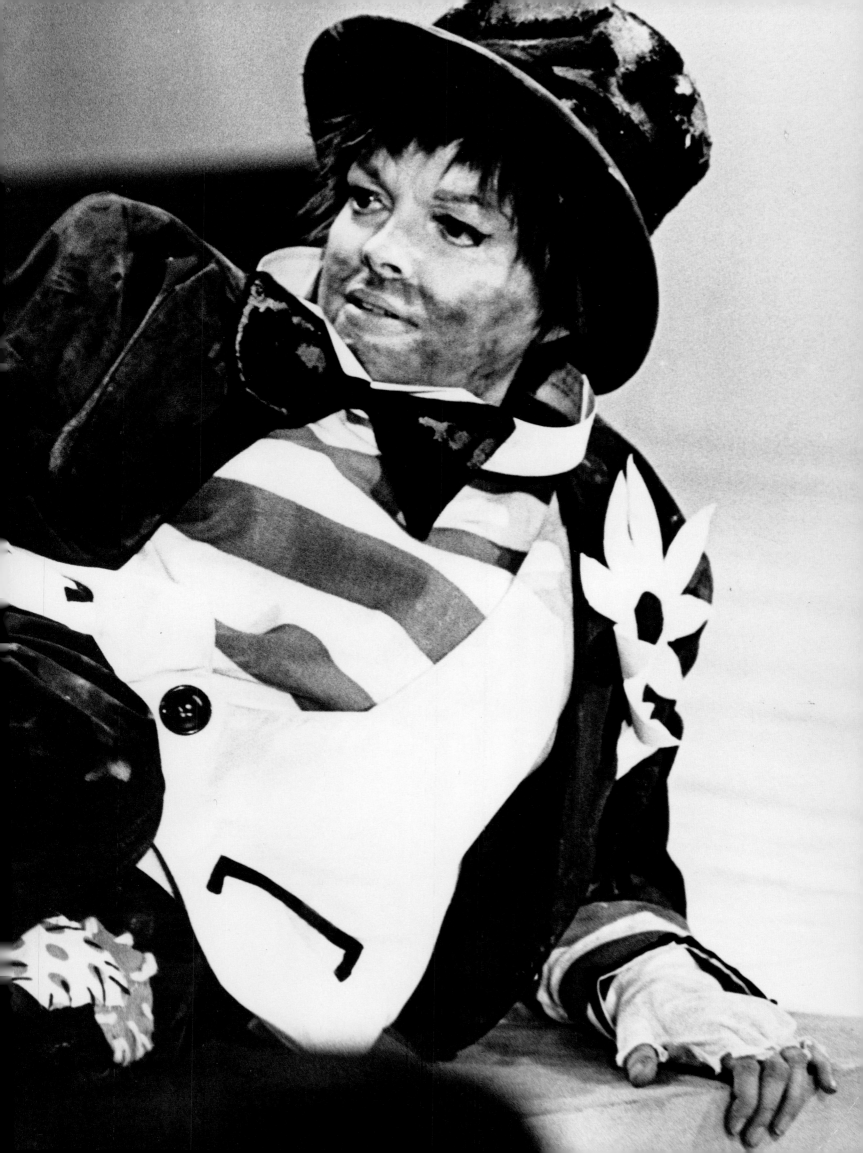

ABOVE: Vincent Price

OPPOSITE: Buddy Hackett

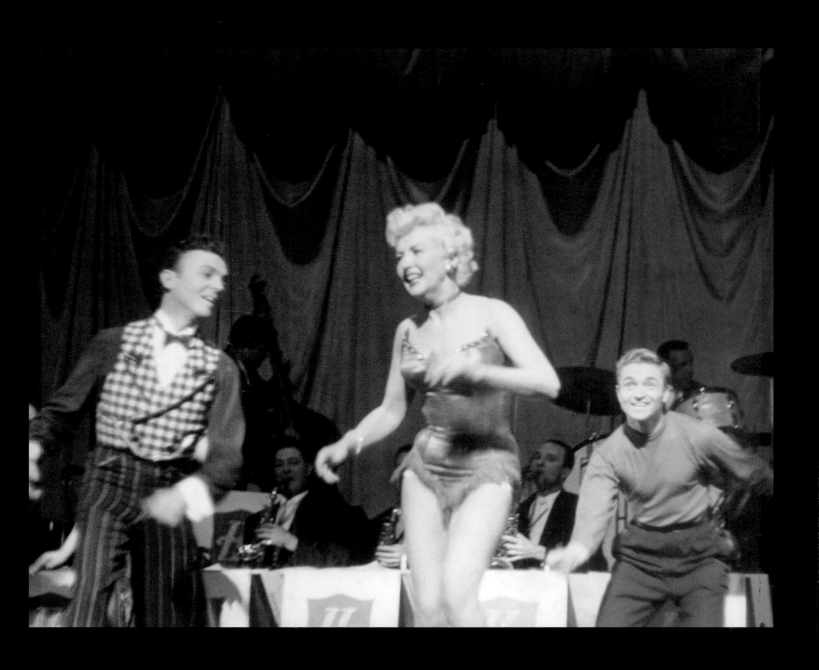

ABOVE: Betty Grable

OPPOSITE: Jayne Meadows

OVERLEAF: Sidney Poitier, appearing on *The Sammy Davis, Jr. Show*. NBC 1965

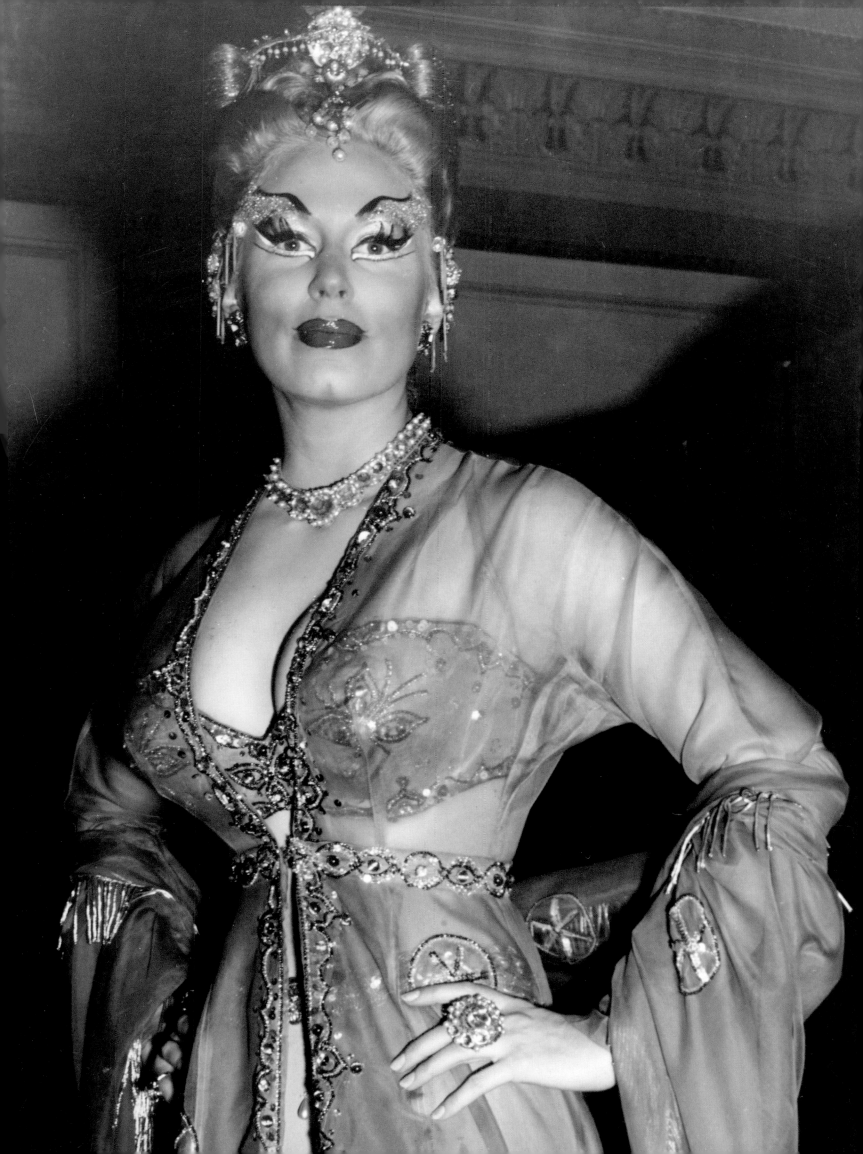

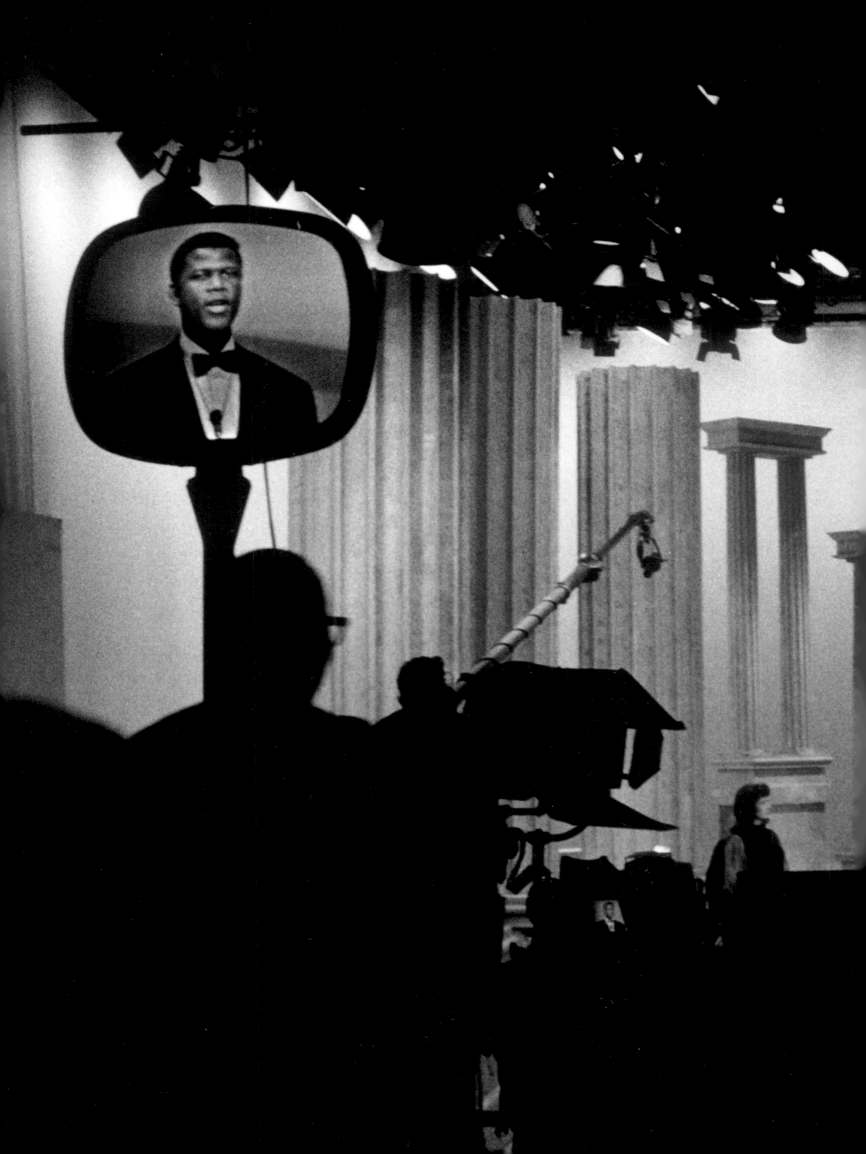

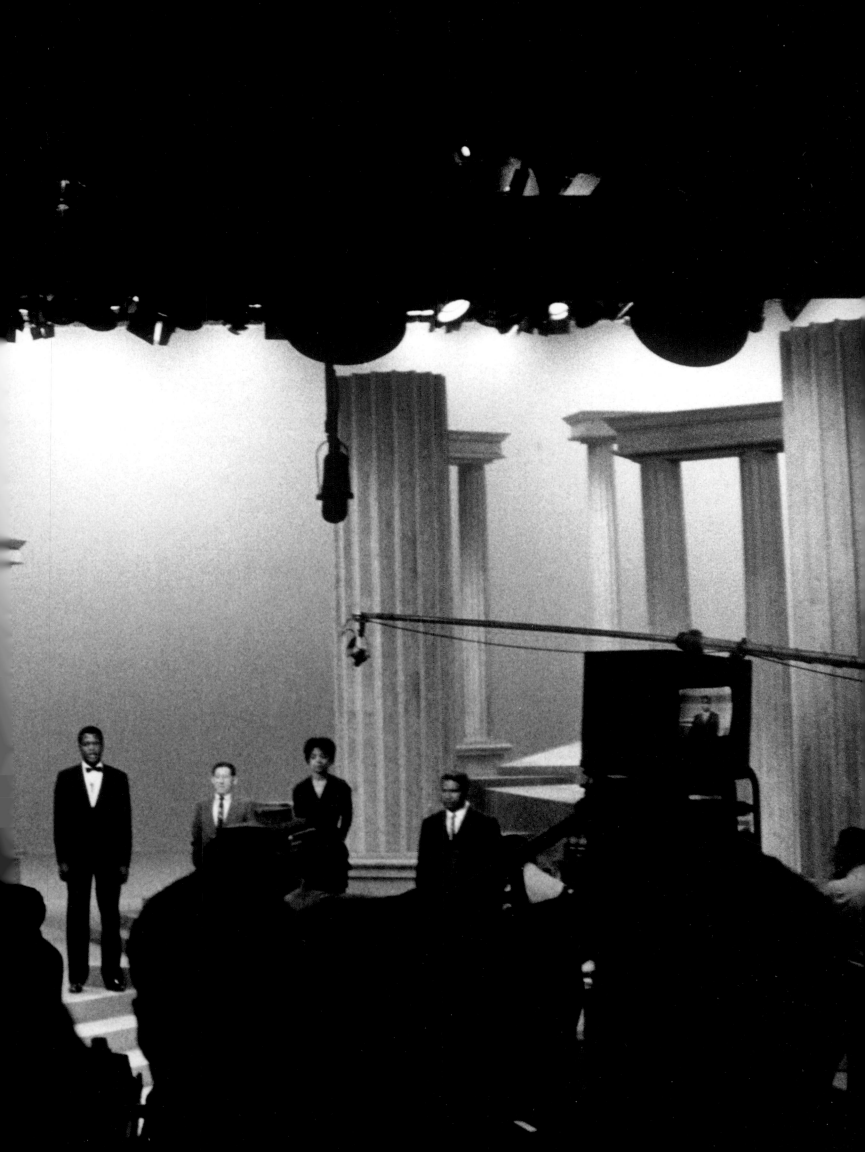

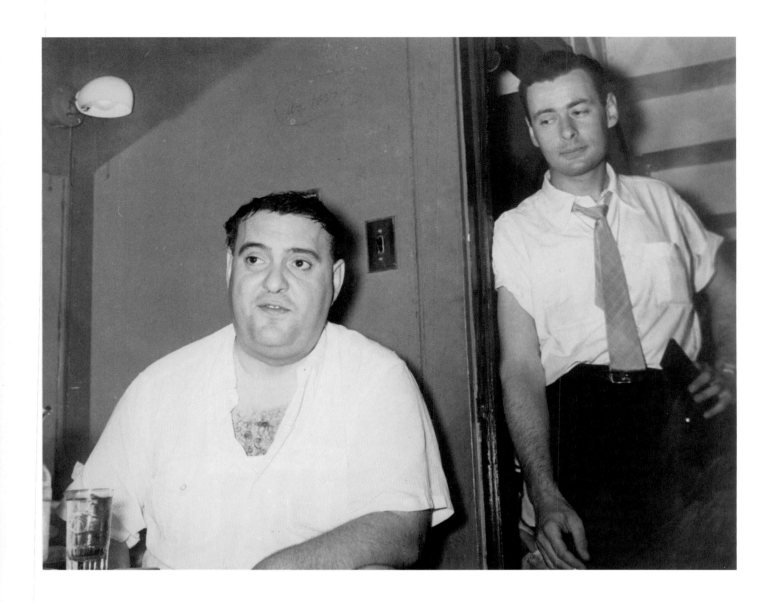

OPPOSITE: Rex Harrison

ABOVE: Zero Mostel and Morty Stevens

Timing is everything, Sammy admitted. "I was nominated for a Tony in 1957 for *Mr. Wonderful*. Up against Rex Harrison in *My Fair Lady*. He won." The second time Sammy was nominated for a Tony, it was for his performance in *Golden Boy*. He was up against Zero Mostel in *Fiddler on the Roof*. Mostel won.

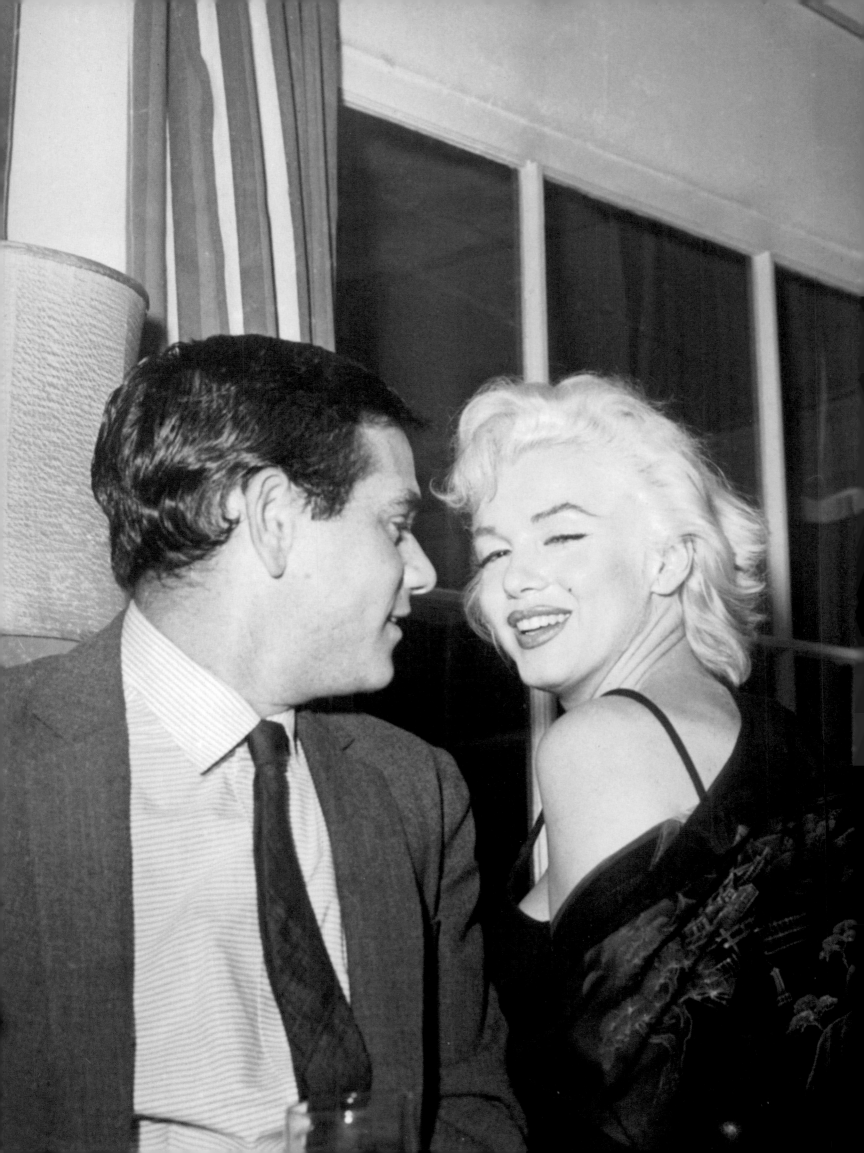

SAMMY'S COMEBACK PERFORMANCE AND PARTY

One night while driving from Las Vegas to Los Angeles to make the sound track for *Six Bridges to Cross*, Sammy had an automobile accident in which he lost an eye. He thought, as did everyone, his career was gone, too. The tragic story of the kid who had finally made it but then lost it just as success had touched his hands was front page news throughout America. The sympathy was so enormous, the press coverage so great, that the hotel in Las Vegas offered him a raise from $7,500 to the unheard of amount of $25,000 a week to return. He would go back to Las Vegas, of course, but Frank Sinatra counseled him not to hurry. "They'll be waiting for you whenever you're ready," Frank told him. After a few months to recuperate, Sammy chose to start again where his new and wonderful life had first begun for him—at Ciro's in Hollywood.

One could not describe the audience that night without naming every movie star of the day: Clark Gable, Carole Lombard, Marilyn Monroe, Ava Gardner, Loretta Young, Dean Martin, Jerry Lewis, the

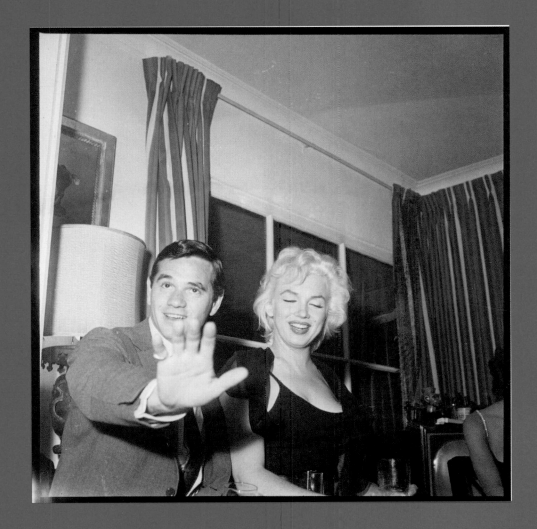

ABOVE AND OPPOSITE: Marilyn Monroe and Milton Greene at a small party celebrating Sammy's after-the-accident comeback performance at Ciro's.

This was at the time when Marilyn defied her studio, refusing to make a movie she hated. 20th Century Fox put her on suspension, and Milton was helping her to break her contract with them. The studio capitulated, gave her her choice of scripts and a huge pay raise.

Bogarts, Sinatra, and Sammy's pals Jeff Chandler, Tony Curtis, and Janet Leigh. Whoever you could name, if they could walk, they were there, rooting for him, on their feet cheering him on to a colossally successful comeback performance. Frank Sinatra had introduced him. Halfway through the show, caught up in the tremendous excitement, Sammy forgot that he had only one eye, spun toward his blind side and cracked his head into the standing microphone. The audience gasped and fell silent. Sammy patted the mic and said, "Oh sorry, Frank, didn't see you come in." The audience screamed with approval and the show continued like a runaway train. "I knew then that if I'd gone for sympathy I'd have gotten it, that the audience will play it whichever way you set it up."

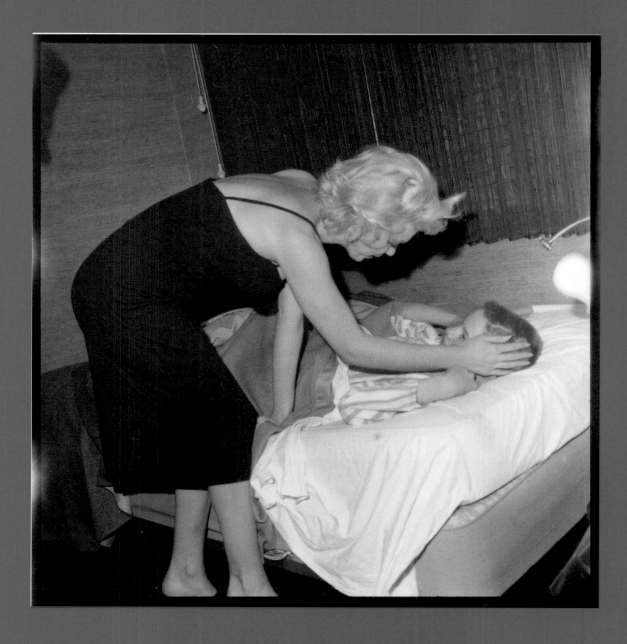

ABOVE: Marilyn putting a boy to sleep at a party after Sammy's comeback at Ciro's.

OPPOSITE: Marilyn

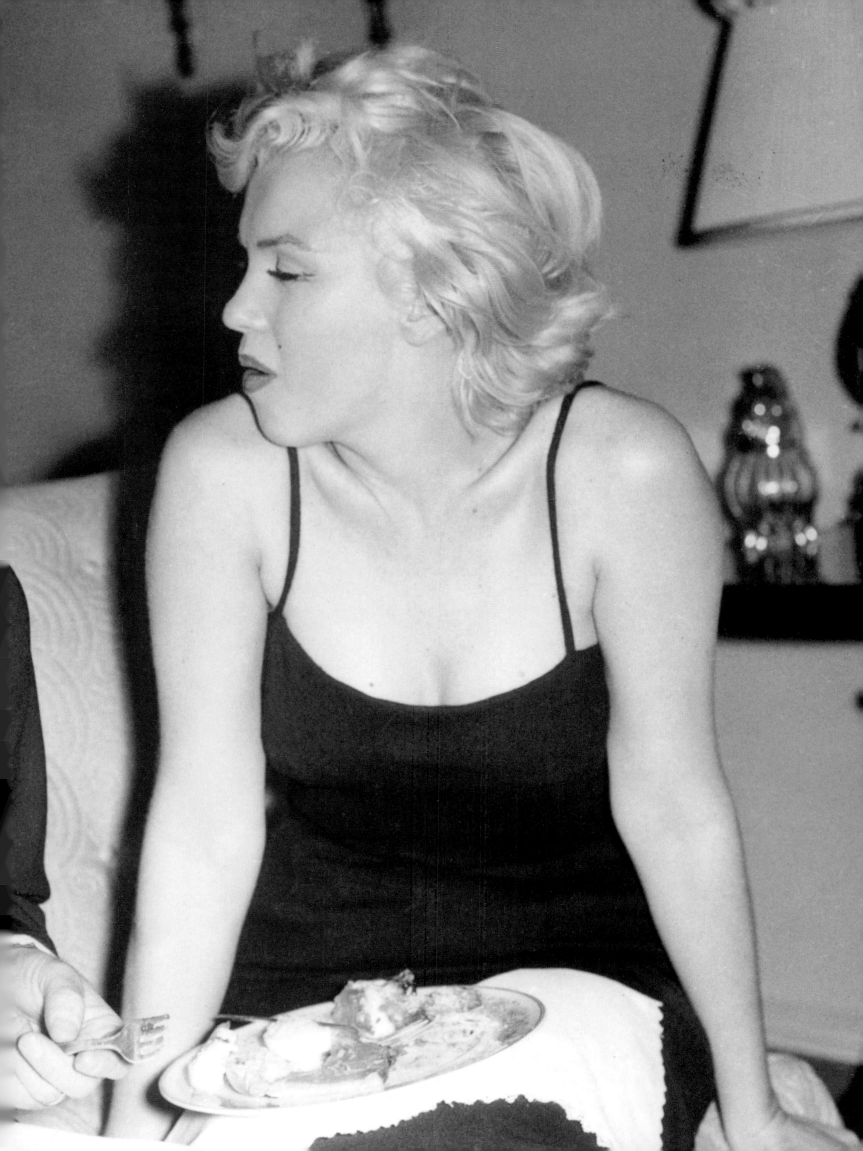

ABOVE: May Britt (left), Robert Culp, and unidentified woman

OPPOSITE: Jack Lemmon and Felicia Farr

OVERLEAF: Milton Berle entertaining Kirk Douglas with a card trick.

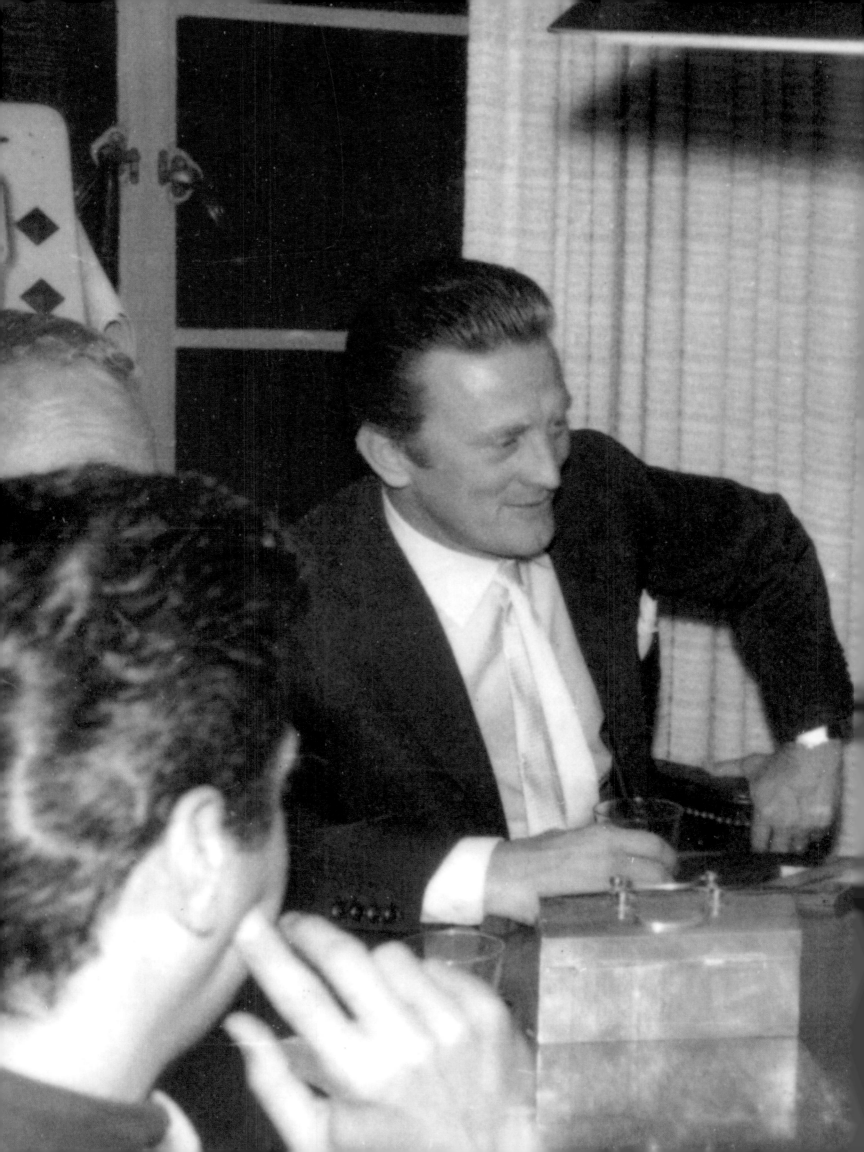

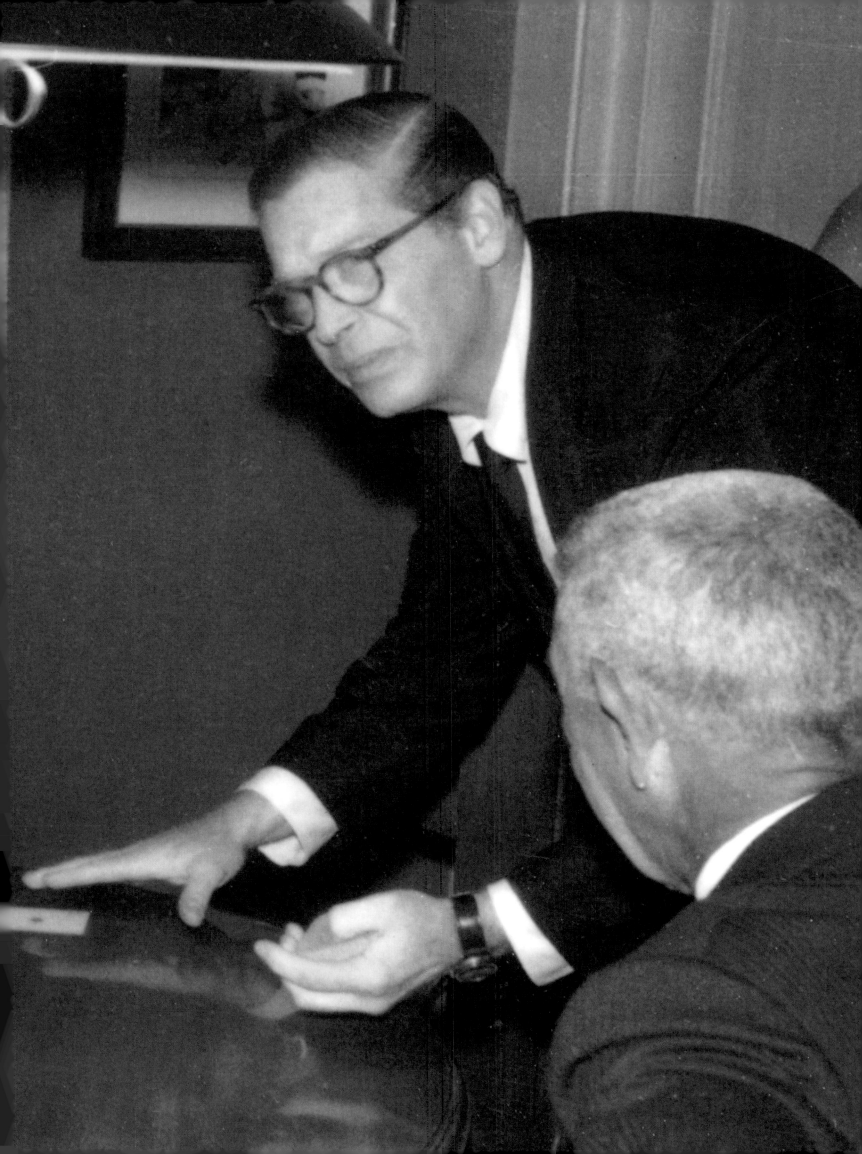

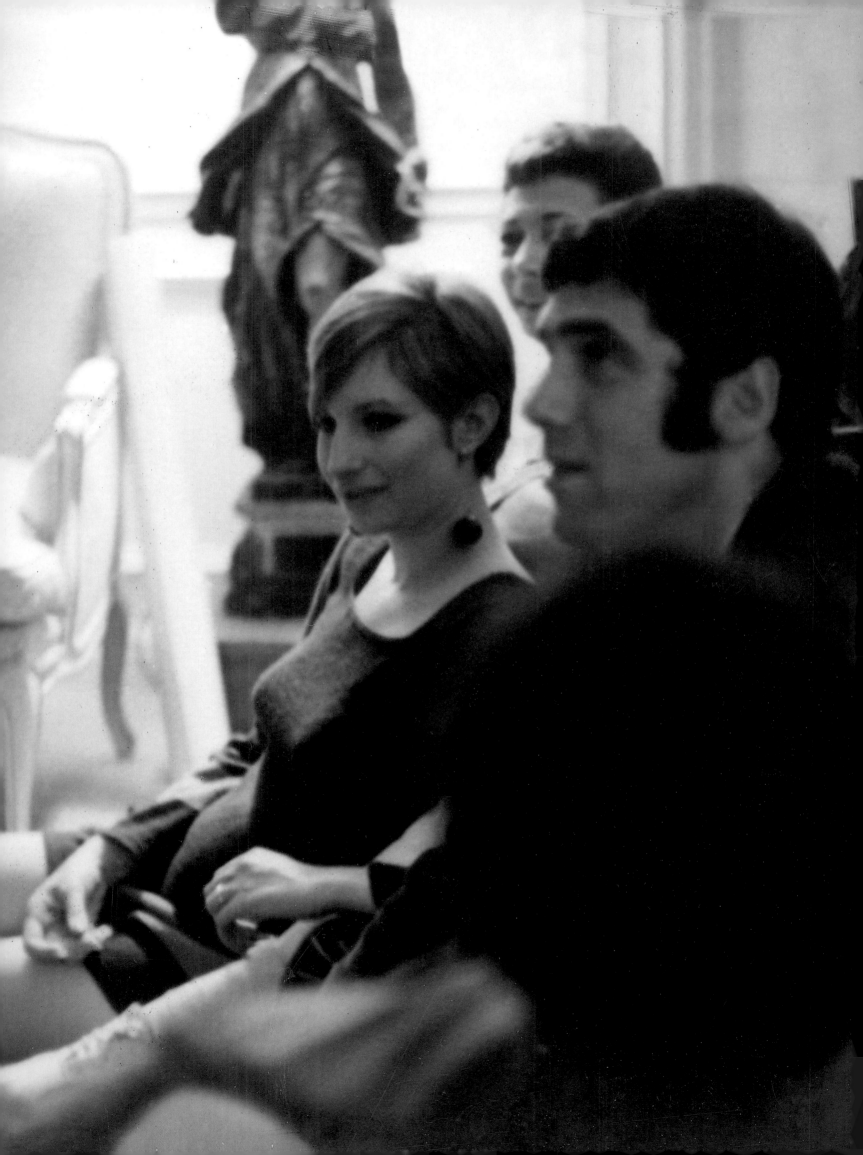

ABOVE: Steve McQueen

OPPOSITE: Barbra Streisand (far left) and Elliott Gould (center)
When Barbra was just becoming noticed (Miss Marmelstein in
I Can Get It for You Wholesale), she wanted to see Sammy at the
Copa but couldn't get a table. Jane and I took them, fully
intending to pay the check but they begged to pay their half.
"We just got our American Express card today, and we're
dying to use it." I have been told that I may be the last person
to whom this happened.

THE ROYAL COMMAND PERFORMANCE

FOR HER MAJESTY THE QUEEN OF ENGLAND WAS THE FIRST TIME SAMMY WOULD EVER APPEAR IN ENGLAND, AND HE WAS FRIGHTENED. NAT "KING" COLE, ALSO ON THE BILL, HAD ASKED THAT THEY SHARE A DRESSING ROOM.

NAT KING COLE

Nat was already there with his valet along with Murphy and George Rhodes, my pianist. I sat down and looked around. Murphy had my clothes and makeup laid out. Nat was sitting across from me, not saying a word, doing some quiet drinking. I looked at the bottle next to him. "Nat, you don't drink scotch."

"I'm drinking it tonight."

"I don't drink scotch either. Lemme have some."

I poured a water tumbler full of straight scotch and dumped it, neat. Whack! I felt it land in my stomach. I looked at Nat and shook my head. "I ain't never been this scared before!"

The show was starting. I could hear the music. Nat was on the bill before me, closing the first half, so he started dressing. When it was time for him to go downstairs I wished him luck, and stood on the third floor landing to listen.

Nat is the personification of sophistication and calm. When he walks on stage whatever nervous-

ness he may feel stays inside of him, it never shows, and it was comforting to hear his smooth, mellow voice—like a touch of home. I started to relax. Then suddenly he cracked. Oh, God! I thought. Nat Cole has never cracked in his life. He has perfect control at all times, under any conditions. Even when he's hoarse he knows how to play with his voice so that it doesn't come out rough, it becomes even more resonant, a little lower, and richer—never cracking!

He came back upstairs, dripping wet, shaking his head miserably. "I don't never want to do that no more! Not ever!" He collapsed into a chair and pulled his tie open. "Man, they is out there tonight!" He beckoned to his valet. "Give me a drink."

I was trembling ten times worse than before, like I had a vibrating machine in my mouth and someone just plugged it in. "Whhhhhhhh—wwwwwhattya mean, They is out there?"

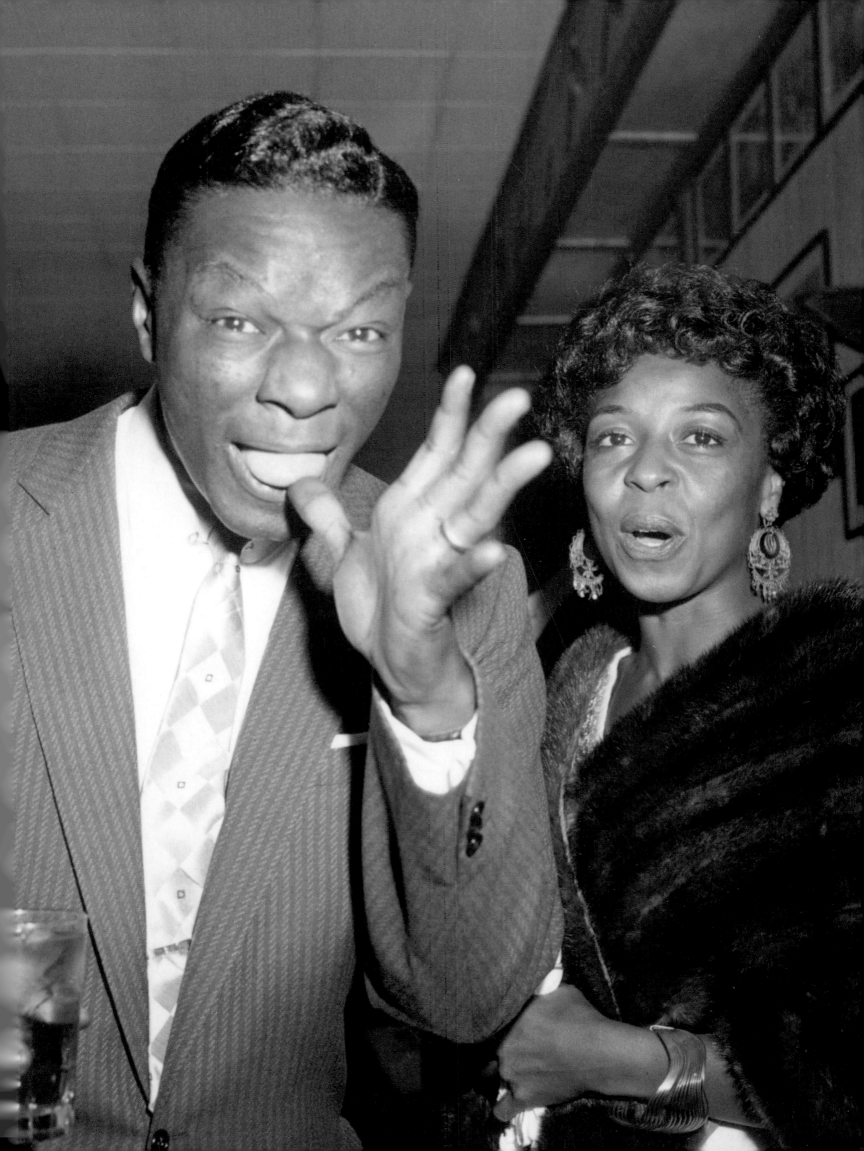

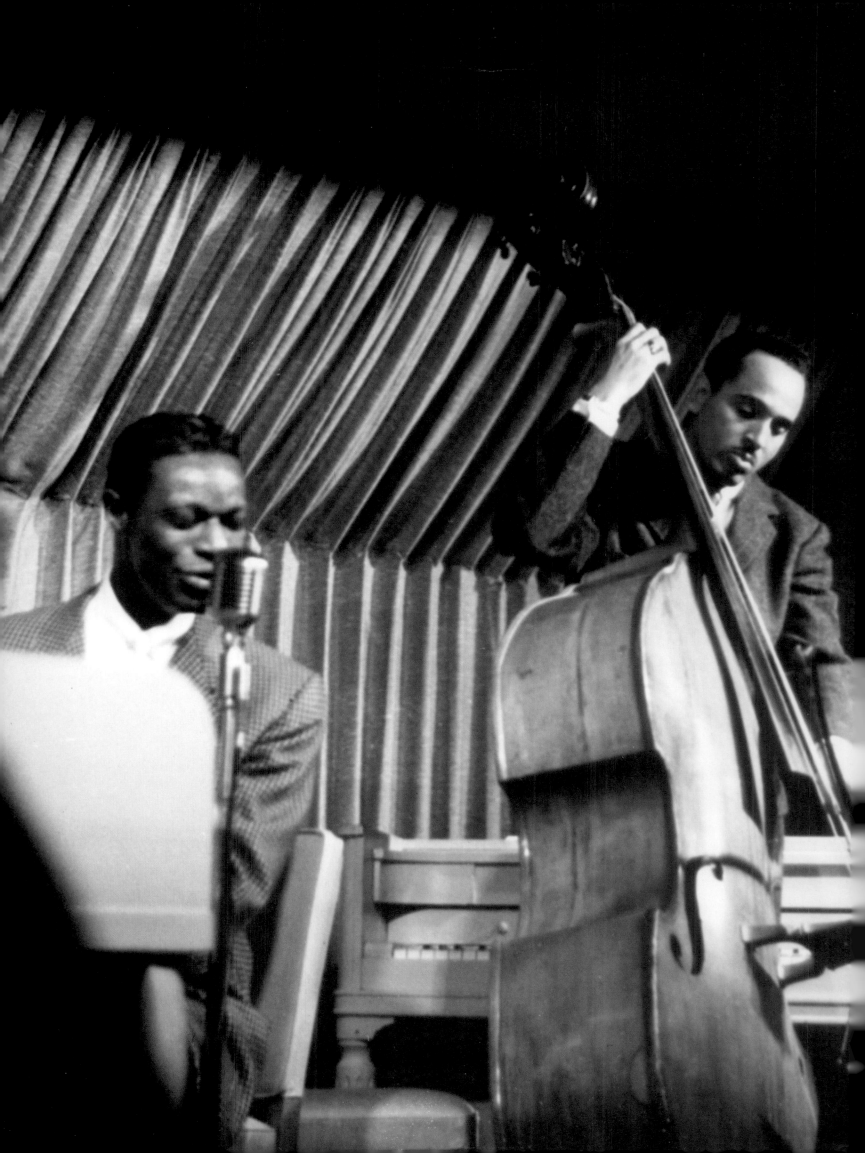

He looked at me. "Get yourself another drink and sit down. Everybody else get out." He closed the door. "Now listen good. When you get out on the stage you go for it. Don't hold back nothin', 'cause they's ready! There ain't nothin' happened down there yet. You is it! They is waitin' fo' you!" He'd been talking colored to emphasize his point, and to relieve some of the urgency, but now he settled down to business. "When you come on, take your bows slow and easy. Don't let anything rush you. Do you remember what we were told, about not looking at the Queen? Forget it. Damn protocol. You give her a sneaky little peek out of your good eye, otherwise you'll be looking for her when you should be worrying about your song. And at the end of your act they're going to try and rush you off. Don't let them. Just take and tear them apart!" He took another shot of scotch. He must have had a dozen in the past three hours but he was cold sober. And, if you don't kill 'em, I'm gonna take my fist and beat you to death.

"Now when it's over and you do your bow, bow to the Queen last. Bow here, here, here and then give her one of them—I know you know how to bow with all that gracious bull you do—so you've got nothing to worry about."

"What did you do, Nat?"

He reached for the bottle again. "I didn't do none of that. That's how I know you should do it."

He was beautiful. He knew that if ever I needed someone from home to encourage me, someone on my own level as a performer, someone who knew me well, I needed it then.

Sammy followed Nat's advice and he was a smash hit, the overnight toast of London.

Years later, Nat gave him advice on another subject which, unfortunately, he did not follow. After watching Sammy perform at Harrah's one night, Nat went backstage and said, "That thing you do with the cigarette while you're singing, exhaling the smoke as you sing, it's good dramatic effect but it's murder on your cords. They're straining to make your sound and the heat of the smoke on top of that is dangerous. Don't do that anymore."

Perhaps Sammy followed his advice and it was already too late, or perhaps he couldn't resist going for the effect, but a few years later Sammy died of throat cancer.

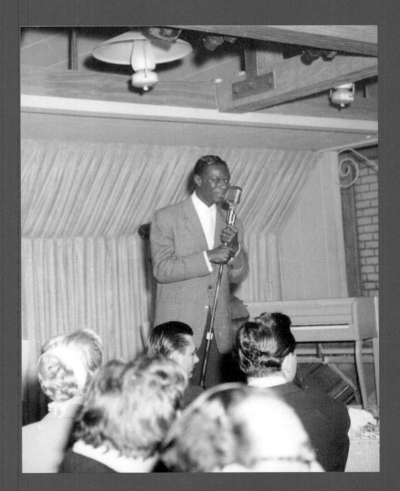

THIS PAGE AND OPPOSITE: Nat "King" Cole onstage at the Beachcomber, Miami Beach, Florida.

PAGE 195: Nat "King" Cole and Ruby Dee

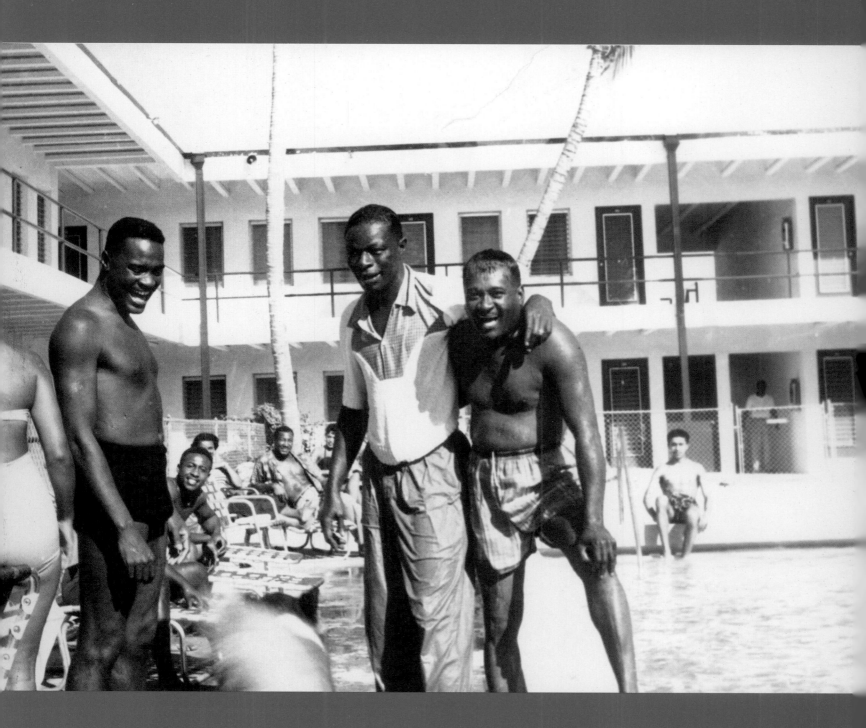

ABOVE: Nat "King" Cole at the Lord Calvert Hotel, Miami, Florida
In the 1940s and early 1950s, black entertainers could be starring at
clubs on Miami Beach but could not live in hotels there. They even
required a police ID card permitting them to be on the Beach to
work. If they did not have cars, only special taxis were authorized to
take them back and forth. Sammy stayed at the Lord Calvert while
starring at the Beachcomber. So did Sugar Ray Robinson, and major
league ballplayers like Jackie Robinson and Roy Campanella.

OPPOSITE: Nat "King" Cole and Sugar Ray Robinson's ex-wife,
Edna Mae, at the Lord Calvert, Miami, Florida

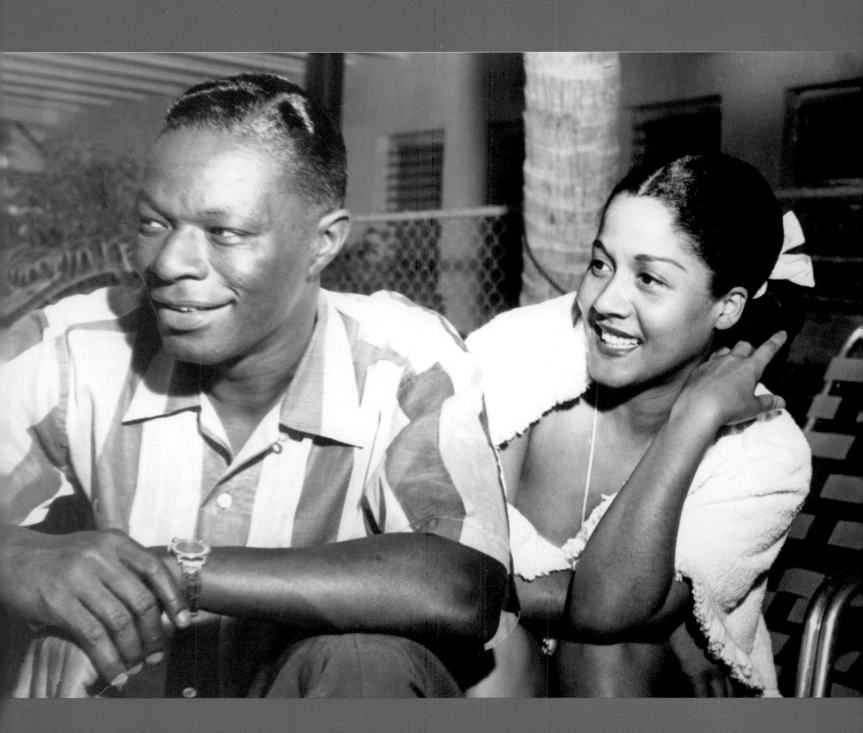

Phil Silvers (right)
and unidentified man

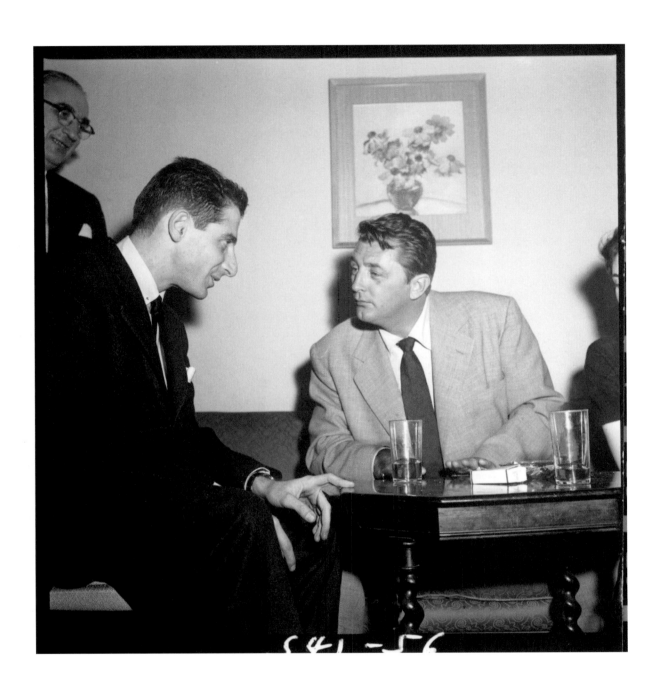

ABOVE: Robert Mitchum (at right) speaking with unidentified man

OPPOSITE: Danny Thomas

ABOVE: George Hamilton and Linda Bird Johnson, 1966

Sammy said of George, "We had such laughs and giggles. And he's
a marvelous actor. He's so busy with bullshit . . . with playing that
image, but there was a picture he did with George Peppard and
Robert Mitchum called *Home from the Hill* [in which he] played

ABOVE: Lee Marvin

OVERLEAF: Bill Cosby, Michael Caine, and Shirley MacLaine

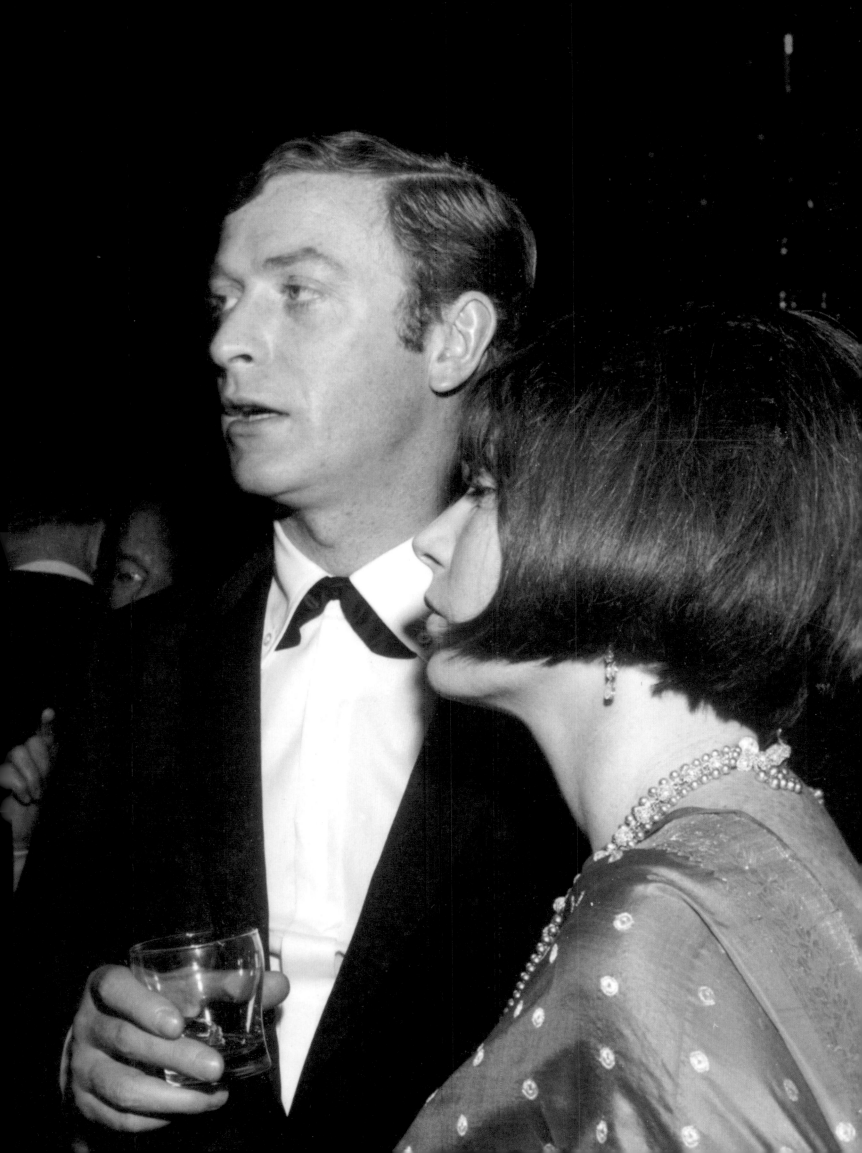

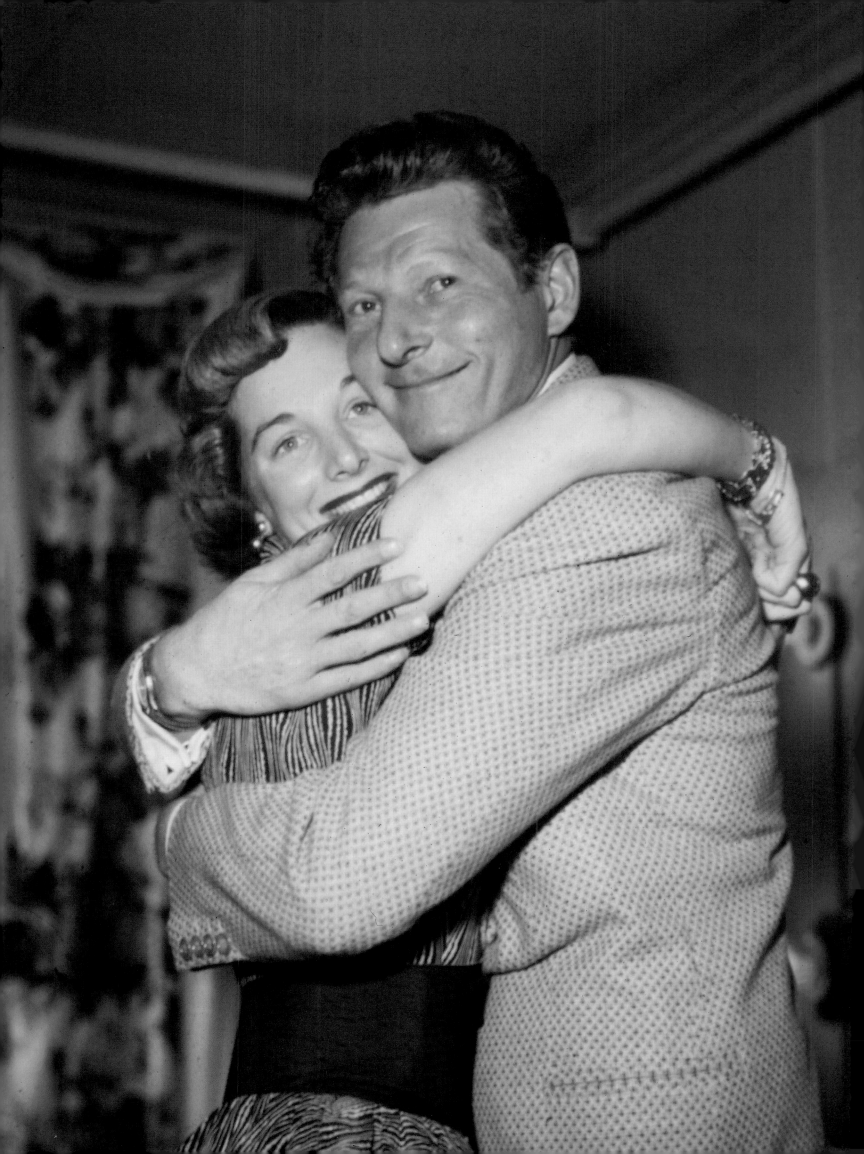

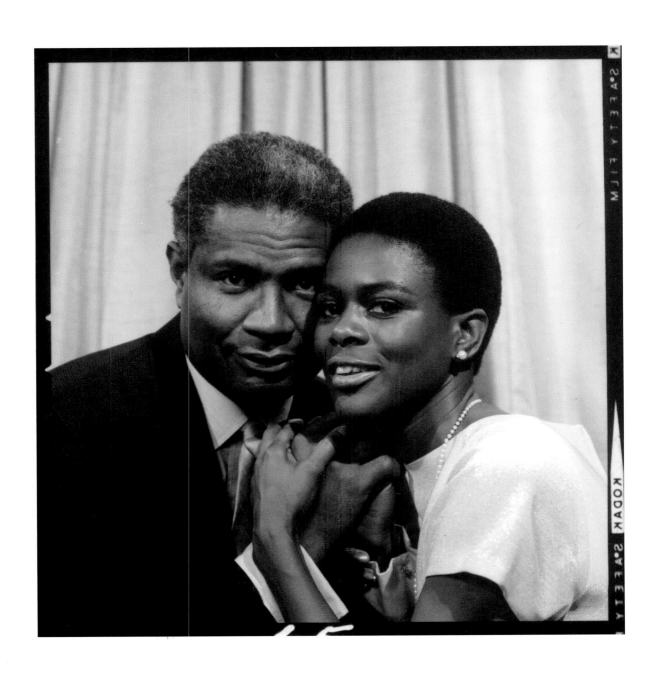

ABOVE: Ossie Davis and Cicely Tyson

OPPOSITE: Danny Kaye with unidentified woman

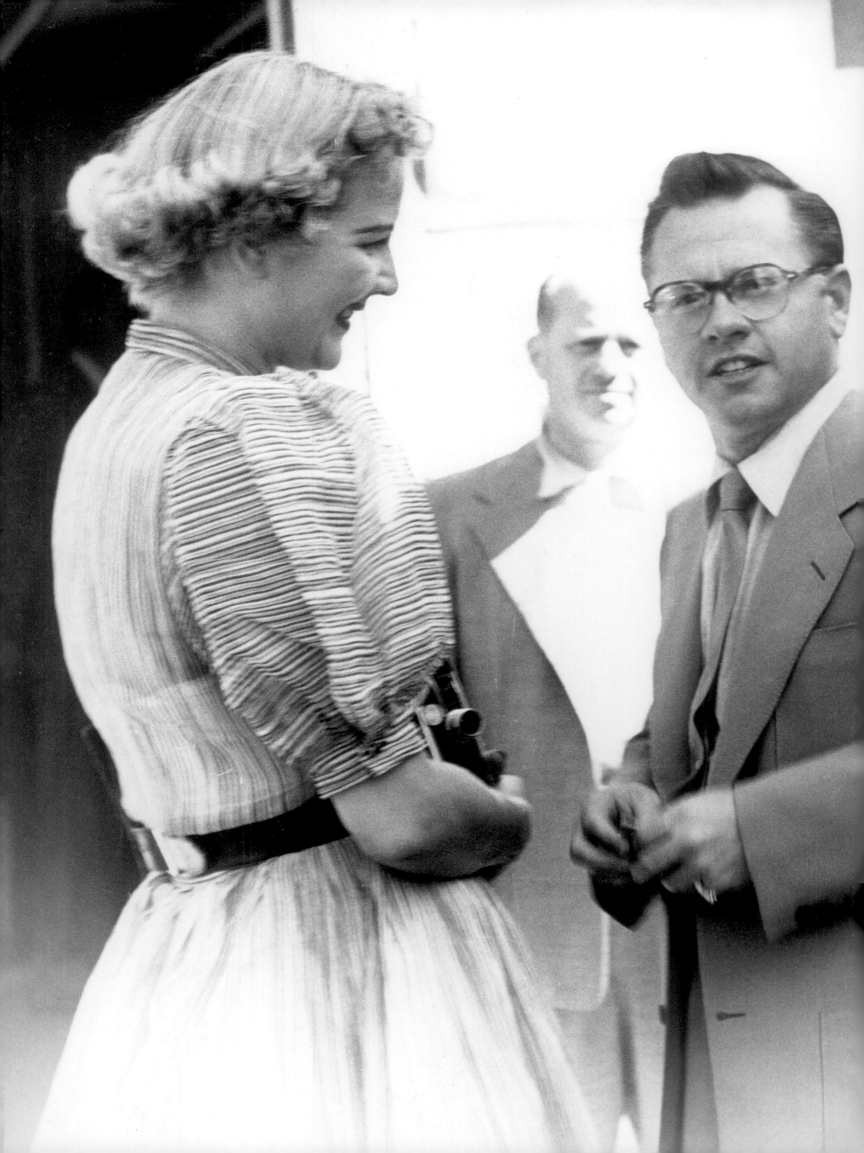

Mickey Rooney

ABOVE: Kim Novak and Steve Allen

OPPOSITE: Ricardo Montalban (right)

ABOVE: Sean Connery

OPPOSITE: Bing Crosby (left) and Jack Benny (right)
Bing suggested, "A dollar a hole?" After awhile, sensing Bing's
impatience Benny said, "I'm thinking, I'm thinking . . . " (A play
on the classic: "Your money or your life?")

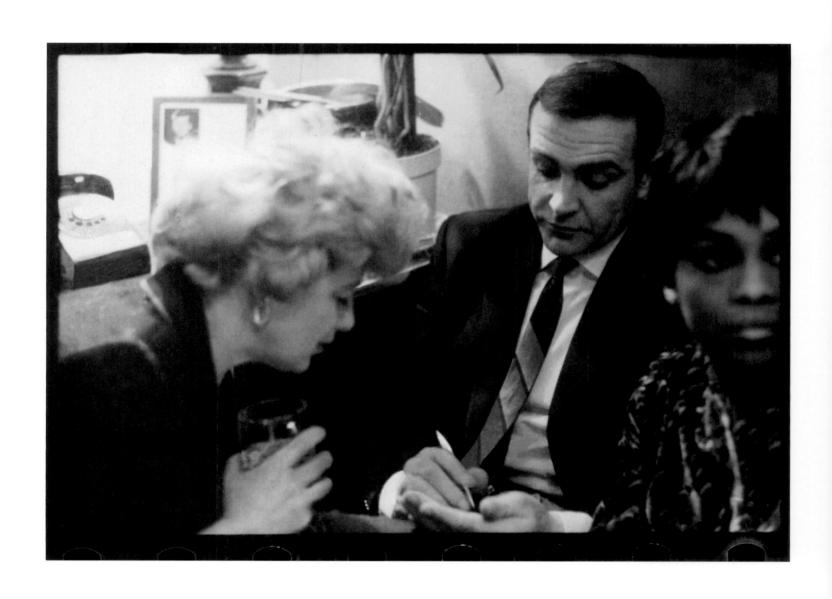

ABOVE: Shelley Winters (left), Sean Connery, and Lola Falana

OPPOSITE: Kim Novak shooting a picture of Sammy, who was in turn shooting a picture of her.

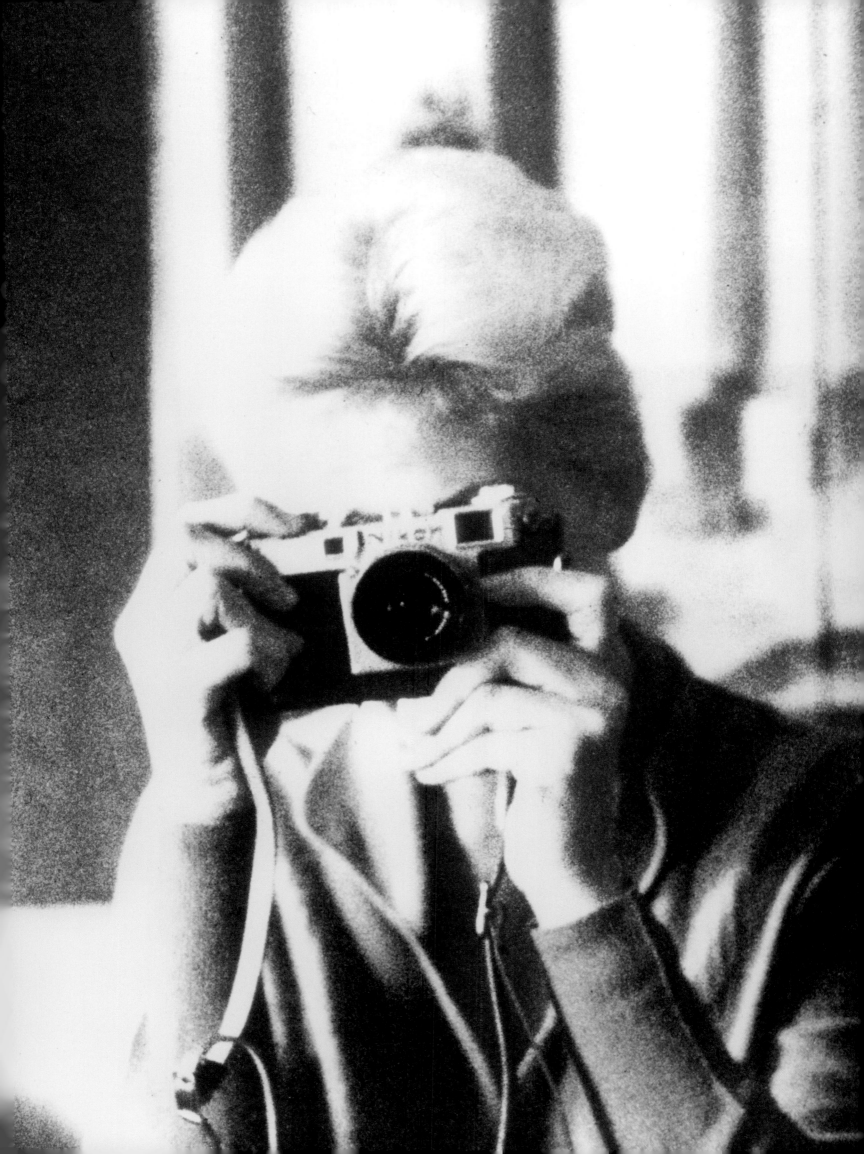

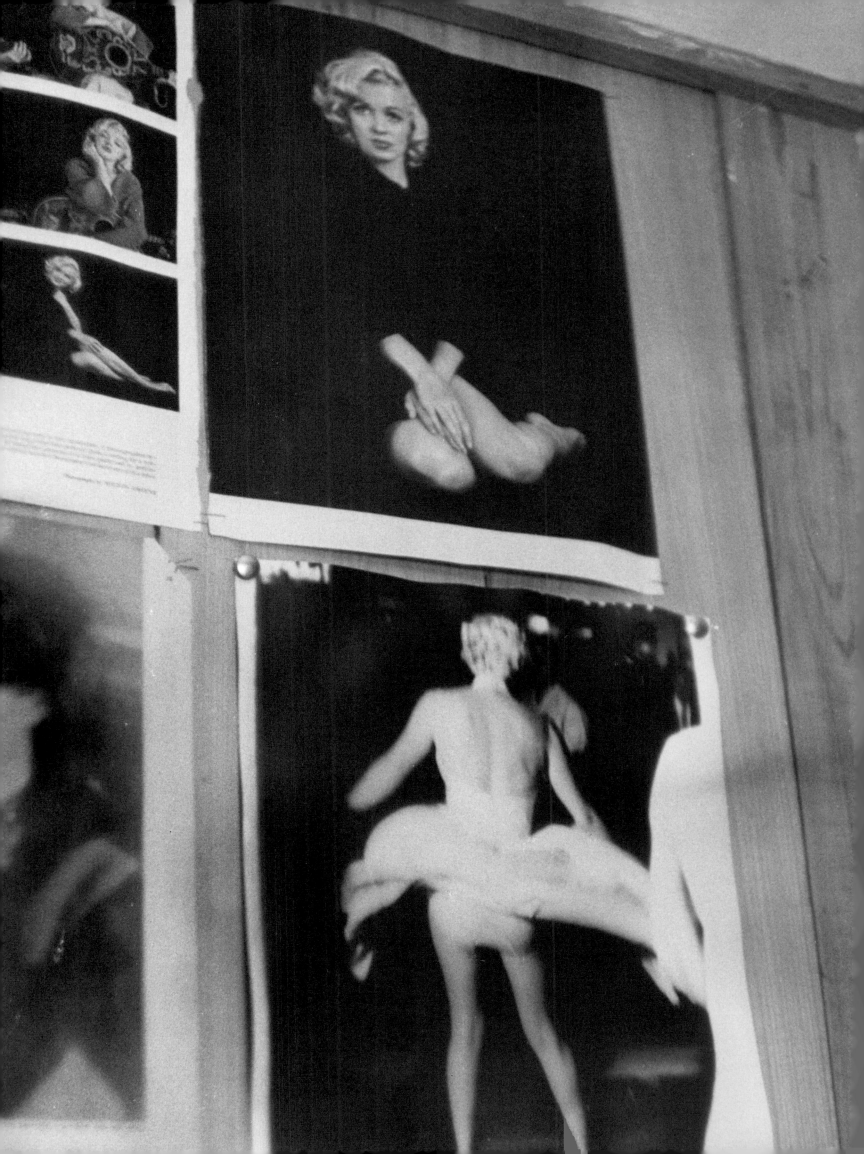

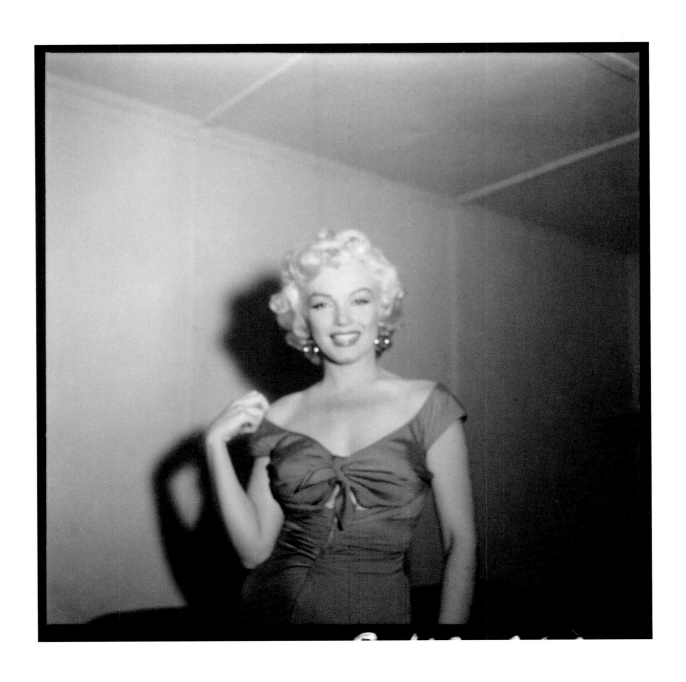

ABOVE: Marilyn Monroe

OPPOSITE: A wall of photos of herself at Marilyn Monroe's house
Sammy understood why Marilyn would hang photos of herself
in her house. He said, "When you're a superstar, even though it
took you twenty years to get there, and you've got a lot of
proof of it, the money, the marquee, this, that, and the other...
you can't always feel it. So, when you're Marilyn, the icon of all
icons, and it happened like overnight... I'm sure she had this
need to check and make sure."

OVERLEAF: Marilyn coming...and going, while Danny Thomas
enjoys the view.

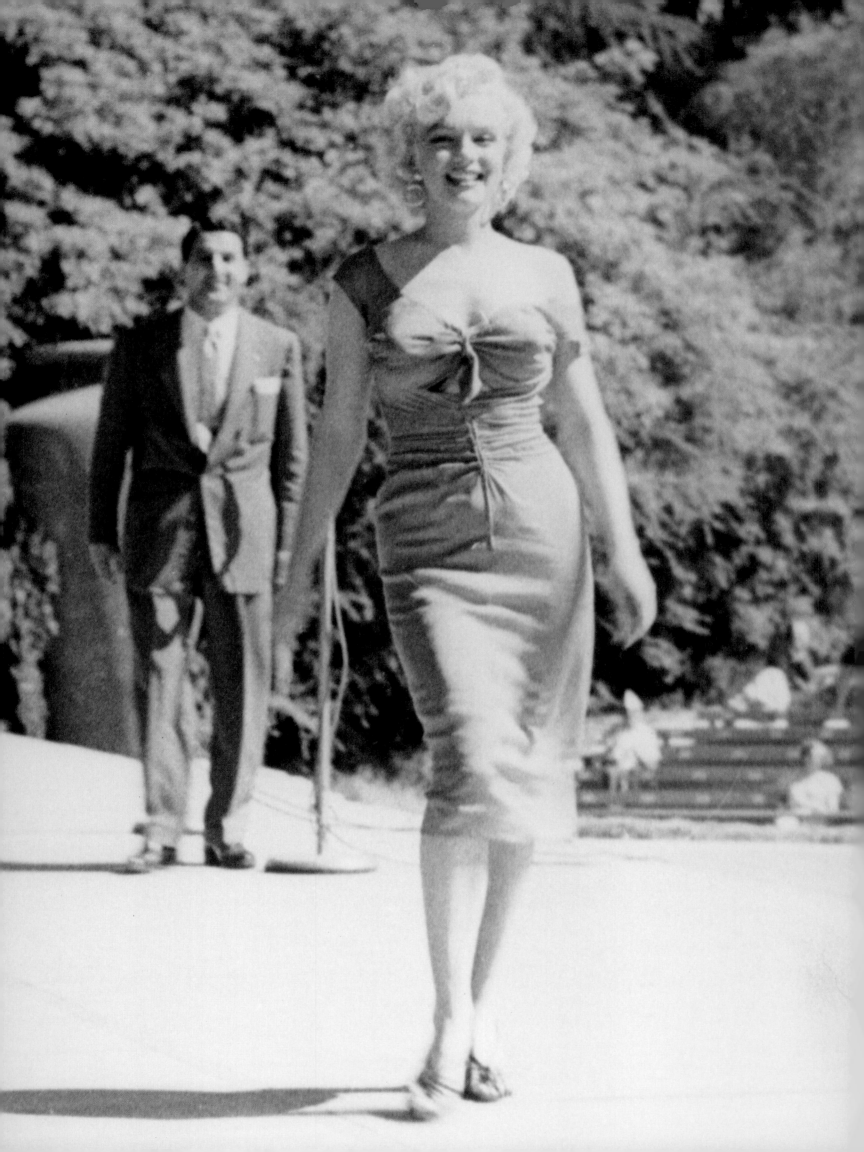

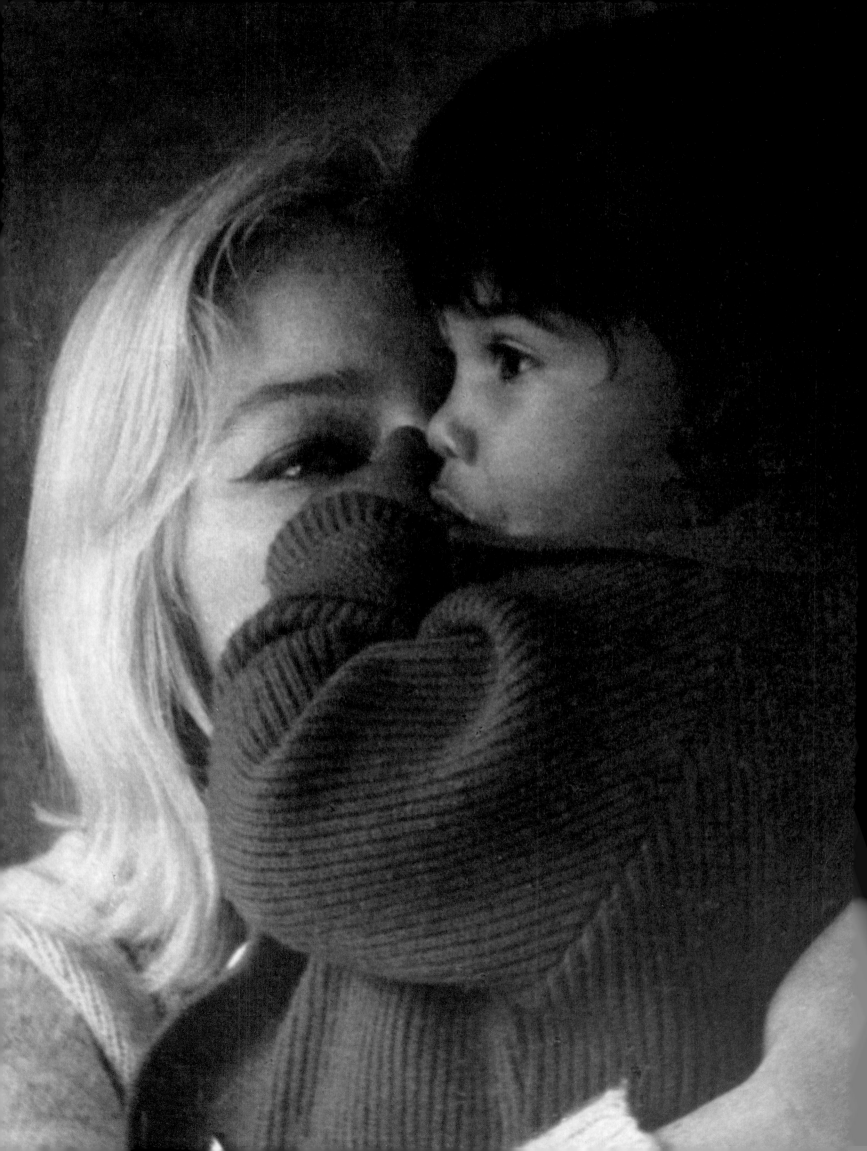

THE FAMILY ROOM

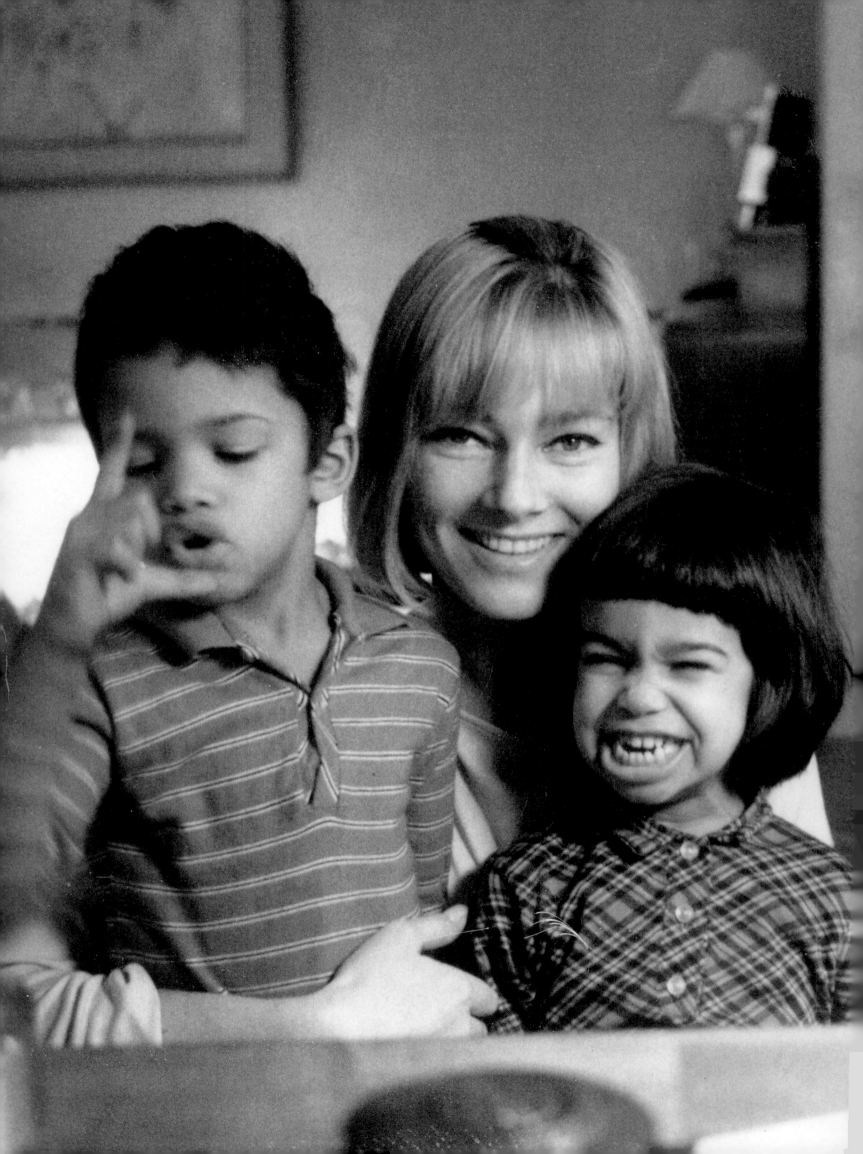

THE SAMMY DAVIS, JR. FAMILY
BEGAN WITH HIS MARRIAGE IN 1960
TO BEAUTIFUL SWEDISH ACTRESS MAY BRITT.

Pronounced "my," May was legally Maybritt Wilkins—Maybritt being a fairly common name in Sweden. But for films she separated her first name and became simply May Britt. Their family expanded in 1961 with the birth of their daughter Tracey Hillevi Davis—Hillevi was in honor of Maybritt's mother.

Before they were married, as they discussed having children and all the love they had to give, they agreed that there were so many black children already living, with no parents, no one to love them, that they would bring some of those children into their lives—how appropriate then to reach out for a big brother for Tracey. So, in 1962, they adopted then two-year-old Mark Sidney Davis. Mark brought so much joy to them and to his baby sister that another little boy was added to the family in 1964—Jeff Nathaniel Davis. Several years later, lamentably, Sammy and May decided to divorce. He bought her a beautiful house in Lake Tahoe where she could raise their three children in clean air and in an environment in which children did not concern themselves with parents being over-the-title, and A-List.

In 1970 Sammy married Altovise Gore, a stunning classical dancer he met in the London company of his show *Golden Boy*. They renewed their vows around ten years later and lived happily together until Sammy's death from throat cancer in 1990.

OPPOSITE: Mark, May and Tracey

PAGE 222: Tracey and May

OVERLEAF: Mark and Tracey

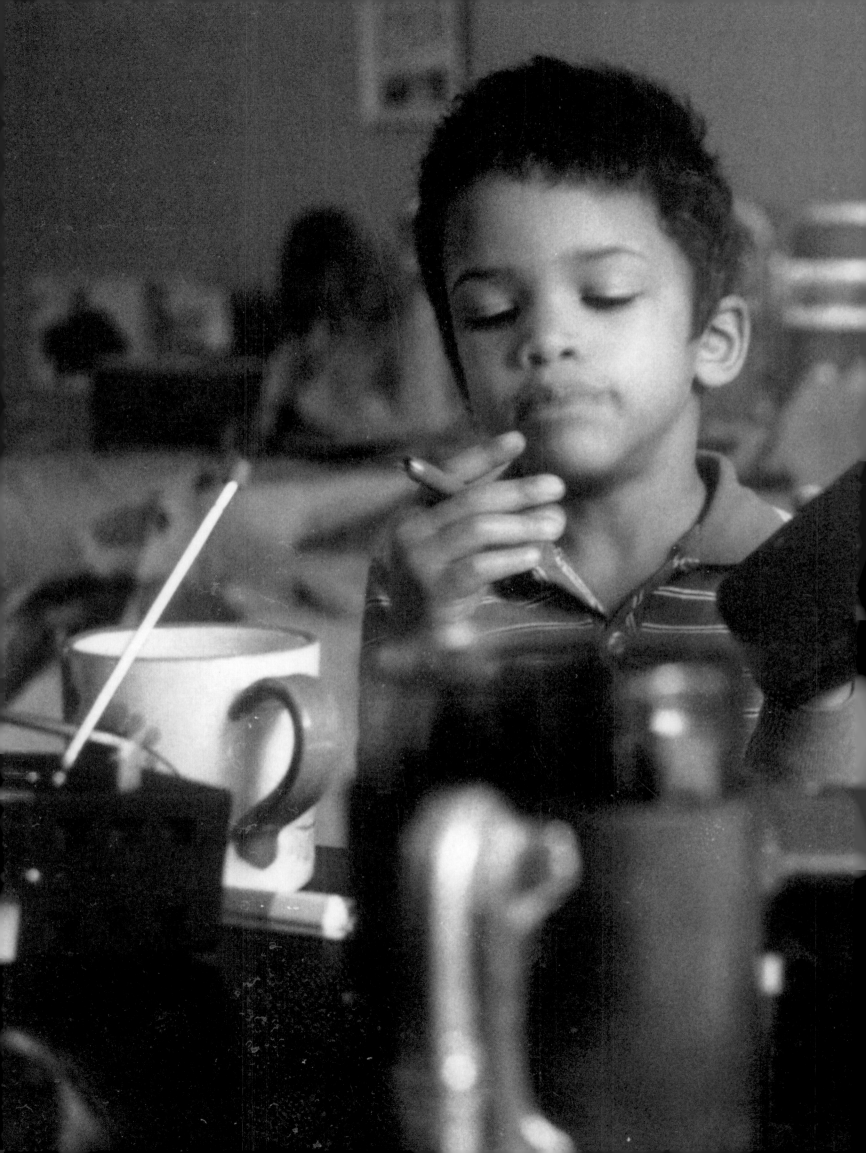

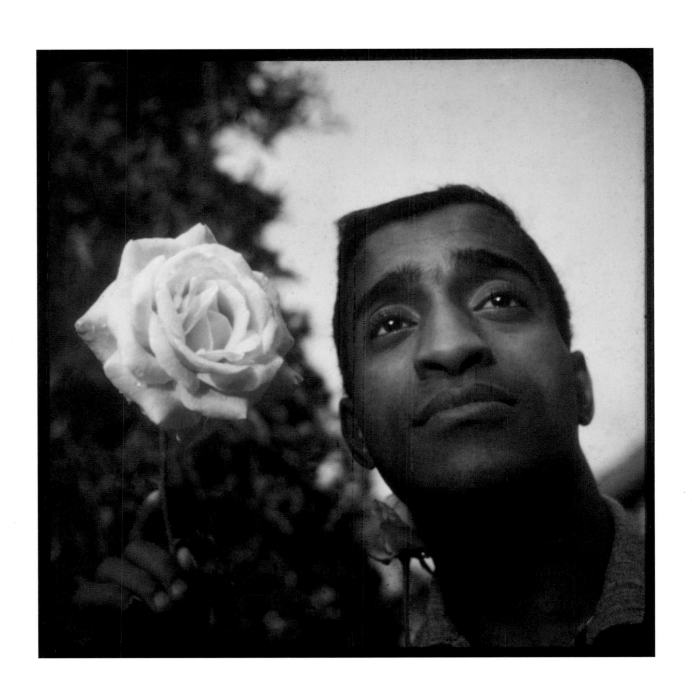

ABOVE: Self photo

OPPOSITE: May

OVERLEAF: May

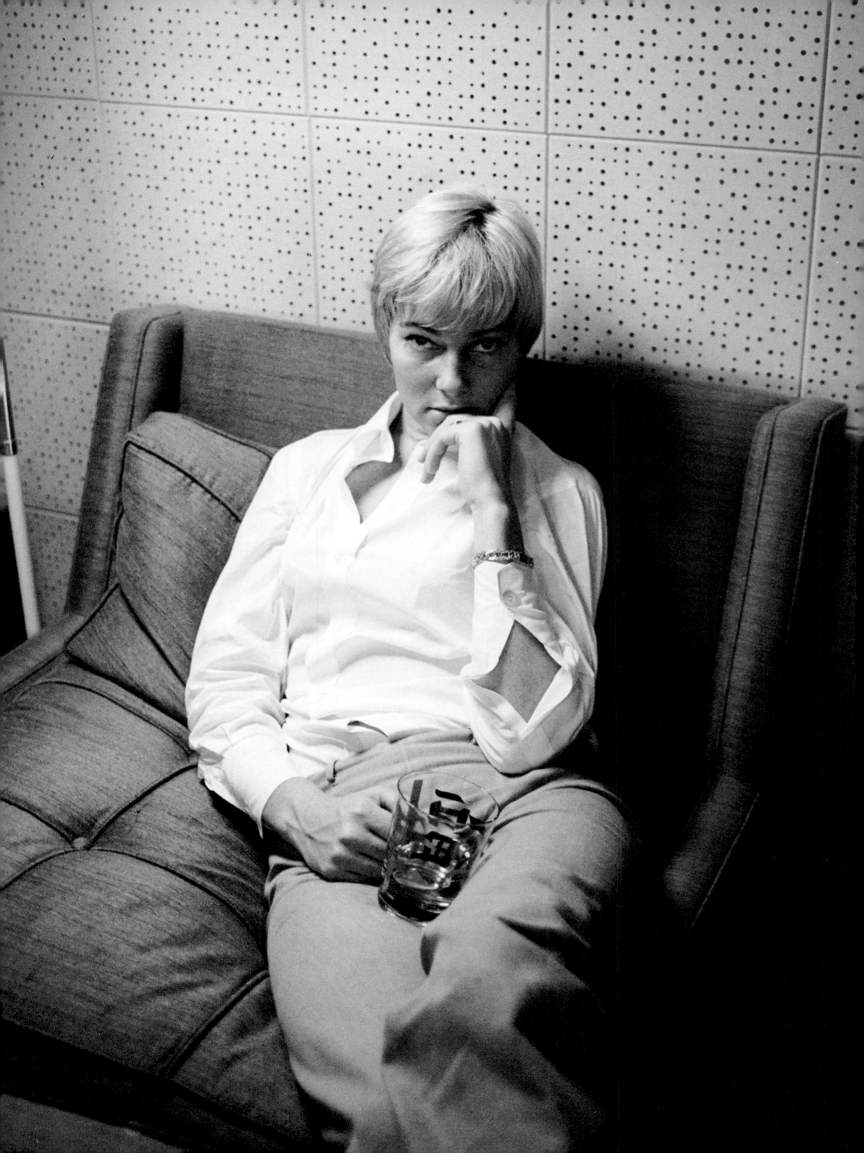

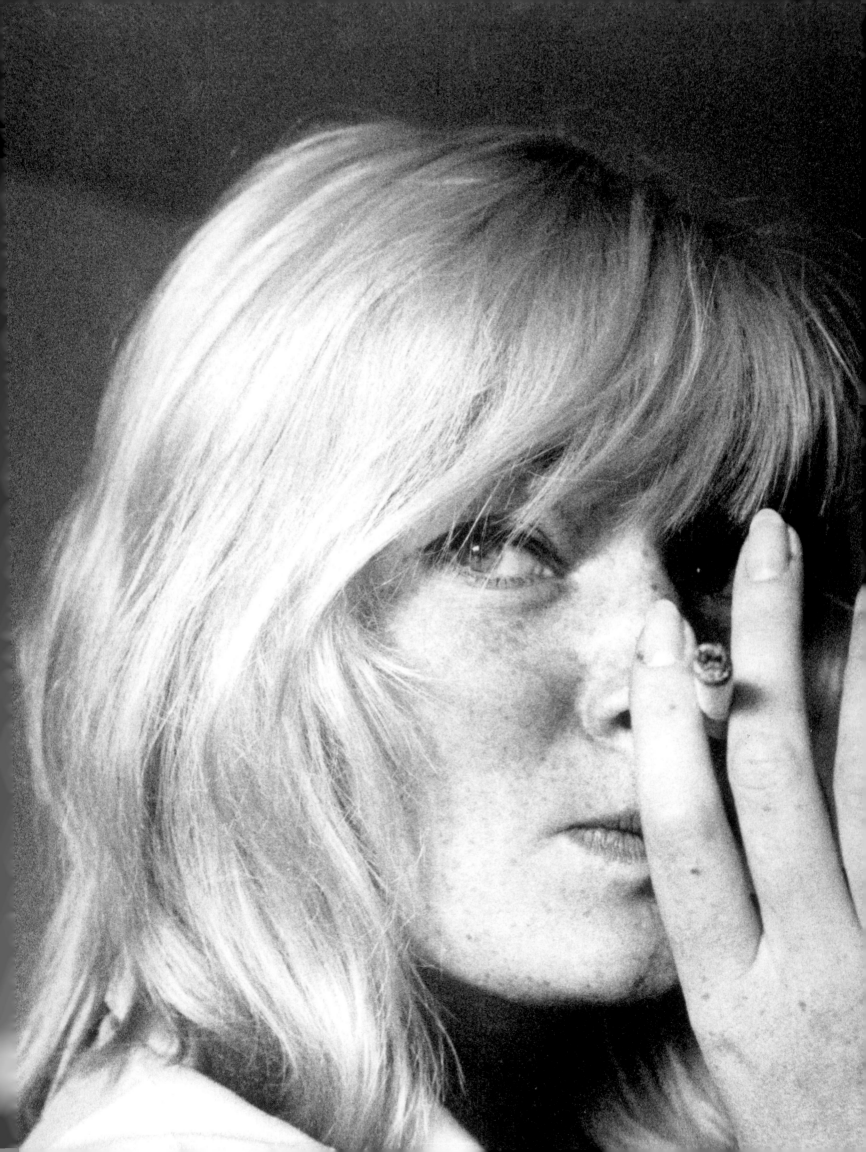

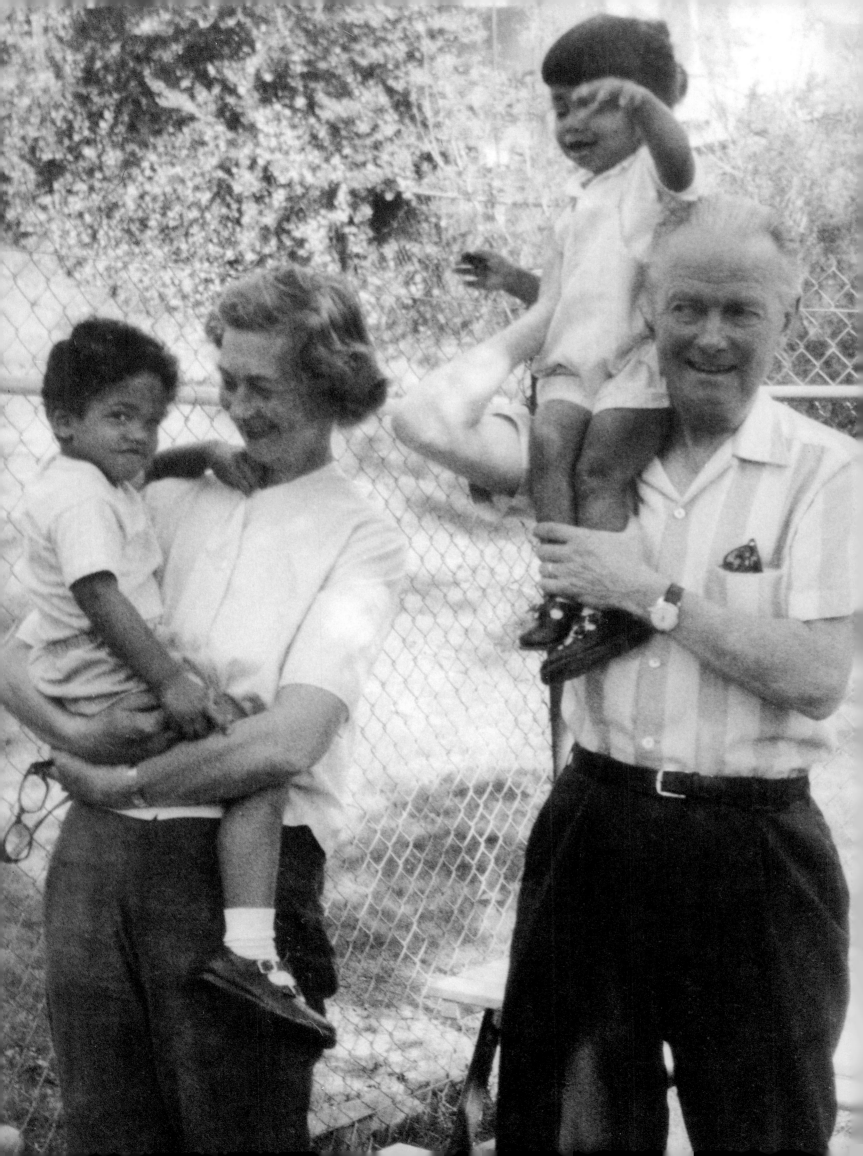

ABOVE: Rosa B. Davis

Sammy's paternal grandmother was known as "Mama." She was the strongest female force in his life.

OPPOSITE: May's parents, Hillevi and Ernst Hugo Wilkins, with Mark and Tracey

ABOVE AND OPPOSITE: Tracey Davis with her mother, May

Sammy, a great movie buff, adored *The Philadelphia Story* and its remake *High Society*. The lead role of Tracy Lord was played by, respectively, Katharine Hepburn and Grace Kelly. Sammy was so taken with the elegance of the character that he knew one day he would give his own daughter that name.

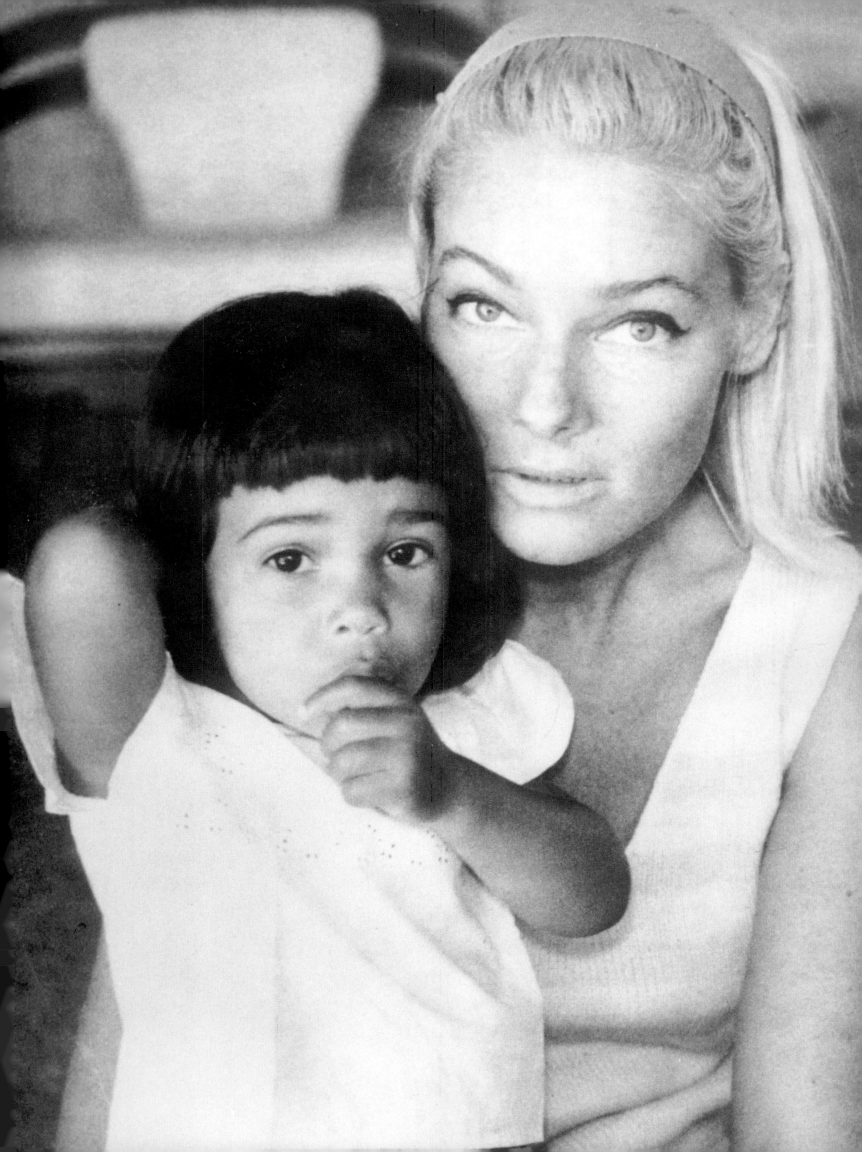

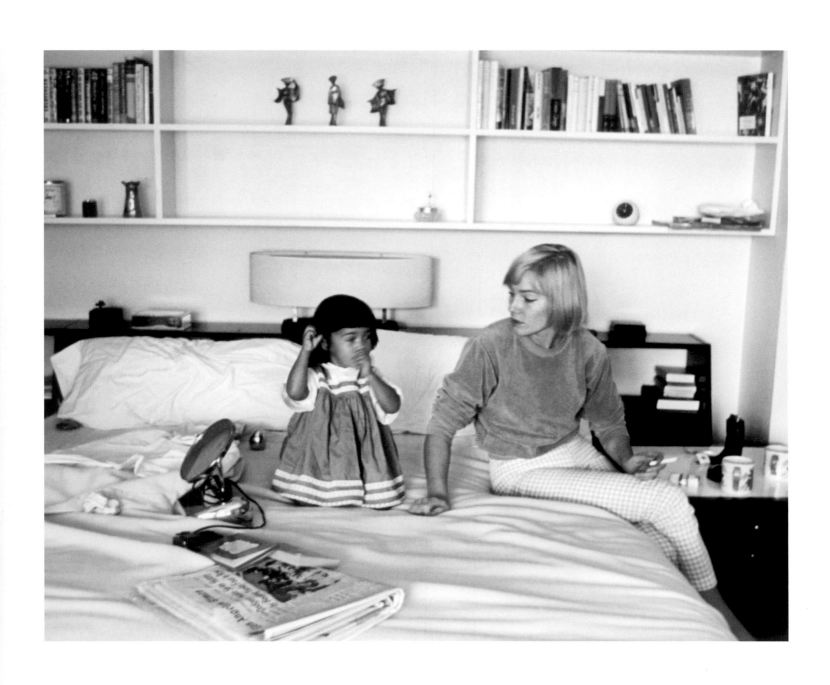

ABOVE: Tracey and May

OPPOSITE: May

MARK SIDNEY DAVIS

Mark's middle name, Sidney, is in honor of Sidney Poitier. It was immediately following the birth of their daughter, Tracey, that Sammy and May once again discussed adopting a child to add to their family. Jane and I were staying with them at their house on Evanview Drive in the Hollywood Hills a week after Tracey's birth when May said rather whimsically, "Too bad Tracey can never have a big brother." Sammy replied, "Why not? There are so many children that no one wants...instead of bringing another baby into the world, why don't we find one of them who needs us and give him all the love we have to give a child?"

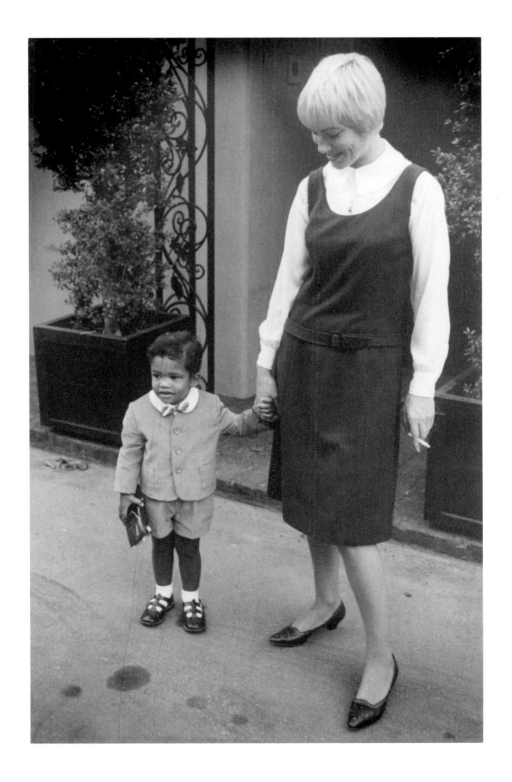

OVERLEAF: Mark

ABOVE: Jeff Nathaniel Davis

When Sammy lost an eye in the automobile accident in the early '50s, his close friend and "big brother" Jeff Chandler offered to give him one of his eyes. Jeff's first name is in honor of that lasting friendship and Nathaniel is in honor of Nat King Cole.

OPPOSITE: Tracey, May and Mark

OVERLEAF: Jeff, Tracey, May and Mark in Hawaii

Though divorced, Sammy and May remained close throughout his life.

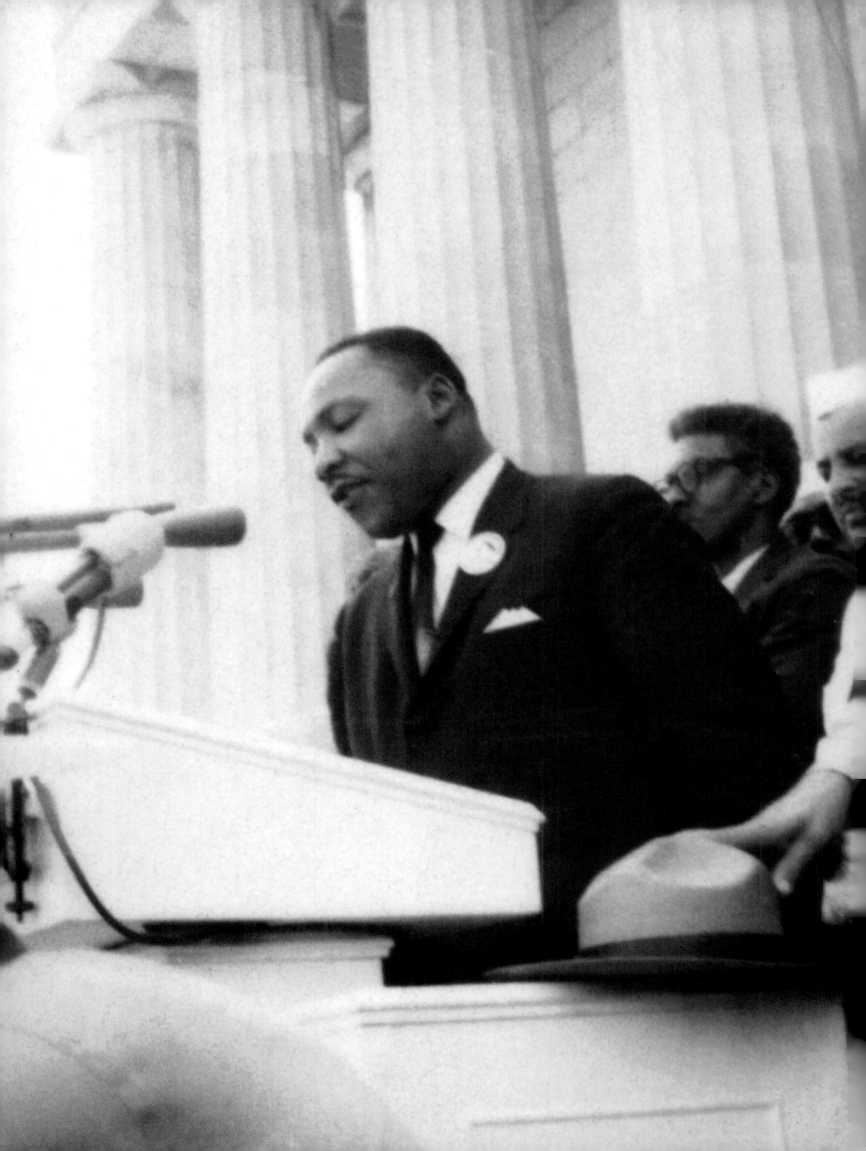

CHAPTER 5
THE STRUGGLE

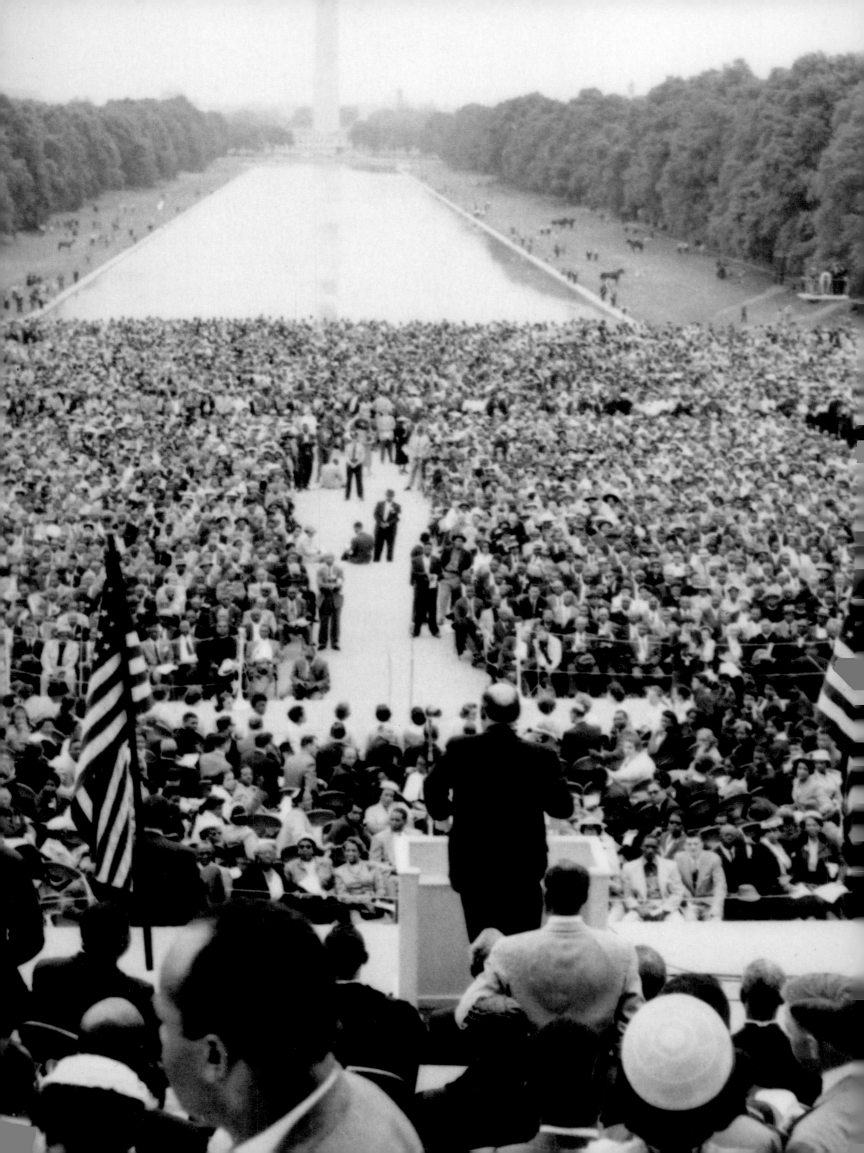

AUGUST 28, 1963
THE MARCH ON WASHINGTON

IN HIS OWN WORDS, SAMMY'S RECOLLECTION OF THAT DAY:

"We left early, first thing, flying out of Detroit to Washington. We got in and it was early in the morning...and it was already happening. The streets were alive and buzzing. We met at the Lincoln Memorial. That's where the 'I have a dream...' speech was given. So you looked down from the Lincoln Memorial and there's the Washington Monument. Filled. Just filled on both sides, all the way down.

"I was scared. You know, 'Wonder what's going to happen?' The anticipation of what was going to happen. They were saying things like, 'If ten thousand people show up it'll be something.' You know, maybe twenty thousand at best. And all the police! Within around three hours of arriving, you knew there was not going to be a riot. Everybody was smiling. And the malcontents were kept so far away that they couldn't interfere. You saw everybody, you saw them all. Lerone Bennett and a few of the other guys from Johnson Publications, *Ebony* and *Jet*, a few of the photographers; black and white photographers that I knew. We were standing on the steps before the speakers started. Then King got there. And I'm standing, looking down from Lincoln down to the Washington Monument, and going, 'It's going to be a good day, man,' and everybody starts smiling and you know there ain't going to be no trouble. This is going to be great. This is what we prayed for. And it was like a virus that spread among the people. It was everybody. I saw little vignettes of things. People touching, holding

OPPOSITE: The crowd gathers on the Washington Mall.

PAGE 246: Martin Luther King, Jr. delivering his "I Have A Dream" speech.

hands, probably people who had never—black people who had never touched white people, or hugged or had a physical line of communication before in their lives. And vice versa. White people who had never been next to a poor, humble black woman and her child that she's holding—and everybody had love—it was unbelievable.

"It really was an unbelievable day, and I remember somebody saying to me, 'Come on, sit on the podium.' And I said, 'No. I can't see from the podium. I want to see it. I want to be out front.' And one of the guys from *Ebony* said, "Well, Sam, come sit down here," and I went down like in the first, second row because I was taking pictures and I wanted to be where I could see what was happening, as opposed to being up there looking out at the people. And then afterwards I came up and there were some pictures taken and I walked up to Martin, and everybody was crying, and I just remember saying, 'Thank you. Thank you.' And I couldn't say any more than that. And he grabbed me and hugged me and I hugged him, and they swept him away.

"Later that day we were up in Harry's [Belafonte] suite and Harry said, 'Call Bobby Kennedy and tell him the artists would like to have a meeting at the White House.' I was the one with the closest ties to the Kennedys and so it was up to me to call. It was a chaotic moment and although Bobby took my call, he was adamant, 'No. The performers can't come up here. Nobody can come up except the civil rights leaders. I'm fighting for my life, Sam, just to get the civil rights leaders in. The president's got a lot of advisors telling him he shouldn't meet with anybody, not Dr. King, nobody. If the performers come up, then it becomes a spectacle, the press would make it a farce. We don't want any more cartoons…' he said, referring to a flood of them showing Frank, Dean, myself, and Peter Lawford, an actor, with captions like 'The Rat Pack Takes

OPPOSITE: Dr. Martin Luther King, Jr.

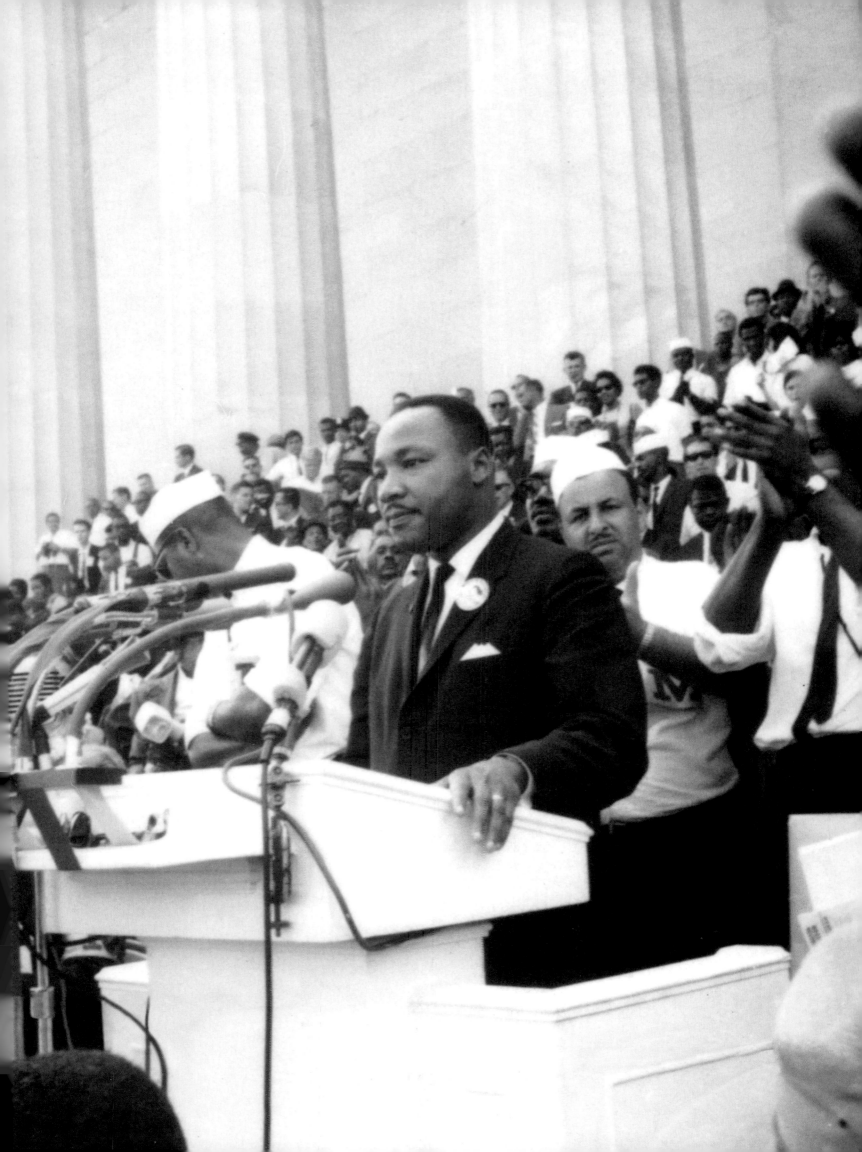

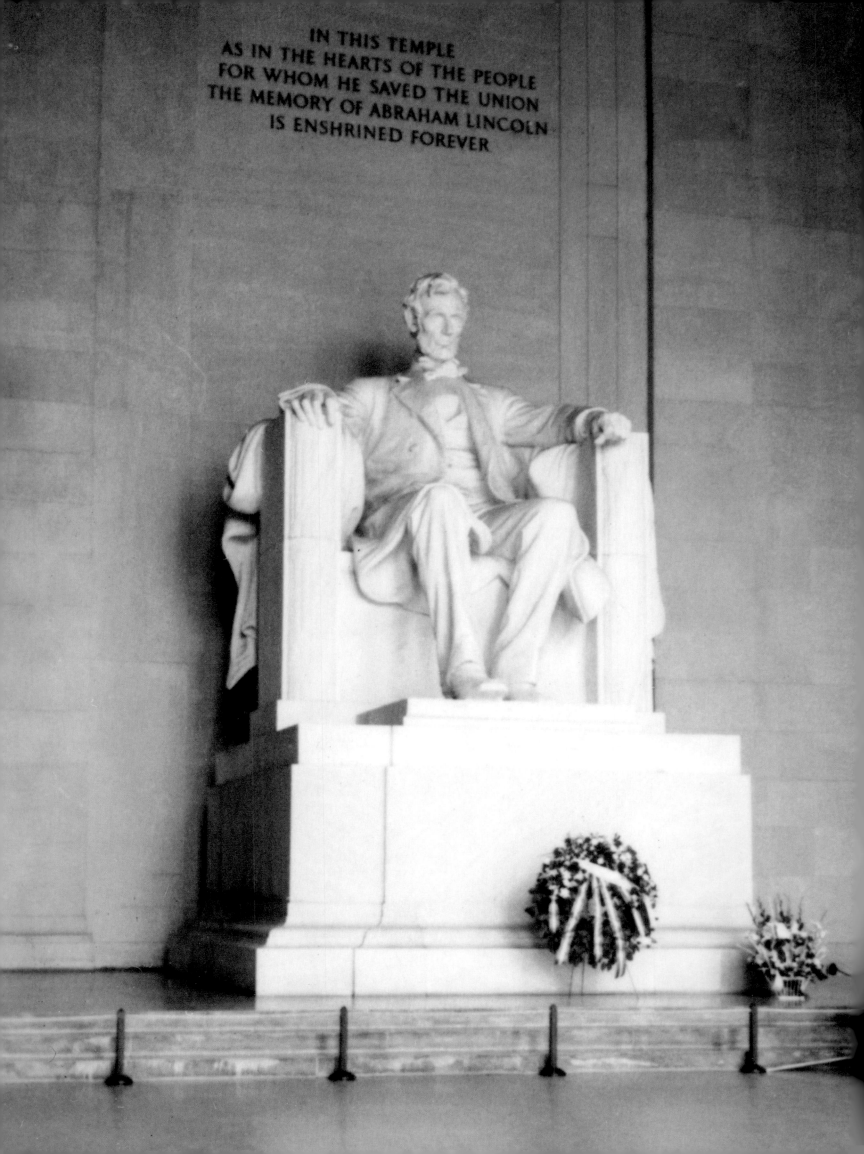

over the White House,' and one of me as a butler serving fried chicken and watermelon to JFK: 'But, will it still be the WHITE House?' Bobby was right, of course, and he had used his power as attorney general to allow the march to happen and to protect the demonstrators when he could.

"I never had that feeling before, or since. There were hundreds of thousands of people there, and everybody felt the same way. You knew there was something going on and that you were a part of it. Take it twenty-four hours before, twenty-four hours earlier, maybe they would have killed each other. I don't know, but for that suspended space in time there was more love in the mall in Washington than the world has ever known.

"It was a monumental day in many respects. First of all, more than any single incident, the galvanizing of what the civil rights movement was about, was that day. It showed that we could live together, the blacks and whites and Hispanics and everybody else, that we should be pulling together.

"Twenty years later to the day of the march we all went back. And we recaptured it, the affection, and to see people who had been there twenty years earlier and to see the people who now were there, the young faces, it was joyous. A couple of kids came up to me and said, 'Sam? You were here before. Is this what it was like?'

"I said, 'Yeah. Keep it going, man, keep it going.'"

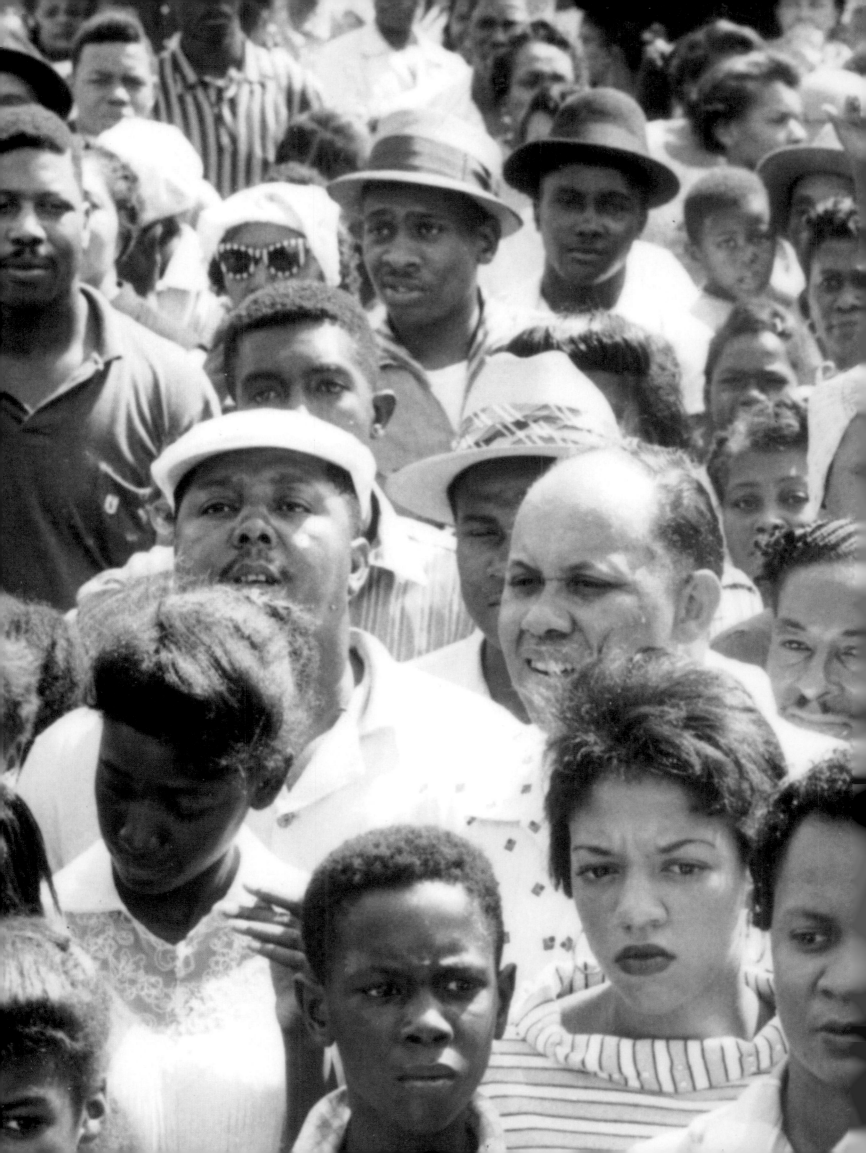

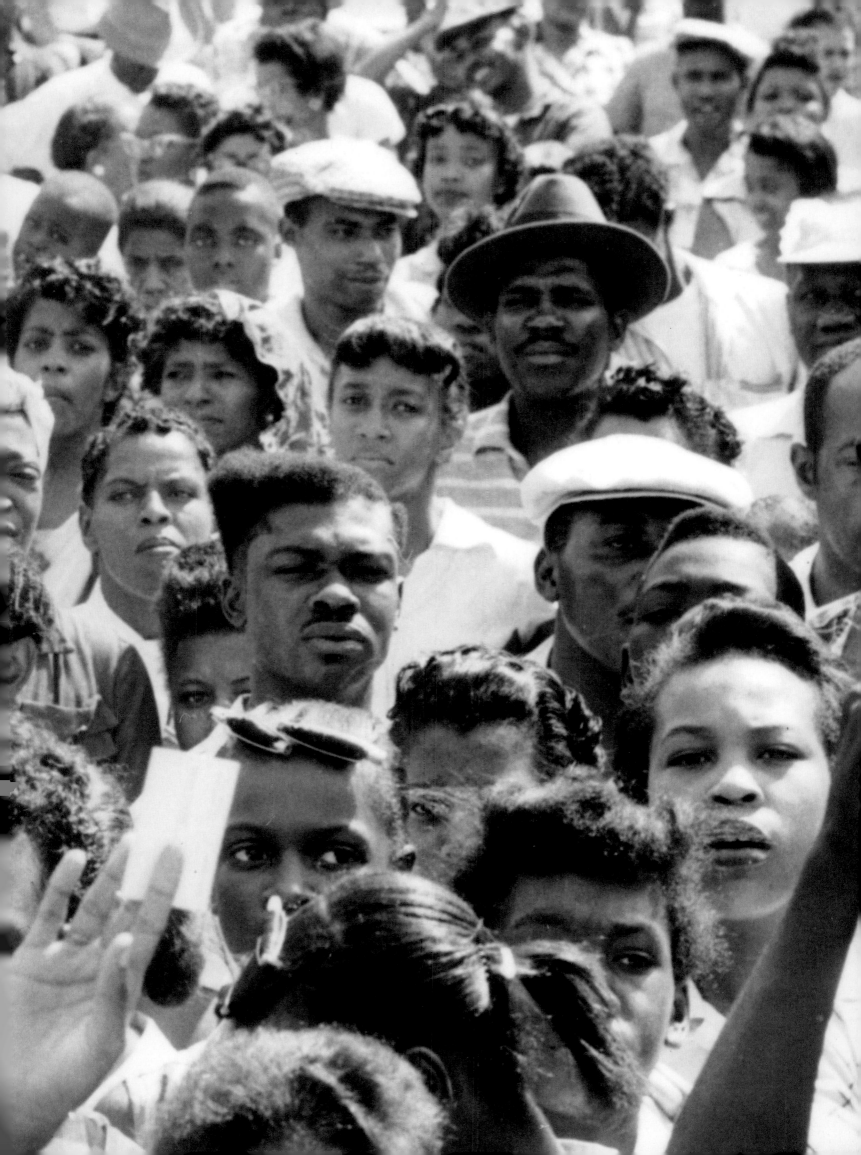

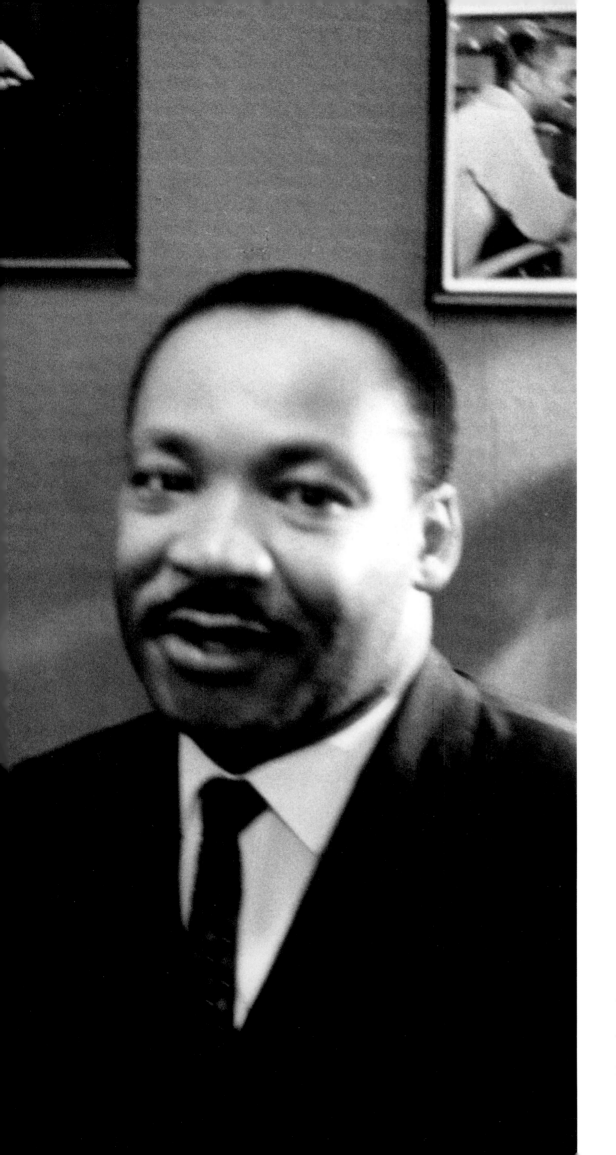

Johnny Brown, who played
Sammy's brother in *Golden
Boy*, and Martin Luther
King, Jr., in Sammy's dressing
room... Majestic Theater in
New York

ABOVE: Harry Belafonte

OPPOSITE: Sidney Poitier

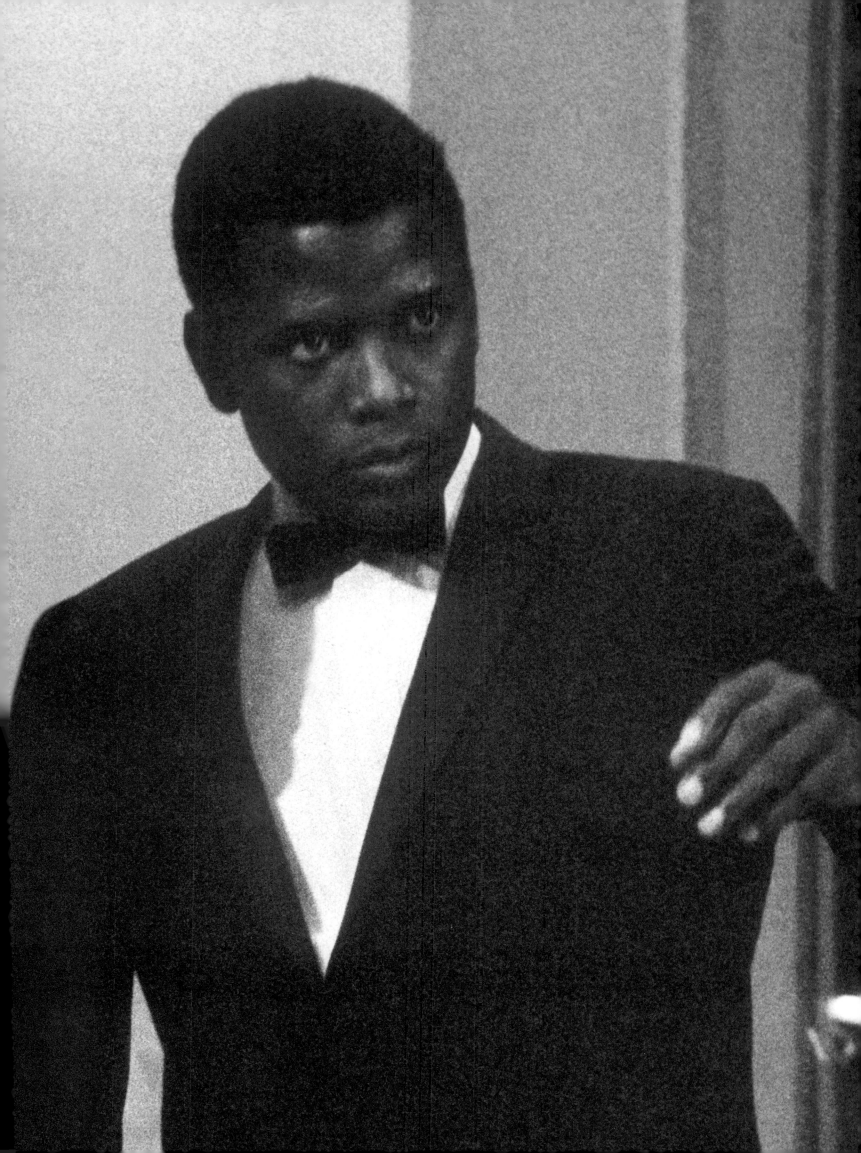

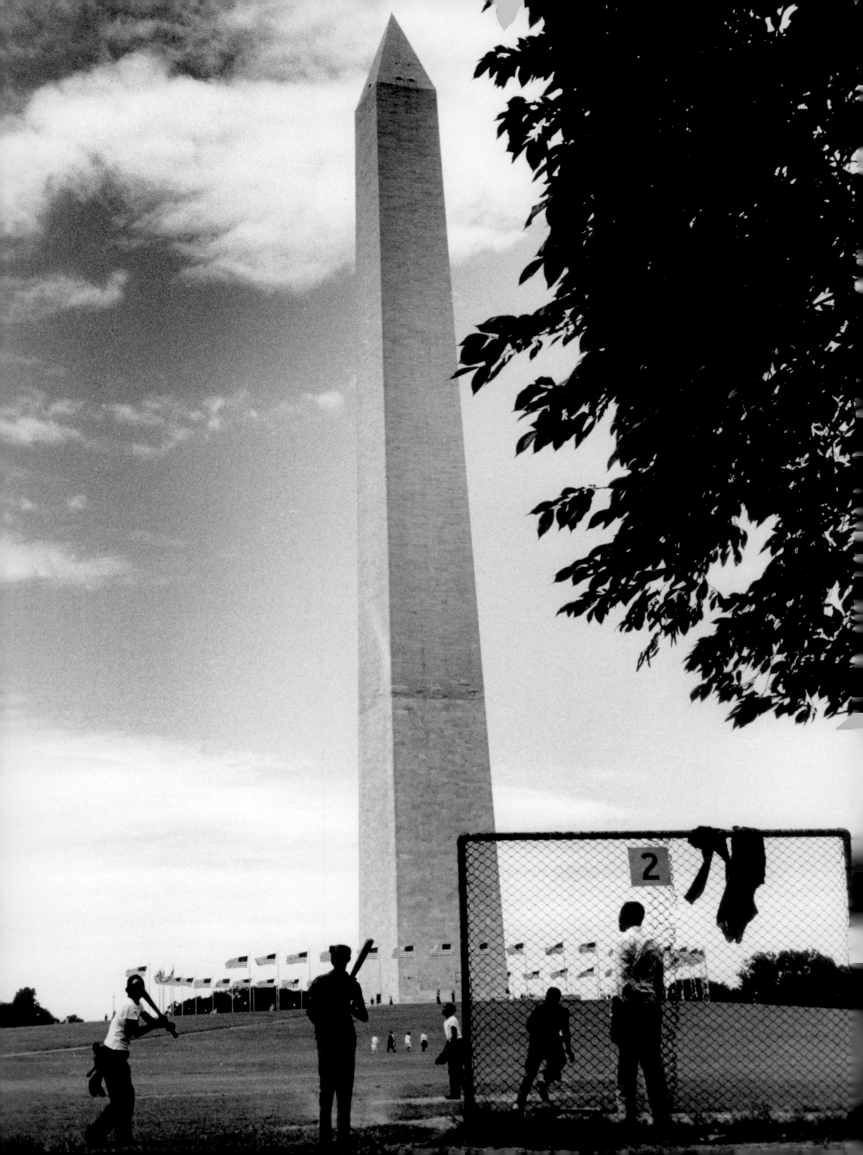

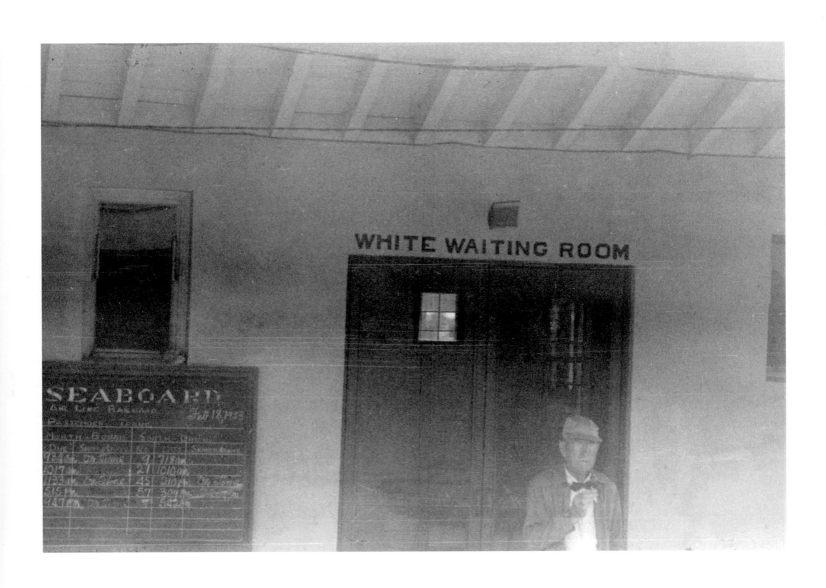

ABOVE: The view from the car window en route to star on
Miami Beach, where all blacks—including Sammy—needed
a special pass allowing them to be there.

OPPOSITE: The Washington Monument

"THERE WOULD HAVE BEEN NO CIVIL RIGHTS MOVEMENT IF IT HADN'T BEEN FOR BOBBY KENNEDY."

ROBERT KENNEDY

Sammy on Bobby Kennedy: "I didn't do grass-roots campaigning for Jack the way I did for Bobby, when he ran. For Jack if there was a Jewish affair, anything that was ethnic, I took over. I did those in Los Angeles, I went to the garment district, Mexican Americans, Watts, those things. And went with somebody, usually Ethel Kennedy or on a couple of occasions Jack and I were together. Jack was a very, very, very nice man. But very slick. Very sophisticated, very sort of raised eyebrows. Terribly articulate and bright. But I think his energies and his mind were in other areas. He liked to have a good time. He liked to party.

"Bobby was never involved in any of that. Never was. He was Mr. Straight, Mr. Clean. During early '60s when the campaign for John was going on we all saw Bobby. But Bobby was not enamored with the group. When I say 'the group' I mean Frank and Dean. It was a little fast paced for him. I think that Bobby would have made one hell of a president because his line of integrity never wavered and he took his integrity to a point that if he had a vendetta against somebody

he never eased up. He just went with it. The Jimmy Hoffa thing for an example.

"It would have been a different civil rights movement without Bobby Kennedy. The voter registration, the lunch counter sit-ins, the pray-ins, were often violent, but he kept it from being the bloodbath it could have been. Supportive of it, he gave protection. There is no counting the lives he saved, the bloodshed he prevented. I had a lot of contact with John during the civil rights movement, but my relationship with Bobby was always a little different than with John because John was John. Bobby was a humanist. He was not a do-gooder, but a good-doer. A knight of old in a button-down collar shirt. A man who saw wrongs and wanted to right them. I never heard him raise his voice. John would smoke cigars and walk a lot and get mad and pound the table, 'We've got to do this.' Bobby would say, 'Take it easy, there's a way to get it done.'

"After the election when Bobby became attorney general it was very, very heavy in terms of him calling me because there were a lot of things going on with the civil rights movement. Bobby would

give me certain informational things like, 'You're on the list,' meaning the Ten Most Wanted list that the white supremacists had, the Klan, the White Citizens' Council. 'You're moving up on the list, Sam,' he'd say to me.

"Just before we all went down to Tupaloo, Mississippi, I was having dinner with Peter at Matteo's. I'd chartered a plane to take us all down for a march on a college there, one of those big affairs with thousands of students, and SNICK and CORE. Anyway, Peter hands me the phone and says, 'There's a friend of yours who wants to talk to you,' and Bobby Kennedy says, 'Hello, Sam, I've got some bad news for you. We've only got a few men down there. Don't go there. They're out to get you this time and I'm telling you don't go. I think that you should pull out of this.' I said, 'I can't. You know what my commitment is and you know that I promised everybody that I'd be there.'

"And he said, 'Well, Sam, I wouldn't go if I were you.' After about three minutes of this he said, 'Most of my men will have on white, soft white Panamas, that's the only way I can identify them for you. They'll have on Panama hats.'

"Well, we get off the plane and I tell Murphy, 'I ain't seen a Panama hat yet. Still waiting to see a

Panama hat. Now we're down here in the bowels of the south. I knew I should have listened to Bobby. I'm going to die down here. Somebody going to shoot me and I won't even know, nobody'll know, nobody cares ... and I started feeling sorry for myself and laughing at the same time. I'd hired this Lear Jet and brought Rafer Johnson and Brando and Tony Franciosa, about seven of us.

"I introduced Martin [Luther King] that night and Martin says to me, 'I got you to Mississippi. I got you down here, Sam. I knew I'd get you down to Mississippi.' I said, 'Selma wasn't bad enough. Now you got us to Mississippi. Well, that's it, Martin! I love you, you are my spiritual leader but you have gone too far ...' and we're laughing and this is going on right there on the stage while the preliminary speeches were happening.

"Then I hit the stage, a cheer went up from the audience. Big cheer. There's Harry [Belafonte], there's Sidney [Poitier], they had already been down there three or four days. They were terribly brave, because they were plain scared. I was scared. I did what I had to do but I wasn't going to bullshit myself, I was scared. But Harry and Sidney were like Black Knights, man, they were always seven feet tall, good looking and 'Don't be afraid of nothing, Sam, we're here to protect you.' Except they ain't got nothing to protect me with except their spirit and their heart and their love. I said, 'You're crazy. They can kill you, too. Don't you know that? These rednecks down here will kill you, too.'

"So now we get up there and Martin is doing jokes with me and I tell Sidney and Harry what Bobby Kennedy told me before I left L.A. and Martin says, 'Well, we'll talk about it tomorrow.' I said, 'Unless you're coming back to L.A. with me you won't talk to me about it. I'm leaving right after this is over.'

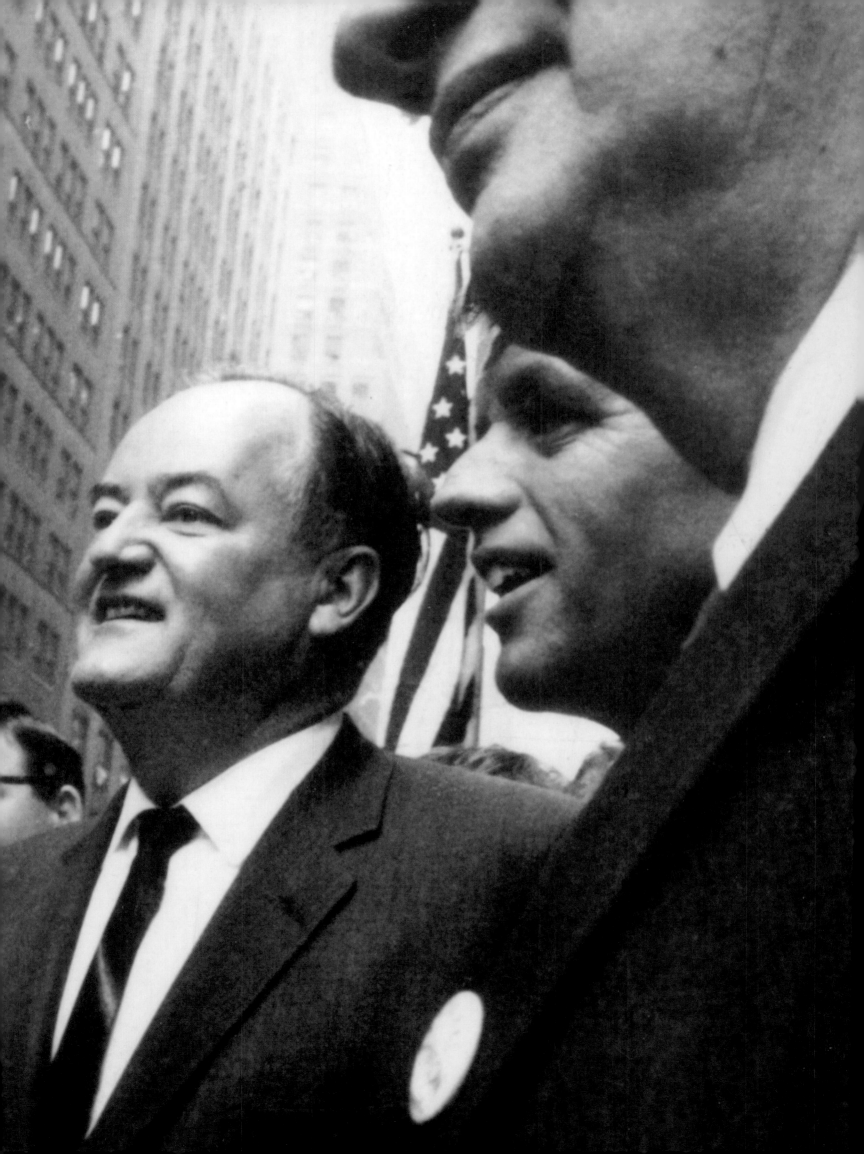

"'Oh, no, no, no. We got the reception to go to.'
"I said, 'Okay, I'm going to the reception but after that I'm leaving. I've got no business down here.'

"Martin says, 'I'll meet you at the Reverend's house because we got to talk you into staying tomorrow for a big thing we're doing.'

"I said, 'Martin, I love you but I am not staying for tomorrow.'

"So he laughed, 'Oh, you down here now, we got you down here, ha ha ha. . . .'

"I said, 'Okay, you just want to see me out here dead someplace. These people out here gonna kill me.'

"Martin waved that away, 'Ain't nobody gonna bother you. You're too little to be bothered with anyway.'

"So I laughed a little and then Harry turns to me and says, 'Make sure we all leave in a group.'

"I looked at him, 'A group?'

"'Well, that way we can protect you.'

"I said, 'Hold it. One minute you're telling me "no need to be afraid," and next it's "Let's leave in a group?"'

"So we're all at the Reverend's house having a cup of tea and I'm sitting by a window and one of the sisters of the church said, 'Oh, Hazel, look where's he's sitting. That's right by the window where … oh you got the pane fixed.' I went, 'What pane?' 'The window pane. That's where they threw the fire bomb in.'

"I did all the grass [grassroots campaigning] in '68. Small little groups, going out of town. I was in Illinois rehearsing six weeks of *Golden Boy*, in Chicago, so I did all the stuff leading up to that before he won the primary. In the afternoons, I'd go out to colleges and there would be cocktail parties. I did an awful lot of that. Fund-raisers for Bobby Kennedy, 'We'd like to say a few words, you know why we're all here, blah blah blah, we need

your money.' It was very, very easy in terms of getting money. There was no problem there. They walked in with money. You were underwritten, it was not like fighting for help like you did with the civil rights thing.

"Bobby and I, of course, campaigned all over New York together when he ran for the Senate. We had a very, very, very marvelous time, Bobby and I, in the garment district in New York. And I took him to Harlem and he was really fantastic, really marvelous. His image with the ethnic groups was so much deeper than Jack's. They loved Jack. But Bobby seemed to have a deep rooted thing, like they knew that during the presidency he had fought for civil rights and most of the black people knew that it was he who said, 'Find them sons of bitches that killed those three boys.' He's the one as attorney general who had an emotional key to the black people. More than Jack did. Jack was president during all those things but as attorney general they knew the support Bobby gave to the whole civil rights thing. For all his front-running liberalism, Jack Kennedy never had a black man close to him. Never. There would have been no civil rights movement if it hadn't been for Bobby Kennedy.'"

OPPOSITE: Hubert Humphrey (left) and Robert Kennedy

ABOVE: Patricia Kennedy Lawford

OPPOSITE: Jacqueline Kennedy

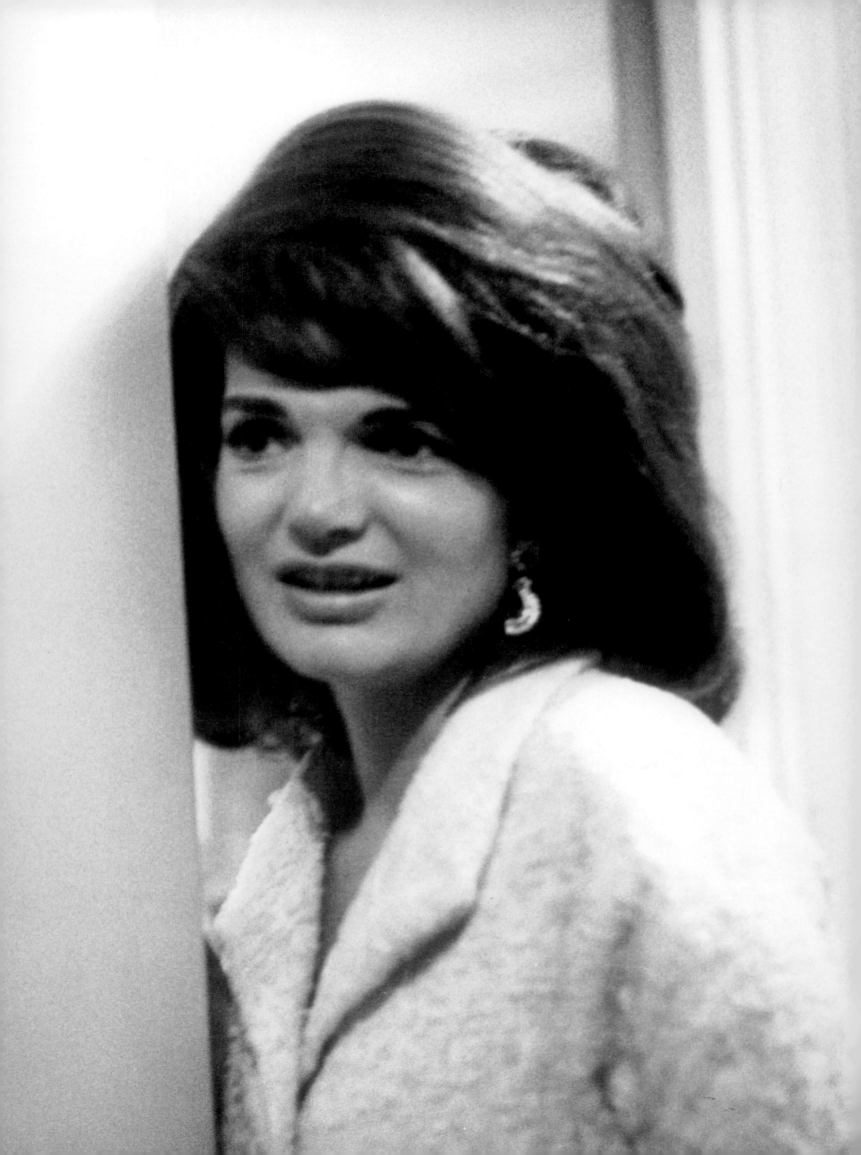

ABOVE: Jacqueline Kennedy and May Britt Davis

OPPOSITE: Jacqueline Kennedy

RICHARD NIXON

Sammy was headlining at the Copa in the 1950s. He was in his dressing room when he got a phone call from Ronnie, the Copa's maitre d'. "Sammy, there's a guy outside with his wife, says he's a Senator Nixon from California, that he just got to town, and that he's an admirer of yours, but we haven't got a table for him, not an ash tray, we're sold out."

"Baby," Sammy said, "put a couple more chairs at my table, will you?"

Later, Senator Richard and Pat Nixon visited Sammy in his dressing room. It was

the beginning of a friendship that would make worldwide headlines when, at a Young Democrats for Nixon rally in Miami Beach, Sammy hugged the president in a photo that was front page news around the world. President Nixon, a surprise guest at the rally, had been thanking the audience for being there, telling them,

"YOU CANNOT BUY SAMMY DAVIS, JR.'S HELP. I CAN'T OFFER HIM AN OFFICE AT THE WHITE HOUSE BECAUSE HE MAKES MORE MONEY THAN I DO."

"You can only buy Sammy by doing good things for America." At this point Sammy, standing behind the president, felt compelled to step forward and put his arms around him. That hug closed a thousand doors to Sammy. The Kennedys cut him off completely; Ethel Kennedy would no longer take his calls. But Sammy gained the ear of the president of the United States. Nixon appointed him to the National Advisory Council on Economic Opportunity, and because of his access to the president, Sammy was of significant help to African Americans, few of whom understood the value he had to them.

Sammy stayed at the White House for his first meeting with the president. "After Altovise and I settled in, and after the excitement and giggling, you realize, man you're living in the White House and this bedroom is where the Queen of England slept (the bedroom is called the Queen's Bedroom). We went to sleep and had to get up early because it was a ten o'clock breakfast meeting with the president. It was a late breakfast for them, almost a brunch, lunch, rather. We went into the study and Mrs. Nixon was there. We had a cup of coffee together and then Mrs. Nixon took Altovise and they went to her private quarters and they had lunch and the president and I sat down. He was concerned about what is the precept in terms of, what are black people looking for. And he said, 'Is that the right terminology? You call people now, *black?*'

"And I said, 'Yes, Mr. President, you can say black now. Negro, colored, those are not . . . everybody's so proud of the word *black.*'"

President Nixon's admiration for Sammy was such that once when he was away from Washington and he learned that Sammy would be there for a meeting he sent word, "Tell Sammy not to stay at a hotel. Use the house." And Sammy Davis, Jr., slept in the Lincoln Bedroom, in President Lincoln's bed.

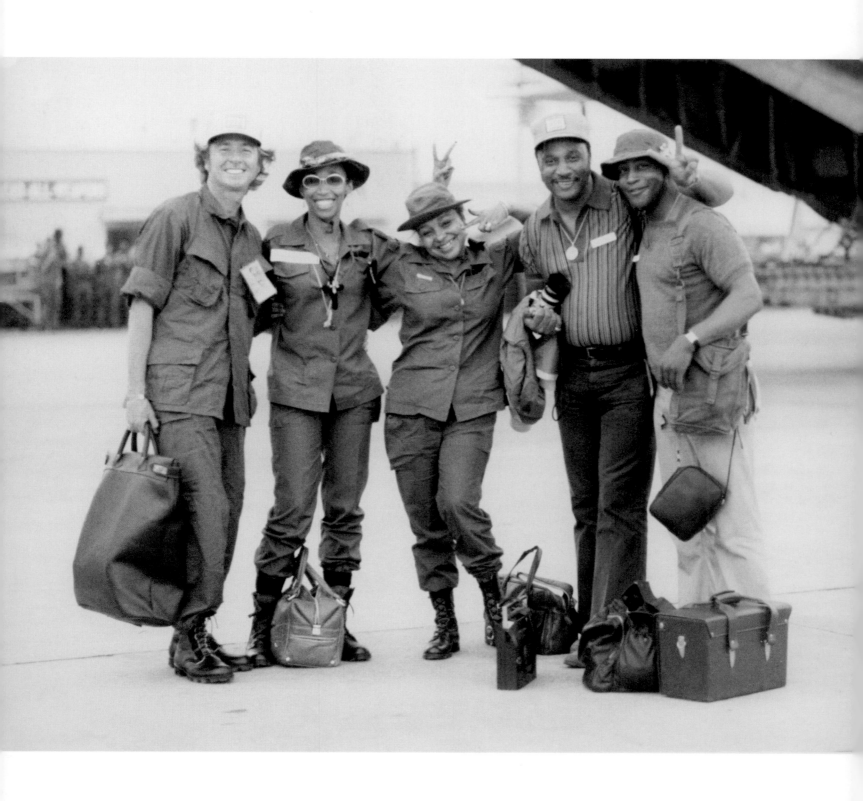

ABOVE: Sy Marsh, Altovise Gore Davis, Shirley Rhodes,
George Rhodes, and Joe Grant

They were about to depart on a trip to Vietnam, sponsored
by President Nixon.

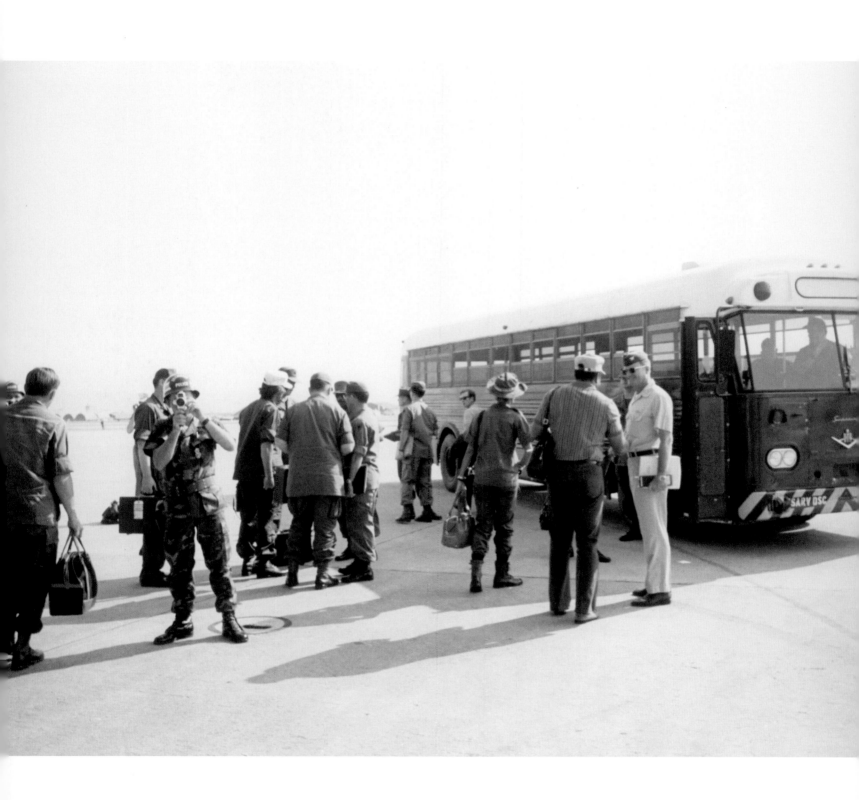

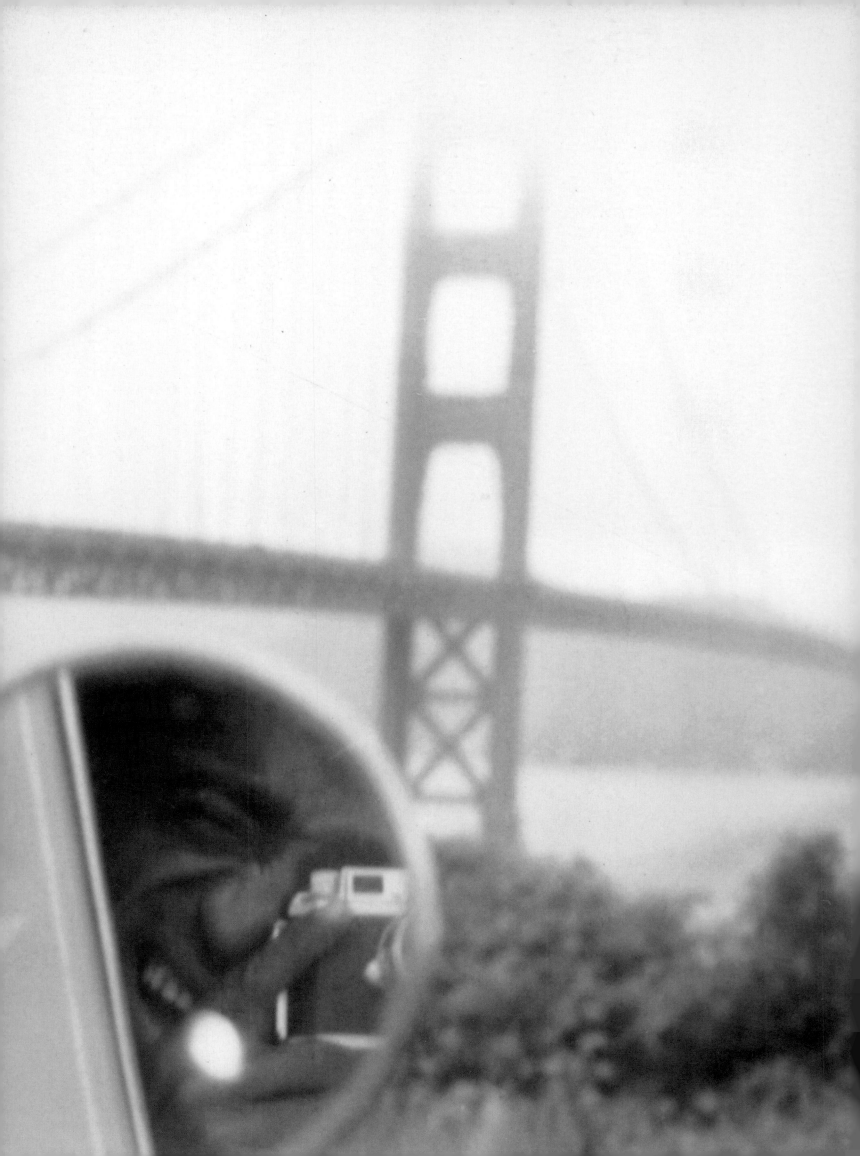

IMAGES FROM THE ROAD

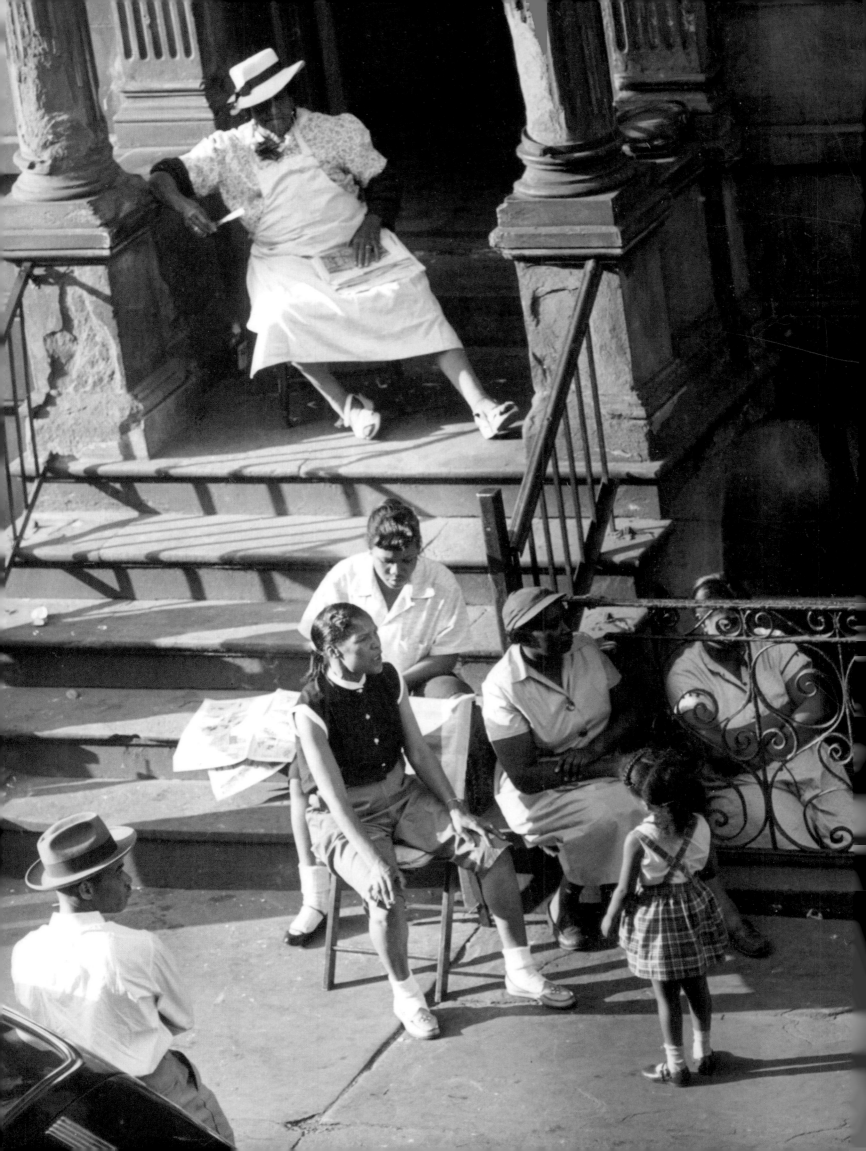

SAMMY NEVER WENT ANYWHERE WITHOUT A CAMERA. THERE WAS NO BRIDGE, HISTORICAL LANDMARK, OR PERSON WHO WAS SAFE FROM CAPTURE BY HIS CAMERA LENS.

For Sammy, the one drawback of his popularity was not being able to walk down the street unnoticed. So he would explore whatever city he was in from the windows of his hotel room—always with a camera at hand. He was always challenging himself as a photographer—to capture dancers in motion, the sun as it was setting over a city skyline, or a bridge illuminatec at night. Sammy also loved the human form, and in particular, the female human form. He would often have his wife and others—even women he did not know—sit in various poses to capture a look or an emotion. For Sammy, the camera was an extension of his artistic self.

ABOVE: The view from Sammy's San Francisco suite.

OPPOSITE: A warm day uptown New York City.

OPPOSITE: San Francisco

great example of Sammy's talent for photography

A brilliant dancer's admiration

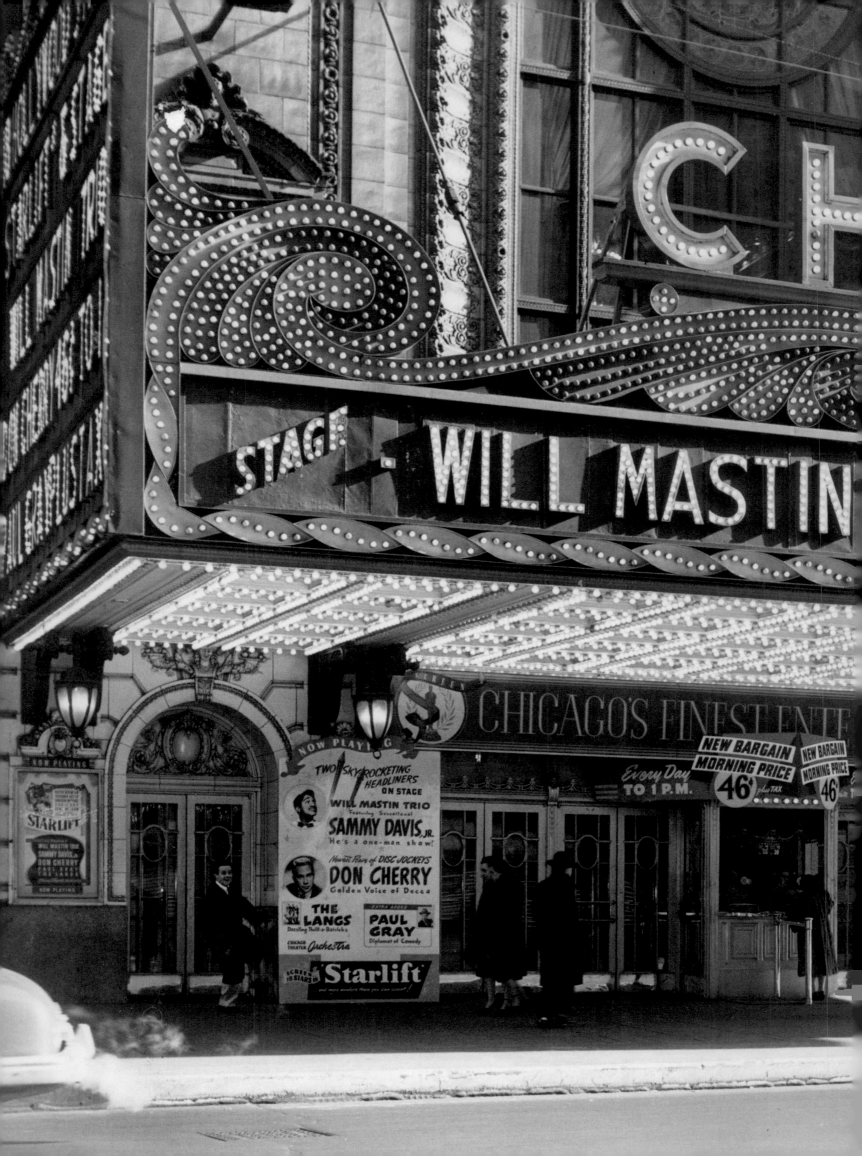

Sammy loved photographing women and took thousands of
photos of beautiful women all over the world.

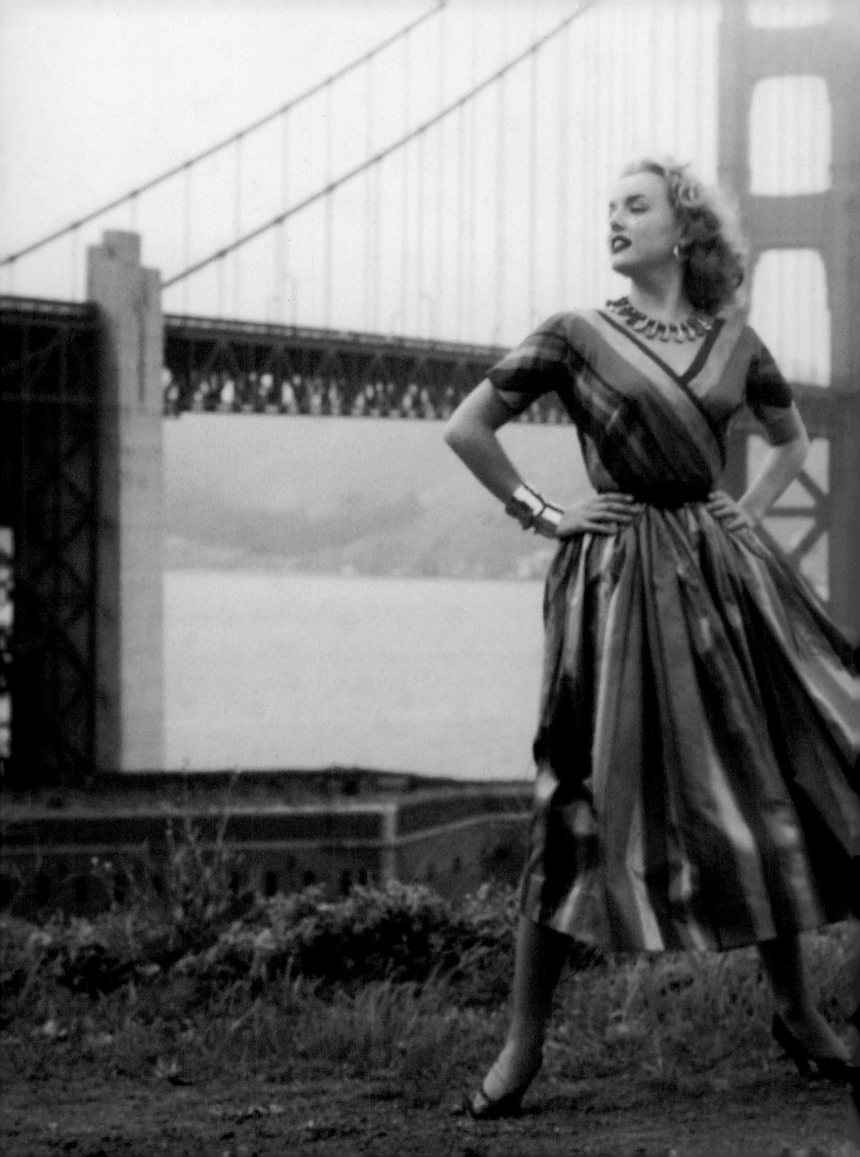

ABOVE: Unknown girls at the pool, Lord Calvert Hotel, Miami.

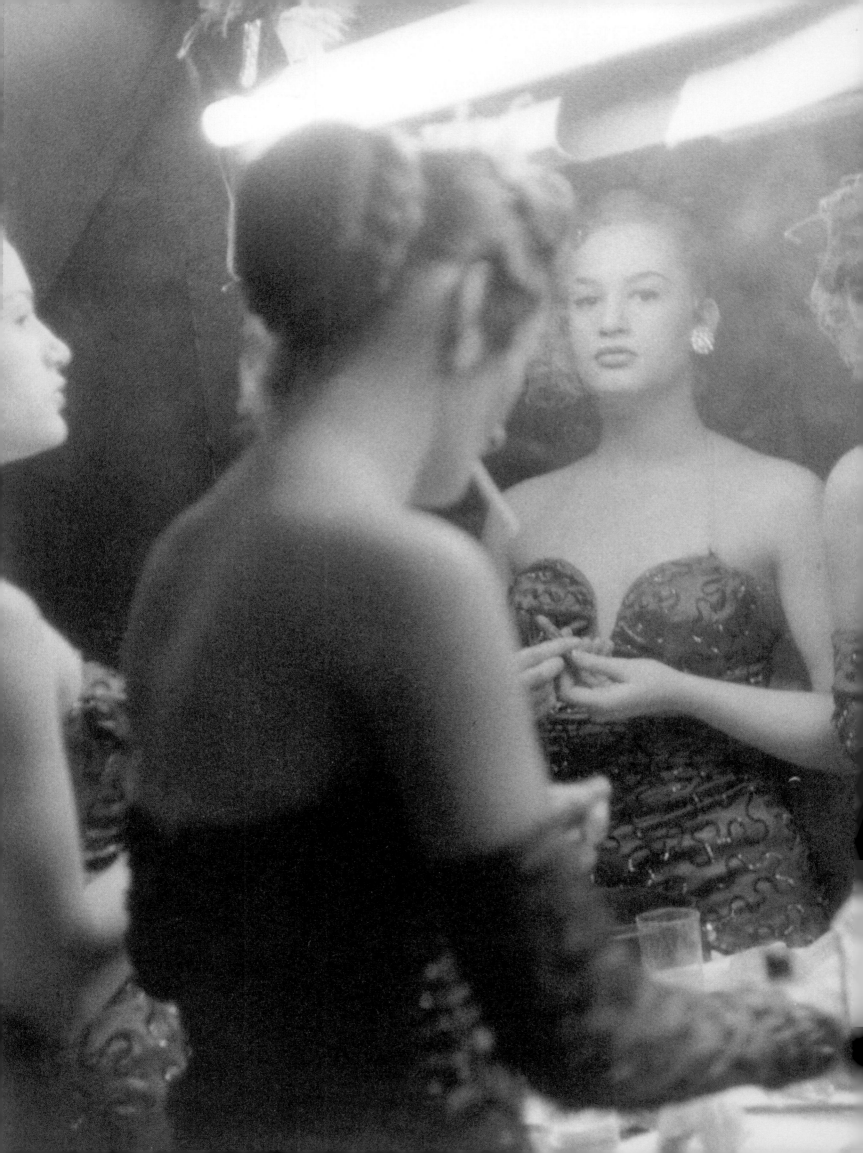

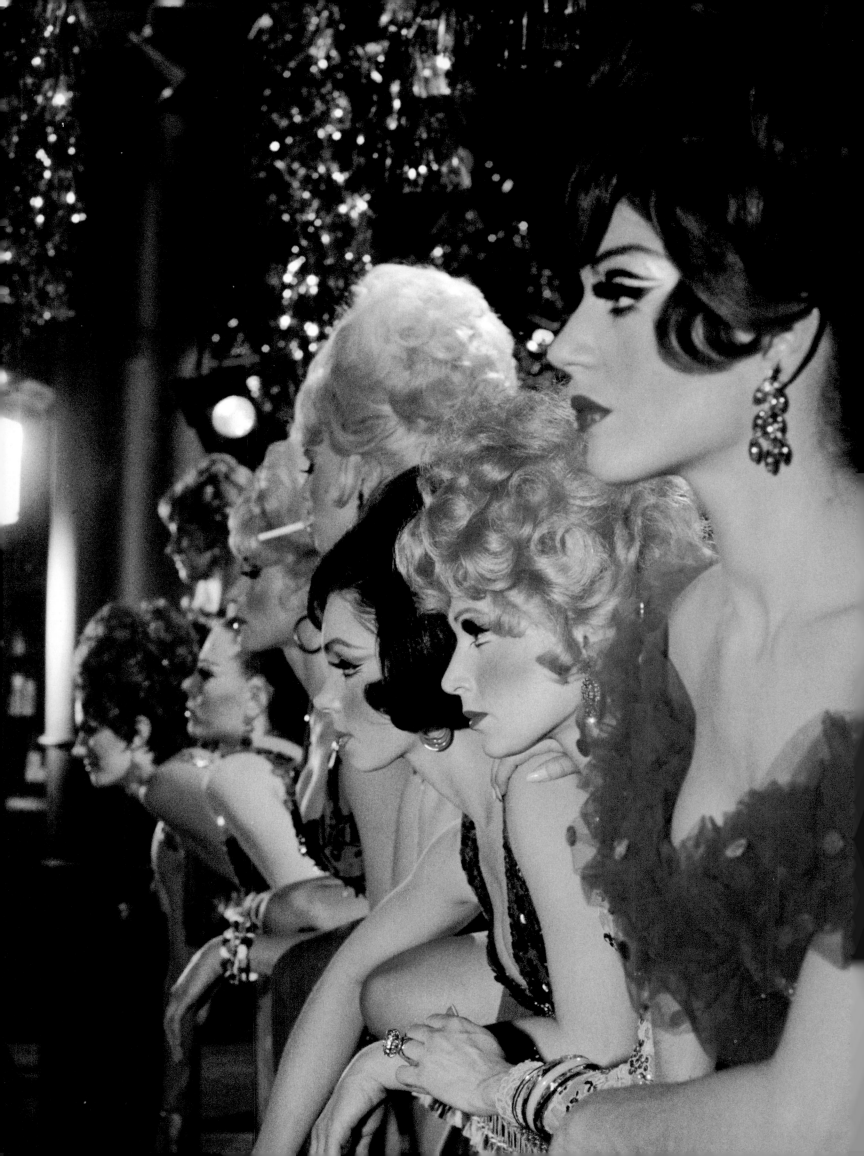

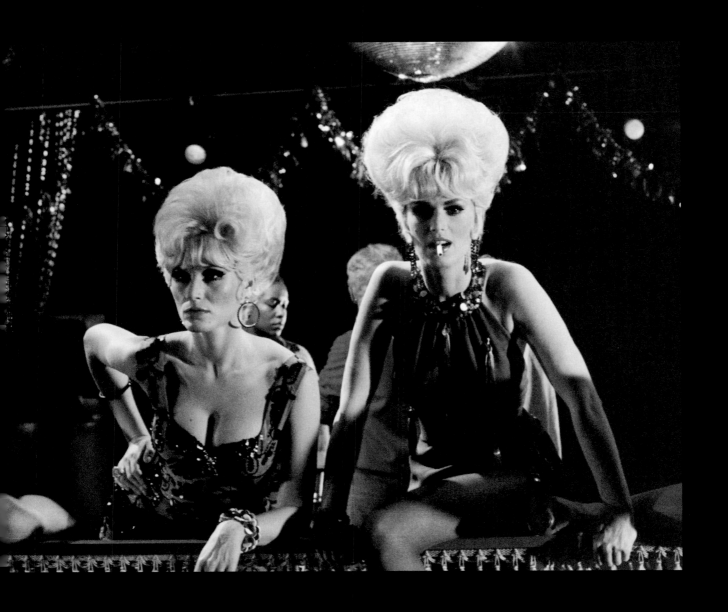

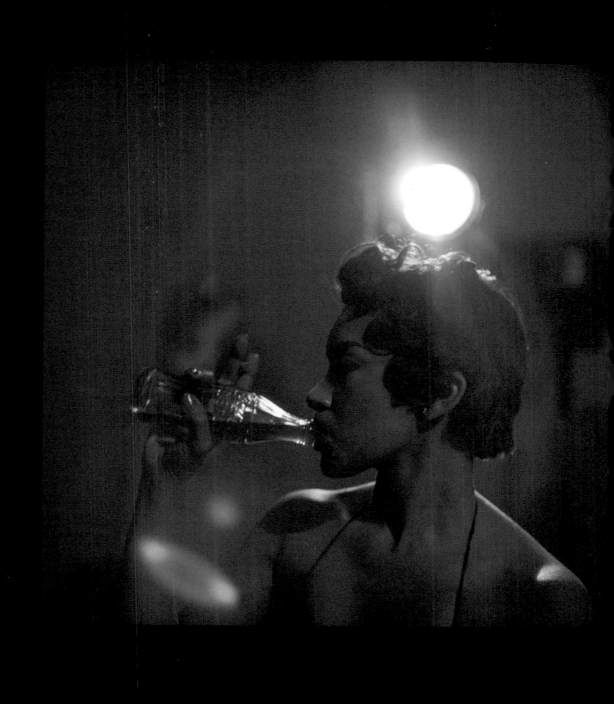

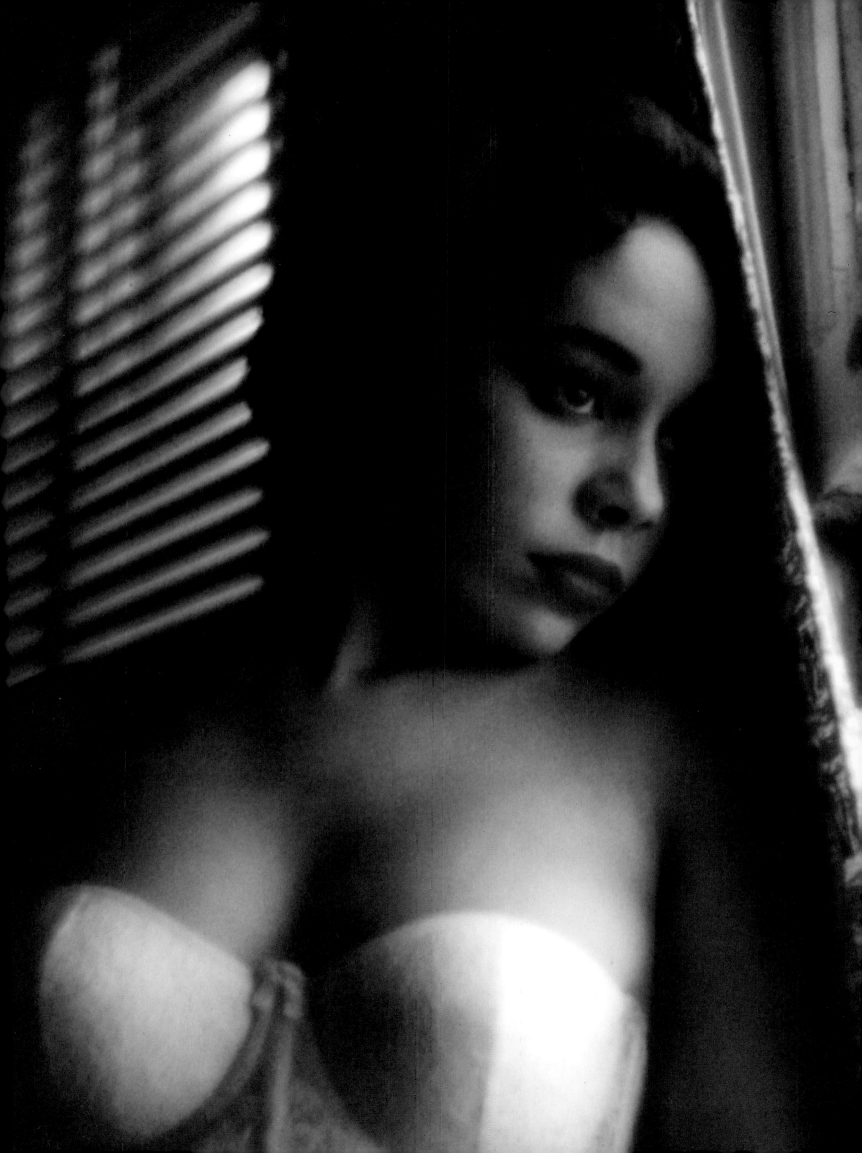

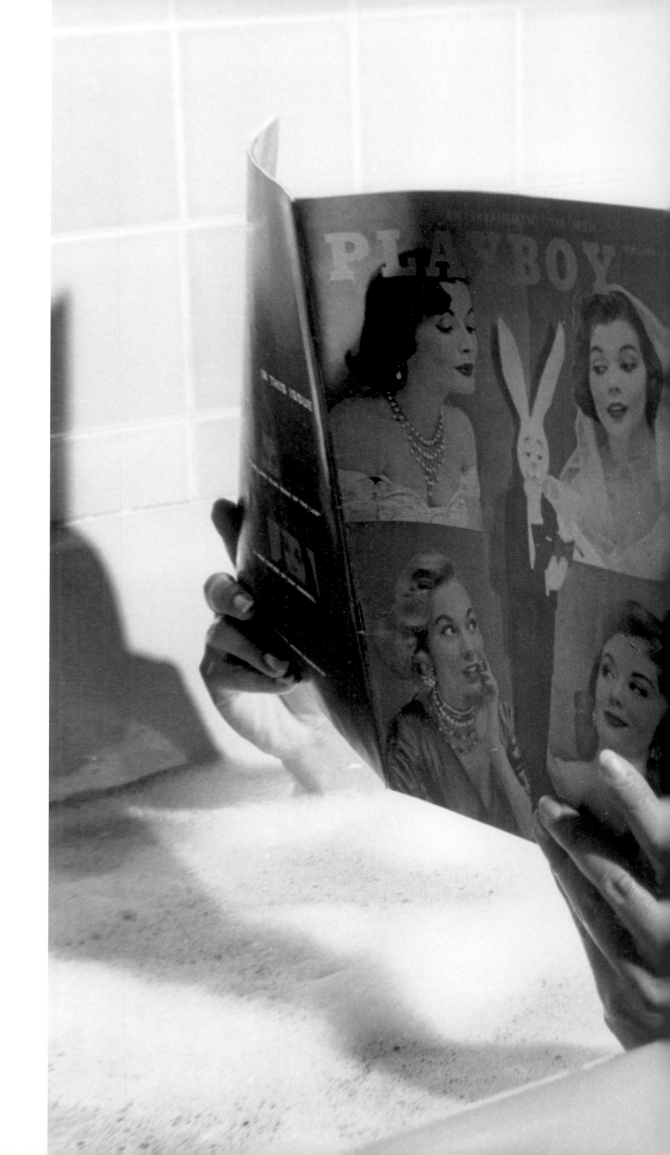

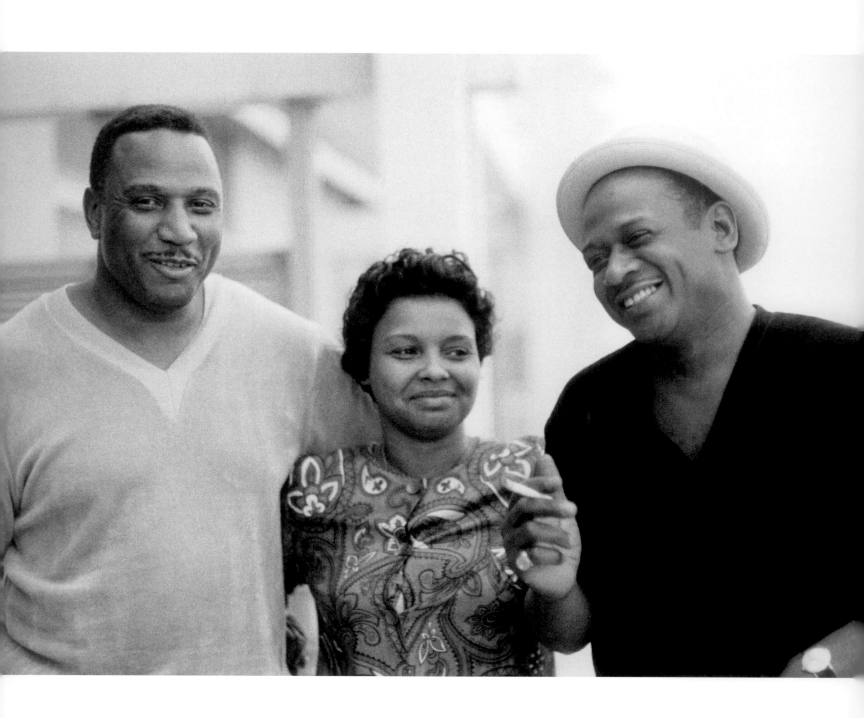

ABOVE: **George Rhodes, Shirley Rhodes, and Murphy Bennett**

George was Sammy's musical arranger-conductor. Murphy, or
"Murph" as Sammy called him, began as his valet and became
his confidant, carrying his money (never less than $10,000), and
signing his checks and sometimes even his autograph. Shirley,
George's wife, was Sammy's lifelong friend and president of
Sammy's company, TransAmerican Entertainment. She once
described herself as "the only woman who loved Sammy and
never slept with him."

OPPOSITE: **Murphy Bennett**

Murphy Bennett and
Joe Grant, Sammy's
bodyguard at the time
Half the life of a roadie is
traveling city to city, learning
to sleep anywhere.

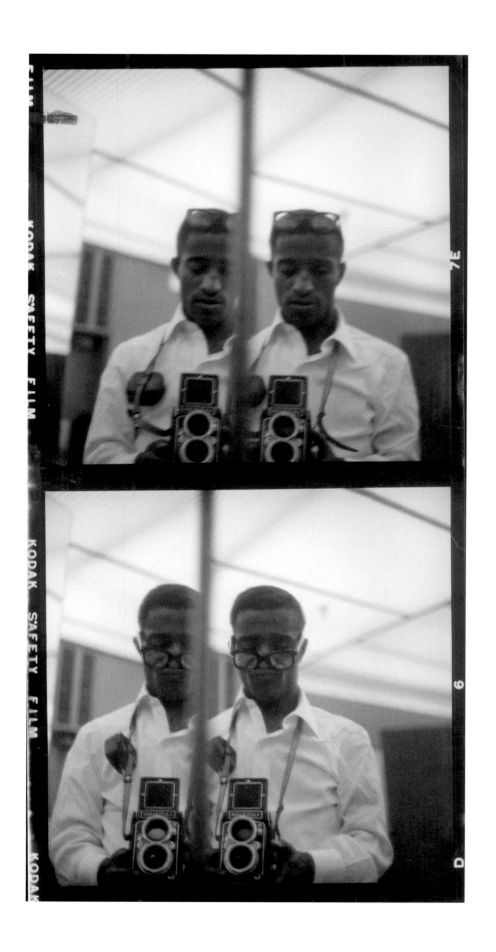

ABOVE: Sammy taking photos of himself in the mirror.

OPPOSITE: Murphy Bennett and May Britt

OVERLEAF: Sammy's roadies

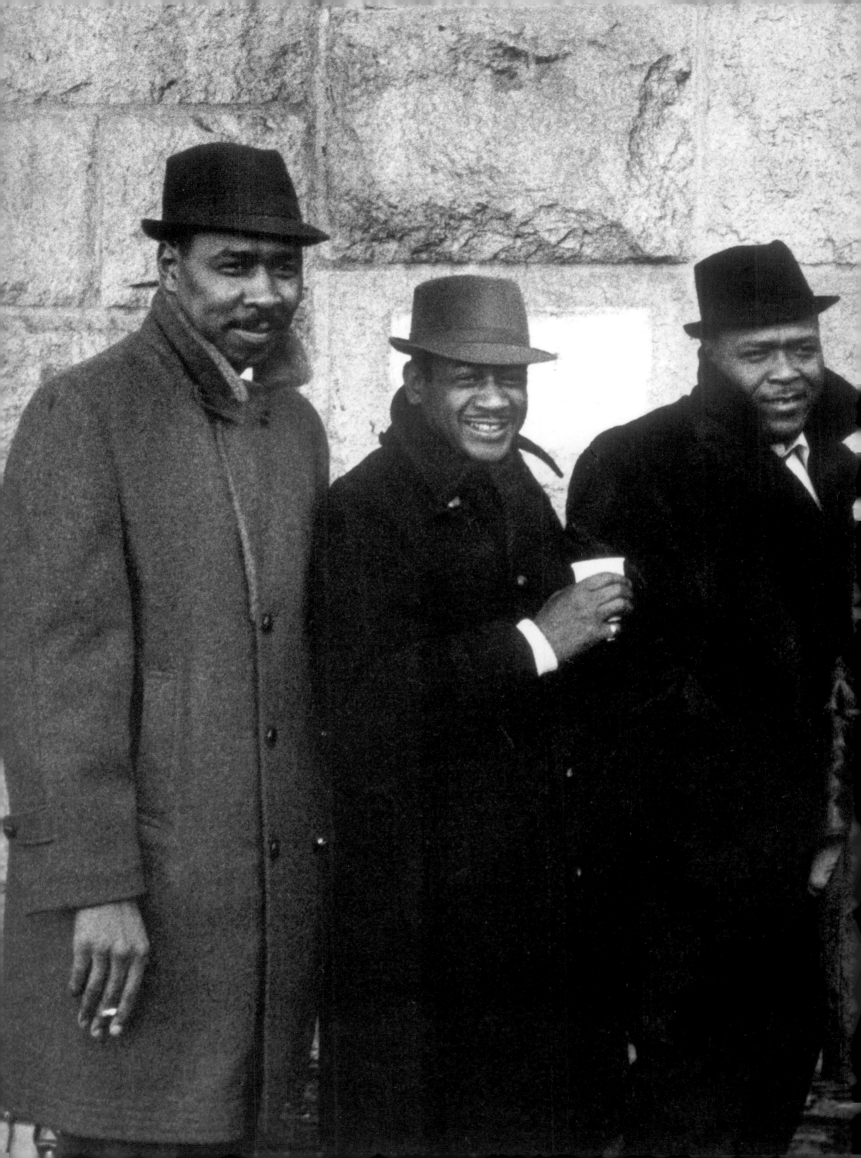

ABOVE: Outside the apartment in Harlem where the child
Sammy lived with Mama, the grandmother who raised him.

A New York street
scene, 1950s

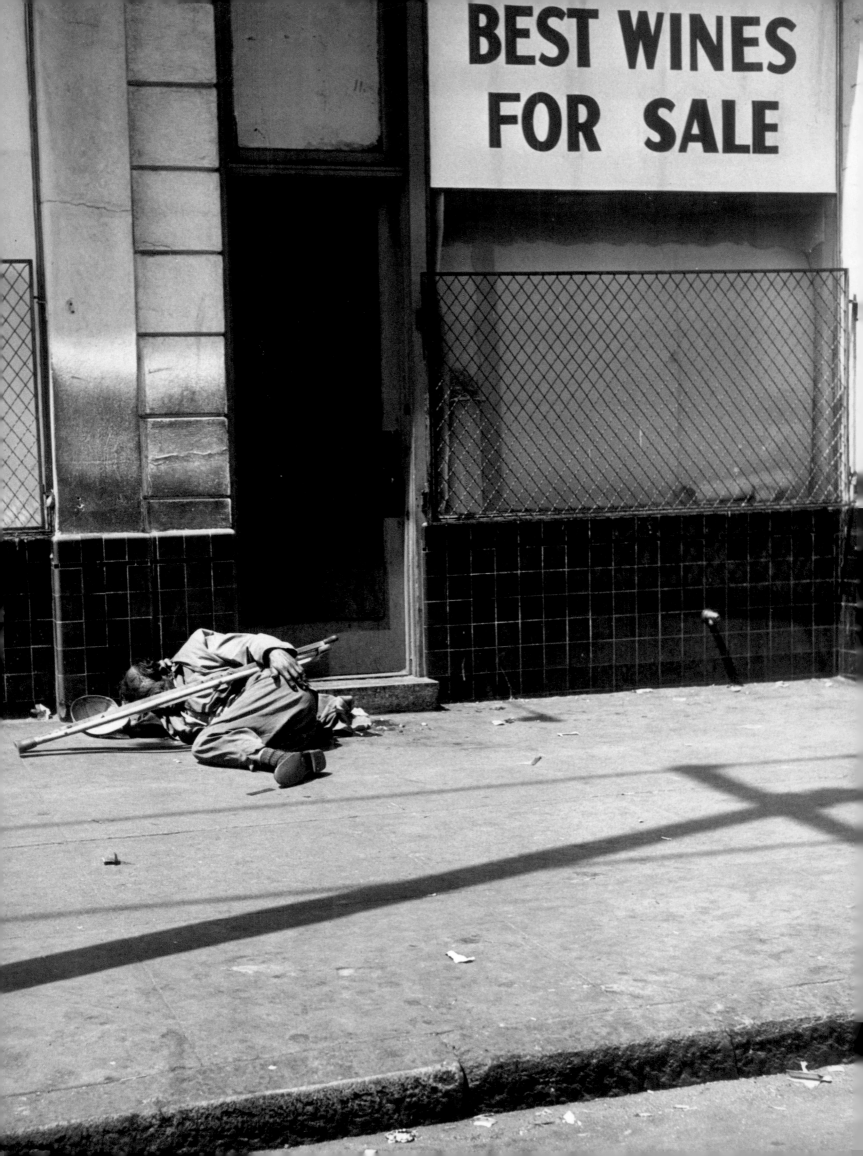

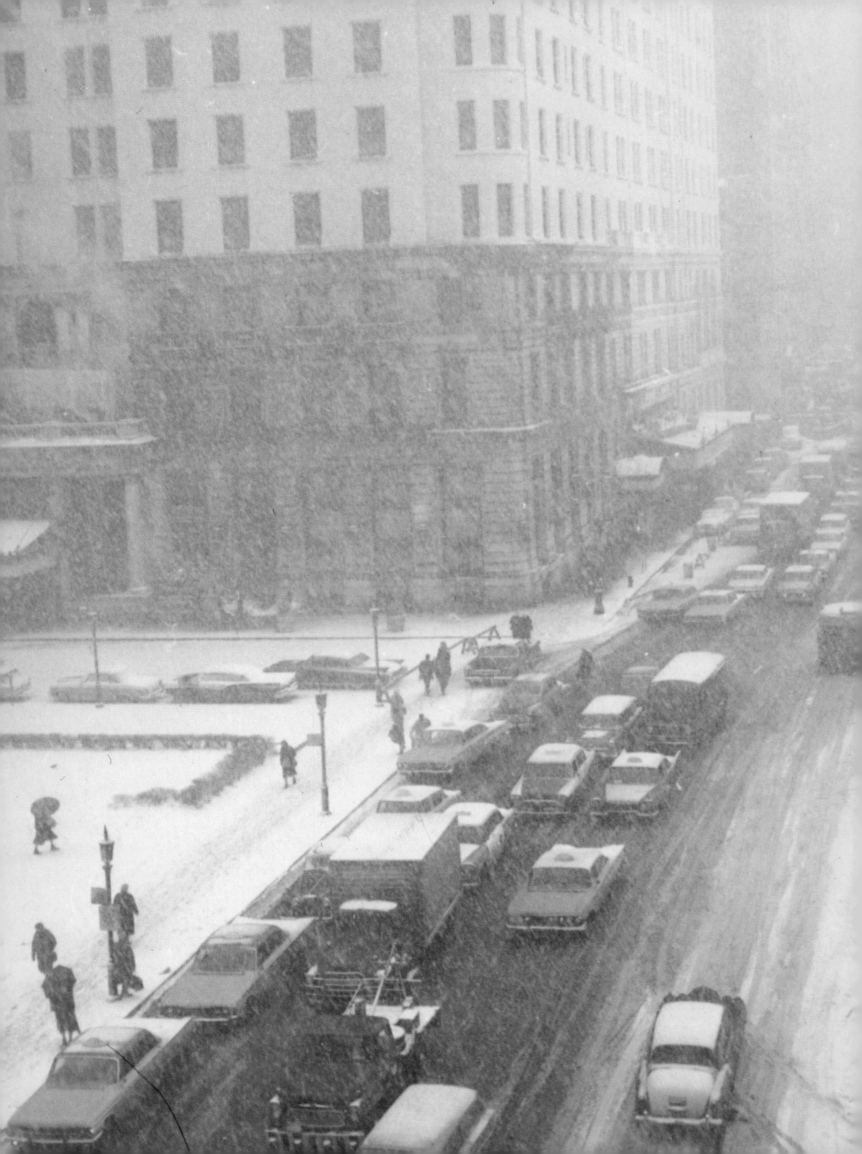

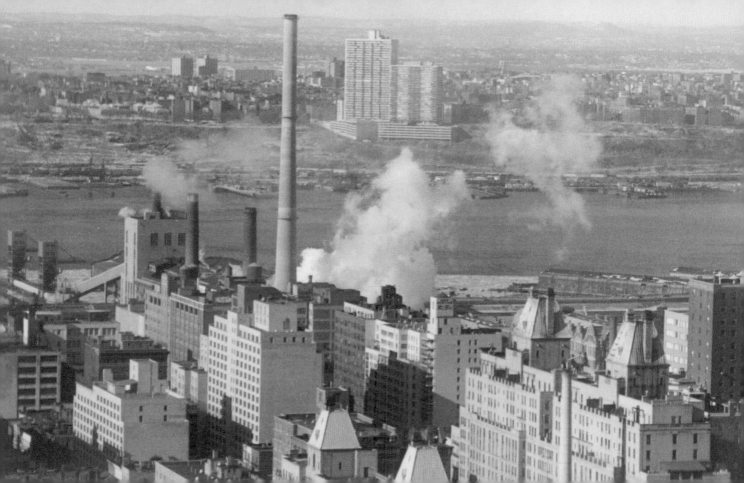

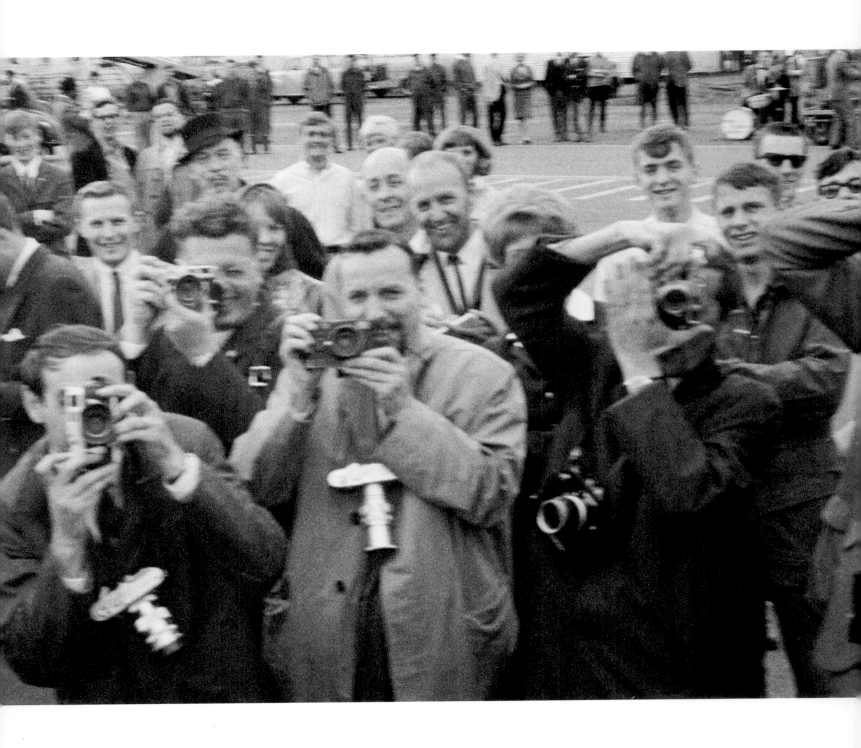

A favorite shot: photographing photographers photographing him.

OVERLEAF: Colony Record Shop

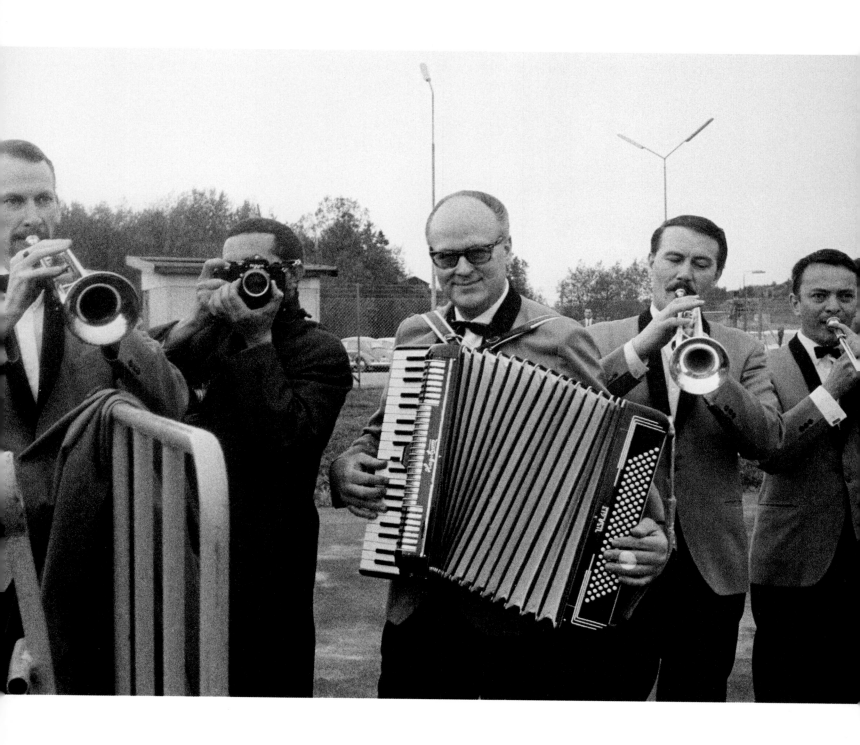

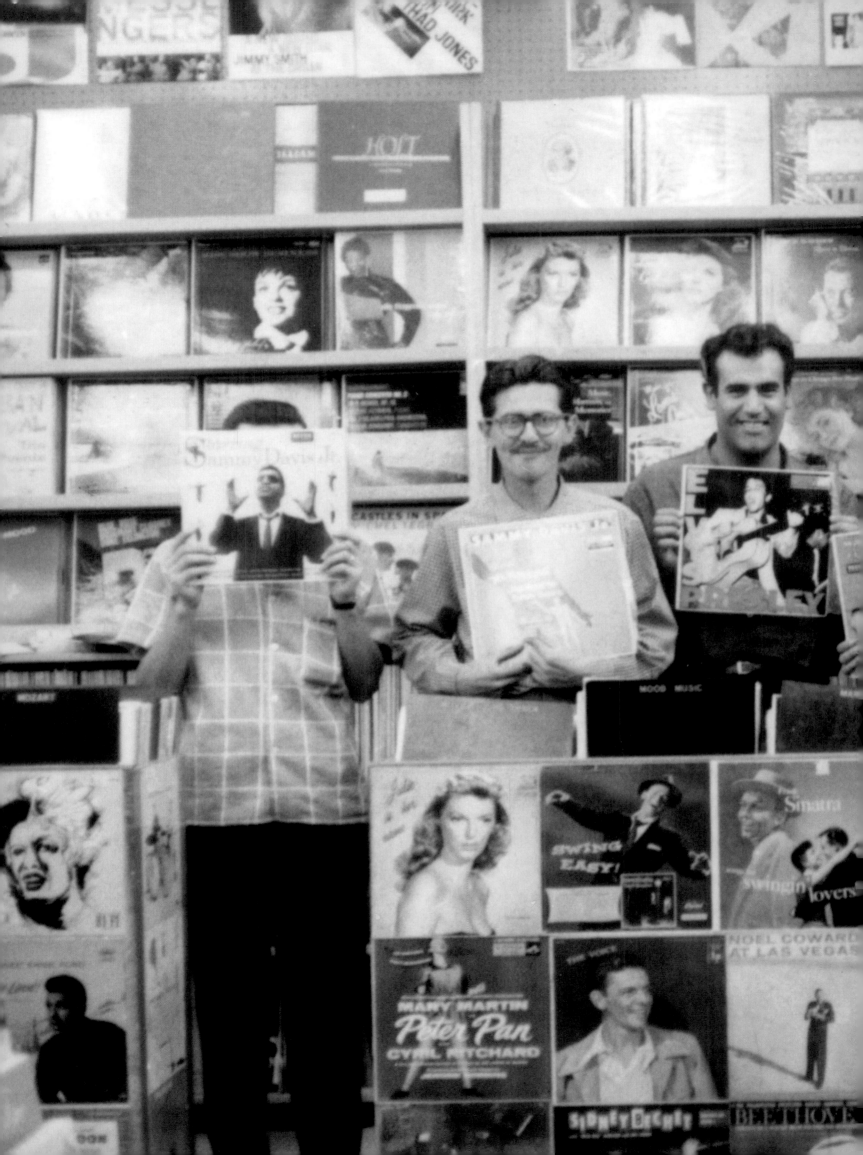

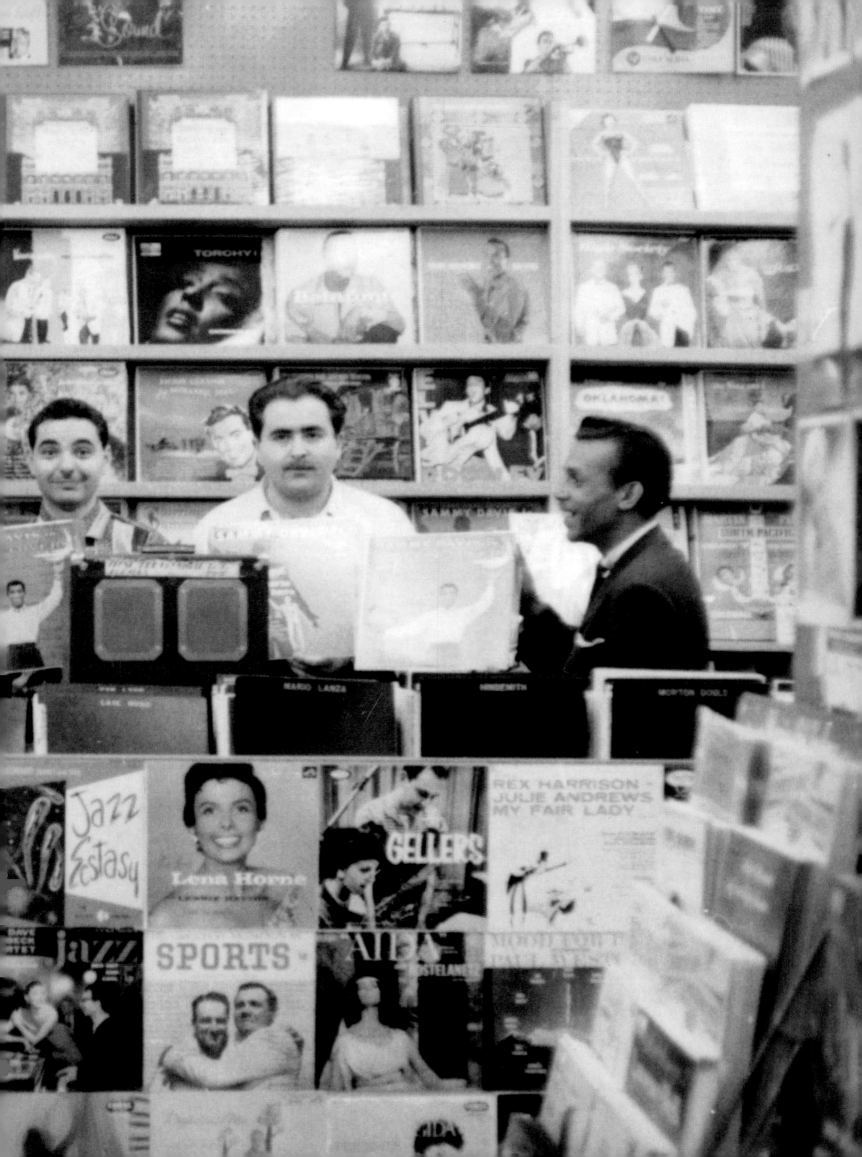

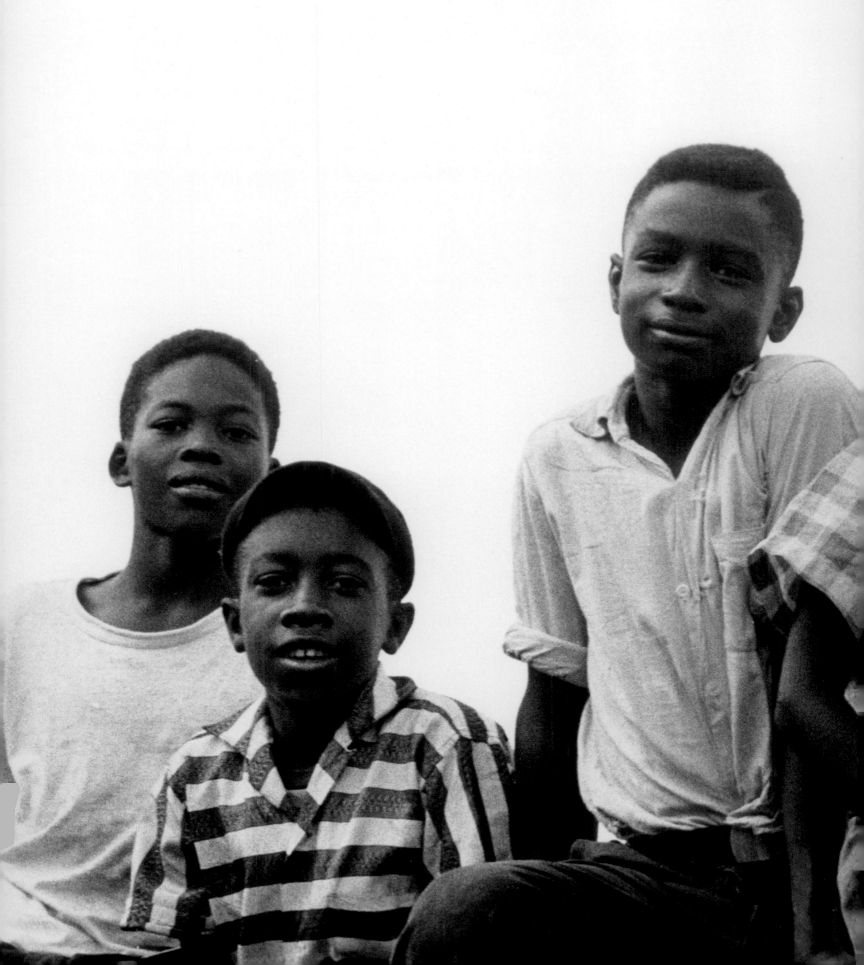

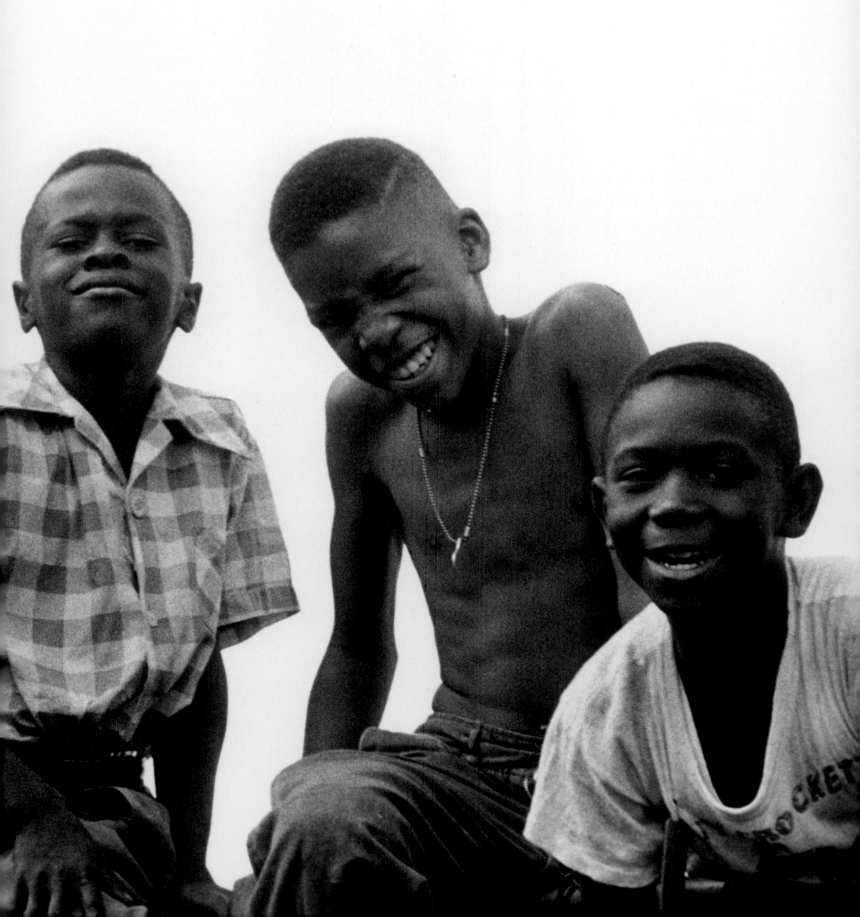

AFTERWORD

Following Sammy's passing, I would meet people who learned I had a connection to him. At first their faces lit up with pleasure: "Such a great talent ..." Then came a frown, "What a shame he was such a fool with money. Left his family broke ..." and, "I heard that Frank Sinatra had to pay for his funeral." Both are categorically untrue. The bum-rap of all time.

Sammy was as brilliant at living as he was at performing. He planned his life. He once confided to me, "What's really satisfying is to make a plan, work toward it, and see it work out." He also said, numerous times, "When I die I don't want them reading big numbers over my grave, like: 'He left twenty million...' If I hear that, I'm going to sit up and shout, 'You mean I *wasted* twenty million.' I'm going to *enjoy* my money." Sammy had no intention of leaving any unused cash behind.

But he was never irresponsible. To be certain that he took financial care of his wife and children in death as he did while he was living, he kept himself insurance-rich. Sammy died on May 16, 1990. On June 19, 1990, the National Fidelity Life Insurance Company issued check #44167 to Altovise Davis in the amount of $1,008,424.65. Another check, from Connecticut Mutual, #07139157, dated June 4, 1990, also payable to Altovise Davis, was in the amount of $285,862.80. There were seven other checks from Connecticut Mutual, making a total of $1,580,151.25. Additionally, each of Sammy's three children, Tracey, Mark, and Jeff, received checks for $500,000.00, and Sammy's ex-wife and the mother of his children, May Britt, received $250,000.00.

Then there were the pensions from the American Guild of Variety Artists, Screen Actors Guild, Actors Equity, and the American Federation of Television and Radio Artists. Sammy's lifetime earnings were immense. He worked forty to fifty weeks a year for fifty years, and toward the end was paid $250,000 a week in Las Vegas and other casinos; he always received top money on television. Performers' dues and contributions to pension and welfare funds are based on earnings, and their pension returns reflect those payments.

Sammy Davis, Jr., left his family financially better off than 99 percent of the world's population.

As to Frank paying for the funeral: he neither had to, nor did. Shirley Rhodes, who was the president of Sammy's company, went to Forest Lawn and chose and paid for—with company money—the finest casket and an elaborate funeral befitting her beloved friend, boss, and superstar.

Sammy's funeral ceremony was held on May 18 at Forest Lawn in Hollywood because they have a theater-size chapel,

whereas the chapel in Glendale, where he would be buried, was too small. Even the thousand-seater in Hollywood was not large enough. Hundreds waited outside. I know there were five eulogists, but the attendees are a blur. I remember Frank Sinatra entering the chapel from a side door at the front, escorting Altovise. With them were Milton Berle and Bob Culp, Red Buttons and Dean Martin, and Joey Bishop, Sidney Poitier, and May Britt. They were all seated in the front row with Altovise, who eulogized her husband. I'm sure that Shirley MacLaine was there because she loved Sammy, and it would not surprise me if Kim Novak slipped in unnoticed. I know that she quietly visited Sammy in the hospital just before the end. I can still see Gregory Hines crying, and Alan King and George Hamilton and Tony Curtis—like watching a kaleidoscope of Hollywood faces. Bill Cosby, who loved Sammy, was not there because he does not go to funerals.

The eulogists praised Sammy's humanitarianism. There was no worthy cause that he hadn't found the time and energy to help. And it was emphasized that the man to whom we were bidding farewell was also a significant hero of the civil rights movement, who suffered many a broken nose and broken heart pushing doors open—for himself, but always aware that others would be able to follow.

The interment was to be at Forest Lawn in Glendale, a forty minute drive.

In the history of Hollywood funerals the motorcade has always been a straggly, interrupted mess because the area between Hollywood and Glendale is composed of about a dozen townships and counties, all with separate police, possessive of their jurisdictions and never willing to allow a motorcycle escort of Hollywood police to pass through. A longtime friend of Sammy's, Mark Nathanson, took it upon himself to go to each and every police department and implore, "Sammy never said no to any of you when it came to a benefit or a contribution. He would be so happy if . . ." And for the first time, they all agreed to allow a Hollywood police motorcycle escort lead and protect the cortege of more than three hundred cars to pass uninterrupted all the way to Glendale with a dignity befitting the diminutive giant who was the greatest entertainer that ever lived.

During all the years he performed with the Will Mastin Trio, the group stood with Will on the right, Sam Sr. on the left, and Sammy in between them, dubbed by the press as "the kid in the middle." He was a showman to the very end. At the cemetery in Glendale, in a small gated area, there were two graves already filled: those of Will Mastin and Sam Sr. When Sammy was lowered to rest, it was in the open grave between his father and Will, a spot he had reserved long before.

And The World's Greatest Entertainer was once again The Kid in the Middle.

ACKNOWLEDGMENTS

With great affection, the author wishes to thank the following:

Mrs. Sammy Davis, Jr., Altovise Gore Davis, for graciously allowing the use of her late husband's photographs. And Alto's representative, Barrett LaRoda, who facilitated our access.

Judith Regan, who has more and better foresight than most people have hindsight.

Laurye Blackford, who edited this book with great skill, taste, and perseverance until she thought we had it right.

Literary agent, advisor, and friend, Irene Webb.

Robert R. Bloomingdale and Howard Burkons, my partners in the film version of *Yes I Can*, who discovered these thirty-to-forty-year-old photographs and negatives among Sammy's papers, and worked with me over the many months of restoration.

Shirley Rhodes, Sammy's dearest, lifelong friend, for her unwavering help and support.

Stephen Schmidt, whose creative book design took hundreds of images and thousands of words and gave them rhyme and reason.

And the fabulous team at Regan—Kurt Andrews, Adrienne Makowski, Suzanne Wickham and the entire production, publicity and marketing groups.

In Sammy's words, **"THERE IS NO SUCH THING AS A ONE MAN SHOW."**

BURT BOYAR was a longtime friend of Sammy Davis, Jr. whom he met in the late '50s when Davis was starring on Broadway in *Mr. Wonderful* and Boyar was a Broadway columnist. Along with his late wife, Jane, Boyar collaborated with Davis on his bestselling memoir *Yes, I Can*, published in 1965 and on *Why Me?* published in 1989. He lives in Los Angeles, California.

To receive notice of author events and new books by Burt Boyar, sign up at www.authortracker.com.